Early Theravādin Cambodia

Perspectives from Art and Archaeology

Early Theravādin Cambodia

Perspectives from Art and Archaeology

Edited by
Ashley Thompson

NUS PRESS
SINGAPORE

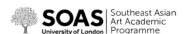

SOAS
University of London | Southeast Asian
Art Academic
Programme

Published by NUS Press with the Southeast Asian Art Academic Programme,
SOAS, University of London under the Art and Archaeology of Southeast Asia:
Hindu-Buddhist Traditions Series.

NUS Press
National University of Singapore
AS3-01-02
3 Arts Link
Singapore 117569

Fax: (65) 6774-0652
E-mail: nusbooks@nus.edu.sg
Website: http://nuspress.nus.edu.sg

ISBN 978-981-325-149-6 (casebound)

National Library Board, Singapore Cataloguing in Publication Data

Name(s): Thompson, Ashley, 1965- editor.
Title: Early Theravādin Cambodia : perspectives from art and archaeology / edited by
 Ashley Thompson.
Other Title(s): Art and archaeology of Southeast Asia : Hindu-Buddhist traditions.
Description: Singapore : published by NUS Press with the Southeast Asian Art Aca-
 demic Programme, SOAS, University of London, [2022]
Identifier(s): ISBN 978-981-325-149-6 (casebound)
Subject(s): LCSH: Cambodia--History. | Buddhism and state--Cambodia. | Bud-
 dhism and art--Cambodia.
Classification: DDC 959.6--dc23

Cover image: Head of Buddha image from Western Prasat Top (Monument 486),
Angkor Thom, Cambodia. Photograph courtesy Inoue Tadao, 2010.

Concept and typographical design by: H55

Printed by: Mainland Press Pte Ltd

To the sculptors and scribes who made the work we seek to understand.
To the practitioners who gave and give it meaning.

CONTENTS

LIST OF FIGURES, MAPS AND TABLES

LIST OF FIGURES

LIST OF MAPS

LIST OF TABLES

TECHNICAL NOTES

ON LANGUAGE

For the spelling of Khmer proper names and toponyms we use established phonetic transcriptions when these exist. This can be cause for confusion in particular as some established spellings used in English are derived from French usage and do not render Khmer pronunciation. For example, "Preah Pean" is the established English-language version of the French "Preah Péan" which is a loose French phonetic rendering of late 19th-century Siem Reap provincial pronunciation of what would appear today in transliteration as *braḥ bān'*, translated as "[Gallery of] a Thousand Buddhas", an area inside Angkor Wat temple. Despite its evident disadvantages, our choice to maintain established usage is meant to facilitate scholarly connections over time and space.

Otherwise, we use transliteration to render Khmer written forms. For the transliteration of Khmer, we use the relatively simple system set out by Saveros Lewitz in 1969 ("Note sur la translittération du cambodgien", *BEFEO* 55, pp. 163–9). For extensive commentary on relative advantages for the many developments on this system used in epigraphic, manuscript and print contexts and for different script types, see Michel Antelme, "Inventaire provisoire des caractères et divers signes des écritures khmères pré-modernes et modernes employés pour la notation du khmer, du siamois, des dialectes thaïs méridionaux, du sanskrit et du pāli", *Bulletin de l'AEFEK* 12, June 2012, pp. 1-81 (https://www.aefek.fr/wa_files/ antelme_bis.pdf); and Trent Walker, "Unfolding Buddhism: Communal Scripts, Localized Translations, and the Work of Dying in Cambodian Chanted Leporellos", PhD dissertation, University of California, Berkeley, vol. 1, pp. xiii–xix.

Both Sanskrit and Pāli appear in Khmer usage over time. Pāli forms are used throughout this volume, with the exception of Sanskrit terms adopted in English usage, such as "dharma", and those required by context. This too can lead to confusion, when for example in one text (the Introduction) the Sanskrit form "Maitreya" is used to designate the future Buddha to best reflect widespread Khmer usage historically and today, while in other chapters the Pāli "Metteya" is used with reference to specific Pāli texts and to maintain internal chapter consistency. We presume nonetheless that any confusion can be overcome through understandings of the particular historical Theravādin complex in which both forms can maintain. All Sanskrit and Pāli terms appear in transliteration, likewise

with the exception of common toponyms and other words commonly used in English without diacritics – such as the term "Sanskrit" – and/or in phonetic transcription. Our usage of the Sanskrit/Pāli terms designating funerary or commemorative monuments is exceptional in its complexity as we attempt to attend to specificity of usage in multiple academic and local Buddhist practitioner milieux. Throughout the volume readers will find the Sanskrit *stūpa*, which is the best known designation of the Buddhist funerary monument in English-language academic literature broadly defined (although the term is not used in this designation in Khmer). The Sanskrit *caitya*, which has been used in the art historical literature of Cambodia to designate a type of monolithic sculpture with a *stūpa*-like form, appears with reference to one exemplar of this type (although the type is not known to have ever been called *caitya* in Khmer). The Pali *cetiya*, used in both Khmer and Thai to designate the Buddhist funerary monument, appears in both transliteration (*cetiya*) and phonetic transcription (*chedei*), as the latter form is commonly used in academic literature on Khmer and Thai culture.

Cambodian author names generally follow Khmer usage, with the surname preceding the first name. There is thus no comma separating the two in bibliographical entries, while footnote entries maintain Khmer word order. For example, "Ang Choulean" appears as such in both footnotes and bibliography. Exceptions to this rule maintain for authors who have themselves established Western usage. Thus "Saveros Pou" appears as such in footnotes, but as "Pou, Saveros" in bibliographical entries.

ABBREVIATIONS AND ACRONYMS

AA: *Arts Asiatiques*
ANM: Angkor National Museum
BEFEO: *Bulletin de l'École française d'Extrême-Orient*
DCA: Dépôt de la Conservation d'Angkor
EFEO: École française d'Extrême-Orient
FAD: Fine Arts Department, Thailand
IMA: *Inscriptions moderne d'Angkor*, Middle Khmer inscription inventory number prefix
JA: *Journal Asiatique*
JFCA: Journal de Fouilles de la Conservation d'Angkor [manuscript, unpublished, EFEO Archives]
JSS: Journal of the Siam Society
K.: "Khmer", inscription inventory number prefix
Ka.: National Museum of Cambodia stone sculpture inventory number prefix

Mod. Kh.: Modern Khmer
Mid. Kh.: Middle Khmer
NMC: National Museum of Cambodia
NRICPN: Nara National Institute for Cultural Properties
PEFEO: Publications de l'École française d'Extrême-Orient
RCA: Rapport de la Conservation d'Angkor [manuscript, unpublished, EFEO Archives]
MG: Guimet – Musée national des arts asiatiques object inventory number prefix

ACKNOWLEDGEMENTS

I am grateful to Hiram W. Woodward for his careful review of early drafts of each of the essays included here. His life's work underpins the volume in multiple ways. The vast network of colleagues who supported the refinement and completion of individual essays with thoughts, sources, data, images and enthusiastic care continues to impress me: I add my deep thanks to the individual credits to these people appearing throughout the volume. I second the authors also in thanking the anonymous peer reviewers for their insightful comments.

I am grateful also to Peter Schoppert of NUS Press for his steady support of the volume, and the new series of which it is a part. And finally, thanks are due to the SOAS Southeast Asian Art Academic Programme and the Alphawood Foundation whose financial support has contributed in no small way to making the book and the series possible.

MAPS

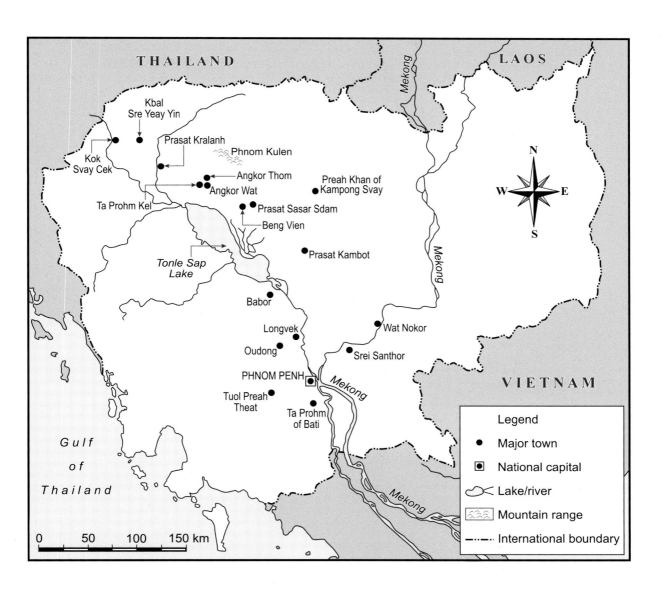

Map 0.1 Cambodia, showing places discussed in this volume.

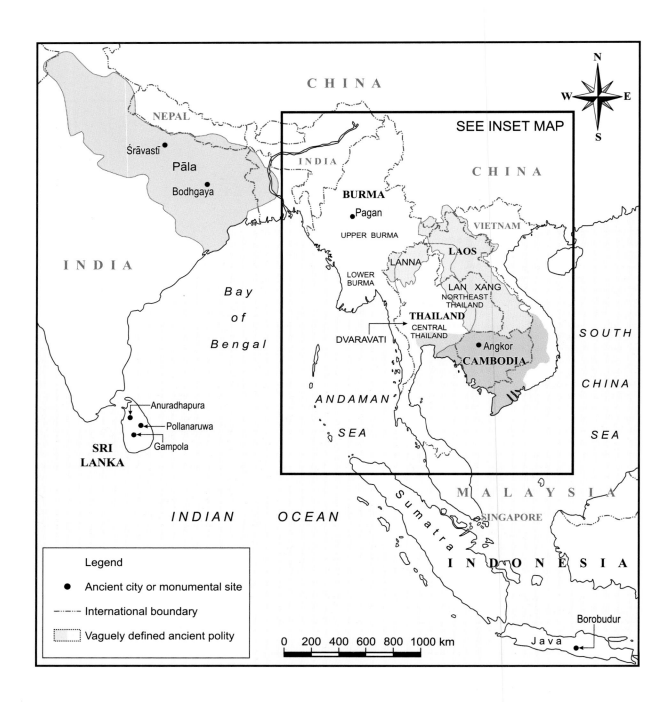

Map 0.2 Second millennia Southeast Asia in its regional setting: A historical palimpsest showing places discussed in this volume.

Map 0.3 Inset map of second millennia Southeast Asia in its regional setting.

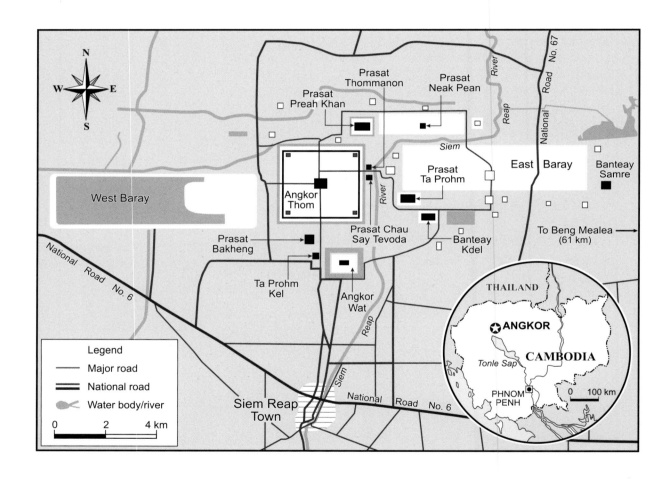

Map 0.4 Central Angkor, showing places discussed in this volume.

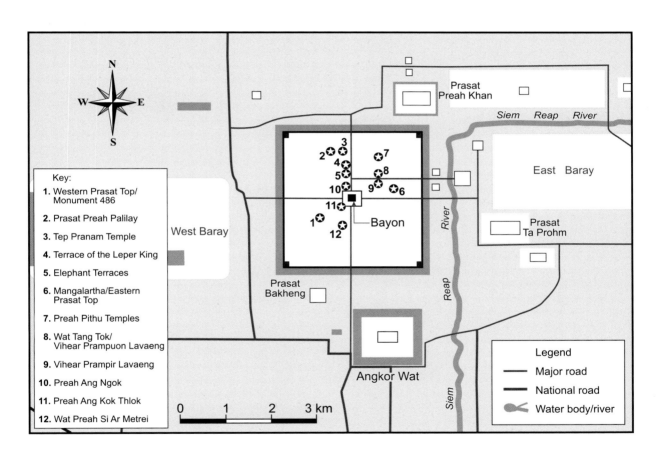

Map 0.5 Angkor Thom, showing places discussed in this volume.

EARLY THERAVĀDIN CAMBODIA: TERMS OF ENGAGEMENT

Ashley Thompson

The present volume is a response to a growing sense of the need and potential for breaking down the national barriers which have long defined the bulk of art historical and archaeological research on Cambodia's post-Angkorian or Middle Period (for our initial purposes here, dating from the 13th to 18th centuries), and for energising the interpretive dimensions of this area of study in methodological and theoretical terms. While the significant strides made, largely in empirical terms, in the fields of Middle Cambodian art history and archaeology in the past two decades are matched by those, largely in interpretive terms, in Theravādin Buddhist Studies, little dialogue exists between these two bodies of scholarship. One group has been homing in on Cambodia as the other has sought to conceive the commonalities of a cosmopolitan religion anchored in very local realities differing over space and time; one has focused on refining understandings of chronological historical developments in Cambodia, while the other has sought to sound the *imaginaires* borne by Theravāda Buddhism more broadly. Conceptual innovations in the field of Middle Cambodian history seeking precisely to account for the preponderant role of Buddhist *imaginaires* in the historical developments after Angkor have furthermore remained largely beyond the purview of both of these groups.

Emblematic of the progress in Buddhist Studies is a 2012 essay by Sven Bretfeld, "Resonant Paradigms in the Study of Religions and the Emergence of Theravāda Buddhism".[1] In this piece, Bretfeld advances a sonic metaphor to encapsulate his complex reading of the "emergence of Theravāda Buddhism" in the 19th to 20th centuries through the contact developed between Orientalist research and contemporary transformations in the Buddhist world of Sri Lanka. He writes,

> The stress of this approach lies on the *relational* notion of religion, which could be described metaphorically as a polyphone 'concert' of different agencies, interests, ideas and power relations. Religion 'sounds' different depending on

> who speaks about or for it, and depending on who is
> observing and who is observed. Nevertheless, all these voices
> are interrelated and 'resonate' each other. Focusing on
> resonances, the religious field can be analyzed as a
> polymorph, dynamic formation emerging from the effects of
> contact.[2]

With this approach, furthered in other publications detailing the work of intra-Buddhist relations in earlier historical moments as these laid the ground for this modern "emergence of Theravāda Buddhism", Bretfeld acknowledges the necessity and insights of postcolonial critique of the study of "religion" while striving to overcome its critical pitfalls. There is not one single origin of Theravāda Buddhism – be it in the veritable words of the Buddha as some Buddhist texts suggest, or in those of the Orientalist as suggested by some postcolonial critics; instead in Bretfeld's words we hear the term "emergence" chiming with the paradigm of "resonance" to encourage us to tune our ears to the "concert" that is Theravāda Buddhism.

A preliminary title of the present volume, *The Emergence of Theravāda Buddhism in Cambodia: Perspectives from the History of Art and Archaeology*, echoed such concerns. This title was however ultimately overridden by other concerns emerging from the specificity of the project on early Middle Period Cambodia, probing in particular 12th- to 14th-century developments. *The Emergence of Theravāda Buddhism in Cambodia* came to suggest to my ears an awkward, imprecise premise that the two substantives – Theravāda and Cambodia – could be separated, with the dynamic, polyphonous emergence of the one (Theravāda) set against the backdrop of the other singular, static, defined entity of the other (Cambodia). In modifying the title to *Early Theravādin Cambodia: Perspectives from the History of Art and Archaeology*, I have sought to signal something more on the order of a co-emergence, to affirm the integral role of Theravāda in defining the Cambodian state after Angkor, and to suggest that just as Theravāda was making Cambodia, so was Cambodia making Theravāda. Yet another alternative title to our volume could have been thus *Early Cambodian Theravāda: Perspectives from the History of Art and Archaeology*.

The pendant to Bretfeld's work on Theravāda in the field of Cambodian history is for me Grégory Mikaelian's 2012 "Des sources lacunaires de l'histoire à l'histoire complexifiée des sources. Éléments pour une histoire des renaissances khmères (c. XIV–c. XVIIIe s.)" [From lacunary sources of history to the complicated history of sources. Elements for a history of Khmer renaissances (c. XIVth–c. XVIIIth centuries.)].[3] In this essay, Mikaelian throws down the gauntlet to his

peers and successors, challenging us to transcend the tired colonially riveted view of Cambodia's "decline" after Angkor purportedly reflected at once in the relative dearth of historical sources and the self-effacing piety of Theravāda Buddhism. Mikaelian's complaint that colonial scholars, like those mimicking them in their wake, have seen nothing but the absence of historical sources after Angkor resonates with Bretfeld's subtle corrective to conclusions drawn from the postcolonial revelation that the term "religion" and its –isms have no term-for-term equivalent in many non-Western contexts in which the said "religions" have been expounded upon for centuries by Western scholars. The two authors point up the same methodological misstep in which scholars seek mirror images of Euro-American constructs in their non-Euro-American objects of study. Some have sought and purported to have found "exact matches of the contingent concepts fashioned in specific European discourse"[4]; others seeking and not finding any such match have refashioned the formers' purported discovery as mere invention. In what I would like to call a decolonising approach whereby we seek the multiple disparate agencies participating in the construction of any historical matrix – which is never short of interpretation – Bretfeld sees neither the presence nor the absence of "Buddhism" in premodern Sri Lanka; rather he sees how

> the 'isms' of Religious and Buddhist Studies resonate reificated conceptualizations of the Teaching of the Buddha that have already been used for centuries in Sri Lankan differentiations that singled out specific material, cognitive, pragmatic and experiential spheres of social and individual life, as well as condensed them in a conceptual design that we can render as 'Buddhism'....[5]

Likewise, Mikaelian's critique does not aim to demonstrate the absence or the presence of Middle Cambodian historical sources per se. Instead, he advocates probing material and textual cultures as forms of historical sources embodying local conceptualisations of history and realisations thereof. For Mikaelian these barely tapped sources for understanding Cambodian history after Angkor are intimately linked to court and religious centres and are themselves contingent upon Buddhist perceptions of cyclical rebirth – the "renaissances" of his title. They are the inland heart whose beat set the historical rhythms of a Cambodia evolving integrally with the Southeast Asian region, in what came to be known as the age of commerce. To hear the resonance of these sources with the accounts of Chinese chronicles or Portuguese missionaries, or even with Euro-American "history" derived from or mirrored in modern Cambodian chronicles ... one must be able to hear them, first, on their own Buddhist terms.

The present volume aims to go some way towards achieving this interpretive goal, and to provide others with materials and pathways for going further. In the following I will explore the terms of our title in further detail before presenting each of the volume's chapters with an eye on ways in which art historical and archaeological work can contribute to these broader conversations in Buddhist studies and Southeast Asian history while also evolving themselves through the contact.

"THERAVĀDA"

What is it that scholars have for so long and often blithely called "Theravāda" Buddhism? What is it, specifically, in Cambodia after Angkor, the ninth- to thirteenth-century Khmer polity dominated by Hindu religio-political expression and which dominated mainland Southeast Asia in its time? What are its sources? Its ingredients? How did it shape the land and the people – physically, socially and conceptually? And how was Theravāda shaped by them? The work presented here reinforces contemporary Buddhist Studies scholars' questioning of the salience of the term "Theravāda" to characterise apparently dominant religious practices across mainland Southeast Asia in the second millennium. The revolution in Buddhist studies has been anchored in textual analyses producing fresh insight into the modern shaping of a general usage of the term itself contrasted with specific and limited usage in the relevant historical textual records, and a concomitant frustration with the persistent assimilation of the two related but distinct historical groupings of "Theravāda" and "Hinayāna" in defining contrast with "Mahāyāna"; the authors in this volume, on the other hand, take to the ground, revealing the ways in which material evidence can attest to a specific cultural complex bearing the hallmarks of Theravāda without, however, reinforcing the essentialist stereotypes by which the latter has come to be defined.

The volume is effectively a modest and circumscribed sequel to the seminal 2012 collective volume *How Theravāda is Theravāda?*, a title that itself boldly pursued the lead of Prapod Assavavirulhakarn in his 2010 *The Ascendancy of Theravāda Buddhism in Southeast Asia*.[6] Both publications prompt readers from the outset to consider the interpretive balancing act required to convey the context in question with adequate nuance. Readers will immediately note the unbalanced treatment of the term "Theravāda" in Assavavirulhakarn's monograph: the straightforward usage of the volume's title is retracted on opening in its table of contents, with the term appearing in scare quotes in the penultimate chapter title: "'Theravāda Buddhism' in Southeast Asia". The oxymoronic logic underpinning the title *How Theravāda is Theravāda?* presents the same

challenge. Maintaining the term while interrogating its authority, this title posits Theravāda as an undecidable category: it both *is* and *is not*. The titles and subtitles in question query Theravāda in ontological terms. This is not just a case of correcting inaccurate past scholarship. Nor is it reducible to the general conundrum faced by all of us bricoleurs as sketched by Jacques Derrida in response to Claude Lévi-Strauss: like any other we cannot construct the totality of our language and are instead bound to borrowing from "the text of a heritage that is more or less coherent or ruined".[7] But insofar as modern scholars of Buddhism are largely themselves – and ourselves – responsible for the coining of the term as a blanket cover for a range of practices many of which do not readily correspond to the defining criteria which we, likewise, have attributed to it ... we are doubly bound: to developing critical awareness of our past and present usage of the term, and to correcting the distortions in interpretation induced by more than a century of usage. In privileging close analysis of specific material evidence of Theravāda in early Middle Cambodia, the present volume is attentive to this ongoing reassessment across the Buddhist studies field, and means to inform the same in some small way.

A 1997 essay by Peter Skilling entitled "The Advent of Theravāda to Mainland Southeast Asia" is a key precursor to these book-length studies.[8] In opening, the essay makes a simple but crucial point in highlighting the contrast between the distinct development of a historically conscious *thera*-related collective identification in first-millennium Sri Lankan Pāli literature and the lack of like textual production beyond the island in this period. The dominant textual evidence of what will come to be called Theravāda in first-millennium mainland Southeast Asia is instead in the Pāli epigraphic record in which Pāli scriptural extracts and commentarial references feature extensively, attesting to liturgical practices and doctrinal orientations rather than historiographical ones. Both types of writing practice could attest to modes of defining affiliation, though the latter, Southeast Asian citational writing, does not convey in any explicit way the self-productive institutionalised determination to categorise monastic-institutional affiliation evidenced in the Sri Lankan chronicular traditions. Instead of examining usage of the term "Theravāda" or other associated appellations, Skilling's essay compiles and analyses the epigraphic evidence for both the use of the Indic Pāli language and references to the Pāli canon and known Pāli extra-canonical works in the first millennium of the Common Era. Noting how Buddhist traditions themselves recognised dialect as a defining feature of different schools, Pāli and references to Pāli literature are taken as "a strong indication of Theravādin activity in the region", in fact suggesting the predominance of Theravādin practices in the Irawaddy and Chao Phraya river basins from the fifth century. The

essay comprises a concise and cogent guide to Theravāda in the mainland at this time, warning all the while, however, that the affirmation of Theravāda is not to be assimilated with affirmation of a monolithic religious society in any one place or across the region as a whole.

The comprehensive sequel to the above-mentioned work treating Theravāda as a heterogeneous whole is Kate Crosby's 2013 *Theravāda Buddhism: Continuity, Diversity and Identity*.[9] Crosby's volume, a monograph-cum-textbook for specialised students, goes a long way toward clarifying the unifying factors of Theravāda *and* highlighting the diversity of practice therein. Crosby explicitly distinguishes her approach from that of her contemporaries struggling "to untangle the extent to which 'Theravāda' is *thera-vāda*", highlighting in her formulation the lingering concern with linking what we call Theravāda to the authentically ancient "word" (*vāda*) of the "Elders" (*thera*, the Buddha's early disciples). Crosby instead stakes her claim to a critical subject position amongst those who positively "identify themselves as Theravāda Buddhists now and in recent history" as well as their predecessors, "those who contributed to the creation and continuity of the forms and manifestations of Buddhism on which 'Theravāda Buddhists' have been able to draw".[10] The purported shift is a subtle one, privileging exploration of the histories and effects of what have come to be known by "Theravādins" as "Theravādin" forms while still accounting for the impact of modern academic interpretation. Still, Crosby's Introduction reiterates in its own manner Assavavirulhakarn's varied usage of the term "Theravāda"; only with Crosby we begin with the scare quotes and end with their removal. Crosby's first subsection, "Problems with the Definition of 'Theravāda Buddhism'" is paired, thus, with a closing subsection entitled "Revisiting Conceptions of Theravāda", a summary of advances the book makes in addressing the previously defined problems.

What, then, is the now abundantly critiqued vision of Theravāda that the present volume encounters? At the risk of reducing inordinately the reductive characterisation under fire, this vision of "Theravāda" in fundamentally flawed ontological terms is: a form of Buddhist doctrine and practice characterised by the use of the cosmopolitan Indic Pāli language to the exclusion of Sanskrit, and core reference to the Tipiṭaka (Pāli canon), specifically including what are considered early Buddhist texts, the *Vinaya* (texts setting out the monastic discipline) and the *Sutta* (discourses attributed to the Buddha), as well as a third, later *Abhidhamma* (systematic elaboration of doctrine) section, along with commentaries on the canon; a privileging of the extended life story of the Historical Buddha Sākyamuni; a conservative adherence to the Historical Buddha's own words, and so to an originary, pure form of Buddhism; a monastic commitment to personal salvation structuring a fundamentally

apolitical orientation of the religious order at large and, paradoxically, a democratic opening to ordinary people to participate in core practice.

In the above well-established – and now well-critiqued – vision of Theravāda, each of the above traits is set starkly against the counter-traits defining Theravāda's supposed other, Mahāyāna Buddhism and its offshoot, Vajrayāna: the use of the cosmopolitan Indic Sanskrit language; reference to the same first two sections of the early Buddhist canon *plus* a large body of other writings including different *Abhidharma* texts and evincing an embrace of notions of revelation by a Buddha continuing to disseminate teachings from a heavenly realm;[11] investment in the simultaneous multiplicity of Buddhas and bodhisattvas (Buddhas-to-be) and associated esoteric practices; a monastic commitment to communal salvation underpinning the imbrication of religion in politics.[12]

Allow me a few comments on the above definitions with reference to both Crosby and the focus of the present volume, before directly addressing the other two operative terms of our volume title – Cambodia and periodisation. The thick contextualisation that preoccupies each author in this volume in and of itself challenges the characterisation of Theravāda as maintaining a privileged relationship with early Indian Buddhism. As Crosby aptly notes, Theravāda is "the process and product of over two and a half millennia since the historical person referred to as the Buddha began preaching the teachings and institutions from which all forms of Buddhism developed".[13] Integral to the ongoing re-evaluation of Theravāda Buddhism is an awareness that historically conditioned ideological appeals to maintaining a connection to early Buddhism must be distinguished from the connection itself. In art, the appeal is perhaps best expressed in an emphasis on representations of the so-called Historical Buddha. Of course, the connection-cum-divide between the actual and the ideological lies at the heart of the long artistic history of representation of the Historical Buddha where the factitiousness of representation itself is perpetually challenged and obscured through ritual processes of image animation. There are myriad ways by which images of the "Historical" Buddha have long been made to live in the here and now. On a more practical level, the predominance of iconographic representation of the Historical Buddha Sākyamuni in early Theravādin Cambodia remains hypothetical. In the absence of specific narrative context, be it textual, iconographic or compositional, we cannot know how Buddha images were identified by their makers and users; evidence suggests in fact a discrepancy between, on the one hand, the common art historical identification of "the Buddha" which presumes a singular historical figure and, on the other hand, local practices by which Buddha images embody multiple identities, ranging from other Buddhas to local historical or legendary figures. Underpinning this capacity to

embody more than one identity is the fact that the "Historical Buddha" is himself larger than life. The Buddha is understood to have been a real historical figure whose career as a religious practitioner and teacher in the fifth century BCE laid the ground for what we now call "Buddhism". Before becoming a "Buddha" or "Enlightened One", he was a prince named Siddhattha Gotama of the Sākya clan. This historical figure is sometimes called the Gotama Buddha after his family name, or the Sākyamuni Buddha, the "Buddha, Sage of the Sākya Clan". However, in the historical context at hand, nothing would suggest that reference to this historical figure is ever devoid of the mythic, supernatural dimensions of the same figure's life story. Beyond the factitiousness of representation, we must query to what degree a given image of the Sākyamuni Buddha is perceived to be without attributions of divinity and attendant soteriological powers, and is in such a reflection of "realism" – Crosby's term for the problematic scholarly investment in the Historical Buddha typically taken to define Theravāda up against its Buddhist others. Furthermore, when depicted in the absence of textual or sculpted narrative context, many Buddha images appearing in milieux presumed to be Theravādin cannot be simply or singularly identified as representing Sākyamuni; tautological arguments can dominate here, where the Buddha presumed to be Sākyamuni confirms the Theravādin context underpinning that same presumption. At every step we must recall that the term "Buddha" is a title. In Frank Reynolds and Charles Hallisey's analogy, like the term "king", "*buddha* denotes not merely the individual incumbent but also a larger conceptual framework". The title "buddha" "suggests the otherness and splendour associated with those [so] named".[14] Any Buddha is perceived as a transformed historical figure; representations of *the* Buddha are always on some register representations of *a* Buddha. The onus is on the modern viewer to determine if the one can be disentangled from the other in distinct contexts.

The splendorous otherness – or divinity – of the Historical Buddha in Theravādin representation has often been attributed by modern scholars, monastics and layfolk alike to contamination from Mahāyāna. Yet, the paradigm of influence, relying as it does on clear distinction between contrasting entities, proves insufficient in explaining many common Pāli Buddhist contexts in which conceptions of and practitioner relations to the Buddha and Buddhahood manifest something other than perception of the Buddha within a strictly historical frame. To attend to this troubling interpretive situation we find terms such as "Tantric Theravada", a recent scholarly invention seeking to describe widespread esoteric practices within Pāli Buddhist contexts.[15] Viewed through the established interpretive frame, "Tantric Theravāda" appears to be an oxymoron explicable only through influence of one tradition on another.

Seeking to privilege evidence in the place of modern categorisation, attentive to the historically inaccurate oppositional pairing of a monastic lineage ("Theravāda") and a doctrinal orientation ("Mahāyāna"), and so to the porosity historically maintained between them – in short hearing the "concert" of Buddhism – the current critical approach posits the seemingly oxymoronic phrase as a provisional measure for naming "Theravāda" itself in certain contexts. Though the Southeast Asian region's multifaceted religious past no doubt impacted Pāli Buddhist developments in Cambodia, the latter must also be understood in light of the cultural matrix shared by diverse monastic affiliations and doctrinal orientations – a matrix shared from their origins but also cultivated in their ongoing developments.

Lastly, any argument for the fundamentally apolitical nature of Theravāda has little traction with the material evidence explored here. If, for example, the typical spatial arrangements of Theravādin sites of worship in Cambodia suggest relatively open access to central icons and religious officiants, there is no doubt that associated religious practices were integrated into political power structures at and after Angkor. Here too essentialist definitions of Theravāda have been formulated through contrast with Mahāyāna and Vajrayāna constructs dominating Angkorian royal expression on the eve of Theravāda's rise. This book argues that the manifest differences in relations between these different Buddhist constructs and political power are to be considered in conjunction with their otherwise common heritage characterised by porosity rather than opposition. On this political point, too, relations between Theravāda and its supposed Buddhist others in Cambodia are far more than sequential.

A last brief word on Pāli. By and large the use of Pāli in Southeast Asia can be said to mark Theravāda, with the term now taken in the complexity I have evoked above. On one basic level, it can be said that Pāli replaces Sanskrit in the wake of Angkor, with the earliest definitively dated Pāli composition in Cambodia dated 1309, arriving just in the wake of the last known dated Sanskrit inscription, dated 1307–8.[16] Yet we cannot affirm that all Pāli usage in Cambodia denotes Theravāda in the rigidly established terms noted above; nor can we affirm that the presence of Sanskrit always attests to non-Theravādin practice; nor, lastly, can we affirm that the *absence* of Pāli attests to the absence of Theravāda. Further attention to hybrid usage in the region would strengthen current platforms for analyses of these suppositions.

Even more importantly, the contrast between Sanskrit and Pāli usage before and after Angkor is to be qualified in multiple ways. This is not a case of one language, associated with one religion, replacing another language associated with its own religion. In addition to the challenge that the Cambodian evidence brings to established notions of such

one-to-one correspondence between a discrete religion and a discrete language, it is equally crucial to note that Pāli usage in early Theravādin Cambodia is in many ways *unlike* that of Sanskrit in the pre-Angkorian and Angkorian periods. Sanskrit was a language of epigraphic composition in ancient Cambodia. It was paired with the vernacular Khmer language, the two together participating in the consolidation of a division of compositional labour, which relegated poetic developments to Sanskrit and prosaic documentation to Khmer. Pāli, on the other hand, did not come to replace Sanskrit in its literary role in Cambodia. Shifts in the quantity and quality of epigraphic composition in the wake of Angkor included the rise of Khmer as the dominant medium of epigraphic expression. Rather than working predominantly side by side, the vernacular came to subsume the vocabulary and literary verve of the Indic languages. It is true that the few Pāli (and closely related Prakrit) epigraphs of pre-Angkorian Cambodia were, as noted above, citational, like those elsewhere in mainland Southeast Asia of the first millennium; and that Pāli usage in Cambodia from the early 14th century was, in contrast (but *like* Angkorian Sanskrit) compositional. Still, Pāli composition did not take hold in Cambodia at this time, while Khmer-language composition did. It is in this sense that it must be said that, after Angkor, Khmer, rather than Pāli, came to replace Sanskrit.

An inadequately studied dimension of these developments in multilinguality of particular pertinence to this volume is the way in which Khmer also came to function as a prestige language. Khmer's replacement of Sanskrit as a language of literary composition in Middle Cambodia is one indicator of this prestige role; but it is most sharply apparent in the areas at the limits of Angkorian territorial reach, during and after the Angkorian period, where we find multiple declensions of bilingual epigraphy (for example, Khmer and Pāli; Thai and Khmer; Khmer and Sanskrit; Thai and Pāli), but also a notable wielding of the Khmer writing system decoupled from the Khmer language. The Khmer writing system had, from its origins in pre-Angkorian times, been used to render Sanskrit and Pāli; this is exemplary of usage across the "Sanskrit cosmopolis", the vast region of Sanskritic culture stretching from present-day Afghanistan in the west to Bali in the east over the first millennium, where a range of more or less localised writing systems were used to render the cosmopolitan Sanskrit. When, however, the Khmer writing system came to render Thai, or, for example, Pāli in a bilingual Thai-Pāli inscription in which the Thai language portion was written in Thai script, we see a crucial shift. This participates in a new wave of localisation of Indic culture in the wake of the demise of the Sanskrit cosmopolis as vernacular languages rose to prominence across the vast region; the specific Khmer-Thai phenomenon represents the ongoing cosmopolitisation of Khmer

also at the heart of the formation of what would become Thai culture. For the localisation of a culture indicates its cosmopolitan status: in future Thailand, Khmer culture was adapted for specific purposes in the place of or as a form of venerable (Indic) culture even while composition also developed in both Pāli and Thai. The retention of Sanskritic spellings in Indic loanwords in Thai otherwise reflects the Khmer heritage, as do "Thai" mantras deploying Sanskrit, Khmer and Pāli.[17] If evidence of the vernacular Khmer being put to work in critical interpretation of Sanskrit has been identified in the Angkorian period, by the 17th century we see that the consolidation of the written vernacular has contributed to a regional practice of creative translation involving Pāli and Khmer as well as neighbouring Thai.[18] The place of Pāli and the Pāli canon in defining Theravāda in this region must be placed in this hierarchised linguistic matrix out of which nation states were ultimately formed.

In short, giving the label "Theravāda" to any material evidence of Buddhist practice that appears to bear any or even all of the above-named traits risks putting the cart before the horse. The cart we in this volume call, according to modern designation, "Theravāda", is made of myriad component parts, none of which on its own renders the cart as a whole, and each of which in turn begs the question of its own singular unconditioned definition. Some will note that I am staging a rhetorical encounter here between the English adage on putting first what should logically come second, and the ancient Pāli "Simile of the Chariot". The latter, a short text staging an episode in an ancient encounter between a Greek king and a Buddhist monk, speaks well to our conundrum in gauging the very existence of something presumed to exist. The textual encounter is one of many in which the Indo-Greek King Milinda questions the Buddhist monk Nāgasena on specific doctrinal points. This one, "The Simile of the Chariot", concerns Buddhist conceptions of personhood. The text challenges any crude conceptual distinction between material object and concept: an object, like a human subject and like a name, is a construct. Following a bold opening bid in which the monk Nāgasena appears to affirm that he himself is nothing but a name, he compares the existence of his person to that of a chariot as a means of bringing the king to reach an understanding of this particular area of Buddhist theorisation of ontology:

> "If you, sire, came by chariot, show me the chariot. Is the pole the chariot, sire?"
>
> "O no, revered sir."
>
> "Is the axle the chariot?"
>
> "O no, revered sir."

"Are the wheels the chariot?"

"O no, revered sir."

"Is the body of the chariot the chariot ... is the flag-staff of the chariot the chariot ... is the yoke the chariot ... are the reins the chariot ... is the goad the chariot?"

"O no, revered sir."

"But then, sire, is the chariot the pole, the axle, the wheels, the body of the chariot, the flag-staff of the chariot, the yoke, the reins, the goad?"

"O no, revered sir."

"But then, sire, is there a chariot apart from the pole, the axle, the wheels, the body of the chariot, the flag-staff of the chariot, the yoke, the reins, the goad?"

"O no, revered sir."

"Though I, sire, am asking you repeatedly, I do not see the chariot. Chariot is only a sound, sire. For what here is the chariot? You, sire, are speaking an untruth, a lying word. There is no chariot. You, sire, are the chief rājah in the whole of India. Of whom are you afraid that you speak a lie?" [...]

Then King Milinda spoke thus to the venerable Nāgasena:

"I, revered Nāgasena, am not telling a lie, for it is because of the pole, because of the axle, the wheels, the body of a chariot, the flag-staff of a chariot, the yoke, the reins, and because of the goad that 'chariot' exists as a denotation, appellation, designation, as a current usage, as a name."

"It is well; you, sire, understand a chariot. Even so is it for me, sire, because of the hair of the head and because of the hair of the body ... and because of the brain in the head and because of material shape and feeling and perception and the habitual tendencies and consciousness [i.e. the five *khandhā*] that 'Nāgasena' exists as a denotation, appellation, designation, as a current usage, merely as a name. But according to the highest meaning[19] the person is not got at here. This, sire, was spoken by the nun Vajīra face to face with the Lord:

> Just as when the parts are rightly set
> The word 'chariot' is spoken,

So when there are the *khandhā*
It is the convention to say 'being'."[20]

To turn the "Simile of the Chariot" to our ends: rather than simply *being* ontologically, it – Theravāda – is "because of" its constituent elements. On account of all these things, it, Theravāda, "exists as a denotation, appellation, designation, as a current usage, merely as a name" – "Theravāda". In naming something "Theravāda", we must probe its constituent parts and the ways these come together while nonetheless maintaining a vision of the real factitiousness of the construction at hand.

In the rest of the present Introduction, I use the term "Theravāda" in this conventional manner highlighted by the venerable Nāgasena. Unless otherwise noted, the term is taken to designate a form of Buddhist practice including expression in Pāli and vernacular Southeast Asian languages but not necessarily to the exclusion of Sanskrit; a privileging of reference to the Historical Buddha but not to the exclusion of elaborate conceptions of Buddhahood and esoteric developments; and communal physical and social structures participating variously in the political management of territory and human resources.

"CAMBODIA"

The definition of the thing we call "Cambodia" is no less problematic. As with Theravāda, the problem cannot be reduced to anachronistic usage. The English toponym "Cambodia" derives from *kamvuja*, "born of" (*ja/ jā*) a mythical ancestor named "Kamvu". The term appears in compounds with territorial designations in ancient Khmer and Sanskrit epigraphy to designate the successive geo-political entities preceding today's Cambodian nation state and dominated by those "born of Kamvu" – the Khmer(-speaking) people. From this point of view, the term fits "Cambodia" of any time from Angkor on. The linguistic equivalence masks, however, important territorial differences. While modern Cambodia is clearly demarcated in territorial terms, "early Theravādin Cambodia" is not, and the one does not correspond to the other.

In fact, there is a sort of vanishing point where Theravāda and Cambodia meet, highlighting the entanglement of politics and religion in this space and time. The northern and western land borders of pre-Theravādin Cambodia – assuming there is one to speak of, an issue that will be addressed below – can be defined precisely through the identification of Theravāda as a dominant feature in what is now Thailand. Pāli Buddhist culture(s) stood for centuries, it would seem, as a sort of bulwark against "Cambodia", as if the former constituted a counterbalance to the latter even without anchoring in a strong,

structured singular political entity mirroring that of Angkor. The nature of exchange and, in an increasingly intensive manner from at least the tenth century, veritable patchworked overlap between the Buddhist cultures of what is now Central and Northeastern Thailand and Angkorian culture is a point of debate raised variously in the present volume. A crucial question concerns at what historical moment Khmer speakers came to inhabit different parts of these regions, and to what degree they, along with related Mon speakers, practiced Pāli-based Buddhisms to the exclusion of the types of Sanskritic Brahmanic and Buddhist cults prevalent in Angkorian culture. As Khmer speakers spread across religious borderlands, their presence served to at once share and distinguish between cultures. As noted above, the Khmer language also came to be used as a prestige language by those for whom Khmer was not the mother tongue. When, in these overlapping or border regions, we see Khmer language and/or script paired with Pāli, or with Mon or Thai, we cannot be sure what sort of local usage it represents beyond that to which it manifestly attests: elite written culture referencing Angkor beyond the capital or, at times, as part of Angkor the empire. This begs questions of the presumed discrete nature of ethno-linguistic identity and the mapping of these onto territory characterising modern historiography. How can we envisage premodern "Khmer-Thai" situations without having recourse to the modern prism by which nations appear pre-destined as such by the apparent natural correlation between ethno-linguistic identity and territorial borders? And this question leads to another: Whether or not Angkorian expansion across religious borders from the tenth century should be considered by any measure a colonisation? And this question leads to yet another at the heart of the present volume: Whether Theravādin expansion from the late Angkorian period, but especially from the 13th century, should itself be considered a sort of cultural occupation or colonisation of Cambodia, and ultimately conceived in relation to occupations or colonisations of a political order?

Two scholarly œuvre are particularly pertinent in exploring these questions. The first is that of art historian Hiram Woodward, whom I will more or less let speak for himself in this volume's second chapter, which, along with its extensive bibliography, conveys the pre-13th-century evidence in this regard. Here I will briefly discuss historian Michael Vickery's work focused on the textual evidence for the early post-Angkorian period, from either side of today's Thai–Cambodian border. Through meticulous comparative analyses of epigraphic and chronicular evidence, Vickery ultimately understood the two areas, of the Angkor plain on the one hand, and, on the other hand, the central Chao Phraya basin stretching into Northeast Thailand, from the 13th century, to be characterised by similar ethno-linguistic cultures, with relations evolving

through mutual assimilation rather than conquest and subordination.[21] With this, Vickery challenges the dominant historiography anchored in modern nation states and pitting ethnic Tai against ethnic Khmer. In his words, the relations between Ayutthaya, an early "Siamese" capital and precursor to modern Bangkok, and Cambodia, so often anachronistically described in terms of international war, become "conflict between rival dynasties for control of mutual borderlands, and … of what both considered to be their old, traditional capital" – Angkor.[22] I insist on the qualification of Ayutthaya as "Siamese" rather than "Tai" or "Thai" with reference also to Vickery's interrogations of scholarly suppositions that the term *syām* could have initially referenced Mon speakers, or peoples and cultures of the Chao Phraya basin irrespective of ethno-linguistic identity, which is to say a mixture of Mon-Khmer and Tai groups drawing substantially on the religious and political heritage of Angkor.[23]

In the first instance, Vickery's formulation reveals the distorting prism by which the historical development of "Cambodia" and "Thailand" or "Siam" have been conceived. Just as European nation states were drawing national borders between "Cambodia" and "Siam", so were historians tracking the origins and historical limits of these same states, with the one process feeding the other in a mutually reproducing loop. The racial categorisation figuring in this conjoined political and academic demarcation of the region is nowhere more evident than in the art historical field, where arts are classified according to national styles identified with the physical features of the "races" thought to have inhabited the lands in question.[24] The racial categorisation brings with it, of course, attribution of value-bearing characteristics to whole peoples; this serves to establish moral hierarchies between the various so-defined groups, which in the contexts in question are distinctly anchored in value judgements of religious practices, categorised as they are in the art-historically bound racialising process. The art becomes more than the embodiment of the physical traits of "Khmer" or "Thai", but also a window into the moral rectitude, intellectual capacity and creative flair of these so-defined peoples. In our particular early post-Angkorian case study, Cambodian art is read as attesting to decadence, while Thai art attests to the promise of a dynamic people coalescing into an independent Buddhist state. In the process, originating in and then perpetuated well beyond the colonial period proper, Southeast Asian nations were drawn in the image of modern Europe. Shattering this lens, Vickery pushes us to see "Cambodia" and "Thailand" together, variously, as one and yet not the same, from the end of Angkor.

Angkor plays a crucial and complex role in the overlaid historical and historiographical processes under our lens here. The rival regional powers – Southeast Asian and/or European – all laid claim to the ancient capital

in assimilated geographic and symbolic terms. As the fraught tracing of national borders between the French and the Siamese in the late 19th to early 20th centuries centred around possession of Angkor, so were premodern relations to Angkor interpreted as integral to a fraught tracing of borders between the "Thais" and the "Cambodians" as the post-Angkorian period evolved.

The rhetorical frame that George Cœdès constructs around his impactful 1958 essay on the watershed of the 13th century in Southeast Asia is fascinating for the nuance it adds to my rapid characterisation here. In a sort of meditative, even despondent, mood, Cœdès proposes an analogy between his times – post-World War II which saw the dismantling of the European colonial enterprise in Southeast Asia – and 13th-century Southeast Asia with its own narratives of (post-)colonisation. Anticipating readerly reactions to his dramatic yet banal designation of this historical moment in Southeast Asia as a "turning point", Cœdès justifies the characterisation in personal, emotive terms: "From a period in which people have the impression there is no reason why anything would change (impression that my generation had at the beginning of this century) there succeeds a period where everything is put into question, where tomorrows are unforeseeable, and where one hears everywhere moaning about 'our filthy times'."[25] This opening bid is mirrored in the last paragraph of the essay, where Cœdès reiterates the parallel between the two "decadent" historical periods. The summary leading up to this finale addressed to "amateurs of comparisons between past and present",[26] notes the "the sterilisation of art for which Singhalese [i.e. Theravāda] Buddhism, hostile to personality cults and hardly favorable to the flourishing of the plastic arts, shoulders a good deal of responsibility".[27] Cœdes' ambivalence with regards to Theravādin art is hardly obscured by the following rapid acknowledgment that "on the ruins of Khmer and Burmese art of the twelfth and thirteenth centuries, a new art is born, the Siamese art of Sukhothai".[28] For, in the next discreetly damning sequence, we find our author pondering to what extent those people living through the change are conscious of its momentousness. On this point, he cites the retrospective epigraphic account of a 14th-century Sukhothai king: "From that year on [1218 CE or the death of Angkor's last great king, Jayavarman VII], the nobles, the dignitaries, the brahmans and the rich merchants no longer held the highest place in society; from that moment on, astrologers and doctors also lost their prestige; from that moment on they were no longer valued or respected".[29] Initially, Cœdès recounts, he understood the 14th-century Tai king in question to be lamenting the loss of the aristocratic Indic world embodied by Angkor; on further reflection on this king's outlook, however, he reinterprets this passage as a celebratory expression of satisfaction in the Tai establishment of

independence from that very world. The replacement of the "refined aristocracy, guardians of Sanskrit culture" by a "decadence" caused by the "adoption of Indian civilisation by a growing number of indigenous people who impregnated it little by little with their own particular tendencies"[30] is clearly not to Cœdès' liking. That Cœdès' ambivalence is so palpable here, and that the moral judgements regarding cultural developments after Angkor are so profoundly felt, can only be attributable to his own "parallel" experience of displacement at the advent of a new era.

Vickery's work reminds us, however, that Angkor's potentiality far exceeds any modern European model. Like the Ganges, or Mount Meru of Indic geographies, Angkor can be transposed. Vickery highlights research demonstrating that Sukhothai, further north, in the 13th century, was spatially modelled after Angkor; while Ayutthaya in the Chao Phraya basin, appearing in Chinese annals from the late 13th century, was, by the 14th century, Angkor's successor state.[31] Sukhothai and Ayutthaya comprise two iterations of a single phenomenon in which the reproduction of Angkor participates in the production of a new polity. Modern historiography variously conceives of both as cradles of modern Thailand. This might be considered the same phenomenon by which Theravādin Cambodia was born. Note, for example, that Srei Santhor, a region hosting Cambodian royalty in the early Cambodian Middle Period, derives its name from the ancient name for Angkor, Yaśodharapura.[32] Or that the foundation legend of the enduring Middle Period capital, Phnom Penh, recounts the discovery of a four-faced statue found floating downstream from the north in a likely reference to Angkorian iconographies.[33] Material remains – textual, sculptural and architectural – demonstrate all of these sites to have been Theravādin, that is they are the cores of polities in which sovereign power and territorial dominion were predominantly developed through Theravādin Buddhist expression. This apparently paradoxical situation in which Theravādin states can be said – if somewhat provocatively in some circles – to have emerged out of non-Theravādin Angkor has drawn attention to the symbolic power of Angkor reigning in the region long after the demise of its political might. Yet the nature of this symbolic power shown up by these exemplary polities cannot be mapped onto real, demarcated territorial possession, on the model of the bordered nation state. Nor is it limited to a discrete integration of Angkorian Brahmanic ritual at courts on either side of an imagined border – another established interpretation of the place of Angkor following the shift of the capital at Angkor from the Angkorian plain implicitly challenged by Vickery's work. The assimilated ethnolinguistic cultures emphasised by Vickery precede the post-Angkorian period, and pervade it.

The unique and multifaceted role of Angkor also speaks to the power of Theravāda and its others in the region. To be sure, Marxist historian Vickery was little concerned with the inner workings, meanings and power of religion itself. His interpretation of the historical evidence was oriented instead to pinning down the historical facts attesting to "ethno-linguistic cultures". Yet, his formulations go some way to mitigating also against the stark contrast established in the scholarly literature between Theravāda and Mahāyāna and/or Brahmanism as both religious practice and political operator in the region; for the particular vision articulated by Vickery of Ayutthaya – if not also Sukhothai – as successor to Angkor also begs interrogation of the stark contrast found in modern historiography between Brahmanic/Mahāyānist Angkorian and Theravādin post-Angkorian Cambodia and Siam. Despite himself, then, Vickery makes an important contribution to understandings of the workings of religion: in addition to understanding the *differences* between the groupings emphasised in modern scholarship, in following Vickery's lead, we need now to examine more closely the common ground – both physical and metaphysical – shared by Mon-, Khmer- and then Thai-speaking practitioners of this or that religion.

The contributions to this volume show that, beyond any shadow of doubt, Angkor must be understood as an organising principle of evolving regional Theravādin practice. Much of the material evidence explored – sculpture, architecture, ceramics, texts – attests to the travel of practices, concepts and ideologies across the region. As a number of chapters demonstrate, Angkor-the-site functioned as a veritable reference point for mainland Theravādin practices during and after Angkor-the-empire. In such, it is, along with Sri Lanka or the Pāli canon, a source of mainland Theravāda – which is also to say that Theravāda after Angkor also bears witness to Angkor. Note however that the denomination of "*kambujā*" (a variant of *kamvujā*) in 13th- to 16th-century devotional epigraphic texts, at Angkor and beyond, suggests a geo-cultural consciousness associated with but not limited to Angkor proper – in temporal or territorial terms – to have been embedded in and reproduced by Theravādin practice. The quintessential example of this lies in 16th-century texts inscribed by royalty on the walls of the 12th-century Vaishnavite temple of Angkor Wat. The royals record their pious Buddhist works at the temple, including the restoration of the temple itself, aimed at restoring *kambujā* to its ancient glory.[34] In a text inscribed on a temple on the eastern outskirts of the ancient capital, a man is said to have ordained before travelling to study at Angkor, where he became a scholarly court priest. The epigraph symbolically juxtaposes a series of sacred sites consecrated "in the kingdom of Cambodia" (*kamvujārāsdhr*) with the many *stūpa* which the prototypical Buddhist monarch Aśoka is

said to have founded across India.[35] Another set of epigraphs in Khmer but seemingly written by Thai speakers from Ayutthaya recount a 16th-century pilgrimage to Angkor and the southerly royal site of Oudong.[36] Likewise here, restoration of statues is posited as a powerful, pious Buddhist act aiming to ensure the stability of the "country of *kambujā*" (*kambūjades*, in *K. 465* and *K. 285*). Angkor was not perceived as co-terminus with *kambujā*, but can be said to have acted as a draw in defining it; at the same time, that is in the same devotional actions of travellers, *kambujā* was an integral part of an evolving regional Theravādin world.

I am suggesting here that the hermeneutic implications of a body of postcolonial research have not been fully digested. The *maṇḍala* model of Southeast Asian statehood developed variously by Stanley Tambiah and O. W. Wolters, and which took particular hold in the wake of Thongchai Winichakul's *Siam Mapped*, has certainly shifted understandings of classical Southeast Asian states as comprising shifting centres and flexible borders radiating out through expanding and contracting movements.[37] This shift in scholarly vision seems, however, to reach its limits in the historiography of Cambodia from the 13th century, as if the classical *maṇḍala* states were then singularly replaced with bordered nation states. Interestingly, Thai historiography does not singularly follow this trajectory, as the successors of the "great *maṇḍala*" exemplified by Angkor are often today indeed seen in the *maṇḍala* of post-12th-century future Siam.[38] This does not however stop Thai historiography from stumbling into the trap of by and large seeing Cambodia starkly opposed to (future) Thailand from this moment on. Further attention to the perpetuation of the *maṇḍala* model, along with full acknowledgement of the implications of Vickery's insistence that we shed the organisational principle of historiographies pitting Thais against Cambodians, opens new interpretive horizons. In this context, what shall we make of the established narrative by which Thailand, on the one hand, is understood to have been born in the 13th century, beginning then centuries of more or less continuous expansion, while, on the other hand, Angkor is said to have reached its demise and Cambodia to have begun, at the same time, to contract. What, for example, is keeping us from seeing, from the 13th century, a certain expansion of Angkor? The question is a provocation, of course. But one which pushes us to see the continued distortions of our viewing lens crafted in and for the consolidation of the modern nation state with its complex investment in notions of discrete religions. An expanding Angkor of this order is accomplished not through expansion out from a singularly powerful centre on the model of empire, but rather through the otherwise expansive mode of operation of the *maṇḍala*: replication.

PERIODISATION

The search for beginnings heralding this volume is as much temporal as it is geographical. Identifying the first signs of Theravāda in Cambodia has long presumed not only that the demarcation of Theravāda and Cambodia are themselves self-evident, but also that the absence or presence of Theravāda itself has defined Cambodia in distinct historical periods. As I have emphasised above, however, the more we attend to research in this field, the more we are brought to question the validity of the categories upon which we seek to craft our historical narrative.

The purportedly "first Pāli inscription in Cambodia", *K. 754* documented in the eponymous 1937 article by Cœdès, has long been taken as a marker for a period divide between Ancient and Middle Cambodia, according to one of the many appellations of the latter which I will discuss briefly below.[39] Dated 1309, the bilingual Pāli-Khmer inscription purportedly from Kok Svay Cek to the west of Central Angkor certainly indicates important politico-cultural change otherwise attested in the material record. This is the earliest Pāli epigraph to have been found in the Angkor region that can be positively and precisely dated. For the comparable graphics, another Pāli epigraph, *K. 501*, found further to the west of the core capital, is likely to date from around the late 13th to early 14th centuries; it is in this same area that, in 1267, a Buddha image was consecrated as *kamrateṅ jagat śrisugatamāravijita*.[40] Pre-Angkorian materials often taken to demonstrate Theravādin presence within the Khmer realm prior to the expansion of Angkorian reach are ambiguous in this regard. Peter Skilling has debunked previous interpretation of the canonical extract inscribed in pre-Angkorian writing on a pre-Angkorian Buddha image from Tuol Preah Theat in Cambodian's southwestern Kompong Speu province as attesting to Theravāda: the inscription is in a mixed or Sanskritic Pāli rather than the canonical idiom of Theravāda as has been previously understood.[41] This refinement of our understandings of linguistic evidence, in conjunction with our increasingly refined understandings of relations maintaining between monastic lineage and doctrinal orientation in premodern contexts, also destabilises established assumptions that the stylistic and iconographic resemblances between Dvāravatī and pre-Angkorian Buddha images such as this one from Tuol Preah Theat necessarily attested to sectarian affiliation. The presence of Dvāravatī-style *sīmā* (Buddhist boundary stones) in the Kulen mountains on the northern edge of the Angkor plain, along with what may be contemporaneous Buddhist sculpture, may affirm a pre-Angkorian Mon Theravādin presence in this site, which would become the cradle of Angkorian civilisation. These sculpted stones are common in Dvāravatī contexts north of Angkor in what is now Thailand.[42] But in the absence of

substantial archaeological research, we cannot affirm the nature or extent of the beliefs and practices with which they would have been associated. In short, the paucity of Pāli epigraphy prior to the 13th and 14th centuries mirroring that of the sort of sculptural and architectural evidence variously characterising Theravādin production elsewhere in the mainland over the first millennium – *stūpa*, votive tablets, sculpted wheels of the Law, *sīmā* – speaks volumes. In such, research in the wake of Cœdès' naming of the 13th century as a "turning point" in Southeast Asian history has largely served to confirm his dramatic stance.

We seek here however to temper such a reading. Recent research does affirm that the steady, intensive *non-Theravādin* architectural, sculptural and epigraphic production characterising the Angkorian state was not simply replaced by Theravādin production from the 14th century; by the end of the 13th century, material production in stone of any order had indeed slowed significantly. Yet, the art and archaeological evidence sheds light on transitional processes at hand, combining at once change *and* gradual evolution in and out of the multiple shared heritages developing at this time.

The "first [definitively dated] Pāli inscription in Cambodia" gives us some sense of these processes. *K. 754* is in fact a bilingual inscription on the Angkorian model of royal text eulogising a king and recording cadastral organisation made in the name of religion. It is, like *K. 501*, an original composition. These texts are a far cry from the extracts of canonical scriptures or commentarial references characterising Pāli epigraphy in first-millenium mainland Buddhist areas. In both form and content *K. 754* conveys the very particular parameters of this first firm written evidence of Theravāda at Angkor. Territory once under the authority of a *liṅga* is placed, now by the text and in the ritual acts it records, under the authority of a Buddha image who is named, in good Angkorian fashion, after the king. This naming, however, happens only in the Khmer portion of the text, where the king's name appears in Sanskrit – not Pāli. Otherwise quite similar to the Khmer, the Pāli portion of the epigraph simply omits this detail. Other proper names which do appear, in Pāli, in the Pāli portion of the epigraph, appear in Sanskrit in the Khmer portion. The text demonstrates, thus, a critically selective use of Pāli to operate and document territorial conversion to Theravāda in the Angkor plain on the model, nonetheless, of established Angkorian practice.

K.501 is in Pāli verse, and comes from a site, further to the west, Prasat Kralanh, which also bears an earlier tenth-century Sanskrit Buddhist inscription. *K. 501* also recounts conversion to Buddhism but of a "favourite" of the king; though this text does not, like *K. 754*, explicitly enumerate borders of the territory associated with the new religious

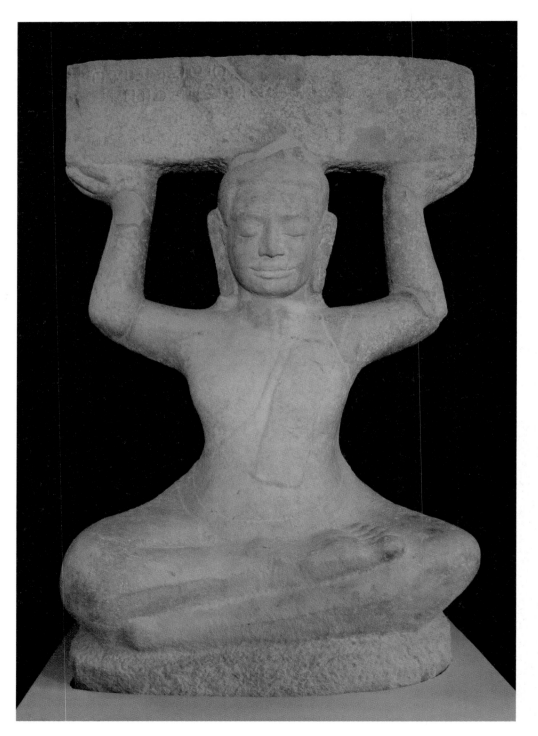

1.1

construction and its Buddha image, it does record the installation of a Buddha image by the king's "favourite" and celebrates his offering of human and land resources to the service of the Buddhist foundation.

K. 241, from Prasat Ta An and dated 1267, likewise commemorates the installation of a new Buddha image at an older Buddhist site dating to the tenth century. Though this text is not a Pāli composition, in the name of the Buddha image, *kamrateṅ jagat śrisugatamāravijita*, it attests to a like process of conversion by which established Angkorian constructs are harnessed to Theravādin ones such that the Buddha in his legendary Victory over Māra (*śrisugatamāravijita*) takes the divine place of the Angkorian "Lord of the World" (*kamrateṅ jagat*). In each of these cases statuary gave body to the evolution at hand.

This concentration of early Theravādin evidence to the west of Central Angkor is notable also in light of an enigma woven into the verse text of *K. 501* from Prasat Kralanh. The donor of the new Buddhist foundation is said to have pronounced it as such: "Sojourn of those who destroy caimans, the river [...]; making people live with these, the Buddha is turned to the west."[43]

Divine images, it should be noted, are nearly systematically erected facing east in Cambodian contexts. The westerly facing Buddha evoked in *K. 501* makes a strong statement, akin to that made by the most notable exception to the Angkorian rule, Angkor Wat temple, which faces west

Fig 1.1 Seated Buddhist figure holding inscribed tablet, from Preah Khan of Kompong Svay, Preah Vihear province, Cambodia. Sandstone. Mid 13th to early 14th centuries. Height: 147 cm; width: 93 cm; thickness: 53.5 cm. National Museum of Cambodia, Phnom Penh. Inventory Number: Ka. 1697. Photograph courtesy National Museum of Cambodia.

Fig. 1.2 Profile of Ka. 1697 featured in Fig. 1.1. Photograph courtesy National Museum of Cambodia.

Fig. 1.3 Back of Ka. 1697 featured in Fig. 1.1. Photograph courtesy National Museum of Cambodia.

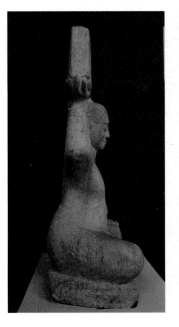

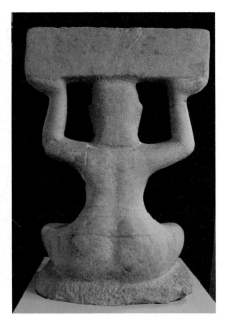

1.2 1.3

and whose central image would have done so as well. To the west of Prasat
Kralanh lies, indeed, a river. In exceptionally facing west, the Buddha
evoked at Prasat Kralanh would have effectively turned its back to Angkor
and turned its gaze to the Theravādin west of what we now call Thailand.
A solution to the enigma that remains to this day may lie in further
research in this area to the west of Central Angkor.

Early Pāli inscriptions from Angkor are otherwise preceded by a body
of Pāli written in Khmer script, at times in conjunction with a Khmer-
language text, documented within the outer reaches of ancient Angkorian
maṇḍala. These can be canonical or extra-canonical extracts, or texts
praising and documenting Buddhist foundations with or without
cadastral implications. Each case requires textual and contextual analysis
to determine, however, if it reflects extension of Angkorian territorial and
associated politico-cultural dominion, extra-Angkorian practice by Khmer
speakers inhabiting areas now in Thailand, or an appeal to the prestige of
Khmer.[44]

Crucially, our "first" (post-)Angkorian Pāli inscriptions appear in the
same liminal period as a bilingual Sanskrit-Khmer Buddhist epigraph
whose doctrinal orientation remains ambiguous. This text, inventoried as
K. 888, is, unusually, engraved in convex lettering on an unusual
monolithic sculpture which, I will argue, represents in a fabulously
condensed manner the multiple issues at play in defining "early
Theravādin Cambodia".

The sculpture, inventoried as Ka. 1697 and held by the National
Museum of Cambodia, comprises a seated figure holding aloft a stone
tablet (Figs. 1.1–1.3).[45] The engraved text, on the tablet which may
represent a leporello manuscript, has until recently been understood to be
in Pāli. However, in a 2018 study, Skilling has shown the text to be a
Sanskrit liturgical verse followed by a phrase in Khmer.[46] The epigraph is
not dated. Linguist Saveros Pou has, however, highlighted the similarity of
the script to that of *K. 754*, and suggested a late 13th- to 14th-century
attribution.[47] As we know, though Pāli Buddhism was expanding under
elite patronage at this time, Sanskrit remained in use as a language of
composition in Shaivite contexts into at least the third decade of the 14th
century. Skilling has demonstrated that the Buddhist Sanskrit text, *K. 888*,
is not a case of enduring Sanskritic usage within Khmer or Pāli
composition; while much of the text's vocabulary is shared by Pāli and
Sanskrit, the inflections are distinctly Sanskrit, making this a Sanskrit
composition. Or, perhaps more accurately, it is a citation of Sanskrit verse
– on the order of those, predominantly in Pāli, characterising Buddhist
contexts widespread in mainland Southeast Asia *beyond* Cambodia in the
first millennium of the Common Era. Unlike *K. 754* – which documents
an act of territorial conversion from Shaivite to Theravādin authority at a

relatively minor Angkorian site, or *K. 241* and *K. 501*, which also come from minor sites – *K. 888* was found at a vast Buddhist temple complex, Preah Khan in Kompong Svay, some 100 kilometres east of Angkor. Ongoing research is demonstrating this Preah Khan complex to have been a crucible for Buddhist practice in Cambodia from the late tenth to early eleventh centuries for centuries to come, thus bridging what are so often thought to be two monolithic, distinct historical periods – the Angkorian and the post-Angkorian.[48]

Skilling has demonstrated that *K. 888* is a verse of homage to the "Three Jewels" (the Buddha, the Dharma, and the Saṅgha or Buddhist Order) associated with the ancient Indian poet Mātṛceṭa (c. fourth century). Tracking multiple iterations of the verse, from a fourth-century poem to contemporary Nepalese liturgy in passing by the Cambodian appearance in question, Skilling explores the development of pan-Asian intertextuality through movement of people, development of monastic lineages, ritual performance, teaching, etc., ultimately suggesting the verse represents "common Buddhist property".[49] Different modalities of the formula feature in this 13th- to 14th-century Cambodian context and in modern Thai and Cambodian contexts. This situation shows a shared reference point for a wide range of practices, which in scholarly circles have typically been labelled "Mahāyāna" on the one hand and "Theravāda" on the other; these include veneration of the Three Jewels; the notion of refuge offered by one or all of these three; and an aspiration to awakening. Instead of isolating discrete formulas within discrete Buddhist schools, Skilling explores how the fundamentals of the verse take on their own lives within disparate contexts.

The sculpture incorporating *K. 888* is also ambiguous. Published dating of the piece to the late 13th to 14th centuries is implicitly queried by Skilling – as if scholars had long been led by its presumed Theravādin nature, in an example of the circular reasoning mentioned in opening by which Theravādin traits (here, mistakenly attributed to Pāli usage) are taken to place materials as being from the late 13th century, which date is then used to confirm said materials as Theravādin. Notably, Skilling explicitly addresses neither the paleographic dating of *K. 888* to some 100 years after the reign of Jayavarman VII, nor art historians' consistent attribution of the sculpture to this same period, and stops short of advancing any date range for the text himself.[50] He evokes other material considerations to emphasise instead an affiliation with the Jayavarman VII period, in the late 12th to early 13th centuries, that is *at* rather than *after* the height of Angkor. This is indeed the dating adopted by the National Museum of Cambodia where the sculpture is currently displayed. Skilling makes two observations in this regard. First, the piece shares features with another unusual sculpture found in the same area of the vast Preah Khan

site, Ka. 1848, a fragmented triad of the *nāga*-protected Buddha-Prajñāpāramitā(-Lokeśvara) set on a high pedestal encompassing a fourth figure in high relief; this piece has itself been dated on iconographic and stylistic bases to the late 12th century (Fig. 1.4).[51] Second, viewed in profile, the tablet-bearing statue distinctly resembles the famous presumed portraits of King Jayavarman VII, one of which was found in the same temple site of Preah Khan of Kompong Svay (see Fig. 1.2).[52] This is to say that, if the statue's morphology, along with the modelling of the facial features, associate the unusual tablet-bearing figure with the Bayon-period style, or its wake, the specific morphology of the torso makes it one in a series of variations on one of the very hallmarks of the Bayon style, the Jayavarman VII portrait type (Figs. 1.5–1.7). In this context, let me recall that the introduction of a certain brand of realism in the art of the Bayon period brings new dimensions to interpretation of style in ancient Cambodian art: with Jayavarman VII, the period style can be indistinguishable from the relatively naturalistic representation of the king himself.[53] The similarity of the Ka. 1697 figure with the Bayon-period statue-portrait cannot be taken simply to show the former to be a portrait of Jayavarman VII or even to date to his reign. In general terms, Woodward has kindly reminded me in discussing the present Introduction, portraiture rarely escapes style. But my point here is not that portraiture in our context is so dominated by period style that it melds with it; but rather that, with the Bayon style, we may be seeing something of an inversion of the general art historical rule insofar as the portrait of the king, or his physical traits, can appear to have themselves underpinned the development of the style under his reign. The king's features, like the period style, could inspire enduring sculptural practice as well as innovating imitation after the fact.

These basic observations give rise to a series of apparent contradictions in the sculptural work, ultimately leading to key questions concerning the identification of the figure, as well as that of the possible lineage affiliation and/or doctrinal orientations of the sculpture-cum-text. Skilling asks a fundamental question that echoes those I raised many years ago in the above-cited exploration of style and realism in the art of the Bayon period, also with reference to Ka. 1697's sister sculpture, Ka. 1848: Are we looking at a monk, or a king, an ascetic, a brahmin or a lay devotee? The morphological allusion to the Jayavarman VII portrait in Ka. 1697 noted above could suggest a royal identification; yet the figure's drapery suggests a monastic figure. The drapery on Ka. 1697 is nearly identical to that of the Buddha figure at the centre of the triad of the top register of Ka. 1848. This monastic dress, with right shoulder bared and a folded robe over the left shoulder, is in fact "characteristic of ... Thai, Lao and Khmer Buddhism"; Skilling goes even further to suggest that it may not

Fig. 1.4 Seated adorant with *uṣṇīṣa* supporting a Buddhist Triad, from Preah Khan of Kompong Svay. Late 12th to 13th century. Sandstone. Height: 84 cm; width: 48 cm; thickness: 19 cm. National Museum of Cambodia, Phnom Penh. Inventory number: Ka. 1848. Photograph courtesy National Museum of Cambodia.

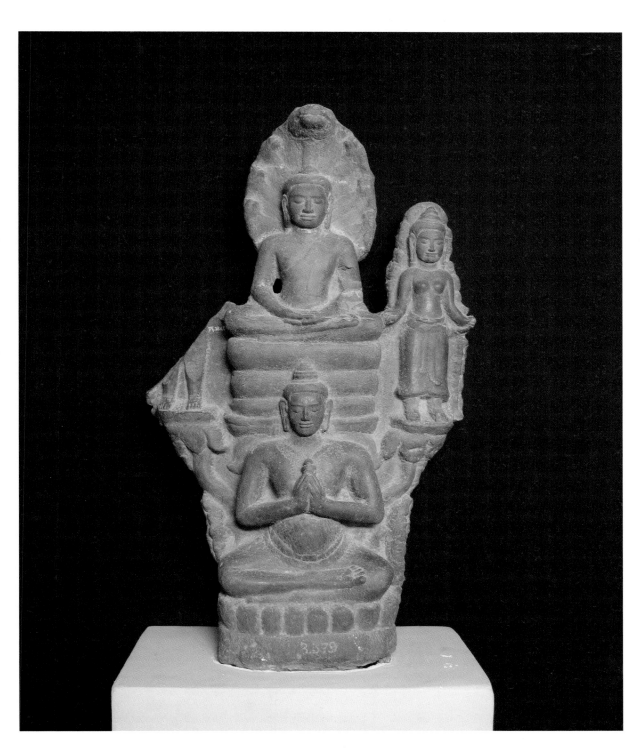

be "characteristic of early Indian Buddhist art or of non-Theravāda fraternities".[54] This is an area requiring further research. In particular, there is no sustained critical study of monastic drapery in Cambodian sculptural form attentive to François Bizot's extensive textual and ethnographic research on Southeast Asian Theravādin monastic dress, which might refine arguments regarding Theravādin identification.[55] Bizot has explored how the different elements of Southeast Asian monastic dress, along with different modes of adjusting the dress, reflect fundamental differences in practices defining distinct monastic groups. Historically, choices in modes of appearance are anchored in questions concerning exposure of the monastic body to the lay world, and include distinctions between forest- and village-based monks, and modes of subsistence ranging from autonomous forest living to wholesale dependence on alms-collecting social networks. Through textual analyses and observation of contemporary practices, Bizot seeks to link specific modes of dress to distinct origins in specific Sri Lankan or Mon groups. Further research in this area with a sustained focus on sculptural representation could yield important historical data. Of import also for our consideration here is the resemblance of the monastic drapery to that of the Jayavarman VII portrait-statue in the National Museum of Cambodia: though there is no folded robe over the portrait's left shoulder, the upper-body garment of both figures is distinguished by a line running diagonally from the upper right waist under the right breast and up to the left shoulder touching the left neckline. Indeed, one of the astonishing features of this presumed portrait of the king is its very absence of regal adornment.

Yet another feature of Ka. 1697 keeps our interpretive pendulum in motion. In contradistinction to the sculptural treatment of the drapery, the treatment of the hair does not correspond to that of a Theravādin monk, nor to that of a Buddha (Fig. 1.3). It is not shorn in monastic fashion; nor is the shorn head replaced with curls adhering to the head topped by an *uṣṇīṣa*, the cranial protuberance marking Buddhahood. From the back, the hair appears to be combed in a blunt cut across the neck, not unlike that of the classic Jayavarman VII portrait. It is unclear whether the topknot featuring on most versions of the Jayavarman portrait also is to be assumed in Ka. 1697, but appears crushed under the weight of the tablet. This material evidence troubles distinctions, first, between monastics, Buddhas and kings in a context of relatively naturalistic representation, and second, between "Mahāyāna" and "Theravāda" on the 13th-century Cambodian ground. How can we reconcile apparently contradictory elements whereby we have a figure in the Mahāyānist Bayon style, if not veritably referencing the Mahāyānist King Jayavarman VII, appearing in apparently Theravādin monastic

dress? How does the dress sync with the treatment of the figure's hair, or with the Sanskrit text incorporated into the monolithic piece? If the paleographic evidence by which the sculpture's epigraph, *K. 888*, syncs with art historical assessment of the modelling of the sculptural body, how can such dating be reconciled with the Sanskrit Buddhist usage in a piece evoking Jayavarman VII? In sum, can this piece be considered another iteration of the transitional complex of "early Theravādin Cambodia" decipherable in the royal Pāli-Khmer(-Sanskrit) inscription of Kok Svay Cek? If the late 13th- to early 14th-century dating is correct, it would be the only example of Sanskrit *Buddhist* usage well after the reign of Jayavarman VII and would be embedded in a context of expanding Pāli Buddhist practice. If this dating is incorrect, such that the lettering of the text and the modelling of the body could be attributed to provincial manufacture around the end of the reign of Jayavarman VII or in its immediate wake rather than to a much later date, we still must grapple with the apparent harmonisation of "Mahāyāna" and "Theravāda" elements in the piece itself and in its setting as I will discuss further below. Is it testimony to the porosity between lineage and doctrinal orientation? Is it a condensation of what might be considered two separate portraits of the king in the central axis of the two-tiered Ka. 1848, the one above in the body of a Buddha to be venerated, the one below in the body of a Buddha(-to-be), venerated in a posture of meditative devotion?

The lower figure of Ka. 1848 is particularly evocative in the complex context at hand. As Woodward has noted, "the adorant seems himself to have become deified, as shown by the presence of an *uṣṇīṣa*".[56] For the vase held between its clasped hands, art historian Nadine Dalsheimer interprets this adorant with *uṣṇīṣa* as the future Buddha Maitreya. While, for Dalsheimer, the sculpture as a whole is "obviously inspired by the Buddhism of the Great Vehicle [Mahāyāna]", she is troubled by the unusual composition comprising a fourth figure underneath the common Jayavarman VII Mahāyānist triad; that this ill-fitting figure would be Maitreya haunts her interpretation as a confounding "Theravadin influence".[57] The regal adornment of the figure in the lower register indeed contrasts with that of the Buddha in the upper register – as with our comparators in the royal portrait and Ka. 1697. The seeming contradiction of a figure simultaneously bearing distinguishing marks of Buddhahood (*uṣṇīṣa*) on the one hand and kingship (adornment) on the other is not however unusual in Theravādin contexts – despite the supposed emphasis on the life story of the Historical Buddha, which hinges upon Prince Siddhattha giving up his princely adornment – jewellery, topknot and all – to reach Enlightenment; the pairing of these features, which appears paradoxical through a certain Buddhist

modernist lens, is in fact a defining feature of Maitreya in modern
Cambodian religious contexts. As the Buddha-to-come, Maitreya
embodies the (paradox of) the Buddhist king and thrives on its very
suggestion of the emergence of Buddhahood in the body of the
worshipped-and-worshipping figure before the worshipper's very eyes,
the political figure ushering in a more perfect future. The bejewelled
Sākyamuni (or "Historical") Buddha is itself widespread in mainland
Southeast Asia from the 11th century, and in Khmer contexts cannot
always easily be attributed to Mahāyāna orientations.[58] This is to say that
the bejewelled Buddha in a Southeast Asian context is not simply
evidence of Mahāyāna "influence"; nor, I would argue, is its presence
here, lifting aloft as it were the Mahāyānist triad, evidence of
"Theravādin influence". The unification of the multiple figures through
the body of the *nāga* is of further interest here insofar as the Buddha
protected by the *nāga* comprises a crossover Mahāyāna-Theravāda image,
as Woodward has frequently noted. In short, Ka. 1848 nudges us to

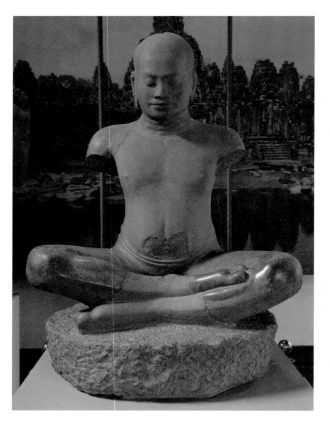

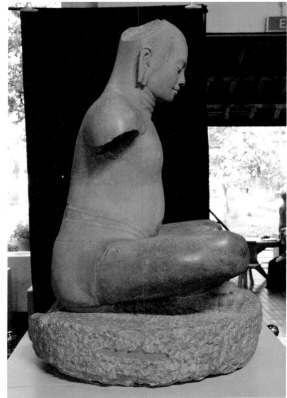

1.5 1.6

reconsider the paradigm of influence as the predominant organising principle of art historical and historical interpretation in the Cambodian context at hand. So, is the figure in the lower register of Ka. 1848 a monk or a Buddha fashioned in the style of the king, or the king-become-monk-Buddha? Could a genealogical progression be embodied here, where the king's descendant follows the path of the Buddha? What we can affirm is that Cambodia's early Buddhist kings could be sculpturally portrayed at once in the body of the Buddha and in that of a devotee – and this in a wide variety of ways, drawing from multiple conceptual resources in and out of Angkor. There is no reason to believe that this practice ceased with the end of Jayavarman VII's reign; to the contrary, evidence suggests it continued in Khmer Pāli Buddhist contexts on and beyond the Angkor plain.

As for any Cambodian Hindu-Buddhist statuary, which always participates in a localisation of cosmopolitan signs, the provenance of these pieces are key to understanding their meaning. Ka. 1697 and Ka. 1848 were part of a group of objects found in the vicinity of a colossal composite statue known today as "Preah Chatomukh" (August 4 Faces), "Ta

Fig. 1.5 "Portrait-statue" of King Jayavarman VII. Late 12th to early 13th century. Sandstone. Height: 138 cm; width: 100 cm; thickness: 93 cm. National Museum of Cambodia, Phnom Penh. Inventory number: Ka. 1703. Photograph courtesy National Museum of Cambodia.

Fig. 1.6 Profile of Ka. 1703. Photograph courtesy National Museum of Cambodia.

Fig. 1.7 Back of Ka. 1703. Photograph courtesy National Museum of Cambodia.

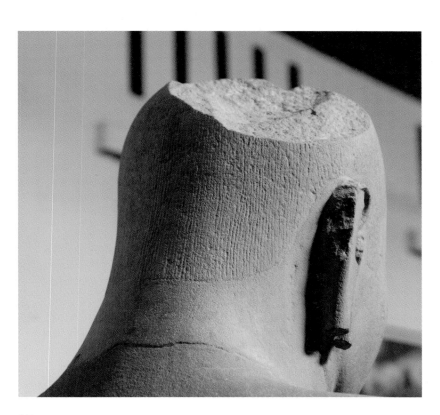

1.7

Prohm" (Grandfather Brahma) or "Preah Ang Thom" (Great Buddha) (Fig. 1.8). This is a towering stone construction of four Buddhas standing back to back which has been tentatively dated to the second quarter of the 13th century. Like Ka. 1697 and Ka. 1848, it too is unusual in the corpus of Khmer statuary of which it is nonetheless an integral part. Preah Chatomukh stands at a short distance from another four-faced monument: one of the Jayavarman VII hallmark face-towers, called Prasat Steung. In morphological terms, the one takes inspiration from the other. The proximity in both time and space of these two similar yet different anthropomorphised architectural bodies begs the question of relations maintaining between the religious practices with which they were both associated.[59]

Woodward's art historical research meets Bizot's textual and ethnographic work in this ensemble of sculptural remains at Preah Chatomukh. Woodward situates the colossal standing Buddha in the line of "18-cubit" Buddhas developed in "the Hinayāna complex of Lopburi" perpetuated in Sukhothai and Lamphun.[60] Drawing on art historical evidence, Woodward posits this Lopburi Hinayāna complex as the "dominant Buddhist sect for the greater part of the thirteenth century" in both Siam and Cambodia. "Its roots," he writes, "lay primarily in Burma. The sect started to challenge the dominant Mahayana of Cambodia toward the end of the twelfth century; it emerged victorious and it persisted until the middle decades of the fourteenth century when it was finally supplanted as a result of new ties with Sri Lanka."[61] Elsewhere Woodward refers to this pre-reform Pāli Buddhism as "Ariya" Buddhism according to the designation of a group transmitted through Pegu's 15th-century Kalyani inscriptions. For Bizot this is the sect at the origin of "heretical" or "tantric" Theravādin traditions known today, and which first became manifest in Pāli Buddhism at Angkor from the 12th to 13th centuries.[62] Links with Lopburi, Sukhothai, Lamphun and Pagan are indeed palpable here. Though they are the subject of ongoing research, they remain poorly understood.[63]

What I would like to point out here is the other salient source of early Cambodian Theravāda as evidenced at Preah Khan of Kompong Svay: Angkor itself and in particular Jayavarman VII's Mahāyāna Buddhism. It is no mistake that a number of the early Cambodian Theravādin sites I have mentioned in this chapter comprise reappropriation of earlier Angkorian Buddhist temples. Nor should we, in my view, be obstinate in attempts to disentangle "Mahāyāna" from "Theravāda" in late Angkorian and early Middle Cambodian times. Why, we must ask, in light of evidence such as that I have just highlighted from Preah Khan in Kompong Svay, can we not imagine "Theravādin" monks in 13th-century Cambodia undertaking practices, using spaces and developing beliefs associated with "Mahāyāna" Buddhism?

Fig. 1.8 Preah Chatomukh, Preah Khan of Kompong Svay, seen from the east, following restoration in 2018 by the Angkor Conservation Office. Sandstone block assemblage. Height: 9.5 m. Photograph courtesy Lam Sopheak, 2018.

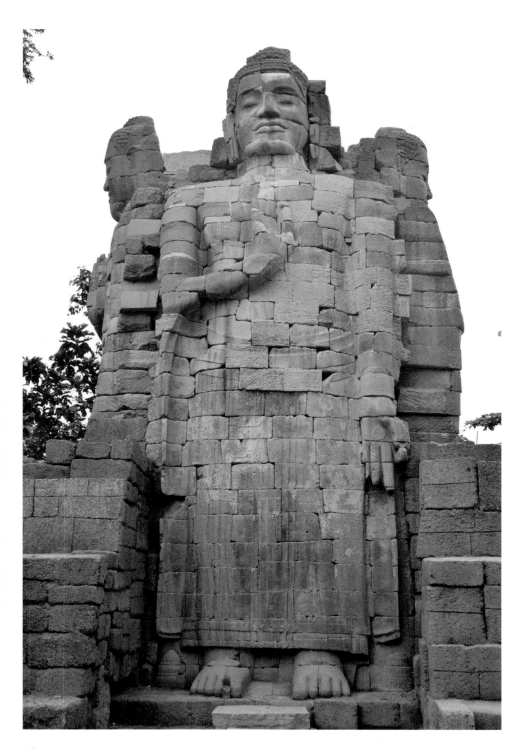

The consternation of art historians before the evidence of a colossal Buddha head found at an early Theravādin site in Angkor Thom is akin to these struggles to reconcile the disparate indices of dating and religious affiliation in the material remains found at Preah Khan's Preah Chatomukh (Fig. 1.9). The colossal head in question, now in the collections of the Musée Guimet in Paris, appears to have originally belonged to the central Buddha figure of the find site, Vihear Prampir Lavaeng.[64] Its siting at this most monumental of Angkor Thom's Buddhist terraces, surrounded by *sīmā* (indicating that Theravādin ordination could have been accomplished here), and its probable association with a colossal Buddha worshipped at this site, make a strong argument for attributing the piece to early Theravādin practice at Angkor. Though only fragments of the central figure were found on site, these, along with the monumental head itself, suggest the statue to have been like other colossal Buddhas in the Angkor region of this time including that of Preah Chatomukh discussed above, composed of large sandstone blocks rather than the monolith characterising Angkorian-period production. Yet, as art historian Thierry Zéphir writes, the head "displays all the characteristics of the art of Jayavarman VII, to such a degree that it could appear to be a sort of double of the central image of the Bayon". Holes bored into the headdress, the ears and the neck of the sculpture likely indicate that it was once, or periodically, adorned with jewellery, which practice, again in Zéphir's words, "would obviously seem to be in discord with an image associated with Buddhism of the Lesser Vehicle [Hinayāna]". For his deep and sensitive knowledge of ancient Khmer sculptural style and modelling, coupled with established scholarly understandings of Mahāyāna and Theravāda as mutually exclusive, Zéphir cannot reconcile the contradiction in a piece which "never ceases to astonish because it seems to participate in two worlds: that of Buddhism of the Lesser Vehicle … and that of Buddhism of the Great Vehicle".[65]

This head was removed from its find site and sent by the École française d'Extrême-Orient (EFEO) to France in 1931. In 1933 the French Head of the Angkor Conservation Office oversaw the recovery of the Bayon's central divinity from a pit underneath the temple's central sanctuary. In 1935 Cambodian King Sisowath Monivong presided over the ceremonial erection of this monumental monolithic *nāga*-protected Buddha in the place of that whose head had been exported to France (see Fig. 2.14, p. 78).[66] Perhaps the king and his entourage – or the labourers who had excavated the Bayon Buddha and lifted it into its new place – understood better than we do today the potentiality of mutual inclusiveness between "Theravāda" and "Mahāyāna" and the innate relations between the "Mahāyānist" Bayon temple and the "Theravādin" terraces of Angkor Thom.

Fig. 1.9 Colossal Buddha head, Vihear Prampir Lavaeng (Buddhist Terrace 1). Sandstone. Height: 100 cm; width: 60 cm; thickness: 60 cm. Guimet – Musée national des Arts Asiatiques. Inventory number: MG18064. Photograph © RMN-Grand Palais (MNAAG, Paris) / Thierry Ollivier.

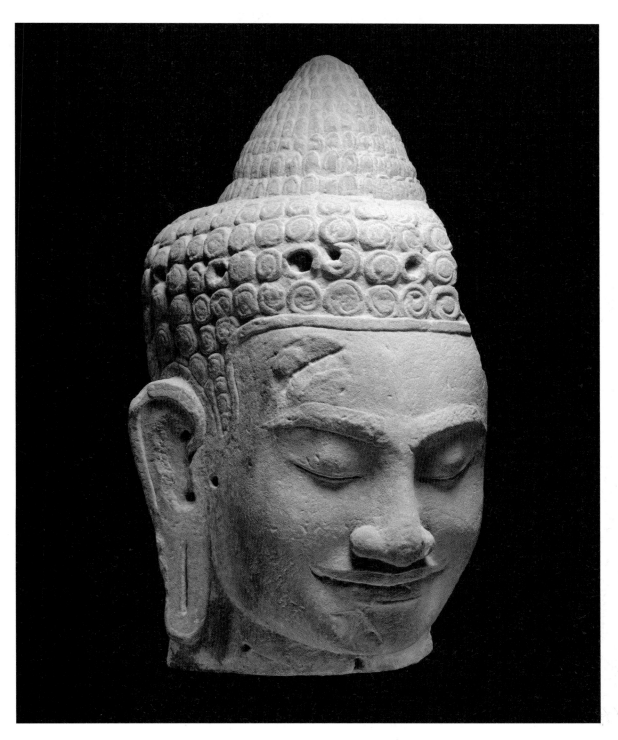

1.9

It should be evident from this brief glimpse into sculptural and architectural remains at Preah Khan in Kompong Svay, as in Angkor Thom, that integral to the growing perception of porous borders between types of religious practice in "early Theravādin Cambodia", along with those between Cambodia and Siam, is a reassessment of periodisation in Cambodian historiography. Readers will note that the "early" period covered by the chapters in the present volume unabashedly reaches into the 12th century.

Yet, the challenge of demarcating the historical period in question goes beyond the specific dating and associated definitional issues raised thus far. The challenge also arises from the history of the academic practice of periodisation anchored in modern Western historiography and politics. This is palpable in the varied usage of contributors to the present volume, where we find the "post-Angkorian Period", the "early post-Angkorian period", the "post-Bayon Period", the "Middle Period", the "early Middle Period", and the "early Modern Period", all referring to more or less the same time. There is a history to the usage of each of these terms, attesting to shifts in perception of time over time, and, periodically, to conscious attempts on the part of individual scholars or scholarly cohorts to engender such shifts within the field. Together they attest to ways in which periodisation is "not simply the drawing of an arbitrary line through time, but a complex process of conceptualizing categories, which are posited as homogeneous and retroactively validated by the designation of a period divide".[67] This is a definition given by Kathleen Davis in the opening of a book concerning the grounding of political order upon periodisation, most specifically, the modern political order dominated by the West since the Enlightenment and grounded upon a period divide between a "modern" secularised historical consciousness and the "Middle Ages" in which theology is seen to preclude conceptualisation of historical time.

In his 2012 essay cited in opening, historian Grégory Mikaelian tracks the evolution of terminology designating the Cambodian early Modern/post-Angkorian/Middle Period in the historiography of Cambodia from the early 20th century, highlighting ideologies determining usage. The "early modern" designation has its origins in the French colonial pitting of classical Angkor against the *époque moderne* whose roots in the wake of Angkor were posited as those of the modern Cambodian people under colonial rule and effectively detached from the Angkorian heritage. The core reference for this usage is established European historiography which sets the *époque moderne* to begin in the 15th century. Its English equivalent, "early modern", has been revived recently by those seeking to interpret Cambodia's history after Angkor within a context of regional and global exchange. The term "post-Bayon", used in art historical and

archaeological milieu to designate 13th-century materials postdating the reign of Jayavarman VII, has not gained traction in broader historical usage. The "post-Angkorian" label appears to have been introduced by art historian Jean Boisselier, and was made widespread by his disciple, Madeleine Giteau with her monograph on "post-Angkorian" art published in 1975.[68] By and large it can be said that this appellation reflected and reinforced a privileging of the Angkorian period as one of intellectual, cultural and political achievement over the post-Angkorian period itself studiously neglected as one of decline, and then confirmed as such in the study of its relatively meagre artistic evidence. Read through this modern prism, the local historical records of these two periods were seen notably to demonstrate a decline in local *historiographical* acuity over time – a decline redressed only with the advent of colonial scholarship. As a riposte to this hermeneutic frame, Cambodian linguist Saveros (Lewitz) Pou substantiated the appellation *époque moyenne*, which appears to have been first introduced in Khmer as *samăy kaṇtāl* by court intellectual Mahā Bidūr Krassem in his 1938 introduction to the Khmer publication of what are still known – in Khmer, French and English – as the *IMA*, the Middle Period inscriptions of Angkor Wat temple inventoried by French officials as the *Inscriptions modernes d'Angkor*.[69] Thanks to Pou's published and pedagogical œuvre developed over many decades in the postcolonial era, this appellation has become relatively commonplace, including in Khmer-language usage effectively retranslated as *samăy kaṇtāl*. In Pou's handling, the term works to dismantle the value judgements inherent in previously established usage. In heralding a focus on cultural continuity over time, the appellation also contributes to that very continuity by raising Cambodian consciousness of the cultural means by which heritage can be actively perpetuated. Some work born of Pou's determination, notably that of Mikaelian and myself, seeks now to take a further step in probing the modes of conceptualisation of historical time operative in Middle Cambodia which have been long overlooked, marginalised, demeaned or misunderstood in modern historiography.[70] My own usage in the present Introduction vacillates between the "Middle Period" and the "post-Angkorian Period". With the former, I aim to acknowledge historical developments specific to Cambodia as distinct from post-Angkorian developments elsewhere in mainland Southeast Asia, and to further Pou's critique of colonial and early postcolonial historiography in its neglect and/or denigration of all after Angkor. My usage of "post-Angkorian" aims to highlight the importance of Angkor in inflecting subsequent historical developments in Cambodia and across the mainland, especially in future Siam. The varied usage by the authors in this volume emerges out of this complex scholarly context and attests to varying degrees of intentionality.

THE CHAPTERS

The present volume is organised in loose chronological order of topic treated, with reference to these very questions of periodisation. With further reference to the related loose geographic definition of Middle Period "Cambodia", it comprises specialists of Cambodia, Thailand and Burma (Myanmar). We open with art historian Hiram Woodward who challenges any facile vision of 13th-century rupture in two ways. First, he culls evidence that "Theravāda Buddhism had long been looked upon in a favourable light" in Cambodia prior to the 13th century, positing the cultural shifts under our microscope as representing a "reinvigoration" or even a "reformation" rather than any "intrusive" movement. Second, he tracks adoptions and adaptations of cultural constructs over time and across space, such that we see, like a gestalt image, now Angkor and post-Angkor as one, now as distinct, just as we see Cambodia and Siam to vacillate between these two apparently mutually exclusive perspectives.

Woodward's essay is a call to arms for a new art history of post-Angkor, and means to serve as a model for it. Woodward's history-to-come would, on the one hand, do for post-Angkor what art historian Philippe Stern did for Angkor, tracking evolution in décor and style as a means of establishing a more granular historical account of both post-Angkorian art and the post-Angkorian period at large. Woodward draws on his two monumental publications on Thai art, *The Art and Architecture of Thailand* and *The Sacred Sculpture of Thailand*, to lay the ground for this work, discerning trends, influences and borrowings evidenced through "diagnostic motifs".[71] The synthetic study of these leads to a picture of stylistic evolution pegged to relative dating of the materials. On the other hand, Woodward models future art historical work through a daring interdisciplinary analysis comprising the second part of the chapter: a comparative reading of a 14th-century vernacular Thai oath with an 11th-century Cambodian oath against visual analysis of 12th-century sculpted reliefs at Angkor Wat temple and the parade of structures running north from the Bayon temple inside Angkor Thom. Analyses of these apparently disparate textual, sculptural and architectural sources lead Woodward to link the reliefs of the southern gallery of Angkor Wat with the creative staging of Angkor Thom's royal plaza as veritable illustrations of the said oath of loyalty to the king, or of the threats advanced against the disloyal. The study seeks to ground new hypotheses on the function of the central plaza of Angkor Thom, overriding extant assumptions regarding its funerary orientation, and, importantly for our purposes here, linking it to Ayutthayan culture. In contending that the face-towers of the Bayon period held nearly the same meaning from both Buddhist and Brahmanical points of view, Woodward

also contributes to the breaking down of barriers erected by scholars over time, effacing experience of meaning on the ground.

In the volume's next chapter, Tuy Danel examines Angkorian sculptural representation of *jātaka* tales. The *jātaka*, stories of the Buddha's past lives that illustrate the bodhisattva's successive performance of good deeds and concomitant progressive attainment of merit, are known in both Sanskrit and Pāli textual traditions; certain traits, however, can be taken to belie distinct sources. The sheer prevalence of representations of scenes from the *Vessantara-jātaka*, a story particularly favoured in Pāli traditions, in and of itself suggests a Pāli reference at Angkor from as early as the first half of the 12th century and into the reign of Jayavarman VII. But it is the detail in narrative representation that confirms the pervasiveness of this presence. Through his microscopic lens Tuy identifies scenes and episodes represented sculpturally at Angkor but, found only in the one or the other textual tradition, demonstrating thus the co-existence of Sanskrit and Pāli sources operating at Angkor. To what degree the references are actually *textual* remains, however, an open question; that is, modes of conveyance of this or that episode or tale informing or supplementing a given sculptural representation could well include the oral, the ritual and, of course, all manner of artistic form.

Tuy's evidence anticipates that analysed by Samerchai Poolsuwan in the following chapter. While in Poolsuwan's western Thai statuary assemblage we will see imitation of Angkorian style, here with Tuy in Central Angkor we see the integration of moral tales prevalent in those regions at the outer reaches of Angkorian administrative oversight. Though it is not Angkor Wat temple itself that attracts Tuy's attention, the author follows in the tracks of others in this volume in demonstrating the Angkor Wat style and period to have been pivotal in developing the Pāli connection. Tuy's comparison with Burmese modes of *jātaka* representation is also instructive in this regard. Pagan, he notes, evinces a like emphasis on the *Vessantara-jātaka*; unlike in Angkor, however, where we see select scenes repeatedly represented as an eclectic element of broader iconographic programmes, such as in the predominantly Vaishnavite reliefs of 12th-century Thommanon temple, at Pagan the tale is found represented in full, with panels detailing each episode in linear progression. Such formal distinctions invite analysis of the status of the source, and particularly any purported textual source, in distinct venues. While *jātaka* representations at both Pagan and Angkor may have sources in Mon Pāli Buddhism, there is little in the Angkorian record to suggest the predominance of a textual transmission above that of a sculptural one. In fact, Tuy hypothesises that the Dvāravatī *sīmā* sculpted with motifs including *jātaka* representations may have been the driver of *jātaka* representations at the heart of Angkor; whereas the detailed sequential

mode of sculptural representation at Pagan is akin to that of a written narrative account.

In the next chapter of this volume, anthropologist-cum-art historian Samerchai Poolsuwan brings us back to the third quarter of the 12th century with a collection of wooden Buddha statues from Tham Phra cave in Western Thailand's Ratchaburi province. The chapter speaks methodologically and topically to that of Woodward in opening as well as to that of Martin Polkinghorne closing the volume. For each of these authors, close formal study of artistic style serves to deepen extant historical understandings in revealing networks of religious exchange. Likewise for all three, 12th-century Angkor Wat is understood to be a determining influence in Theravādin cultural production. The stylistic features of the unique Tham Phra collection are associated with various sources of Buddhist art during the late first and early second millennia – late Dvāravatī, Pāla from Northeastern India and the Bengal area, Khmer most likely from Lopburi, Pagan from Upper Burma, Mon from Lower Burma, and Haripunjaya in Northern Thailand. What we see with Poolsuwan, however, is a certain mobility of style rather than of objects themselves, for the Tham Phra materials, while evidencing each of the above-named cultures, appear to have been produced in local workshops. Indeed, the Tham Phra statues evidence a veritable culture of imitation of those cultures at some distance from the site itself – Pāla/Pagan and Angkor – along with a rather eclectic mixing and matching of select elements. Angkor, for example, is conveyed largely through the imitation of adornment rather than facial features. For Poolsuwan, stylistic imitation does not necessarily correspond to shifts in sectarian belonging or to fusion of distinct religious groups. In his eyes, the Tham Phra statues convey the survival of a pre-reform Pāli Buddhism (Woodward's "Ariya" Buddhism or Bizot's "Tantric Theravāda") beneath a Mahāyāna veneer. Importantly, they also suggest ways in which the Buddhism(s) of 12th-century Angkorian hinterlands came to affect Angkorian sculptural production itself as stylistic elements from materials in these areas come to appear on late 12th- to early 13th-century Angkorian Buddha statues and pedestals in Central Angkor.

The next two chapters in this volume, by archaeologists Ea Darith and Yuni Sato, bring us into the 13th to 14th centuries and shift our focus to the architectural structures understood to cater specifically to Theravādin practices. If the presence of Pāli Buddhism is steadily evidenced in the art historical record at Angkor from the 12th century, these later architectural materials appear to represent a notable shift, with whole architectural structures renovated or singularly constructed seemingly in the name of Theravāda. Ea reviews the unpublished inventory of the "Buddhist terraces" of Angkor Thom carried out by the Cambodian governmental

Authority for the Protection and Safeguarding of Angkor and the Region of Angkor (APSARA) in 2002 against a survey of published work to date on these early Middle Period structures and other prominent Buddhist modifications of Angkorian-period temples in Central Angkor in subsequent centuries. The "Buddhist terrace" is a rectangular stone platform bearing a Buddha statue at its western end, and is surrounded by sīmā. These structures appear to be predecessors of the vihāra of modern Cambodia. The Cambodian vihāra are halls combining two functions that in other Theravādin contexts are relegated to separate architectural structures: a space for lay and monastic worship, and a space for monastic ordination ritual.[72] Following in the steps of his predecessors in this field, Ea notes the existence of two types of Buddhist terrace sites. The first is systematically integrated into a modified Angkorian temple site; in this type, the terrace abuts the eastern entry of an extant sanctuary. The second is a new standalone construction. With reference to the APSARA inventory, Ea proposes a further typology, comprising five types of Buddhist terrace differentiated by size. In the chapter's second section, Ea reviews select highlights of the more monumental modifications of Angkorian structures attributed to later periods. The chapter confirms the importance of the Angkorian material heritage in subsequent Cambodian shaping of Theravādin practice otherwise demonstrated in Woodward and Tuy's texts in particular, where we see Pāli Buddhism at Angkor physically and conceptually embedded in extant constructs rather than as "intrusive" phenomena.

Next, archaeologist Yuni Sato homes in on what has become, through the research of the Japanese-Cambodian team that she leads, the best known "Buddhist terrace" of Angkor Thom, that of Western Prasat Top, a small temple known in the colonial academic literature as Monument 486.[73] Sato's meticulous examination of this minor site yields significant results for our purposes here. Archaeological work has, first, enabled dating of the various stages of construction of this site in the early Middle Period. Because of an inscription recovered at Prasat Top, the site has long been assumed to have had its origins in an early Angkorian Brahmanic temple; Sato's research shows, rather, an original late 12th- to early 13th-century construction likely to have been Buddhist from the moment of inception. Major development of the site, including the construction of two lateral sanctuaries and a terrace to the east of the original sanctuary, is dated to the late 14th to early 15th centuries. The systematic archaeological research also brought significant new material finds, including intriguing architectural, sculptural and epigraphic evidence. Amongst these are reliefs of the walking Buddha found to have been sculpted into false doors of the northern sanctuary. Though the walking Buddha, an iconographic hallmark of Sukhothai, is quite rare in Angkor, the larger iconographic

ensemble found here – a sanctuary sculpted with large standing Buddhas in each of its false doors – is known to have been a defining characteristic of Cambodian Middle Period art.[74] The epigraphic finds are likewise small, but of real significance. These are a brief few words carved into decorative stones found around the terrace in close proximity to *sīmā*. The epigraph found to the south of the terrace names the Buddha "Kassapa in the south"; two fragments found to the west of the terrace are likely to name the Buddha "Sākyamuni to the west". The implications of these particular finds are pursued in the following chapter by art historian Nicolas Revire.

Revire draws from a wide range of evidence, including that unearthed by Sato and her team, to track the historical development of the veneration of past and future Buddhas in Cambodian culture writ large over time and space. The chapter's interpretive goals exceed however the establishment of this particular historical phenomenon insofar as, exploring connections between practices of the body, protective chants, iconographies and architectural layouts, Revire shapes out of the materials a window onto the types of beliefs and practices characterising Cambodian Theravāda. In doing so, he additionally highlights both interregional connections and overlaps between practices typically deemed to be either Mahāyāna or Theravāda. As highlighted in the opening of the present Introduction, Mahāyāna and Theravāda are in fact often set against each other as such for their supposed different conceptualisations of multiple Buddhas. The Buddhas of Theravāda, it is thought on the one hand, are relatively limited in number and typically understood to embody conceptions of seriality and linear chronological progression; this is foundational to the scholarly characterisation of Theravāda as a rational religion, attached first and foremost to the Historical Buddha Sākyamuni who is conceived both as the Buddha of our present era and one in a line of successive Buddhas. The many Buddhas of Mahāyāna, on the other hand, are cosmic, embodying notions of infinitely expanding space and simultaneity; this in turn is foundational to the opposing characterisation of Mahāyāna as relatively esoteric. In positing, in particular, a sustained emphasis on directional Buddhas in Cambodian practice, that is multiple Buddhas distinctly associated with points in space even as they may appear in a series of past Buddhas, Revire's work lays bare certain esoteric dimensions of Cambodian Pāli Buddhist practice, and begs the question of the pertinence of established Mahāyāna/Theravāda distinctions in the early Cambodian Middle Period.

The last chapter in our volume is by Martin Polkinghorne, a scholar who brings disciplinary expertise in both art history and archaeology to a sustained focus on the Cambodian Middle Period. The chapter emerges from the author's inventory of a corpus of 300 sculptures found at Angkor Wat whose stylistic features attest to the complexity of politico-

cultural regional networks operating in this period, and to the prominent role of this temple as a locus of ritual practice oriented to the conservation of both ancient and contemporary materials centuries after its 12th-century construction. Set against reflections on archaeological work at Angkor Wat, Polkinghorne's study of this sculptural corpus contributes to the ongoing development of a more precise historicisation of the often homogenously described "Middle Period" at this site where we see evidence of 13th- to 14th-century activity followed by renewed activity from the 16th century.[75] Three select pieces from the Middle Period Angkor Wat corpus are shown, through close stylistic analysis, to have originated in 17th- to 18th-century Ayutthaya in Central Thailand and Lan Xang in Central Laos. In considering the specific historical contexts, beyond the evidence at Angkor Wat itself, in which such sculptural donations would have been made, Polkinghorne sketches broader critical understandings of the Cambodian Middle Period, along with the sources available for its study and the disciplinary tools with which we approach it. The chapter proposes an understanding of artistic style attentive to the temporal and spatial ramifications of copying, and highlights the pitfalls of any simple assimilation of stylistic features with geographic and ethnic origin of hypothesised artisans. Stylistic analysis of sculpture is embedded in reflections on current understandings, arising largely from archaeological work concentrated on Greater Angkor, and on regional environmental and economic factors leading to shifts in political organisation across mainland Southeast Asia from the 13th century. From this vantage point, Polkinghorne queries early explanatory models of the politico-cultural transition after Angkor, which tended to emphasise the role of Theravāda in causing change, to instead posit religion and even culture at large as non-deterministic. The cultural dimension of the historical complex, embodied in this text by the donation of Buddhist sculpture to Angkor Wat, is, in Polkinghorne's evolving vision, to some degree subsumed into the broader regional geo-economic frame, even as the author opens up our horizons in imagining a yet-to-be-uncovered social and religious world decoupled from royal practices and *not* bound to established historical narratives.

Polkinghorne's chapter joins each contribution to this volume in highlighting the importance of Angkor beyond Angkor in both temporal and geographic terms. Together, they also highlight what is missing here: new art and archaeological research focused on the Middle Period in Cambodia's more southerly regions. Though Angkor undoubtedly looms large in the formation of a range of regional Theravādin cultures and polities, materials and practices in Central Angkor can only be expected to vary from those at a remove from the ancient capital. We have seen one example of this with Poolsuwan's analysis of imitation in the sculptural

assemblage of Tham Phra cave in Western Thailand. At later periods, just as Sukhothai or Ayutthaya take Angkor as a guiding reference while also differing from Angkor, so too must we expect Cambodia's Middle Period capitals to emerge from Angkor even as Angkor fades from view in ways unimaginable on the Angkor plain itself. At the same time, we can expect new networks across the Southeast Asian and broader Asian region to shift into focus. Ongoing archaeological research on Cambodia's southerly regions in the Middle Period boasts a number of the present volume's authors at its helm. With the appearance of our volume, then, we beckon its sequel, and with it further development of the methodological and theoretical horizons we have only begun to glimpse here, where understandings of Theravādin art of Middle Cambodia are developed with particular attention to the visions and experiences of its producer-users. Reinforcing such interpretive frames will enable the disciplines of the history of art and archaeology to transcend the role often attributed them as handmaiden to the discipline of history as defined by post-Enlightenment Euro-American concerns, and to thrive, instead, in detecting the many agencies borne by the objects themselves – even as these will come to inform new historical narratives.

Notes

1 Sven Bretfeld, "Resonant Paradigms in the Study of Religions and the Emergence of Theravāda Buddhism", *Religion* 42, no. 2, pp. 273–97.

2 Ibid., p. 278.

3 Grégory Mikaelian, "Des sources lacunaires de l'histoire à l'histoire complexifiée des sources. Éléments pour une histoire des renaissances khmères (c. XIV-c. XVIIIe s.)", *Péninsule* 65, 2012, pp. 259–305. This text elaborates on a short piece published online under a title that points out more distinctly the concerns shared with Bretfeld: "Écrire l'histoire du Cambodge moyen entre techniques occidentales et doctrines orientales" [Writing the History of Middle Cambodia between Western Techniques and Eastern Doctrines], *Bulletin de l'AEFEK* 8 (http://aefek.free.fr), February 2005.

4 Bretfeld, "Resonant paradigms", p. 294.

5 Ibid., p. 278.

6 Peter Skilling, Jason A. Carbine, Claudio Cicuzza and Santi Pakdeekham, eds., *How Theravāda is Theravāda?: Exploring Buddhist Identities*, Chiang Mai: Silkworm Books, 2012; Prapod Assavavirulhakarn, *The Ascendancy of Theravāda Buddhism in Southeast Asia,* Chiang Mai: Silkworm Books, 2010.

7 Jacques Derrida, "Structure, Sign and Play in the Discourse of the Human Sciences", in *Writing and Difference,* trans. A. Bass, Chicago: University of Chicago Press, 1979, p. 285.

8 Peter Skilling, "The Advent of Theravāda Buddhism to South-east Asia", *Journal of the International Association of Buddhist Studies* 20, no. 1, Summer 1997, pp. 99–104.

9 Kate Crosby, *Theravāda Buddhism: Continuity, Diversity and Identity*, West

Sussex: Wiley-Blackwell, 2013.

10 Ibid., p. 4.

11 The Sanskrit versions of the *Vinaya*, *Sutta* and *Abhidhamma* are the *Vinaya*, *Sūtra* and *Abhidharma*.

12 Bretfeld provides a concise critical account of the modern invention of the opposition between "Theravāda/Hīnayāna" and "Mahāyāna". While "Theravāda" originally denoted "a monastic lineage affiliation", "Hīnayāna" and "Mahāyāna" denoted "personal aspiration and doxo-practical orientation". The modern intervention was to detach the terms "Theravāda" and "Mahāyāna" from their discrete categories to re-fashion them as an opposing pair attached to a singular category of variously defined sectarian affiliation, effectively comparing apples to oranges as the English expression would have it (Bretfeld, "Resonant Paradigms", p. 291). The impact of this intervention on historical interpretation cannot be over-emphasised. Notably, in our early Middle Cambodian case study, the art historical tendency to classify this or that artefact as evidence of exclusive Theravādin or Mahāyānist beliefs and practices has evolved under its influence, neglecting the simple fact that, historically, monastic lineages were mainly defined by sets of prescripts on monastic behaviour rather than specific doctrinal positions; and that when such positions were held by a lineage proper, they were not necessarily binding for its members. As Bretfeld notes with regards to early Indic developments (as well as for medieval Sri Lanka in subsequent discussions), "A monk could be ordained in a certain Nikāya [lineage] but hold the doctrinal views of another. It was even usual that the same monastery was a place for both Hīnayāna and Mahāyāna adepts" (p. 287). On the possibility of esoteric forms of "Mahāyāna Buddhism" evolving "in Theravāda guise" in first-millennium Southeast Asia, see Andrea Acri, "Introduction: Esoteric Buddhist Networks along the Maritime Silk Routes, 7th–13th Century AD" in *Esoteric Buddhism in Mediaeval Maritime Asia: Networks of Masters, Texts, Icons*, ed. Andrea Acri, Singapore: ISEAS-Yusof Ishak Institute, 2016, esp. pp. 10–13.

13 Crosby, *Theravāda Buddhism*, p. 3.

14 Frank E. Reynolds and Charles Hallisey, "The Buddha", in *Buddhism and Asian History: Religion, History and Culture*, eds. Joseph M. Kitagawa and Mark D. Cummings, New York: MacMillan Publishing and Co., 1989, p. 29.

15 See Kate Crosby's detailed review of François Bizot's œuvre in "Tantric Theravada: A Bibliographic Essay on the Writings of François Bizot and Others on the Yogāvacara Tradition", *Contemporary Buddhism*, vol. 1, issue 2, 2000, pp. 141–198. This essay marks the start of what is now an œuvre unto its own on the topic, culminating – thus far – in Crosby's *Esoteric Theravada: The Story of the Forgotten Meditation Tradition of Southeast Asia*, Boulder: Shambhala Publications, 2020.

16 *K. 754* is the first dated Pāli composition noted above. Another earlier inscription (*K. 241*), in Khmer and dated 1267, records the installation of an image of the Buddha called *kamrateṅ jagat śrisugatamāravijita*; the appellation combines the common Angkorian epithet for gods, *kamrateṅ jagat*, or "Lord of the World", with a Sanskrit or Pāli compound designating the "Buddha, Victorious over Māra", alluding to a pivotal moment in the Historical Buddha's life story, which is frequently depicted in Middle Cambodian Theravādin art in the form of a sculpted figure of the Buddha seated in *"māravijaya"* or "Victory over Māra" posture, often within a sculpted representation of the episode in question. Though the epigraph is not in Pāli, it incorporates this appellation,

which could be Pāli or Sanskrit, and which suggests it was an image of this type which was consecrated here in the 13th century. Another undated Pāli inscription, *K. 501*, is likely to date from the late 12th to early 13th centuries. *K. 567* is the last dated Sanskrit one. The latter in fact contains four dates, with the latest given above. Another later Sanskrit inscription, *K. 300*, does not contain a numbered date but refers to a reign known to have begun in 1327. Both of these are Shaivite. For recent detailed consideration of the epigraphic records of the late 13th to early 14th centuries as a whole, see Ludivine Provost-Roche, "Les derniers siècles de l'époque angkorienne au Cambodge (env. 1220–env. 1500)", PhD dissertation, Université de la Sorbonne Nouvelle–Paris III, 2010, vol. 1, pp. 22–48 and translations of select texts in vol. 2. (Note, however, that for unexplained reasons she does not include *K. 501* within her study group.)

17 See the second section of Hiram Woodward's chapter in the present volume, and the work from which he draws there: Hiram W. Woodward Jr., "'The Characteristics of Elephants': A Thai Manuscript and its Context", in *From Mulberry Leaves to Silk Scrolls: New Approaches to the Study of Asian Manuscript Traditions*, eds. Justin McDaniel and Lynn Ransom, Philadelphia: Schoenberg Institute, University of Pennsylvania Libraries, 2015, pp. 15–41; and "King Sūryavarman II and the Power of Subjugation", in *On Meaning and Mantras: Essays in Honor of Frits Staal*, eds. George Thompson and Richard K. Payne, Berkeley: Institute of Buddhist Studies and BDK America, 2017, pp. 483–502.

18 On the linguistic and literary mechanisms of the Sanskrit cosmopolis and its aftermath more broadly, see Sheldon Pollock, *The Language of the Gods in the World of Men: Sanskrit, Culture and Power in Premodern India*, Berkeley: University of California Press, 2006. Au Chhieng teases out the linguistic and intellectual dimensions of Khmer vernacular engagement with Sanskrit in his *Études de philologie indo-khmère* series published in the *JA* from 1963–74. (See "Translation" section on Au Chhieng in *Udaya Journal of Khmer Studies* 15, 2020, pp. 127–98.) Trent Walker has tracked the creative multilingual play at the heart of Middle Khmer Buddhist textual production in his doctoral work: "Unfolding Buddhism: Communal Scripts, Localized Translations, and the Work of the Dying in Cambodian Chanted Leporellos", PhD dissertation, University of California, Berkeley, 2018. For other recent work on bilingualism in Khmer epigraphy, see Ashley Thompson, *Engendering the Buddhist State: Territory, Sovereignty and Sexual Difference in the Inventions of Angkor*, Routledge Critical Buddhist Studies, 2016; Chhom Kunthea, "Le rôle du sanskrit dans le développement de la langue khmère: Une étude épigraphique du VIe au XIVe siècle", PhD dissertation, École Pratique des Hautes Études, 2016. Peter Skilling continues to develop meticulous work on the Pāli epigraphy of Southeast Asia, shedding light on relations between Pāli and local languages across the region. On the state of affairs in Southeast Asian epigraphic study more broadly, including Skilling's useful contribution on the multilingual epigraphy from Thailand, see Daniel Perret, ed., *Writing for Eternity: A Survey of Epigraphy in Southeast Asia*, Paris: EFEO, 2018. Many of these studies build on the œuvre of Saveros Pou (Lewitz) as well as those of George Cœdès and Michael Vickery, whose bibliographies are available at https://www.aefek.fr/page42.html.

19 I.e., philosophically speaking, in the ultimate sense, *paramattha*. (Original translator's note.)

20 I. B. Horner, trans., *Milinda's Questions*, London: Pāli Text Society, 1990 [1963], vol. 1, pp. 36–8.

21 For one of his last iterations of this critical position, see Michael Vickery, unpublished revised version of "A New *Tāmnān* About Ayudhya", p. 5, n. 29. The article was originally published in the *JSS* 67, no. 1, 1979, pp. 123–86. My thanks to Geoff Wade for sharing an unpublished collection of revised versions of articles on Thai history by Vickery.

22 Michael Vickery, unpublished revised version of "The *2/k.125 Fragment*, a Lost Chronicle of Ayutthaya", originally published in *JSS* 65, no. 1, 1977, p. 56.

23 Ibid., pp. 136–7. See also Mikaelian, "Des sources lacunaires", p. 277.

24 Maurizo Peleggi has examined dimensions of this question in Thai (art) historiography. See especially "The Plot of Thai Art History: Buddhist Sculpture and the Myth of National Origins", in *A Sarong for Clio: Essays on the Intellectual and Cultural Histories of Thailand – Inspired by Craig J. Reynolds*, ed. Maurizio Peleggi, Ithaca: Cornell University SEAP Publications, 2015, pp. 79–93.

25 George Cœdès, "Une période critique dans l'Asie du Sud-est: the XIIIè siècle", *Bulletin de la Société des Études Indochinoises* XXXIII, no. 4, 1958, p. 387. A first iteration of this essay was delivered as a talk at the Musée Guimet, Paris, in 1957.

26 Ibid., p. 400.

27 Ibid., p. 398.

28 Ibid., p. 399.

29 Ibid., p. 399. On the epigraphic passage in question, see A. B. Griswold and Prasert ṇa Nagara, "The epigraphy of Mahādharmarājā I of Sukhodaya: Epigraphic and Historical Studies 11/1", *JSS* 61, no. 1, 1973, p. 97.

30 Ibid., p. 400.

31 The Ayutthaya question pervades Vickery's œuvre. One example also referencing Sukhothai in these terms (with reference to the work of Griswold and Prasert) is in Michael Vickery, unpublished revised version of "A New *Tāmnān* About Ayudhya", p. 44, n. 300. Recent work by Grégory Mikaelian and Éric Bourdonneau on the multiple variations on the Angkorian *devarāja*, in Siam as in Cambodia over time and across religions and social milieux, adds significantly to the history sketched here, both in empirical and conceptual terms. The multiple objects which the authors demonstrate to be variously linked to the Angkorian cult provide a matrix for constructing geo-temporal models beyond that of the *maṇḍala* on the one hand and the binary of historical rupture versus continuity on the other. The subtle view of "l'histoire longue" proposed by the authors goes further still to challenge the many binaries anchored in the established periodisation of Cambodian history. Given the timing of our respective publications, the present volume anticipates but does not account fully for the authors' theoretical propositions. See Éric Bourdonneau and Grégory Mikaelian, "L'histoire longue du *Devarāja*: *Pañcaksetr* et figuier à cinq branches dans l'ombre de la danse de Śiva", in *Rāja-maṇḍala: le modèle royal en Inde*, eds. Emmanuel Francis and Raphaël Rousseleau, Collection *Puruṣārtha* 37, September 2020, pp. 81–129.

32 Saveros Lewitz, "La toponymie khmère", *BEFEO* 53, no. 2, 1967, pp. 377–450.

33 Ashley Thompson, "Lost and Found: The Stupa, the Four-faced Buddha and the Seat of Royal Power in Middle Cambodia", in *Proceedings of the 7th International Conference of the European Association of Southeast Asian Archaeologists, Berlin, 1998*, eds. Marijke J. Klokke and Thomas De Brujin Hull:

Centre for Southeast Asian Studies, University of Hull, 2000, pp. 245–63; "The Future of Cambodia's Past: A Messianic Middle-Cambodian Royal Cult", in *History, Buddhism and New Religious Movements in Cambodia*, eds. Elizabeth Guthrie and John Marston, Hawai'i: University of Hawai'i Press, 2004, pp. 13–39.

34 *IMA 2* and *3* in Saveros Lewitz, "Inscriptions modernes d'Angkor 2 et 3", *BEFEO* 57, 1970, pp. 99–126. See also Ang Chouléan, "*tūc purāṇ kāl!*" [Like olden times!], *KhmeRenaissance* 3, December 2007–8, pp. 75–7.

35 *K. 177* in Saveros Pou, "Inscriptions khmères K. 144 et K. 177", *BEFEO* 70, 1981, pp. 101–20.

36 *K. 465, K. 285* and *K. 1006*. Khin Sok, "Deux inscriptions tardives du Phnom Bàkhèn, K.465 et K.285", *BEFEO* 65, no. 1, 1978, pp. 271–80; Michael Vickery, "L'inscription K 1006 du Phnom Kulên", *BEFEO* 71, 1982, pp. 77–86; Saveros Pou, "Inscription de Phnom Bakheng (K. 465)", in Saveros Pou, *Nouvelles Inscriptions du Cambodge I*, Paris: EFEO, 1989, pp. 20–5; Saveros Pou, "Inscription de Phnom Bakheng (K. 285)", in Saveros Pou, *Nouvelles Inscriptions du Cambodge I*, Paris: EFEO, 1989, pp. 26–7.

37 Stanley Jeyaraja Tambiah, "The Galactic Polity", in *World Conqueror and World Renouncer: A Study of Buddhism and Polity in Thailand against a Historical Background*, Cambridge: Cambridge University Press, 1976, pp. 102–31; O. W. Wolters, *History, Culture and Region in Southeast Asian Perspectives*, Ithaca: Cornell University Institute of Southeast Asian Studies, first edition 1982, revised edition 1999; Thongchai Winichakul, *Siam Mapped: A History of the Geo-body of a Nation*, Hawai'i: University of Hawai'i Press, 1994.

38 For an unapologetic use of the term *maṇḍala* in the place of "state", and a summary of a succession of Southeast Asian *maṇḍala* in the longue durée, see Prapod Assavavirulhakarn, *The Ascendancy of Theravāda Buddhism*, esp. pp. 18–23.

39 George Cœdès, "Études cambodgiennes XXXII. La plus ancienne inscription en pâli du Cambodge", *BEFEO* 36, 1937, pp. 14–21, (republished in *Articles sur le pays khmer*, t. I, Paris: EFEO, 1989, pp. 282–9).

40 For *K. 501* see George Cœdès, *Inscriptions du Cambodge* III, Paris: EFEO, 1951, pp. 85–8. The date provided in the epigraph is difficult to decipher. Cœdès notes that it could render 1074 CE, but one syllable key to such an interpretation remains enigmatic. For the graphics of the text and presumably its Pāli language, Cœdès favours a later date, but still prior to *K. 754. K. 241* records the erection of the "Victory over Māra" Buddha image. See ibid., pp. 76–8. See also note 16 above.

41 Skilling, "The Advent of Theravāda Buddhism to South-east Asia", p. 104. The statue on which the image figures is held by the Musée Guimet: MG 18891. Skilling has also recently published a study of a seventh- to eighth-century Pāli text inscribed on a clay tablet found in Angkor Borei district; the text, *K. 1355*, comprises the earliest appearance of Pāli in Cambodia known to date. It is citational, thus confirming the nature of first-millennium Pāli in Cambodia like in the Southeast Asian region as noted above. See Peter Skilling, "The Theravaṃsa has always been here: K. 1355 from Angkor Borei", *JSS* 107, no. 2, 2019, pp. 43–62.

42 Stephen Murphy has shown the two closely situated *sīmā* sites on the Kulen to be representative of a culture well developed on the Khorat plateau. As the one instance south of the Dangrek mountains that serves otherwise as a natural border confining the extensive *sīmā* distribution to the northerly

plateau, the Kulen example is also anomalous. (Of his many publications on and around this topic, see for example Stephen Murphy, "The Distribution of Sema Stones throughout the Khorat Plateau during the Dvāravati Period", in *Unearthing Southeast Asia's Past*, Vol.1, eds. Marijke J. Klokke and Véronique Degroot, Singapore: NUS Press, 2013, pp. 215–33.) Recent unpublished archaeological research led by Kyle Latinis (ISEAS, Singapore) and Ea Darith (APSARA, Cambodia) suggests that the Kulen *sīmā* sites were not active after the ninth century. See https://www.researchgate.net/profile/David_Latinis/publication/304353545_Phnom_Kulen_Cambodia_and_Singapore_Projects_-_Royal_Residence_Palace_Site_Banteay_-_Sema_Stone_Sites_Don_Meas_and_Peam_Kre_-_Dvāravati_influence_-_Sema_Stone_quarry_-_Implications/links/576cfa8208ae3c5c932d24a3/Phnom-Kulen-Cambodia-and-Singapore-Projects-Royal-Residence-Palace-Site-Banteay-Sema-Stone-Sites-Don-Meas-and-Peam-Kre-Dvāravati-influence-Sema-Stone-quarry-Implications.pdf (last accessed 24 June 2019). Tun Puthpiseth provides an evaluation of the sculptural evidence he considers to have been associated with the *sīmā* – a *buddhapāda* and a *dharmacakra* sculpted out of the mountain floor. Though he acknowledges the disparate dating given by scholars to these different sculptural elements, as well as the manifest integration of some of them into subsequent cults, he emphasises the affinity of the ensemble with eighth- to ninth-century Dvāravatī materials. See Tun Puthpiseth, "Bouddhisme Theravāda et production artistique en pays khmer: Étude d'un corpus d'images en ronde-bosse du Buddha (XIIIe–XVIe siècles)", PhD dissertation, Paris, Université de Paris IV-Sorbonne, 2015, pp. 78–80.

43 *K. 501*: st. III, in George Cœdès, *Inscriptions du Cambodge* III, pp. 87–8. My translation.

44 For an inventory of primary and secondary texts, see the *Corpus des inscriptions khmères* developed by the Cambodian inscription project team of the EFEO: https://cik.efeo.fr/inventaire-cik-des-inscriptions-khmeres/; and Peter Skilling, "Towards an Epigraphic Bibliography of Thailand", in *Writing for Eternity: A Survey of Epigraphy in Southeast Asia*, ed. Daniel Perret, Paris: EFEO, 2018, pp. 109–22. A key text for establishing further historical bases for understanding Khmer Pāli usage is *K. 966*, a 12th-century bilingual Pāli-Khmer inscription from Dong Mae Nang Meung, Nakhon Sawan, Thailand. The comparative study needed to develop sharper critical assessment of these "Cambodian" and "Thai" epigraphic bodies would also include consideration of the different types of material support on which the texts appear.

45 For the first systematic documentation of the site including mention of this image and the other materials associated with it discussed below, see Henri Mauger, "Práḥ Khăn de Kŏmpoṅ Svày", *BEFEO* 39, 1939, pp. 197–220. For our purposes, see esp. pp. 211–2.

46 Peter Skilling, "Namo Buddhāya Gurave (K. 888): Circulation of a Liturgical Formula across Asia", *JSS* 106, 2018, pp. 109–28. The verse, Skilling notes, contains vocabulary shared by Sanskrit and Pāli, but the word inflections are clearly Sanskrit. This situation highlights two key factors for the present volume: the intimate kinship between the two Indic languages whose distinctions rather than similarities are often emphasised in scholarship in conjunction with rigid categorisation of religious affiliation; and the still rudimentary state of our knowledge in this field.

47 Saveros Pou, *Nouvelles inscriptions du Cambodge* I, EFEO, Paris, 1989, pp. 14–5.

To compare the scripts of the two inscriptions, see Pl. I of *Nouvelles inscriptions* and p. 14 of Cœdès' "La plus ancienne".

48 In a 1967 thesis Bernard-Philippe Groslier built substantially on the work of Mauger cited above. Groslier's work comprises a detailed study of the architectural structure and décor of the core monumental site: Bernard-Philippe Groslier, *Le Preah Khan de Kompong Svay*, thesis, Paris: École du Louvre, 1967. "The Buddhist Towers of Preah Khan" research project led by archaeologist Mitch Hendrickson is building further on this work to develop also an understanding of the site within the broader Angkorian socio-economic fabric over time (http://pkks.sscnet.ucla.edu/). While we await the advancement and publication of this team's research my brief comments on the site here should be set against the backdrop of the developing understandings of the complexity of the site.

49 Peter Skilling, "Namo Buddhāya Gurave (K. 888)", pp. 123–4. Skilling cites Jens-Uwe Hartmann on characterisation of the verse as "common Buddhist property" (p. 123).

50 For art historical assessments, see Madeleine Giteau, *Guide du musée national de Phnom Penh, I: Sculpture*, Phnom Penh, Office national du Tourisme, 1960, p. 50; Nadine Dalsheimer, *L'art du Cambodge ancien: Les collections du Musée national de Phnom Penh*, Paris: EFEO 2001, pp. 178–9. Dalsheimer firmly situates the piece in the 13th to 14th centuries on the basis of the relatively poor modelling of the body, but nonetheless qualifies this dating as an "extension of the art of the Jayavarman VII period".

51 Dalsheimer, *L'art du Cambodge ancien*, pp. 222–3. Hiram Woodward also situates the piece in the Jayavarman VII period; see Hiram W. Woodward, "The Jayabuddhamahānātha Images of Cambodia", *Journal of the Walters Art Gallery* 52/53, 1994/95, pp. 108–9.

52 On the Kompong Svay portrait-statue, along with a figure (Buddha?) in meditation with like morphological resemblance to the portrait, see Christophe Pottier, "A propos de la statue portrait du Roi Jayavarman VII au temple de Preah Khan de Kompong Svay", *AA* 55, 2000, pp. 171–2. The notes include a useful bibliography of other portrait and portrait-like Buddha finds.

53 See Ashley Thompson, "Angkor Revisited: The State of Statuary", in *What's the Use of Art?: Asian Visual and Material Culture in Context*, eds. Jan Mrazek and Morgan Pitelka, Hawai'i: University of Hawai'i Press, 2008, pp. 179–213.

54 Peter Skilling "Namo Buddhāya Gurave (K. 888)", p. 109, n. 2. Hiram Woodward points out the need to differentiate the *saṃghāṭi*, as Skilling names the outer cloth layer draped over the left shoulder, and what Griswold termed a "shoulder-flap" (the turned over robe edge) (Hiram Woodward, personal communication, February 2020). See A. B. Griswold, "The Architecture and Sculpture of Siam" in *Arts of Thailand: A Handbook of the Architecture, Sculpture and Painting of Thailand (Siam)*, ed. Theodore Bowie, Bloomington: Indiana University Press, 1960, pp. 25–157; "Prolegomena to the Study of the Buddha's Dress in Chinese Sculpture: With Particular Reference to the Rietberg Museum's Collection", *Artibus Asiae* 26, no. 2, 1963, pp. 85–131; "Prolegomena to the Study of the Buddha's Dress in Chinese Sculpture (Part II)", *Artibus Asiae* 27, no. 4, 1964–5, pp. 335–48; "Imported Images and the Nature of Copying in the Art of Siam", *Artibus Asiae* 23, 1966, pp.37–73. For a quick description of the two garments and the resemblance of their appearance on statuary, see "Prolegomena" I (1963), pp. 86–8, esp. n. 8. Theoretically, the two can be distinguished through observation of the back of

sculpted imagery. That there is no visible trace of the *saṃghāṭi* on the back of Ka. 1697 suggests that what we see in front is the shoulder-flap, however given that the sculpture is unfinished in places we cannot be certain of this (See Fig. 1.3). We cannot see the backs of the two central figures in Ka. 1848 as they are embedded in the *nāga*.

55 François Bizot, *Les traditions de la pabbajja en Asie du Sud-Est. Recherches sur le Bouddhisme khmer IV*, Göttingen: Vandenhoeck and Ruprecht, 1988; and for a summary presentation: "Bouddhisme d'Asie du Sud-Est", École pratique des Hautes Etudes, Section des sciences religieuses, *Annuaire*, tome 105, 1996–7, pp. 75–86. Tun Puthpiseth's encyclopaedic doctoral dissertation documents variations in sculpted Cambodian "Theravādin" monastic dress including but not limited to the covering or exposure of the right shoulder but remains ambivalent in attributing any significance in terms of lineage or doctrinal orientation to these differences. While asserting that the sculpted dress reflects that worn by monks at the time of artistic production, and leaving open the possibility that certain elements of the dress such as the belt could indicate distinctions in practice, he emphasises that "they [sculpted post-Bayon Buddha images] all belong to Theravādin sanctuaries, [and] do not therefore present specific drapery corresponding to different sects" (Tun Puthpiseth, "Bouddhisme Theravāda et production artistique en pays khmer", p. 168, my translation).

56 Woodward, "The Jayabuddhamahānātha Images", p. 108. Note also that Hiram W. Woodward has long highlighted the Buddha protected by the *nāga* as a crossover Mahāyāna-Theravāda figure.

57 Dalsheimer, *L'art du Cambodge ancien*, p. 222.

58 See Claudine Bautze-Picron, *The Bejewelled Buddha from India to Burma*, New Delhi: Sanctum Books, 2010, esp. pp. 131–40.

59 For more on Chatomukh and Prasat Steung, including the reasoning behind the tentative dating of the former, see Ashley Thompson, "Revenons, revenants: mémoires d'Angkor", in *Temporalités khmères: de près, de loin, entre îles et péninsules,* eds. Nasir Abdoul-Carime, Grégory Mikaelian and Joseph Thach, Berne: Peter Lang, 2021, pp. 345–75. In the following paragraph I draw from this essay. See also Chapter 7 in the present volume.

60 Hiram W. Woodward, "Ram Khamhaeng's Inscription: The Search for Context", in *The Ram Khamhaeng Controversy*, ed. J. R. Chamberlain, Bangkok, The Siam Society, 1991, p. 427.

61 Ibid., p. 424.

62 François Bizot, *Le figuier à cinq branches: Recherche sur le bouddhisme khmer*, Paris: EFEO, PEFEO vol. CVII, 1976, esp. pp. 29–42.

63 In addition to the research presented in the present volume and my own work cited above, see in particular Provost-Roche's evocation of regional comparators throughout her dissertation in analyses of the large Buddha figures in niches on the external sanctuary walls of other early Middle Cambodian sites; and Tilman Frasch's ongoing work on a Cambodian monastic presence at Pagan evidenced in particular by a Pāli inscription from 1248 CE, and other indicators of Cambodia's place in cosmopolitan Pāli Buddhist networks evidenced in particular by another Pagan inscription dated 1270 CE. See Tilman Frasch, "A Pāli Cosmopolis? Sri Lanka and the Theravāda Buddhist Ecumene, c. 500–1500", in *Sri Lanka at the Crossroads of History*, eds. Zoltán Biederman and Alan Strathern, London: University College London Press, 2017, pp. 66–76; "Kontakte, Konzile, Kontroversen: Begegnungen in der Theravada-Kosmopolis,

c. 1000–1300 CE", in *Religionsbegegnung in der asiatischen Religionsgeschichte: Kritische Reflexionen über ein etabliertes Konzept*, eds. Max Deeg, Oliver Freiberger and Christoph Kleine, Göttingen: Vandenhoeck & Ruprecht, 2018, pp. 129–52; and "Pali at Bagan: The Lingua Franca of Theravada Buddhist Ecumene", talk in the Rainy Season Research Seminar Series, Transnational Network of Theravada Studies, 25 September 2020, https://theravadastudies. org/recordings/. I note also the comparison made with Pagan's Ananda temple by Lam Sopheak. For this archaeologist, who led the restoration of Preah Chatomukh, the comparison is evoked both by morphological comparison with the Ananda's configuration of four colossal Buddhas around a central core and playful linguistic comparison between "Pagan" and "Bakan" (pākān). The latter is the common local name for the temple known to international art historians and archaeologists as "Preah Khan", as well as that of the site of another important Middle Cambodian colossal four-Buddha ensemble, at the summit of Angkor Wat temple. See Lam Sopheak, *Rapāy kār(ṇ) juos jul prāsād catumukh*, [Report on the Restoration of Prasat Chatomukh], 2018, unpublished, pp. 47–50.

64 The first mention of this piece is in Henri Marchal's study of Angkor Thom's "Buddhist terraces", a term which he coined to describe the main architectural feature of these early Theravādin sites in Angkor Thom: Henri Marchal, "Monuments secondaires et terrasses bouddhiques d'Aṅkor Thom", *BEFEO* 18, no. 8, Hanoi, 1918, p. 13. Thierry Zéphir provides a comprehensive description in Pierre Baptiste and Thierry Zéphir, *L'Art Khmer dans les collections du musée Guimet*, Paris:Édition de la Réunion des musées nationaux, 2008, pp. 272–3.

65 Ibid., p. 273.

66 For a detailed review of the find of the Bayon Buddha, and consideration of other materials found in the Bayon pit as well as at Vihear Prampir Laveang and a neighbouring Buddhist terrace, see Martin Polkinghorne, Christophe Pottier and Christian Fischer, "Evidence for the 15th-century Ayutthayan Occupation of Angkor", in *The Renaissance Princess Lectures: In Honour of Her Royal Highness Princess Maha Chakri Sirindhorn*, Siam Society, 2018, p. 98–132. In this essay, which is an updated version of an earlier publication by the same authors ("One Buddha Can Hide Another", *JA* 301, no. 2, 2013, pp. 575–624), Vihear Prampir Lavaeng is referred to as "Prasat Prampil Lavaeng". See also reference to this site in Chapters 5 and 6 in the present volume.

67 Kathleen Davis, *Periodization and Sovereignty: How Ideas of Feudalism and Secularization Govern the Politics of Time*, Philadelphia: University of Pennsylvania Press, 2008, p. 11.

68 Madeleine Giteau, *Iconographie du Cambodge Post-Angkorien*, Paris, EFEO 1975.

69 See the second edition: Krassem, Mahā Bidūr, *Silācārik Nagar Vatt/Inscriptions modernes d'Angkor* with a new preface by Saveros Pou, Paris: Cedoreck, 1984, p. *ga*.

70 Mikaelian's latest development on this question is embedded in the above-cited work with Eric Bourdonneau, "L'histoire longue"; mine is in the "Revenons, revenants" cited above.

71 Hiram W. Woodward Jr. and Donna K. Strahan, *The Sacred Sculpture of Thailand: The Alexander B. Griswold Collection, The Walters Art Gallery*, Baltimore: Walters Art Gallery, 1997; *The Art and Architecture of Thailand* Leiden and Boston: Brill, 2003, 2005.

72 In addition to Marchal's 1918 foundational essay noted above, further analysis

of the function and meaning of these spatial configurations can be found in Ashley Thompson, "Mémoires du Cambodge", PhD dissertation, Université de Paris VIII, 1999, esp. pp. 40–114; and "The Ancestral Cult in Transition: Reflections on Spatial Organization of Cambodia's early Theravada Complex", in *Southeast Asian Archaeology 1996: Proceedings of the 6th International Conference of the European Association of Southeast Asian Archaeologists, Leiden, 2–6 September 1996,* eds. Marijke J. Klokke and Thomas De Brujin, Centre for Southeast Asian Studies, University of Hull, 1998, 273–95.

73 Madeleine Giteau's *Iconographie du Cambodge Post-Angkorien* includes close study of those sculptural materials of Western Prasat Top which were accessible during the period of her research preceding the 1979 publication. As noted below, Sato has been able to build on the study of the site's material evidence, including additional sculpture brought to light through new archaeological research. Another close examination of the site's sculpture, preceding Sato's research published here, but usefully set in the context of a near-exhaustive inventory of early Cambodian Middle Period Buddhist statuary, is found in Tun Puthpiseth, "Bouddhisme Theravāda et production artistique en pays khmer".

74 See Ashley Thompson, "Mémoires du Cambodge", pp. 114–253; "Lost and Found"; "The Future of Cambodia's Past"; and "Revenons, revenants". In her dissertation L. Provost-Roche examines this recurrent configuration in relation to the development of the Siamese *prāṅ(g)*, a sanctuary-tower more elongated than its Angkorian predecessor and with niches on each facade containing large sculpted Buddha figures. For a brief summary: Provost-Roche, "Les derniers siècles", p. 210.

75 For description and analyses of the relevant archaeological record at Angkor Wat, see Alison K. Carter, Miriam T. Stark, Seth Quintus, Yijie Zhuang, Hong Wang, Piphal Heng and Rachna Chhay, "Temple Occupation and the Tempo of Collapse at Angkor Wat, Cambodia", *Proceedings of the National Academy of Sciences* 116, no. 25, June 2019, pp. 12226–31.

References

Acri, Andrea. "Introduction: Esoteric Buddhist Networks along the Maritime Silk Routes, 7th–13th Century AD". In *Esoteric Buddhism in Mediaeval Maritime Asia: Networks of Masters, Texts, Icons,* ed. Andrea Acri. Singapore: ISEAS-Yusof Ishak Institute, 2016, pp. 1–25.

Ang Choulean. "*tŭc purāṇ kāl!*" [Like olden times!]. *KhmeRenaissance* 3, December 2007–8: pp. 75–77.

Assavavirulhakarn, Prapod. *The Ascendancy of Theravāda Buddhism in Southeast Asia.* Chiang Mai: Silkworm Books, 2010.

Baptiste, Pierre and Thierry Zéphir. *L'Art Khmer dans les collections du musée Guimet.* Paris: Edition de la Réunion des musées nationaux, 2008.

Bautze-Picron, Claudine. *The Bejewelled Buddha from India to Burma.* New Delhi: Sanctum Books, 2010.

Bizot, François. *Le figuier à cinq branches: Recherche sur le bouddhisme khmer.* Paris: EFEO, PEFEO vol. CVII, 1976.

———. *Les traditions de la pabbajja en Asie du Sud-Est: Recherches sur le Bouddhisme khmer IV.* Göttingen: Vandenhoeck and Ruprecht, 1988.

———. "Bouddhisme d'Asie du Sud-Est". In *Annuaire,* tome 105. Paris: École pratique des Hautes Etudes, Section des sciences religieuses, 1996–7.

Bourdonneau, Éric and Grégory Mikaelian. "L'histoire longue du *Devarāja*: *Pañcaksetr* et figuier à cinq branches dans l'ombre de la danse de Śiva". In *Rāja-maṇḍala: le modèle royal en Inde*, Collection *Puruṣārtha* 37, eds. Emmanuel Francis and Raphaël Rousseleau, September 2020, pp. 81–129.

Bretfeld, Sven. "Resonant Paradigms in the Study of Religions and the Emergence of Theravāda Buddhism". *Religion* 42, no. 2: pp. 273–97.

Carter, Alison K., Miriam T. Stark, Seth Quintus, Yijie Zhuang, Hong Wang, Piphal Heng and Rachna Chhay. "Temple Occupation and the Tempo of Collapse at Angkor Wat, Cambodia". *Proceedings of the National Academy of Sciences* 116, no. 25, June 2019: pp. 12226–31.

Chhom Kunthea. "Le rôle du sanskrit dans le développement de la langue khmère: Une étude épigraphique du VIe au XIVe siècle". PhD dissertation, École Pratique des Hautes Études, 2016.

Cœdès, George. "Études cambodgiennes XXXII: La plus ancienne inscription en pâli du Cambodge". *BEFEO* 36, 1937: pp. 14–21 (republished in *Articles sur le pays khmer,* t. I, Paris: EFEO, 1989, pp. 282–9).

———. *Inscriptions du Cambodge* III. Paris: EFEO, 1951.

———. "Une période critique dans l'Asie du Sud-est: le XIIIè siècle". *Bulletin de la Société des Études Indochinoises* XXXIII, no. 4, 1958: pp. 387–400.

Crosby, Kate. *Theravāda Buddhism: Continuity, Diversity and Identity*. West Sussex: Wiley-Blackwell, 2013.

———. "Tantric Theravada: A Bibliographic Essay on the Writings of François Bizot and Others on the Yogāvacara Tradition". *Contemporary Buddhism* 1, no. 2, 2000: pp. 141–98.

———. *Esoteric Theravada: The Story of the Forgotten Meditation Tradition of Southeast Asia*. Boulder: Shambhala Publications, 2020.

Dalsheimer, Nadine. *L'art du Cambodge ancien: Les collections du Musée national de Phnom Penh*. Paris: EFEO, 2001.

Davis, Kathleen. *Periodization and Sovereignty: How Ideas of Feudalism and Secularization Govern the Politics of Time*. Philadelphia: University of Pennsylvania Press, 2008.

Derrida, Jacques. "Structure, Sign and Play in the Discourse of the Human Sciences". In *Writing and Difference,* trans. Alan Bass. Chicago: University of Chicago Press, 1979, pp. 278–93.

École française d'extrême-Orient. https://cik.efeo.fr/inventaire-cik-des-inscriptions-khmeres/.

Frasch, Tilman. "A Pāli Cosmopolis? Sri Lanka and the Theravāda Buddhist Ecumene, c. 500–1500". In *Sri Lanka at the Crossroads of History*, eds. Zoltán Biederman and Alan Strathern, London: University College London Press, 2017, pp. 66–76.

———. "Kontakte, Konzile, Kontroversen: Begegnungen in der Theravada-Kosmopolis, c. 1000–1300 CE". In *Religionsbegegnung in der asiatischen Religionsgeschichte: Kritische Reflexionen über ein etabliertes Konzept*, eds. Max Deeg, Oliver Freiberger and Christoph Kleine. Göttingen: Vandenhoeck & Ruprecht, 2018, pp. 129–52.

———. "Pali at Bagan: The Lingua Franca of Theravada Buddhist Ecumene". Talk in the Rainy Season Research Seminar Series, Transnational Network of Theravada Studies, 25 September, 2020. https://theravadastudies.org/recordings/.

Giteau, Madeleine. *Guide du musée national de Phnom Penh*, 2 vols. Phnom Penh: Office national du Tourisme, 1960.

———. *Iconographie du Cambodge Post-Angkorien*. Paris: EFEO, 1975.

Griswold, A. B. "The Architecture and Sculpture of Siam". In *Arts of Thailand: A Handbook of the Architecture, Sculpture and Painting of Thailand (Siam)*, ed. Theodore Bowie. Bloomington: Indiana University Press, 1960, pp. 25–157.

———. "Prolegomena to the Study of the Buddha's Dress in Chinese Sculpture: With Particular Reference to the Rietberg Museum's Collection". *Artibus Asiae* 26, no. 2, 1963: pp. 85–131.

———. "Prolegomena to the Study of the Buddha's Dress in Chinese Sculpture (Part II)". *Artibus Asiae* 27, no. 4, 1964–5: pp. 335–48.

———. "Imported Images and the Nature of Copying in the Art of Siam". *Artibus Asiae* 23, 1966: pp.37–73.

Griswold, A. B. and Prasert ṇa Nagara. "The Epigraphy of Mahādharmarājā I of Sukhodaya: Epigraphic and Historical Studies 11/1". *JSS* 61, no. 1, 1973: pp. 71–178.

Groslier, Bernard-Philippe. *Le Preah Khan de Kompong Svay*. Thesis, Paris: École du Louvre, 1967.

Horner, I. B., trans. *Milinda's Questions*, vol. 1. London: Pāli Text Society, 1990. First published 1963.

Khin Sok. "Deux inscriptions tardives du Phnom Bàkhèn, K.465 et K.285". *BEFEO* 65, no. 1, 1978: pp. 271–80.

Krassem, Mahā Bidūr. *Silācārik Nagar Vatt/Inscriptions modernes d'Angkor*, with a new preface by Saveros Pou. Paris: Cedoreck, 1984.

Lam Sopheak. *Rapāy kār(ṇ) juos jul prāsād catumukh* [Report on the Restoration of Prasat Chatomukh]. 2018. (Unpublished.)

Latinis, Kyle and Ea Darith. (https://www.researchgate.net/profile/David_Latinis/publication/304353545_Phnom_Kulen_Cambodia_and_Singapore_Projects_-_Royal_Residence_Palace_Site_Banteay_-_Sema_Stone_Sites_Don_Meas_and_Peam_Kre_-_Dvāravati_influence_-_Sema_Stone_quarry_-_Implications/links/576cfa8208ae3c5c932d24a3/Phnom-Kulen-Cambodia-and-Singapore-Projects-Royal-Residence-Palace-Site-Banteay-Sema-Stone-Sites-Don-Meas-and-Peam-Kre-Dvāravati-influence-Sema-Stone-quarry-Implications.pdf.

Lewitz (aka Pou), Saveros. "La toponymie khmère". *BEFEO* 53, no. 2, 1967: pp. 377–450.

———. "Inscriptions modernes d'Angkor 2 et 3". *BEFEO* 57, 1970: pp. 99–126.

———. "Inscriptions khmères K. 144 et K. 177". *BEFEO* 70, 1981: pp. 101–20.

Marchal, Henri. "Monuments secondaires et terrasses bouddhiques d'Aṅkor Thom". *BEFEO* 18, no. 8, 1918: pp. 1–40.

Mauger, Henri. "Práḥ Khăn de Kŏmpoṅ Svày". *BEFEO* 39, 1939: pp. 197–220.

Mikaelian, Grégory. "Écrire l'histoire du Cambodge moyen entre techniques occidentales et doctrines orientales". *Bulletin de l'AEFEK* 8, February 2005. https://www.aefek.fr/page33.html#wa-anchor-j9elqu5r6jjf8o (last accessed 1 December 2020).

———. "Des sources lacunaires de l'histoire à l'histoire complexifiée des sources. Éléments pour une histoire des renaissances khmères (c. XIV–c. XVIIIe s.)". *Péninsule* 65, 2012: pp. 259–305.

Murphy, Stephen. "The Distribution of Sema Stones throughout the Khorat Plateau during the Dvāravati Period". In *Unearthing Southeast Asia's Past*, Vol.1, eds. Marijke J. Klokke and Véronique Degroot. Singapore: NUS Press, 2013, pp. 215–33.

Peleggi, Maurizo. "The Plot of Thai Art History: Buddhist Sculpture and the Myth of National Origins". In *A Sarong for Clio: Essays on the Intellectual and Cultural*

Histories of Thailand – Inspired by Craig J. Reynolds, ed. Maurizio Peleggi. Ithaca: Cornell University SEAP Publications, 2015, pp. 79–93.

Perret, Daniel, ed. *Writing for Eternity: A Survey of Epigraphy in Southeast Asia.* Paris: EFEO, 2018.

Pollock, Sheldon. *The Language of the Gods in the World of Men: Sanskrit, Culture and Power in Premodern India.* Berkeley: University of California Press, 2006.

Polkinghorne, Martin, Christophe Pottier and Christian Fischer. "One Buddha Can Hide Another". *JA* 301, no. 2, 2013: pp. 575–624.

———. "Evidence for the 15th-century Ayutthayan Occupation of Angkor". In *The Renaissance Princess Lectures: In Honour of Her Royal Highness Princess Maha Chakri Sirindhorn.* Siam Society, 2018, p. 98–132.

Pottier, Christophe. "A propos de la statue portrait du Roi Jayavarman VII au temple de Preah Khan de Kompong Svay". *Arts Asiatiques* 55, 2000: pp. 171–2.

Pou, Saveros. *Nouvelles Inscriptions du Cambodge I.* Paris: EFEO, 1989.

Provost-Roche, Ludivine. "Les derniers siècles de l'époque angkorienne au Cambodge (env. 1220–env. 1500)", 2 vols. PhD dissertation, Université de la Sorbonne Nouvelle–Paris III, 2010.

Reynolds, Frank E. and Charles Hallisey. "The Buddha". In *Buddhism and Asian History: Religion, History and Culture*, eds. Joseph M. Kitigawa and Mark D. Cummings. New York: MacMillan Publishing and Co., 1989, pp. 29–49.

Skilling, Peter. "The Advent of Theravāda Buddhism to South-east Asia". *Journal of the International Association of Buddhist Studies* 20, no. 1, Summer 1997: pp. 99–104.

———. "Namo Buddhāya Gurave (K. 888): Circulation of a Liturgical Formula across Asia". *JSS* 106, 2018: pp. 109–28.

———. "Towards an Epigraphic Bibliography of Thailand". In *Writing for Eternity: A Survey of Epigraphy in Southeast Asia*, ed. Daniel Perret. Paris: EFEO, 2018, 109–122.

———. "The Theravaṃsa has Always been Here: K. 1355 from Angkor Borei". *JSS* 107, no. 2, 2019: pp. 43–62.

Skilling, Peter, Jason A. Carbine, Claudio Cicuzza and Santi Pakdeekham, eds. *How Theravāda is Theravāda?: Exploring Buddhist Identities.* Chiang Mai: Silkworm Books, 2012.

Tambiah, Stanley Jeyaraja. "The Galactic Polity". In *World Conqueror and World Renouncer: A Study of Buddhism and Polity in Thailand against a Historical Background.* Cambridge: Cambridge University Press, 1976, pp. 102–31.

Thompson, Ashley. "The Ancestral Cult in Transition: Reflections on Spatial Organization of Cambodia's Early Theravada Complex". In *Southeast Asian Archaeology 1996: Proceedings of the 6th International Conference of the European Association of Southeast Asian Archaeologists, Leiden, 2–6 September 1996,* eds Marijke J. Klokke and Thomas De Brujin. Hull: Centre for Southeast Asian Studies, University of Hull, 1998, pp. 273–95.

———. "Mémoires du Cambodge". PhD dissertation. Université de Paris VIII, 1999.

———. "Lost and Found: The Stupa, the Four-faced Buddha and the Seat of Royal Power in Middle Cambodia". In *Proceedings of the 7th International Conference of the European Association of Southeast Asian Archaeologists, Berlin, 1998*, eds. Wibke Lobo and Stephanie Reimann. Hull: Centre for Southeast Asian Studies, University of Hull, 2000, pp. 245–63.

———. "The Future of Cambodia's Past: A Messianic Middle-Cambodian Royal Cult". In *History, Buddhism and New Religious Movements in Cambodia*, eds. Elizabeth Guthrie and John Marston. Hawai'i: University of Hawai'i Press,

2004, pp. 13–39.

———. "Angkor Revisited: the State of Statuary". In *What's the Use of Art?: Asian Visual and Material Culture in Context*, eds. Jan Mrazek and Morgan Pitelka. Hawai'i: University of Hawai'i Press, 2008, pp. 179–213.

———. *Engendering the Buddhist State: Territory, Sovereignty and Sexual Difference in the Inventions of* Angkor. Routledge Critical Buddhist Studies, 2016.

———. "Revenons, revenants: mémoires d'Angkor". In *Temporalités khmères: de près, de loin, entre îles et péninsules,* eds. Nasir Abdoul-Carime, Grégory Mikaelian and Joseph Thach. Berne: Peter Lang, 2021, pp. 345–75.

Tun Puthpiseth. "Bouddhisme Theravāda et production artistique en pays khmer: Étude d'un corpus d'images en ronde-bosse du Buddha (XIIIe–XVIe siècles)". PhD dissertation, Paris: Université de Paris IV-Sorbonne, 2015.

"The Two Buddhist Towers of Preah Khan". http://pkks.sscnet.ucla.edu/.

Vickery, Michael. "The *2/k.125 Fragment*, a Lost Chronicle of Ayutthaya". *JSS* 65, no. 1, 1977: pp. 1–80.

———. "A New *Tāmnān* About Ayudhya". *JSS* 67, no. 1, July 1979: pp. 123–86.

———. "L'inscription K 1006 du Phnom Kulên". *BEFEO* 71, 1982 : pp. 77–86.

Walker, Trent. "Unfolding Buddhism: Communal Scripts, Localized Translations, and the Work of the Dying in Cambodian Chanted Leporellos". PhD dissertation, University of California, Berkeley, 2018.

Winichakul, Thongchai. *Siam Mapped: A History of the Geo-body of a Nation*. Hawai'i: University of Hawai'i Press, 1994.

Wolters, O. W. *History, Culture and Region in Southeast Asian Perspectives*. Ithaca: Cornell University Institute of Southeast Asian Studies, 1999. First edition 1982.

Woodward, Hiram W., Jr. "Ram Khamhaeng's Inscription: The Search for Context". In *The Ram Khamhaeng Controversy*, ed. J. R. Chamberlain. Bangkok: The Siam Society, 1991, pp. 419–37.

———. "The Jayabuddhamahānātha Images of Cambodia". *Journal of the Walters Art Gallery* 52/53, 1994/1995: p. 108.

———. *The Art and Architecture of Thailand*. Leiden and Boston: Brill, 2005. First Published 2003.

———. "'The Characteristics of Elephants': A Thai Manuscript and its Context". In *From Mulberry Leaves to Silk Scrolls: New Approaches to the Study of Asian Manuscript Traditions*, eds. Justin McDaniel and Lynn Ransom. Philadelphia: Schoenberg Institute, University of Pennsylvania Libraries, 2015, pp. 15–41.

———. "King Sūryavarman II and the Power of Subjugation". In *On Meaning and Mantras: Essays in Honor of Frits Staal*, eds. George Thompson and Richard K. Payne. Berkeley: Institute of Buddhist Studies and BDK America, 2017, pp. 483–502.

Woodward, Hiram W., Jr. and Donna K. Strahan. *The Sacred Sculpture of Thailand*: *The Alexander B. Griswold Collection, The Walters Art Gallery*. Baltimore: Walters Art Gallery, 1997.

ANGKOR AND THERAVĀDA BUDDHISM: SOME CONSIDERATIONS

Hiram W. Woodward

Among the crucial monuments dating from the final years of Jayavarman VII's reign to the conventional date for the "fall" of Angkor, 1431, are such constructions as the inner gallery of reliefs at the Bayon, the Elephant Terraces, the Terrace of the Leper King, and large sections of the Preah Pithu temples and the Theravāda Buddhist Preah Palilay. The last two sites, where major work was carried out in the decades around 1300, are of particular interest because they stand in proximity and face each other, so to speak, from opposite sides of the principal north–south artery of the city – one complex Brahmanical, the other Buddhist.

Substantial portions of both temple sites date back to the 12th century, and some of the later portions copy 12th-century styles, making for a situation of extreme complexity. An intensive study of the architecture of the 13th and 14th centuries appeared in 2010, but, as an unpublished doctoral

Fig. 2.1 Leaf band at Prasat Top East. Photograph by author.

Fig. 2.2 Leaf scrolls surmounting a niche at Preah Pithu U temple. Photograph by author.

2.1 2.2

dissertation, its circulation has been limited, and its conclusions have not been digested by scholars of Cambodia.[1] Documentary evidence for the period exists in the form of one securely dated monument, the small Brahmanical Prasat Top East (Monument 487; Maṅgalārtha), established in 1295 (Fig. 2.1). We can look at a leaf border at Prasat Top East, compare it with leaf scrollwork at Preah Pithu U (Fig. 2.2), and observe how difficult it is to reach conclusions regarding chronology from the similarities and differences. Nevertheless, eventually it will be possible to make the leap to an actual history, one chronicling vast shifts in religious preferences and cultural practices. Until that time, scholars must resort to turning the issues around in their heads, hoping for fresh insights that will provide new understandings of motivations, of the relative roles of the monkhood, the court, and Brahmanical practitioners, and of the shifting demography of the population.

This chapter will attempt to advance the study of the issues in various ways. After a glance at outdated explanatory theory, I will contend that some knowledge of Theravāda Buddhism had been present in Cambodia for centuries, and so it is wrong to consider it as entirely an intrusive phenomenon. (In this chapter, the term "Theravāda" will be used rather loosely.) Perhaps – despite the absence of evidence either positive or negative – Theravāda Buddhism had long been looked upon in a favourable light. Eventually, of course, a reinvigoration (a reformation?) took place, stemming from Burma (Myanmar), and then enveloping both Thailand and Cambodia. Subsequent sections of the chapter will focus on the reign of Jayavarman VII, on some of the problems involved in understanding the 13th and 14th centuries, and on "civic ritual" – an attempt to provide a fresh interpretation of the functioning of Angkor's royal square in the period following Jayavarman VII.

LOUIS FINOT, 1908

In the short book published in 1963, *Angkor: An Introduction*, which originated in lectures given in Hanoi in 1943, George Cœdès quoted approvingly a passage from a lecture given by the Sanskrit scholar Louis Finot in 1908. It had been directed to an audience of aspiring French colonial officials:

> ... the hardworking population was decimated and spent. Surely they did not defend these rapacious gods or these slave-drivers and collectors of tithes with much ardour. The conqueror on the other hand offered the vanquished a precious compensation: he offered them a gentle religion whose doctrine of resignation suited this tired and discouraged people most appealingly.[2]

Finot provided a psychological motivation with which we can empathise, and, if we differ from him, he challenges us to put forward an explanation that is equally understandable and stark. Still, there is almost nothing in the statement that is not open for discussion. Hardworking? Surely. Decimated and spent? Quite possibly the labourers who built Jayavarman's temples were better off when employed than after. Rapacious gods, slave-drivers, tithe collectors? The data does not exist that would enable us to compare the economic conditions of the peasants named in inscriptions, who provided support for the temples, with those who were not similarly indentured. Conqueror? This suggests that invading Thai were responsible for imposing Theravāda Buddhism. There is no evidence of warfare until the late 13th century (in the account by Zhou Daguan), and it is not easy to determine the ethnic makeup of Northeastern Thailand, Lopburi, and Central Thailand in the 13th century, and the relative number of Khmer, Mon and Thai speakers. (Sukhothai, however, we can say was predominantly Thai.) Vanquished? You mean in 1431? Mightn't that have been more a matter of factional disputes?[3] Gentle religion? Oh, in what way exactly? Doctrine of resignation? As demonstrated in what behavior?

At the end of this chapter, I shall inquire again about motivations and about the characterisation of Theravāda Buddhism.

BUDDHIST TRADITIONS, SEVENTH TO TWELFTH CENTURIES

Dvāravatī, a name attested in both Chinese and local sources, was evidently centred at Nakhon Pathom, but it is not known how far the kingdom extended at the time of its greatest power.[4] Used in a cultural sense, the name Dvāravatī can also be applied to the civilisation of Northeastern Thailand. In both regions, the vernacular language was Mon. In Central Thailand, the dominant religion was Theravāda Buddhism, as inscriptions with quotations from Pāli-language scriptures demonstrate, and this is likely to have been the case in the Northeast (a useful if anachronistic and Bangkok-centric place name) as well, despite the absence of comparable epigraphic evidence of Pāli.[5] The primary icon in both regions was the same: a standing Buddha, both hands performing a gesture of instruction, a type of image not found in India. But the secondary religious artefacts differed, despite some significant instances of overlap: Nakhon Pathom was characterised by the presence of Wheels of the Law and the Northeast by the ubiquity of Buddhist boundary stones (*sīmā*). While Dvāravatī is a good name for the dominant political entity in Central Thailand, there is no satisfactory name for a dominant kingdom in the Northeast.[6]

The links between Cambodia and central Dvāravatī were extensive and have not been completely catalogued.[7] A stone example of the Dvāravatī double-gestured Buddha found in Kompong Speu province, now in the Musée Guimet, bears an inscription with the words of the *ye dhammā* verse.[8] Even if monasteries were not maintained, a visible, inscribed sculpture could remain as a reminder of past practices. Small bronze images have been unearthed elsewhere.[9] Boundary stones are a somewhat different case. On Phnom Kulen there are two sets of Buddhist *sīmā*, related to those found in Northeastern Thailand, and a giant reclining Buddha, quite possibly ancient in date.[10] These objects might have been the result of the occupation of Phnom Kulen by the kingdom of Wendan (centred in Northeastern Thailand) prior to the establishment of the Angkorian dynasty in 802. Whether pockets of Buddhists, who may be considered Theravādins, remained on Phnom Kulen in subsequent centuries will eventually be revealed by archaeological exploration.

The next important moment of intercourse between regions occurred in the tenth century. There is inscriptional evidence of a northward

Fig. 2.3 Image of the Buddha, from Beng Vien. Height: 46 cm. National Museum of Cambodia, on view at the Angkor National Museum, Siem Reap. Photograph courtesy Michael Vickery.

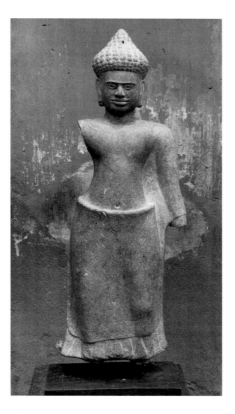

2.3

expansion of the Khmer kingdom by the early tenth century. An expansion westward, presumably during the reign of King Rājendravarman (r. 944–c. 968) in the middle decades of the tenth century, is attested by the construction of a brick sanctuary, Prang Khaek, in Lopburi. In the Northeast, the local boundary-stone culture persisted, and the expansion of imperial power can be traced northward by the appearance of Khmer stylistic and inscriptional elements in the boundary stones. In Central Thailand, developments are much harder to follow. Wheels of the Law had ceased to be carved long before Khmer intrusion, and evidence other than hard-to-date stuccos is not easy to come by. In Cambodia itself, King Rājendravarman set up an inscription (*K. 872*) in 946 at Beng Vien, about 32 kilometres southeast of Angkor, proclaiming that he understood Buddhist doctrine and that he had conquered Rāmaṇya, that is, Monland. The evidence of both artefacts and inscriptions indicate the Buddhism practised in tenth-century Cambodia was overwhelmingly Mahāyāna, with a strong Tantric aspect, but at the site of Beng Vien a Buddha image was recovered showing the Buddha with his left arm hanging at the side, the right hand, though broken, surely originally performing the gesture of instruction (Fig. 2.3). This pose is one found in late Dvāravatī art, in both Central Thailand and the Northeast. It is also found on a *caitya* now in the Angkor National Museum, where it is contrasted with a *nāga*-protected Buddha.[11] The adoption of this pose suggests an acknowledgement within Cambodia of a Theravāda icon of Gotama.[12]

It is a jump of about a century and a half to the next moment of concern, the time of the construction of the temple of Phimai in Northeastern Thailand. Phimai is a Tantric Buddhist temple constructed by a provincial Khmer official (or so it seems) at a time of political weakness at Angkor. The Buddhist content is found on a system of five inner lintels, invisible from the exterior (Fig. 2.4). There is no consensus regarding the nature of the overall programme, but it is understood that two of the images (on the northern and eastern lintels) are exclusively Tantric, and it seems reasonably certain that the other three, as will be seen in the discussion that follows, belonged to a pan-Buddhist repertory. Here it is argued that the builders of Phimai recognised that these three icons – the *nāga*-protected (or *nāga*-enthroned) Buddha; the earth-touching, or Māravijaya Buddha (that is, the Victory over the devil Māra); and the standing crowned Buddha, both hands in the gesture of instruction – were cross-over images, having significance for Theravāda as well as for Mahāyāna Buddhists. What is not known is whether Theravāda and Tantric monks shared a common book of discipline (a *Vinaya*) and were thus able to dwell together – a significant but unresolved matter, as important in the 13th century as at Phimai around 1100.

The main image of the temple, now lost or unidentified, was surely a *nāga*-protected Buddha, like the one that appears on the inner axial lintel. This image type was earlier attested in the Northeast, but it is not known to what degree it originally depicted – as it generally did in Burma – the sheltering of the Buddha during one of the weeks following enlightenment.[13] At any rate, it had also in tenth-century Khmer art come to represent the supreme Buddha of the Mahāyāna, and that is the sense in which it should be understood at Phimai. Nevertheless, subsequently, it became a widespread image type, worshipped by both Theravāda and Mahāyāna Buddhists. Like the *nāga*-protected Buddha, the Māravijaya Buddha, featured on the outer southern lintel, had earlier appeared in the Northeast, probably as a result of contacts with Pāla India around the ninth century. It too became commonplace, but for both Theravāda and Mahāyāna Buddhists, its primary meaning was the Buddha's enlightenment; there is none of the ambiguity inherent in the *nāga*-protected Buddha.

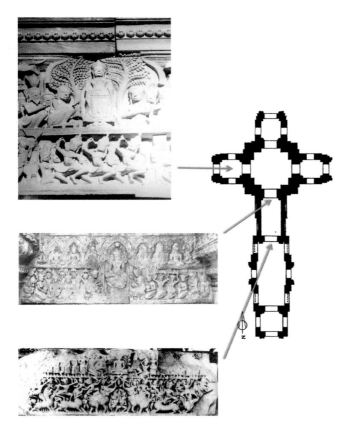

Fig. 2.4 Plan of the central temple, Phimai, showing the location of three of the lintels in the inner system of five lintels. West: standing crowned Buddha. South (1): *nāga*-protected Buddha. South (2): Māravijaya Buddha. Photographs courtesy of Uab Sanasen (*left*); plan, after Jean Boisselier, *Le Cambodge* (Paris: Picard, 1966), Fig. 10a, p. 67; after Manit Vallibhotama, *Guide to Pimai and Antiquities* (Bangkok: Fine Arts Department, 1962), Fig. 35 (*right*); author (*lower right*).

The third image type is the standing crowned Buddha, which appears on the western inner lintel and can be considered the last of a set of four images placed on the inner lintels. Here the double gesture must have alluded to some famous Dvāravatī-period icon. The crown is an addition, historically indebted to Pāla India. I have argued that the four lintels refer to the Victory over the four Māra or devils, as mentioned in a local inscription and described in Mahāyāna texts: the axial *māravijaya* lintel depicts victory over Māra as he appeared to the Buddha, and the standing crowned Buddha stands for victory over the Māra Death.[14] The standing crowned Buddha is another image type that spread widely, in the Northeast and Central Thailand, in the decades following the construction of Phimai, but there is no evidence that the conceptual framework of the Phimai lintels spread with it. At an unknown point in time, a legend was constructed around it, having to do with the magical appearance of the Buddha in order to convert a heretic king.[15]

Once King Sūryavarman II, who supported the Brahmanical religions, came to the throne, it is hard to know how much Buddhist art was produced, as it is difficult to distinguish *nāga*-protected Buddhas made during his reign from ones that may have been carved following his

Fig. 2.5 The central *prang*, Wat Phra Si Ratana Mahāthāt, Lopburi, with the later flanking tower on the left (now collapsed). Photograph by the Fine Arts Department (FAD) of Thailand, 1920s; courtesy FAD 1971.

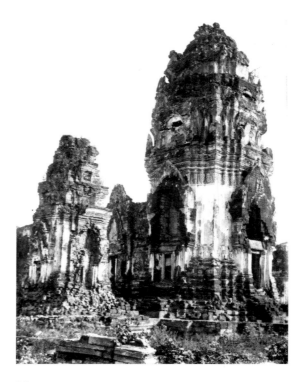

2.5

death. One significant but little-studied Theravāda site is Prasat Sasar Sdam, adjacent to the tenth-century Beng Vien, mentioned previously. A lintel in the Angkor Wat style includes narrative scenes, and a *stūpa* has an upper quadrangular section with a niche containing a defaced Buddha on each side.[16]

Lopburi sent a mission to China in 1155, presumably as a statement of independence following the death of Sūryavarman II. A monument that has been placed in this period is the Mahāthāt in Lopburi, in its original state (Fig. 2.5). Architecturally, the Lopburi Mahāthāt is dependent upon Phimai for two reasons: the height of its basement stories, and the number of re-entrant angles in the plan of its primary story. This means that the Lopburi Buddhists found enough commonality in the Phimai temple, despite its Tantric orientation, to take it as a model. Other evidence points to the rising importance of new Theravāda trends, stemming largely from Burma. An important inscription dating from 1167 was found in Nakhon Sawan province at the site of Dong Mae Nang Muang.[17] Written in the Pāli and Khmer languages, it refers to a king named Dhammāsoka, that is, a king named after King Aśoka of India, who was called Dhammāsoka or Dharmāsoka in Pāli and Sanskrit texts to reflect his proselytisation of Buddhism. The kingdom this 12th-century Dhammāsoka ruled has not been identified. These Theravāda Buddhists assigned a non-Hindu name to their monarch, one that indicates an awareness of Buddhist history and of the fact that they stood at a specific chronological distance from the Buddha Gotama.

The Dong Mae Nang Muang inscription forces us to ask questions about whether it presents a Theravāda ideology that stands apart from Angkorian Hindu, Mahāyāna or Tantric beliefs. It seems to, yet there are considerations that mitigate against maintenance of a doctrinaire position on this score. Naming a king after King Aśoka of India and involving him with relics is a recognition of the fact that the Buddha bequeathed his relics at a moment in time, and that King Aśoka's right to rule was connected with his discovery and enshrinement of relics. The numinous is inherited from the past. Somewhat similarly, in one characterisation of Theravāda Buddhism, the numinous lies in a distant though measurable future, as numerous lifetimes will pass before we reach *nirvāṇa*. This outlook seems different from one that sees the divine as constantly immanent, outside of time, but becoming manifest, say, in an initiation ceremony or the liberation of the soul, as we might suppose to be the case in Angkorian Hinduism and Mahāyāna and Tantric Buddhism.

On the other hand, the contrast can be softened by interpreting a key Pāli text, the *Buddhavaṁsa*, in a certain way. Well established in Pagan, the *Buddhavaṁsa* relates the names and predictions of the Buddhas who preceded Gotama. A bronze image with Buddhas of the Past (Fig. 2.6)

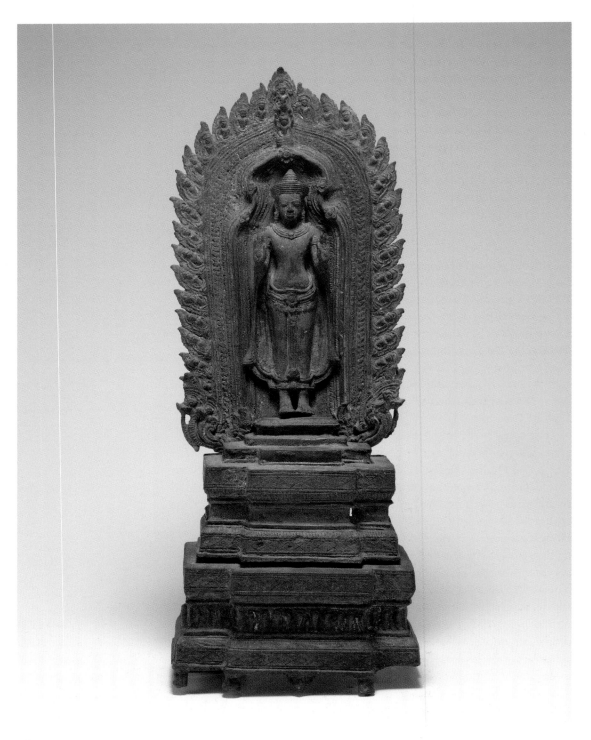

2.6

shows a standing crowned Buddha, the hands in a double gesture.[18] Here the Buddhas appear in leaves attached to the frame of the throne back, in an arrangement that became more common in the 13th century. From one point of view this sculpture and others dependent on the *Buddhavaṁsa* proclaim, like the use of the proper name Dhammāsoka in the Dong Mae Nang Muang inscription, a Theravādin sense of linear time: we stand at a certain historical distance from Gotama. Because, however, each of the Buddhas of the Past taught the same doctrine and because the nature of their Buddhahood was identical, Buddhahood is in fact ever present. Perhaps the Buddhas of the Past are not demonstrating historical distance but present immanence.[19]

JAYAVARMAN VII, r. 1182–1218

There was a degree of compatibility, I have suggested, between Khmer Tantrism and the Theravāda. Whether this holds as well for Jayavarman's Mahāyāna and the Theravāda is an issue requiring more hesitancy. Jayavarman's Mahāyāna – his triad of the Buddha, Avalokiteśvara and Prajñāpāramitā – did in some way develop out of the Tantric traditions of Phimai and Preah Khan of Kompong Svay, but anticipation of its social crusade, especially the establishment of a hospital network, is hard to find in the historical record. It is not possible to engage with all the issues of Jayavarman's reign, and here just a few discrete topics will be addressed.

At the Bayon perhaps one day it will be possible to integrate what is known about the stages of construction with ideological and stylistic developments, and more precise guesses will be made about the dates of the inner gallery of reliefs (the subject of some observations later in this chapter), the covering up of the images of Lokeśvara, the iconoclastic effacement of images of the Buddha, and the moment at which the faces of the towers became known as Brahma (unless, of course, they were called that from the outset).[20] At both the Bayon and at other monuments, if we see elements that the Theravāda shares, their appearance may or may not be an indication of the actual presence of Theravāda Buddhists. Cases in point are representations of *jātaka*, certain scenes from the life of the Buddha, depictions of the earth goddess (as at Ta Prohm), and cosmological features shared by the Mahāyāna and the Theravāda, such as Lake Anavatapta and the four rivers that flow from it, embodied at Neak Pean.[21]

One small detail at the Bayon bears discussion. In relief sculptures of *devatā* attributed by Philippe Stern to the third period of the Bayon style, there are small adorants at the feet of the divine beings and wings at the sides in which curtains hang (Fig. 2.7).[22] The combination of these two elements is an indication of the probability of a borrowing (though some

Fig. 2.6 Altarpiece with the standing crowned Buddha. Bronze. Height: 44.5 cm. Walters Art Museum, Baltimore, gift of the Doris Duke Charitable Foundation's Southeast Asian Art Collection, 2002 (54.2999). Photograph courtesy The Walters Art Museum, Baltimore.

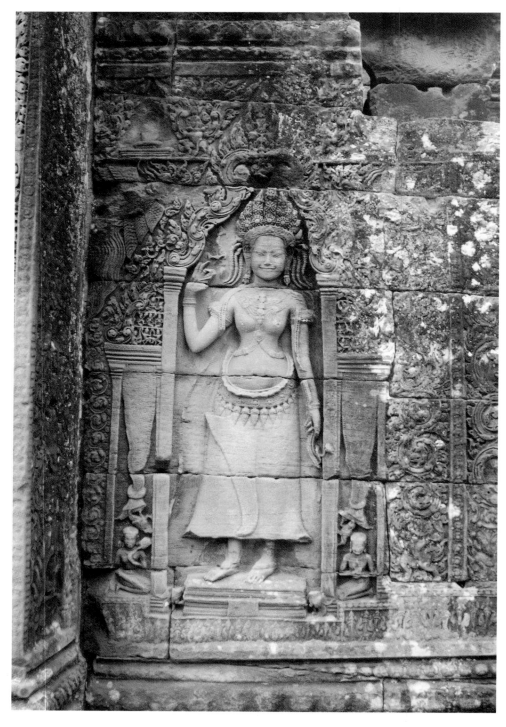

2.7

observers might find it farfetched), namely from a type of votive tablet with stylistic sources in Lower Burma or the peninsula, showing the Buddha at the Mahābodhi temple, adorants, and banners wrapped around columns (a feature, in turn, taken from Pāla sculpture).[23] Tied banners were transformed into hanging curtains.

The kneeling female adorants can be connected with full-sized adorant sculptures, such as the kneeling Perfection of Wisdom (Prajñāpāramitā) in the Musée Guimet.[24] The arms are broken, but originally the hands were placed in adoration or held an offering, and the figure was in fact a portrait image. Inscriptions on the walls of the Bayon sanctuary enable us to understand the context of this and other adorant images (most of which must have been carved from wood): the adorant images are distinguished from the images being worshipped by different titles and by the insertion of a preceding particle, *na*.[25] The inclusion of adorant images and the naming of them in inscriptions are practices found at the Bayon itself but not at the other great complexes.

There is another point that can be made. If a Theravāda element is recognised in the adorant images, and they are interpreted according to the *Buddhavaṃsa*, they are not merely worshipping. They are listening to a prediction concerning when in the distant future they may achieve enlightenment. The degree to which this interpretation is valid depends on judgements as to when exactly the *Buddhavaṃsa* was embraced in the highest circles at Angkor. At any rate, although there seem to be no surviving sets of stone Bayon-period Buddhas of the Past, there is one later image – perhaps early 14th century in date – inscribed with the name of a past Buddha.[26]

The scene in Lopburi and Northeastern Thailand was much the same. In 1186, Jayavarman proclaimed the establishment of hospitals throughout the kingdom; there are vestiges over the Northeast but not in Central Thailand.[27] The guiding scripture was the Medicine Buddha sutra. In 1191, Jayavarman stated that he had distributed images he called Jayabuddhamahānātha, some to towns in Central Thailand. These have been identified as images of a standing multi-armed Avalokiteśvara.[28] Around the same time, the Phra Prang Sam Yot was constructed in Lopburi, presumably to house images of Jayavarman's triad of Avalokiteśvara, the Buddha and the Perfection of Wisdom (Fig. 2.8). In Lopburi itself, numerous sculptures of the *nāga*-protected Buddha were carved in stone, but very few images of Avalokiteśvara or the Perfection of Wisdom.

The images Jayavarman distributed or commissioned projected his compassion. This quality carried into the matter of architectural style, which consisted of a rejection of the Phimai/Lopburi Mahāthāt tradition and its replacement by sanctuaries that were situated closer to the ground

Fig. 2.7 The Bayon, niche with *devatā*, first level, tower 15, portico, northeast angle. Photograph courtesy Phoeung Dara, 2013.

and built to a more human scale; they may be considered the counterpart of the compassion that is the main theme of the cult of Avalokiteśvara. Very close to the time Angkorian power was at its peak – say around 1200 – a new image type appeared at Lopburi. This was the standing Buddha with a right hand on the chest. We have no name for this posture and no textual justification. It can be understood, however, as standing for a Buddha that is simultaneously a Buddha of the Past, a Buddha of the Future, and a Buddha produced by Gotama's miracle of double appearances.[29] These elements are apparent in a type of votive tablet produced in Lamphun, the ancient Haripuñjaya; the setting is the Mahābodhi temple at Bodhgaya, and the mirrored gestures allude to the miracle.[30] The themes can be traced back to Pagan, Burma.

There are other subjects that became important in the course of the 13th century: groups of three seated Buddhas and Buddhas with pointed crowns of Pāla type. Wanting to assign a name to this cluster of traits, I chose "Ariya", referring to the *nikāya* or sect dominant before the arrival of new ordinations from Sri Lanka at various points in time, perhaps in the late 13th century, then around the 1340s, and again in the 1420s. Which of these features were already present in Lopburi in the third quarter of the 12th century, when the Mahāthāt, I have suggested, was founded, and the relative importance of the various geographical sources – Pagan, Lower Burma, Haripuñjaya – are issues not yet resolved. The *nāga*-protected Buddha was welcomed into this pantheon, and the stone workshops of Lopburi continued production along lines set by the Bayon style.

Fig. 2.8 Phra Prang Sam Yot, Lopburi. Photograph by author.

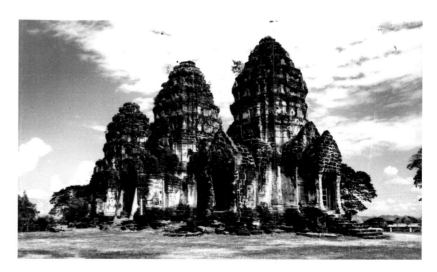

2.8

But with the waning of imperial power, Lopburi's religious life followed the trajectory set into motion in the pre-Jayavarman period. The Mahāthāt became the city's focus; it received new stucco décor, and north and south wings were added, so that it would be able to house a triad of Buddhas, exactly like the ones seen in votive tablets of the period (Fig. 2.9).[31] There is very little evidence regarding the ethnic makeup of Lopburi in the course of the 13th century: conceivably the elite spoke Khmer, and there was a hard-to-determine number of speakers of Mon and Thai.

THE 13TH AND 14TH CENTURIES

Almost nothing is known about Jayavarman's immediate successor Indravarman, and until recently it was thought that his reign ended in 1243, not 1270.[32] As readers of the 2007 compilation *Bayon: New Perspectives* know, many disputed matters deserve renewed analysis.[33] In this book, Vittorio Roveda provided descriptions of the scenes – some Brahmanical, most historical – in the inner gallery of reliefs at the temple.[34] A far more detailed study of these reliefs can be found in the 2010 dissertation by Ludivine Provost-Roche[35], and her conclusions are worth summarising here.

The term Philippe Stern applied to the Leper King figures, "Bayon, third period, extremely advanced" is entirely apt[36] (my translation of the French text). David Chandler made a proposal that enables the dating of

Fig. 2.9 Votive tablet with Māravijaya Buddha at the Mahābodhi temple, flanked by a pair of Buddhas in *māravijaya*. Terracotta. Height: 8.5 cm. National Museum, Bangkok. Inventory number: Lb25 k4. Photograph by author, 1970.

the Leper King Terrace to the post-Jayavarman period to rest on evidence
other than stylistic. He suggested that the name recorded in the 19th
century, *tilean sdach komlong*, means "the terrace of the king who was a
leper" – namely Indravarman – rather than "the terrace where a statue, now
called the leper king, has been found".[37] The name preserves, in this
reading, a genuine historical memory. Still, describing various developments
is one matter; constructing a plausible linear narrative is another.

There is agreement that the buried images uncovered at Banteay Kdei
in 2001 were ritually deposited, but disagreement as to whether the
damage sustained by so many of the sculptures ought to be connected to
the iconoclastic movement.[38] The position taken here is that the damage
did occur at the same time that thousands of Buddha images were
carefully chiseled away at Jayavarman's temples. The Banteay Kdei
sculptures surely include works carved after the death of Jayavarman. One

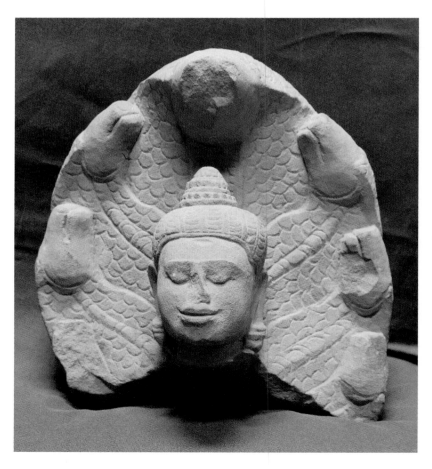

would think that a comparison with the sequence in Lopburi would make it possible to propose a terminal date. For instance, it might seem that the curved profile to the *uṣṇīṣa* in the *nāga*-protected Buddha BK 195 (Fig. 2.10) can be compared with a Lopburi sculpture with a similarly designed *uṣṇīṣa* (Fig. 2.11); ordinarily, in Bayon-period sculpture, the tiers of small petals have a more stepped structure. Yet this Lopburi image is clearly the later of the two, in light of the shape of the face and the pronounced high relief of the eyebrows (somewhat like what can be seen at the Terrace of the Leper King). One of the criteria for establishing a sequence in Lopburi is the design of the lotus medallion at the back; the petals become increasingly simplified and finally don't look like petals at all.[39] This medallion is far along but not at the end of the sequence. No photographs of the backs of the Banteay Kdei sculptures have been published. The roots, at least, of BK 195 seem to lie in the Angkorian sculpture from

Fig. 2.11. *Nāga*-protected Buddha. Height: 36 cm. King Narai National Museum, Lopburi. Inventory number: L.2659. Photograph courtesy King Narai National Museum.

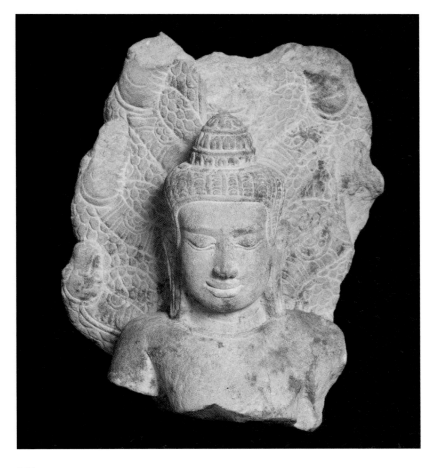

around the 1190s.[40] These considerations lead to thinking that the iconoclastic movement occurred not long after the death of Jayavarman.

The Buddha with hand on chest appears to have arisen in Lopburi within the lifetime of Jayavarman, and the fact that it had long seemed that there was no evidence of a Cambodian reflection of this iconographic type shortly thereafter was a puzzle. The Banteay Kdei evidence indicates that there was, both on steles and on antefixes (Fig. 2.12). The evidence of the antefixes, a feature unattested in Lopburi in stone but viewable on a fragment of a bronze model of a temple superstructure (Fig. 2.13), is especially interesting because it suggests that there was some understanding of the content conveyed by the pose. That is, if these were

Fig. 2.12 Antefix with standing Buddha, Banteay Kdei trove, no. 258. Height: 66 cm. Preah Norodom Sihanouk – Angkor Museum, Siem Reap. New Inventory Number: NSAM 2007.249. Photograph courtesy Preah Norodom Sihanouk – Angkor Museum.

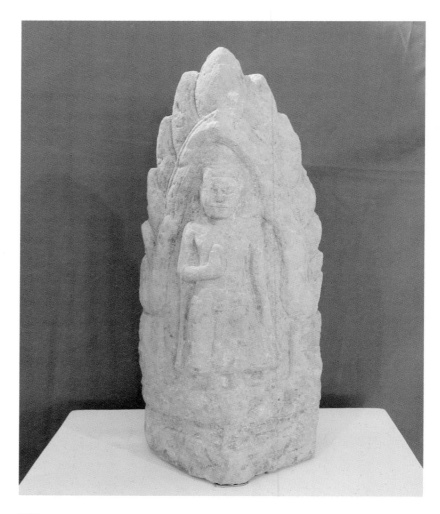

produced images, or projections, as I have argued, then we can imagine a
Buddha in the central sanctuary giving birth to the multiple Buddhas on
the antefixes above.

The reign of Indravarman, with its dearth of documentary evidence,
was followed by a timeframe (1270–after 1327) that could be called the
period of Sanskritic twilight, marked by an increased number of
inscriptions and, presumably, building projects. Four monarchs can be
lumped together in this period: Jayavarman VIII; Śrīndravarman;
Śrīndrajayavarman; and Jayavarmaparameśvara. From the reign of the last
of these four, dates an inscription that might provide a clue regarding the
iconoclastic movement. Bruno Dagens, in a stimulating proposal, blamed

Fig. 2.13 Antefix with standing
Buddha, from an
architectural model.
Bronze. Height: 11.2 cm.
From the crypt of Wat
Ratchaburana, Ayutthaya.
Chao Samphraya National
Museum, Ayutthaya.
Inventory number:
R. 606. Photograph by
author, 1971.

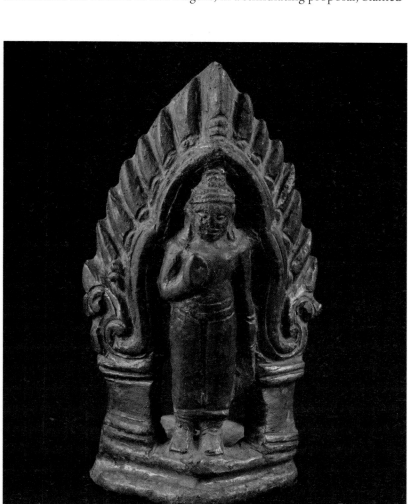

2.13

an outside agitator, someone like Sarvajñamuni, who travelled from India by means of yoga (presumably levitation) and established a lineage of priests, according to the Kapilapura inscription (*K. 300*) found near Angkor Wat.[41] The second priest in this lineage (only the first part of his name, Siddha-, is preserved) was commanded by the lord Shiva to carry out a "winnowing" – one possible meaning of *pavana* (stanza 29) – certainly a plausible description of the destruction of Buddha images.[42] Since the third priest in the lineage served Jayavarman VIII, the second presumably preceded him. These are slender threads, but they point, as does my interpretation of the Banteay Kdei material, to a date prior to c. 1270 for the iconoclastic movement.

In the period of Sanskritic twilight, only a single monument is securely dated, the Brahmanic Prasat Top East of 1295 (*K. 488*). The thorough analyses of Provost-Roche make it possible to arrive at conclusions about how much of the Preah Pithu temples and of Preah Palilay consists of new construction belonging to this time or somewhat earlier, and how much of the fabric dates back to the 12th century.[43] Provost-Roche's analysis of the inner gallery reliefs at the Bayon also makes it possible to fill in the 13th century, but only to a point, because there is an imperfect fit between the visual evidence and the chronological scaffolding established by inscriptions.

The key motif is the triple chignon, which as an iconographical trait is traditionally considered a sign of youth and appears at the Bayon, for example, on representations of Krishna's son Pradyumna and on Pradyumna's previous incarnation Kāma, the god of desire.[44] It also appears in free-standing sculptures of a variety of deities, primarily of the post-Jayavarman period.[45] On humans it can be seen once in the outer gallery and numerous times in the inner gallery, where Provost-Roche believes that variations in the depictions indicate the presence of three different monarchs, all post-Jayavarman VII but none allowing specific identifications.[46] In the outer-gallery reliefs, which are devoted to the reign of Jayavarman, a rare caption identifies a figure with a triple chignon (western gallery face, northern wing) as a royal entering the forest for the Indrābhiṣeka (ceremony).[47] Since Jayavarman VII is consistently shown with a hair bun at the back of his head, it is possible that this figure is the crown prince Śrīndrakumāra known from epigraphy.[48] Banteay Chhmar inscription *K. 227* provides evidence that Śrīndrakumāra was likely as old as Jayavarman VII and could not have been his son, nor have ascended the throne around 1220 and reigned for 50 years.[49] Still, it is possible to speculate, Śrīndrakumāra could have played an important role during the final decade of Jayavarman's life, when epigraphy falls silent (except, presumably, for the short dedicatory inscriptions at the Bayon and elsewhere), and even in the immediate aftermath of Jayavarman's death.

In the inner-gallery reliefs the first of Provost-Roche's three monarchs appears in key scenes in the northeast quadrant, including panels identified as depictions of the legend of the Leper King.[50] Monarch I can also be associated with the triple shrine that resembles Phra Prang Sam Yot in Lopburi, the images of which have been effaced.[51] Contrary to traditional views, Provost-Roche maintains that this shrine, because of the precision of the recarving, originally housed images of Jayavarman's triad. This means that Monarch I reigned at the very end of the Mahāyāna Buddhist period; the Shaivite reaction, according to Provost-Roche, occurred during his rulership, or a little after. The Leper King, it was suggested above, was Indravarman, and, indeed, it is possible that at the beginning of his reign Jayavarman's Mahāyāna was still embraced. But it is also possible to envisage a different scenario – that Monarch I was actually Śrīndrakumāra, in the 1210s.[52]

Monarch II can be distinguished from Monarch I because he has a small mustache and his three-pointed *coiffe* is undecorated.[53] A large portion of the reliefs must have been executed during the reign of this king, except for those on the western side, which may have been carved before the death of Jayavarman. If Monarch I is Śrīndrakumāra, then Monarch II is Indravarman, with a long reign extending to 1270. If Monarch II is Indravarman, on the other hand, then a large portion of the work on the reliefs was not carried out until the reign of Jayavarman VIII.

Finally, there is Monarch III (also with three chignons), identifiable in panels that fill what can be considered leftover spaces.[54] Once again, giving credence to Provost-Roche's analysis, Monarch III would have to be either Jayavarman VIII or his successor Śrīndravarman. It is difficult to say what kind of evidence will eventually have to come to light in order to demonstrate the validity of Provost-Roche's understanding. One problem is whether the small details she relies upon are really indicative of an intention to differentiate between different historical figures or merely idiosyncrasies due to artistic habit. Another is how much of a time gap stood between the actual occurrence of scenes supposed to be historical and their depiction in the reliefs.[55]

The earliest Pāli-language inscription, of 1308–1309, is *K. 754*, from a site southwest of Angkor, Kok Svay Cek.[56] Just one little detail will be noted: among the donated objects (in the Khmer-language section of the inscription) is an *ardhaśaṅkha*, a bronze conch holder.[57] Conch holders featuring a depiction of the Tantric Buddhist deity Hevajra were common in the time of Jayavarman VII, and in later centuries conchs were utilised in royal rituals. Their use in Theravāda worship, however, is exceptional. We can say, therefore, that in 1308, a newcomer to the Theravāda milieu would have found elements of the ceremonial practice in this temple familiar.

Fig. 2.14 *Nāga*-protected Buddha from the central sanctuary of the Bayon, now venerated at Vihear Prampir Lavaeng, where it was moved by the authorities in the early 20th century. Photograph courtesy Martin Polkinghorne, 2011.

In an important and path-breaking article, "One Buddha Can Hide Another", Martin Polkinghorne, Christophe Pottier and Christian Fischer have added a host of new considerations.[58] They contend that in the 15th century, the original central Buddha of the Bayon (Fig. 2.14) was lifted up so that a new, octagonal pedestal could be inserted underneath it, and that it was only much later that the Buddha was thrown into the central pit, perhaps by treasure seekers in the 18th century. Why the central Buddha was not damaged in the iconoclastic movement remains an unresolved puzzle, and the Banteay Kdei sculptures do not present pertinent

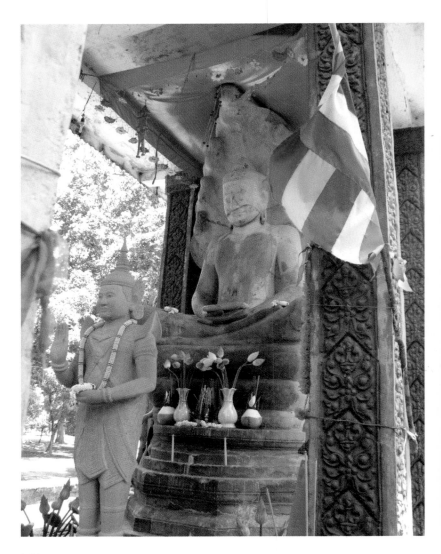

2.14

evidence, according to the authors. Here I offer an alternative scenario. This is that the original Buddha was destroyed, presumably before 1270, and that the surviving Buddha is a replacement installed subsequently, complete with an octagonal pedestal. Later, this Buddha was itself removed. This would explain certain anomalies in the style of the Buddha, especially the design of the *uṣṇīṣa*, which does not have the stepped profile standard on Bayon-period images (compare Fig. 2.15). Octagonal bases were known in 13th-century Buddhist architecture, and this feature need not have been an indication of a much later date.[59] Still, this "alternative

Fig. 2.15 Seated Buddha, on a pediment from Tep Pranam temple, Northern Terrace. National Museum of Cambodia, Phnom Penh. Inventory number: Ka. 1715. Photograph courtesy National Museum of Cambodia.

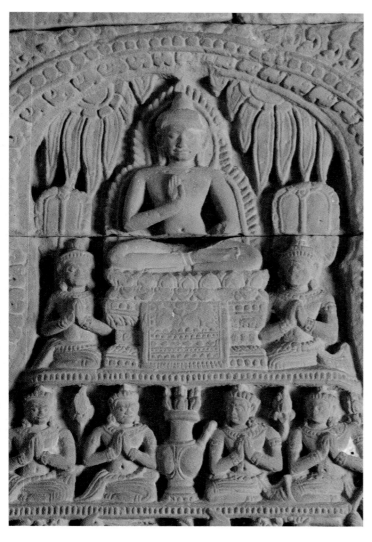

2.15

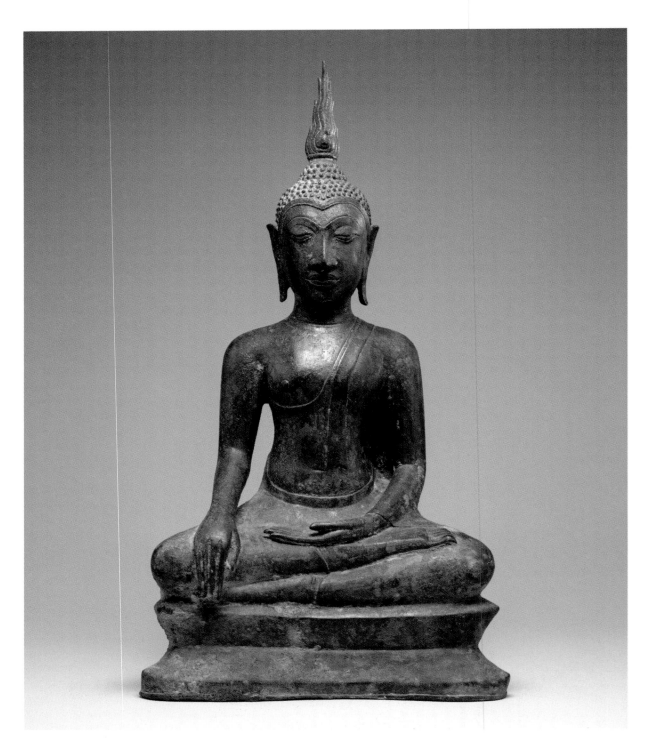

2.16

scenario" is not altogether satisfying because of the gaps that remain when actual dates are proposed.

Around 1300, at Sukhothai a new image type seems to have become prominent: the standing Buddha, the right hand performing a gesture at the side, the left arm hanging down. This is the iconographic type seen previously in the tenth century (Fig. 2.3), but not in the intervening centuries. Perhaps it was carried to Sukhothai from the Northeast. At about this time, in Lopburi, the *nāga*-protected Buddha passed out of fashion. Production of Ariya-sect icons also gradually ceased. A new

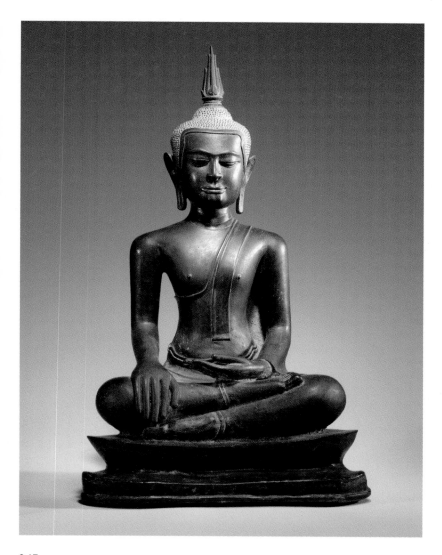

Fig. 2.16 Māravijaya Buddha. Leaded bronze. Height: 36.8 cm. Walters Art Museum, bequest of A. B. Griswold, 1992. Inventory number: 54.2800. Photograph courtesy The Walters Art Museum, Baltimore.

Fig. 2.17 Māravijaya Buddha. Leaded bronze. Height: 58 cm. Walters Art Museum, bequest of A. B. Griswold, 1992 (54.2792). Photograph courtesy The Walters Art Museum, Baltimore.

2.17

paradigmatic type of Buddha image arose, with an oval face, lowered
eyelids, planar eye sockets and a flame protuberance, a development that
could not have occurred without some sort of contact with Sri Lanka.[60]
The shift probably occurred at more or less the same time in various
places, but extended over a period ranging from the late 13th century
until well into the 14th. As late as the 1420s, but no later, Buddha images
in Ayutthaya were made in accordance with two distinct modes, one
oval-faced (Fig. 2.16), the other descending from the Khmer tradition
(Fig. 2.17). In the 1920s, the Khmer-tradition images were given the
name "U Thong style". The pedestals of both types of image follow the
same design. These two modes must have had names, a conceivable clue
to which is found in the northern chronicle the *Jinakālamālī*, which
states that in 1483 a Buddha image was founded resembling the
"Lavapaṭimā", the Lopburi image.[61] Whether the modes can be aligned
with different Buddhist sects is not known. The oval-face type was
eventually carried to Angkor, possibly but not necessarily because of
military conquest.[62]

This chronological survey will close with a glance at Prasat Top West,
Monument 486, a late 12th- to early 13th-century temple to which wings

Fig. 2.18 *Nāga* antefix, Prasat Top West. Photograph by author.

Fig. 2.19 Stucco ornament at Wat Nakhon Kosa, Lopburi. Photograph by author.

2.18 2.19

were added in the 14th century.[63] These wings are Angkorian versions of the wings at Wat Mahāthāt Lopburi and those found on various votive tablets (Fig. 2.9), in the scheme I have designated as "Ariya". The ornament no longer follows the classical models – as it still did in the buildings of the Sanskritic twilight period – and displays some similarities to the ornament seen on such temples in Lopburi as Wat Nakhon Kosa (Figs. 2.18 & 2.19). The scrolling hooks may appear at first as debased versions of classical ornament, but in fact it may be possible to show that they were adaptations of Burmese designs.

Fig. 2.20 Head of the Buddha. Height: 28 cm. King Narai National Museum, Lopburi. Inventory number: L.2584. Photograph courtesy King Narai National Museum, Lopburi.

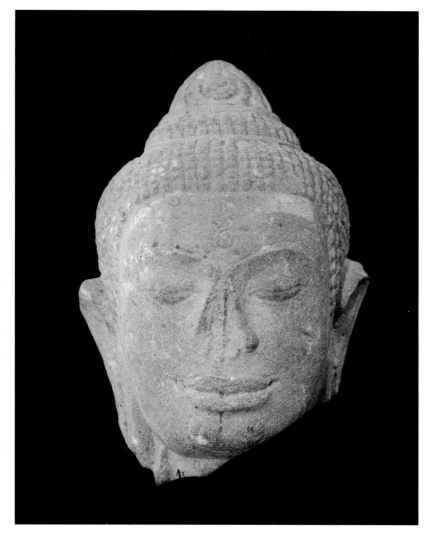

2.20

The standing Buddhas on the wings display the hand-on-chest gesture (See Figs. 6.21–6.23, p. 220). The temple configuration and the pose of the Buddhas follow the Ariya scheme with one significant difference. In the early Lopburi model and on the Banteay Kdei antefixes, the pendant left arm is shown with the hand palm forward. Here, the palm faces the hip, conforming to the type that was revived in about the late 13th century. These Buddha images at Prasat Top West have flame protuberances. When we look at an example of the new 14th-century style as manifested in Lopburi (Fig. 2.20), we can see that some of the features were adopted by the Angkor sculptor: the shape of the eyes, the rounded lowered lids and the profile of the eyebrows. The actual modelling of the eyebrows, however, displays a continuation of the high-relief treatment seen on the Leper King Terrace and elsewhere.[64]

CIVIC RITUAL

In this section an attempt will be made to describe the significance of certain buildings standing in front of the Angkor Thom palace complex and facing the royal square.[65] The analysis will be generated from a text, the *'Ōngkān chæng nam*, the Thai oath of allegiance, a recitation accompanied by the drinking of water potentially poisonous to the disloyal. The *'Ōngkān chæng nam* may well have been composed, at least in part, prior to the foundation of Ayutthaya in 1351, by Thai-speaking people living – possibly – in the Suphanburi region.[66] It is written in native verse forms, in an archaic Thai that is more Lao-like than the inscriptions of Sukhothai, and that has very few Khmer loanwords. It is invoked here in the belief that it reflects the Angkorian world view of the mid 13th to early 14th centuries and that it can serve as a point of reference not only for an earlier text, the Sūryavarman I oath, but also for two visual sequences, one the southern gallery of bas-reliefs at Angkor Wat, the second the parade of structures running north from the Bayon. The key element common to the two sequences and the Thai oath is one whose significance has only recently been recognised – a ritual enabling the subjugation of enemies, incorporating a mantra originally intended to subdue a mad elephant.[67]

There are 70 verses of varying length in the oath, which in Michael Wright's analysis comprise ten sections: Invocation of the Hindu Trinity (stanzas 1–3); Cosmology and Civilisation (4–15); Introduction to the Curse Proper (16–17); Calling of Witnesses (18–25); Beginning of the Curse Proper (26–33); Additional Calling of Witnesses (34–38); Invocation of Local Spirits (39–51); The King's Right to Root out Treason (52–58); Final Curse (59–62); The King and His Munificence (63–70).[68] The offences are not spelled out in the "curse proper" but

repeatedly referred to as the state of being un- (*bò*) faithful (*sü*), or treasonous ("Treasonous, may water cut his throat", in Wright's translation of one line).[69] The punishments are imminent and not postponed until rebirth in hell. The character of the text differs substantially from the much shorter Khmer oath engraved eight times on the pillars of a palace entry hall in 1011, early in the reign of King Sūryavarman I (*K. 292*).[70] This text is written as prose, but at least some of it has a verse-like character. Here is the first of many sentences beginning with the word *dah* ("if"), appearing here as if it were poetry. (In fact, if this is verse, the metrification differs from anything attested later.[71]) Sanskrit loanwords appear in italics; the other words are all Khmer.

Dah mān campāṅ	If there's a battle
yeṅ *udyoga* chpāṅ	we endeavour to fight
nu *sarvvātmaṇā*	and with all our soul
vvaṃ sṅvan ta āyuḥ	not to love life
hetu bhakti	because of (our) devotion (to the king),
vvaṃ rat leṅ campāṅ	(and) not to flee from battle.

Because the names of the oath-takers are engraved below the texts, each with the name of his county (*sruk*), approximately 400 names in all, perhaps the inscription should be understood as a palace document rather than as a transcription of a spoken oath. It may be that the Sanskrit elements are merely a way to elevate the tone of a speech act that was originally more like the later Thai oath. It is hard to say. At any rate, what is owed to the king is devotion (*bhakti*), just as to a divinity.[72] The witnesses to the oath are few in number – just the sacred flame (*vraḥ vleṅ*), the sacred gem (*vraḥ ratna*), and the Brahman instructors (*vrāhmaṇācāryya*). It is not known what the sacred gem was.[73]

The Thai oath, on the other hand, constructs a complete worldview, one that creates a frame around the oath itself. This frame is revealing because it is neither exclusively Brahmanical nor Buddhist. Especially worthy of note are the positions of the god Brahmā, the primordial king, and the ritual lasso. Stanza 3, in Wright's translation:

Om! Victory! Victory!
Revealer of the sixteen Brahma realms.
With faces all about,
Lord of the full-blown golden lotus,
Flying upon the king of swans,
He created earth and sky.[74]

Although the tenor of the passage is Brahmanical, the 16 Brahma realms are a feature of Buddhist cosmology – places of rebirth, corresponding to the world of pure form. Therefore it can be said that the text considers the Brahma realms (or Brahmaloka) belonging to this world indistinguishable from the god Brahmā. The beings in Brahmaloka do not perish in the fire that ends the *kalpa* (era), and because they have exhausted their positive merit, they are reborn on the newly formed earth as men – an event referred to in a subsequent stanza (number 10).[75]

In stanza 13, on the re-populated earth, an honoured man is chosen king and called Sammatirāja: this is the Mahāsammata of the Pāli text the *Agaññasutta*. Then, in stanza 15, there is an invocation of the piled-up rope of a lasso (*pāśa*), called Grandfather Phra Kam, who has flown in and established the rites of the spirit egg, incense and candles.[76] This Phra Kam (Kāṃ) is clearly the predecessor of the Thewakam (= Devakarma) who in the elephant rites of the 18th to 19th centuries is the god who supplies to humans the mantra that makes it possible to subdue a rampaging elephant.[77]

Fig. 2.21 Terrace of the Leper King, view of the outer wall. Photograph by author.

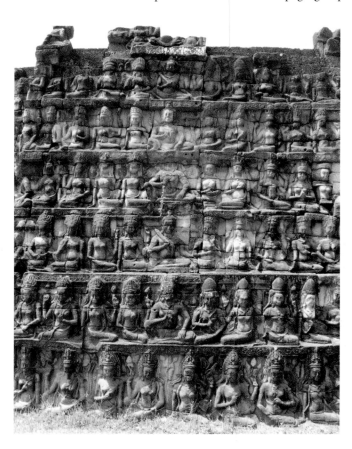

2.21

The corresponding visual sequence at Angkor Wat begins near the western end of the southern gallery. King Sūryavarman II appears seated on a mountain. He holds a snake lasso, a *nāgapaśa*.[78] Reliefs in the southwest corner pavilion might illustrate the way the lasso came into Sūryavarman's possession, through divine intervention. The lasso can be considered to stand for a mantra, and it is also an emblem of a supernatural ability, the power of subjugation (*vaśīkaraṇa*), not only over elephants, but human enemies as well.

Along this wall, subsequently, appears a royal procession, consisting of 18 elephant-riding generals and their troops, plus the king himself, as well as a palanquin supporting a container for the sacred fire (*vraḥ vleṅ*). They are all headed to a point of judgement, beyond the door that marks the central axis, where some may climb up to heaven, others descend to hell, according to the decree of the god of death and his secretary. There are 32 different hells, nearly all labelled, each displaying gruesome punishments. If there is a point of review, at which the generals and the troops may be supposed to be reciting an oath, it is only implied, and it would have to be the axial doorway, through which the power of the image in the central sanctuary could be said to radiate.

In the Thai oath, nearly all the punishments described occur in this life. In the Sūryavarman I oath, punishments are invited but not described (if we "do not keep this oath…, we ask that His Majesty inflict on us royal

Fig. 2.22 Terrace of the Leper King, view of the inner wall, showing *nāga* on the bottom register. Photograph by author.

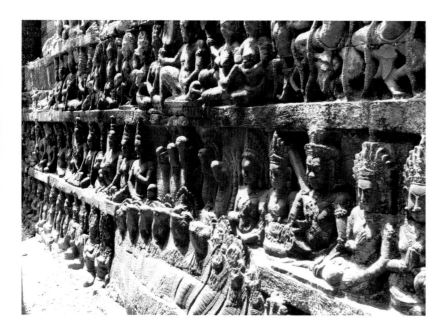

2.22

punishment of all sorts"), and if we escape those, "may we be reborn in the thirty-second hell as long as the sun and moon shall last".[79] At Angkor Wat, all the depicted punishments are posthumous – but surely such gruesome tools as tongs for the extraction of tongues reflect reality.

A related visual sequence can be identified at Angkor Thom. The central axis of the city runs from the Bayon north and south to the city gates. Imagine taking the southern gallery of Angkor Wat, turning it at right angles, and placing it upon the artery running north from the Bayon. Since the royal square just north of the Bayon remained vibrant in the later part of the 13th century and through the 14th century, what we are interested in are the ways a broad context sheds light on the experiences of the city dweller in this period. Start with a glance south toward the Bayon and recall the Thai oath – "Om! Victory! Victory! / Revealer of the sixteen Brahma realms / With faces all about!" This Brahmā is both Buddhist and Brahmanical; there is no point in distinguishing between the two. A much later, Bangkok-period Thai text provides a name for the face towers: *brahmabaktraprāsāda* (Brahma-face temple).[80]

Moving north, we pass the entrance to the palace complex and then the first of the two royal terraces, the Elephant Terrace. Whether this terrace was established in the later part of the reign of Jayavarman VII or soon thereafter is not easily determined; what is important is its longevity, since it remained viable until some sections were reconstructed at the time of the establishment of a *stūpa*, a project that has been dated to the 16th century.[81] It is not possible to look at the multitude of elephants that adorn the base of the Elephant Terrace without thinking that here is a proclamation of the king's mastery over elephants and of his possession of a mantra endowing him with the power of subjugation – just as in the depiction of Sūryavarman II at Angkor Wat and in the invocation of the lasso and of Phra Kam in the Thai oath.

The Leper King Terrace just north of the Elephant Terrace was also long-lived, functioning at least until the time the Leper King statue was inscribed, in the 14th or 15th century.[82] Just how it relates to the two paradigmatic sequences, the southern gallery at Angkor Wat and the Thai oath, is more problematic. The Leper King Terrace consists of two parallel, zigzagging walls, each with seven registers of reliefs, the same subject matter appearing on each wall, the outer wall hiding the inner (Fig. 2.21). On the terrace above and behind, the Leper King statue was placed. The current interpretations of the terrace tend to combine long-standing speculations with opinion based on excavations, and the evidence has not always been presented clearly. In *Angkor: An Introduction*, Cœdès wrote, "These interior bas-reliefs, intended to remain invisible, almost certainly represented creatures who were supposed to haunt the subterranean slopes of Meru."[83] The first part of the statement

is now considered erroneous because there is evidence that the outer wall was constructed when the inner wall, where the reliefs would originally have been entirely visible, started to collapse.[84] The reliefs on the outer wall are of inferior quality (but still likely to have been executed prior to 1270).[85] As for haunting the subterranean slopes, the terminology is discouragingly vague.

It is here proposed that the reliefs accord with standard Buddhist cosmology and that what they depict is the realm of the four great kings (*lokapāla, caturmahārājika*).[86] This level of the cosmos stands at the height of the innermost of the seven mountain ranges (Yugandhara) that surround Mount Meru. Among the indications that it is this kingdom rather than the realm of the *asura* that is depicted are the nature of the presiding deities, the attributes carried by their attendants (especially banners), and, most importantly, the presence of *nāga* at the very bottom of the walls, who correspond to the *nāga* that dwell in the Sīdantara Ocean that separates the rings of mountains (Fig. 2.22).[87] The *asura*, on the other hand, dwell under the base of Mount Meru. Although it could be considered appropriate for them to be hidden, they are not what are shown. Whether the seven registers of reliefs on the walls are intended to allude to the seven concentric mountain ranges cannot be determined.

Thinking back now to the scenes of heaven and hell at Angkor Wat, it would appear that here is something different. There are no punishments for the disloyal, nor are there simple heavenly paradises for the virtuous. The Realm of the Four Guardian Kings is a paradise, but it is one whose main role is to invite the public officials into a divine circle and to serve notice that they have a bounden duty, a sacred duty, to protect the kingdom.

The Leper King sculpture was described by all the early visitors to Angkor, but it only became clear that it was originally placed at the centre of a group of four half-kneeling sword-bearing guardian figures in 1969, in the course of excavations carried out by Bernard-Philippe Groslier (Fig. 2.23).[88] These figures, two of which are in the Angkor Conservation Depot, are similar in style to figures on the registers of the terrace. Although only the production and analysis of an extensive inventory of motifs will lead to precise chronological conclusions, the free-standing sculptures may date from the time of the construction of the inner, earlier wall. The Leper King statue is pre-Angkorian in date and so was found elsewhere, thought to be appropriate, and moved.[89] It bears an inscription dating from the 14th or 15th century. There are, therefore, two possibilities, with no clear evidence allowing a choice between the two to be made: one is that in the time of Indravarman the statue stood here, uninscribed; the other is that another sculpture

entirely was placed here. Nevertheless, here it will be maintained that the inscription offers clues to the identity of the original sculpture, whether or not it was the Leper King.

This inscription identifies the figure as *Braḥ pāda dharmmādibbatiy dhirāja*, an expansion of the epithet *dharmarāja* or *dhammarāja*, the righteous king.[90] Cœdès took *dharmarāja* in a Hindu sense to mean Yama, lord of the dead. At Angkor Wat, the scribe Citragupta is shown next to "Braḥ Dharmma". This conforms with the words of the *Padma Purāṇa*, "Chitragupta was placed near Dharmarāj to register the good and evil actions of all sentient beings, that he was possessed of supernatural wisdom and became the partaker of sacrifices offered to the gods and fire".[91] In the *Padma Purāṇa*, "Dharmarāj" can be considered an epithet

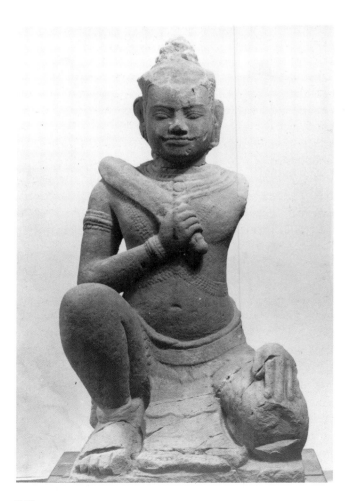

2.23

for Yama. But in Buddhist cosmology, Yama's position is just above the hells, far below the Realm of the Guardian Kings. Furthermore, there is no need for a judgement call anyway, if the only destiny is in the Caturmahārājika.

Fresh interpretations of the identity of the statue can be proposed. A possibility is that the inscription has a double reference, first to a reigning king, and second to Mahāsammata, the very first king according to Pāli scripture, and a figure mentioned in the Thai oath. Linking the sculpture to a reigning king is the royal title *dharrmikarājādhirāja*, which is found on one side (nearly completely effaced) of a 14th- to 15th-century inscription (*K. 489*) discovered at the site of a nearby Buddhist terrace.[92] The Thai oath names and praises the reigning monarch (Rāmādhipatī I), but does not mention a statue of him, the Phra Thep Bidǫn (*devapitra*, "god-father"), which was probably established posthumously and served as a witness to the oath throughout the Ayutthaya period.[93] Maybe the Leper King was the Khmer counterpart to the Phra Thep Bidǫn.

Mahāsammata was also a righteous king: according to the Mon *Dharmasāstra*, Law Treatise, "he governed the people with righteousness" (*janaṃ dhammena rakkhati*).[94] It might be objected that Mahāsammata was born on earth, not in the Realm of the Four Guardian Kings. But there is a legend found in the Thai *Thammasāt* (*Dharmasāstra*) that makes the placement seem justified. A *ṛṣi* (ascetic with supernatural powers) named Bhadra flew to the wall of the universe, where he copied down the letters of the treatises of the *Vedāṅga* and the verses of the *Veda*, which he then taught to King Mahāsammata. Later, Bhadra's brother Manosāra also flew to the wall and copied down the Pāli text of the *Dharmasāstra*, which was written in letters as big as elephants.[95] This wall, the *cakkavāla* mountain range, stands beyond the seventh of the seven concentric mountain ranges, 42,000 *yojana* high, the same height as the innermost range, therefore, the most practical route crosses the Realm of the Four Great Kings. The Vedic verses brought back by Bhadra might be considered to include the elephant lasso mantra. So Mahāsammata, and his surrogate, the reigning monarch, are supported by two pillars – knowledge of magical formulas, on one hand, and the law, on the other.

These considerations do not resolve definitively the possibly complex identity of the Leper King statue, its kinship to the Ayutthayan statue or the question of the function of the Terrace of the Leper King. It may be that an oath was recited here, that it bound the oath-takers to the state, as if they were inhabitants of the Realm of the Guardian Kings, and that the Leper King statue, once it was installed, was the counterpart of the Ayutthayan Phra Thep Bidòn.[96] But this remains a hypothesis. What it may show is that, contrary to long-standing speculation, there is little evidence that the terrace had anything to do with cremations. Nevertheless

these arguments can be taken a step further, keeping Angkor Wat as a template. At Angkor Wat we leave the southern gallery and proceed onto the western gallery, where the churning of the sea of milk is illustrated. When they co-operate, the gods and the demons (*asura*) produce the good things of the world, including the nectar of immortality. The path northward from the Bayon leads to the northern Angkor Thom gate, where the gods and demons flank the bridge across the city moat, recalling the churning scene. Just north of the royal square, there is also an east-west division, the newly built structures on the west being Buddhist, the ones on the east – the Preah Pithu temples – being Brahmanical. To produce the good things of the world, they must co-operate, and the king must give equal weight to each faction if he is to rule successfully. A concern for harmony between Buddhist and Brahmanical beliefs is evident in an inscription of Jayavarman VII (*K. 484*), in which the roots, trunk and branches of the Buddhist Bodhi tree are equated with Brahmā, Shiva and Vishnu.[97] Some kind of equilibrium was generally maintained between Buddhists and Brahmans – except when it wasn't, such as at the time of the iconoclastic movement.

MOTIVATIONS

Here, as a kind of postscript, are a few considerations that differ somewhat from those presented by Finot. Firstly, it might be wondered what happens if we ask about Buddhist, as opposed to Brahmanical, relations with territorial spirits. Buddhist boundary stones, which are explicitly described in the Pāli inscription of 1308–1309, have an important place. Did the Buddhists have a more effective way than the Brahmans of creating an inviolate space, unmenaced by territorial spirits? When this space becomes the place for ordinations, the newly reborn monks inherit the sanctity of the enclosure. They can be said, therefore, to rank higher than hereditary Brahman priests, who may be made priests by their blood but who are also tainted by it.

Secondly, we have no good evidence, so far as I know, as to how universal was access into the monkhood, nor do we know in this period whether short stays in the monkhood were a feature of the practice. At any rate, surely the relative democracy of monastery life was one of its attractions, as well as the social interactions brought about by the daily rounds with alms bowl.

Thirdly, ethnic mixture must also be a factor in the rise of Theravāda Buddhism. There were Khmers who lived in Lopburi and returned to Angkor, bringing a different religious outlook with them. In addition, I suspect that Jayavarman had resettled prisoners of war in the Angkor area to serve as labourers in his building projects, and some of these would have

been Thai speakers. The mutual influence of the Thai and Khmer languages is so deep that only long-standing intermixture of populations can explain it.[98]

Notes

1 Ludivine Provost-Roche, "Les derniers siècles de l'époque angkorienne au Cambodge (env. 1220–env. 1500)", 2 vols., PhD dissertation, Université de la Sorbonne Nouvelle–Paris III, 2010. Another important dissertation is Tun Puthpiseth, "Bouddhisme Theravāda et production artistique en pays khmer: Étude d'un corpus d'images en ronde-bosse du Buddha (XIIe–XVIe siècles)", 3 vols., PhD dissertation, Université de la Sorbonne–Paris I, 2015.

2 George Cœdès, *Angkor: An Introduction*, Hong Kong: Oxford University Press, 1963, p. 107; Louis Finot, "Les études indochinoises", *BEFEO* 8, 1908: p. 224. Cœdès added, in his own words, "This religion so aptly described by Louis Finot, who knew it well, was Buddhism of the Lesser Vehicle, imported from Ceylon to Siam through the Mons and the Burmans. Basically opposed to individual personality, this Buddhism without deities, so different from that of Jayavarman VII, could not but destroy the cult which was both personal and nationalistic, and which forced people to worship the god-king and the deified princes."

3 In the light of Michael Vickery, "The *2/k. 125 Fragment*, a Lost Chronicle of Ayutthaya", *JSS* 61, pt. 1, Jan. 1973: pp. 1–80.

4 The greater part of the views expressed in the first section of this chapter appeared previously in Hiram Woodward, *The Art and Architecture of Thailand*, Leiden and Boston: Brill, 2003, 2005.

5 The inscriptional evidence is thoroughly analysed in Nicolas Revire, "Glimpses of Buddhist Practices and Rituals in Dvāravatī and Its Neighboring Cultures", in *Before Siam: Essays in Art and Archaeology*, eds. Nicolas Revire and Stephen A. Murphy, Bangkok: River Books and the Siam Society, 2014: pp. 240–71.

6 There are a few known names, like Canāśa (from inscriptions) and Wendan (in Chinese sources), but we cannot be sure where they were located or of their territorial extent. For Wendan, see Hiram Woodward, "Dvaravati, Si Thep, and Wendan", *Bulletin of the Indo–Pacific Prehistory Association* 30, 2010: pp. 87–97.

7 Some types of ornament have been carefully studied: Robert L. Brown, *The Dvāravatī Wheels of the Law and the Indianization of Southeast Asia*, Leiden: Brill, 1996. Other aspects of the relationship are addressed in Hiram Woodward, "Stylistic Trends in Mainland Southeast Asia, 600–800", in John Guy, ed., *Lost Kingdoms: Hindu-Buddhist Sculpture of Early Southeast Asia*, New York: Metropolitan Museum of Art, 2014, pp. 122–9; Nicolas Revire, "Dvāravatī and Zhenla in the Seventh to Eighth Centuries: A Transregional Ritual Complex", *Journal of Southeast Asian Studies* 47, 2016: pp. 393–417.

8 Pierre Baptiste and Thierry Zéphir, *L'Art khmer dans les collections du musée Guimet*, Paris: Réunion des musées nationaux, 2008, pp. 27–8.

9 Louise Allison Cort and Paul Jett, eds., *Gods of Angkor: Bronzes from the National Museum of Cambodia*, Washington: Arthur M., Sackler Gallery, Smithsonian Institution, 2010.

10 Woodward, "Dvaravati, Si Thep, and Wendan".

11 Woodward, "Aspects of Buddhism in Tenth-Century Cambodia", in *Buddhist Dynamics in Premodern and Early Modern Southeast Asia*, ed. D. Christian Lammerts, Singapore: Institute of Southeast Asian Studies, 2015, pp. 218–60. For the two sculptures, Fig. 7.5, p. 227, and Fig. 7.7, p. 229.

12 In a later inscription from Angkor (*K.887*), dating from 983, there is mention of a *sthavira* monk (*bhikṣu*), who may or may not have been a Theravādin: G. Cœdès, *Inscriptions du* Cambodge, 8 vols., Hanoi and Paris: EFEO, 1937–66, vol. 5, pp. 153–5 (st. XV, *bhikṣuṃ sthaviran...*). Note should also be made of the term *Mahāyānasthavira*, in an 11th-century inscription found in Lopburi: George Cœdès, *Recueil des inscriptions du Siam Deuxième Partie: inscriptions de Dvāravatī, de Çrīvijaya et de Lavo*, Bangkok: Siam Society, 1961, pp. 10–12. For references to discussions of this term, Hiram Woodward, "Image and Text in Eleventh-Century Burma", in *India and Southeast Asia: Cultural Discourses*, eds. Anna L. Dallapiccola and Anila Verghese, Mumbai: K R Cama Oriental Institute, 2017, pp. 101–2, and p. 118, n. 22.

13 On the Khmer adoption and transformation of the *nāga*-protected Buddha, Jean-Pierre Gaston-Aubert, "Nāga Buddhas in the Dvāravatī Period: A Possible Link between Dvāravatī and Angkor", *JSS* 98, 2010: pp. 116–50; Peter D. Sharrock, "The Nāga-enthroned Buddha of Angkor", in *Khmer Bronzes: New Interpretations of the Past*, eds. Emma C. Bunker and Douglas Latchford, Chicago: Art Media Resources, 2011, pp. 481–92.

14 Woodward, *The Art and Architecture of Thailand*, pp. 146–55. A recent addition to the literature is Pia Conti, "Tantric Buddhism at Prasat Hin Phimai: A New Reading of Its Iconographic Message", in *Before Siam: Essays in Art and Archaeology*, eds. Nicolas Revire and Stephen A. Murphy, Bangkok: River Books and the Siam Society, 2014, pp. 374–95.

15 Evidence has recently come to light of a depiction of the *Kapphina Avadāna* in a temple in Pagan, thereby strengthening the supposition that the Thai story of the crowned Buddha (the *Jambupati Sutta*) derived from this *avadāna*. See Samœchai Phunsuwan (Samerchai Poolsuwan), *Chittrakam phutthasatsana samai Phukam* [Buddhist Painting of the Bagan Period], 2 vols., Bangkok: Mahawitthayalai Thammmasat, 2016, vol. 2, p. LVII, (in Thai).

16 There is also an unread doorjamb inscription, *K. 871.* "Chronique", *BEFEO* 37, 1937: p. 636; Henri Marchal, *Le décor et la sculpture khmers*, Paris: Vanoest, 1951, pl. XXV, no. 89, (lintel); Marchal, "Note sur la forme du stūpa au Cambodge", *BEFEO* 44, no. 2, 1951: pp. 581–90. See also the remarks by Nandana Chutiwongs, *The Iconography of Avalokiteśvara in Mainland South East Asia,* Proefschrift, Rijksuniversiteit, Leiden,1984, n. 97, p. 391. There is also material evidence at other sites, such as Beng Mealea (probably post-Sūryavarman) and Prasat Chrap, Pursat (probably pre-Sūryavarman). For its lintel with Phimai connections, Jean Boisselier, *La statuaire khmère et son évolution*, 2 vols., Paris: EFEO, 1955, Planches, pl. 61, (National Museum of Cambodia).

It is no longer thought that the Theravāda temple of Preah Palilay might date from the reign of Sūryavarman II. According to the thorough analysis of Ludivine Provost-Roche, both construction methods and elements of the décor indicate that it was established in the period between the reigns of Sūryavarman II and Javavarman VII (making it a contemporary of the Lopburi Mahāthāt) and renovated later, perhaps beginning as early as the decades following the death of Jayavarman VII, judging by the composition of certain pediments. In the opinion of Tun Puthpiseth, however, a pediment depicting the assault of

Māra – a key element in Provost-Roche's argument regarding the date of establishment – in fact dates from about the end of the 13th century, as do the other pictorial sculptural elements. See Ludivine Provost-Roche, "Les derniers siècles ", pp. 115–31; Tun Puthpiseth, "Bouddhisme Theravāda", vol. 3, p. 40, (caption, Ill. 2.41). For a brief survey of opinion regarding Preah Palilay and Woodward, *The Art and Architecture of Thailand*, pp. 203–4, n. 159. To the works cited there can be added Bernard-Philippe Groslier, *The Art of Indochina*, New York: Crown, 1962, p. 166; J. Dumarçay, *Documents graphiques de la Conservation d'Angkor 1963–1973*; Paul Courbin, *La fouille de Sras-Srang*, Paris: EFEO, 1988, caption to pl. LX; Claude Jacques, "The Royal Square of Angkor Thom and Jayavarman VII", in *Southeast Asian Archaeology 1998: Proceedings of the 7th International Conference of the European Association of Southeast Asian Archaeologists, Berlin, 31 August–4 September 1998*, eds. Wibke Lobo and Stefanie Reimann, Hull: Centre for South-East Asian Studies & Berlin: Ethnologisches Museum, 2000, pp. 77–83.

17 *K. 966*. George Cœdès, "Nouvelles données épigraphiques sur l'histoire de l'Indochine centrale", *JA* 246, 1958: pp. 125–42. For discussions, David K. Wyatt, "Relics, Oaths, and Politics in Thirteenth-Century Siam", *Journal of Southeast Asian Studies* 32, 2001: pp. 3–66; Woodward, *The Art and Architecture of Thailand*, pp. 163–5.

18 A key 12th-century example, showing the Buddhas of the Past around the pedestal, is illustrated in Woodward, *The Art and Architecture of Thailand*, pl. 70 (B).

19 How the presence of an esoteric Theravāda (possibly with links to Ariya Buddhism) might bear on these issues remains to be explored. Here are three surveys of the literature: L. S. Cousins, "Aspects of Esoteric Southern Buddhism", in *Indian Insights: Buddhism, Brahmanism and Bhakti: Papers from the Annual Spalding Symposium on Indian Religions*, eds. Peter Connolly and Sue Hamilton, London: Luzac, 1997, pp. 185–207; Kate Crosby, "Tantric Theravada: A Bibliographical Essay on the Writings of François Bizot and Others on the Yogāvacara Tradition", *Contemporary Buddhism* 1, 2000: pp. 141–98; Ian Harris, *Cambodian Buddhism: History and Practice*, Honolulu: University of Hawai'i Press, 2005, pp. 93–104.

20 Issues addressed in one place or another in Joyce Clark, ed., *Bayon: New Perspectives*, Bangkok: River Books, 2007. The chapter by Michael Vickery provides a guide to contradictory opinions, supplemented by his more extended "Bayon: New Perspectives Reconsidered", *Udaya* 7, 2006: pp. 101–58. I shall here make two comments concerning the Bayon. One is that it should be possible to integrate the construction and destruction of the *kuṭi* into political history. For instance, a bronze replica of the Jayabuddhamahānātha of Phetchaburi would only have been installed when Phetchaburi was still part of the kingdom (T. S. Maxwell's transcriptions in *Bayon: New Perspectives*, p. 123, inscription 6(L)2). Perhaps the *kuṭi* were torn down when the more distant territories broke away. Secondly, the face towers might have originally had both exoteric and esoteric explanations. If the exoteric identification was "Brahma" (that is, the Brahmas of the Buddhist Brahmaloka heavens; see above, p. 86), a passage in the Thai text on the crowned Buddha Jambūpati might provide a rationale for Zhou Daguan's identification of them as the Buddha (and also legitimise the Kathmandu parallel). This text compares the appearance of the crowned Buddha to Brahma. See Woodward, "The Buddha Images of Ayutthaya", in *The Kingdom of Siam*, ed. Forrest McGill, San Francisco: Asian

Art Museum, 2004, p. 56.

21 For a discussion of many of these features, Vittorio Roveda, *Images of the Gods*, Bangkok: River Books, 2005, pp. 226–59. I have been associated with the suggestion that Jayavarman himself turned to the Theravāda (see Vickery, "Bayon: New Perspectives Reconsidered", p. 125). There are elements of this view in Woodward, "Tantric Buddhism at Angkor Thom", *Ars Orientalis* 12, 1981: pp. 57–67. Vickery proposed that this opens the way to the possibility that the destruction of images was carried out by Theravādins opposed to the Mahāyāna, a possibility I find unlikely (as does Peter Sharrock: see *Bayon: New Perspectives*, n. 7, p. 233). Provost-Roche expressed the view that there was at least Theravāda connivance in the desecration because of the pattern of damage ("Les derniers siècles", vol. 1: p. 82).

 A twist on the role of the Theravāda–Mahāyāna divide is that the destruction was the responsibility of Hindus angered at the Theravāda (the Mahāyāna being more compatible). For this, William A. Southworth, "The Alteration and Destruction of Buddhist Images at Angkor during the Thirteenth and Fouteenth Centuries", in *In the Shadow of the Golden Age: Art and Identity in Asia from Gandhara to the Modern Age*, ed. Julia A. B. Hegewald, Berlin: EB-Verlag, 2014, pp. 197–225.

22 Philippe Stern, *Les monuments khmers du style du Bàyon et Jayavarman VII*, Paris: Presses Universitaires de France, 1965, Figs. 27 & 28.

23 Woodward, *The Art and Architecture of Thailand*, pl. 68 (A). For banners in a Pāla prototype, Susan L. Huntington and John C. Huntington, *Leaves from the Bodhi Tree*, Seattle: University of Washington Press, 1990, pl. 19.

24 Baptiste and Zéphir, *L'Art khmer dans les collections du musée Guimet*, pp. 268–71.

25 Woodward, "The Jayabuddhamahānātha Images of Cambodia", *Journal of the Walters Art Gallery* 52/53, 1994/95: pp. 105–11.

26 "Dharmadarśi", *K.294*: Cœdès, *Inscriptions du Cambodge*, vol. 3, p. 197. For an illustration, Tun Puthpiseth, "Bouddhisme Theravāda", vol. 3: p. 151, (Ill. 3.26).

27 For references to publications concerning the hospitals and a discussion of the identification of the images installed in them, Hiram Woodward, "Cambodian Images of Bhaisajyaguru", in Bunker and Latchford, *Khmer Bronzes: New Interpretations of the Past*, pp. 497–502, (Appendix 4).

28 Woodward, "The Jayabuddhamahānātha Images of Cambodia".

29 For a discussion of these connections, Woodward, "Image and Text", pp. 103–4.

30 Woodward, *The Art and Architecture of Thailand*, pl. 56.

31 This path of development was not followed everywhere. At Prasat Muang Sing in Kanchanaburi province, for instance, far western Central Thailand, Jayavarman's Mahāyāna persisted. The administrative links between Sukhothai and Angkor were strong, and there, as Betty Gosling showed, *Sukhothai: Its History, Culture, and Art*, Singapore: Oxford University Press, 1991, p. 14, the addition of a worship hall at Wat Phra Phai Luang has parallels at Angkor (and might provide a chronological anchoring point for the middle decades of the 13th century there). In the Northeast, however, for reasons that have not been explained, there is little evidence of new monumental construction, although bronze workshops most likely continued production.

32 The change is a result of the decision that the chronogram *antara* in *K. 567* (Maṅgalārtha), st. 3, stands for the digit *9* rather than *0*. See Claude Jacques, "The Historical Development of Khmer Culture", in *Bayon: New Perspectives*,

ed. Joyce Clark, Bangkok: River Books, 2007, p. 41.

33 See note 20.

34 Vittorio Roveda, "Reliefs of the Bayon", in *Bayon: New Perspectives*, ed. Clark, pp. 286–311.

35 Provost-Roche, "Les demiers siècles".

36 Stern, *Les monuments khmers du style du Bàyon*, pp. 23–4 and caption, pls. 32 & 33.

37 David P. Chandler, "Folk Memories of the Decline of Angkor in Nineteenth-Century Cambodia: The Legend of the Leper King", *JSS* 67, pt. 1, Jan. 1979, pp. 56–7.

38 Yoshiaki Ishizawa, ed., "Special Issue on the Inventory of 274 Buddhist Statues and the stone Pillar discovered from Banteay Kdei Temple", 2 vols, *Renaissance culturelle du Cambodge* 21, 2004.

39 For some illustrations, Hiram W. Woodward Jr., "Some Buddha Images and the Cultural Developments of the Late Angkorian Period", *Artibus Asiae* 42, 1980: pp. 155–74.

40 One early instance of an Ariya-sect triad in Cambodia is a small votive tablet that could date from the 1190s. See Boisselier, *Le Cambodge*, pl. XLIV, 1. Compare the Cleveland finial, Woodward, *The Art and Architecture of Thailand*, pl. 70 (A); also, the presence of a gem in the palm.

41 Bruno Dagens, *Les Khmers*, Paris: Les Belles Lettres, 2003, p. 180. A thorough review of the problem is Southworth, "The Alteration and Destruction of Buddhist Images at Angkor". Southworth opts for a date of c. 1327, when King Jayavarmaparameśvara erected a *liṅga* at the Bayon in the first year of his reign (*K. 470*).

42 Abel Bergaigne, *Inscriptions sanscrites du Campā et du Cambodge*, Paris: Imprimerie nationale, 1893, pp. 560–86. Stanzas 7–10, which characterise Sarvajñamuni, were translated by Alexis Sanderson, "The Śaiva Religion among the Khmers (Part 1)", *BEFEO* 90, 2003, p. 413. Sanderson apparently understood the date of Sarvajñamuni to have been in the distant past.

43 See note 16. The complete photographic documentation provided in Provost-Roche, "Les derniers siècles", makes it possible to draw conclusions. For a discussion of the relationship of a Preah Pithu lintel to the Angkor Wat style (and providing clues as to why the Preah Pithu monuments were so long thought to be 12th century in date) see the entry by Thierry Zéphir in Baptiste & Zéphir, *L'Art khmer dans les collections du musée Guimet*, pp. 384–7.

44 Bruno Dagens, "Étude sur l'iconographie du Bayon (Frontons et linteaux)", *AA* 19, 1969: p. 137 and Fig. 16.

45 Triple-chignon images of note include: (1) MG 18135: Baptiste and Zéphir, *L'Art khmer dans les collections du musée Guimet*, pp. 290–91 (contrary to the opinion of the authors, this sculpture postdates Jayavarman VII and is unlikely to depict Mañjuśrī). (2) A standing female figure in the National Museum, Phnom Penh: Jean Boisselier, *Le Cambodge*, Manuel d'archéologie d'Extrême-Orient, 1st part, vol. 1 (Paris: A. & J. Picard, 1966), pl. XXXIX, 1. (3) A Vishnu in the Asian Art Museum of San Francisco, 1993.134. These three sculptures all have backslabs, a 13th-century feature. (4) The attendant (Vishnu) paired with Shiva in the pediment from Preah Palilay, National Museum of Cambodia; for a discussion, Hiram W. Woodward, Jr., "Thailand and Cambodia: the Thirteenth and Fourteenth Centuries", in *Rūam bot khwām thāng wichākān 72 phansā thān āchān Sâtsatrâchan Mòm Čhao Suphattradit Ditsakun / Studies & Reflections on Asian Art History and Archaeology: Essays in Honour of H. S. H.*

Professor Subhadradis Diskul (Bangkok: Silpakorn University, 1995), pp. 335–42.

46 Provost-Roche, "Les derniers siècles", pp. 90–113, especially the summary, pp. 111–2.

47 Roveda, "Reliefs of the Bayon", p. 315. For a discussion, Peter D. Sharrock, "The Mystery of the Face Towers", in *Bayon*, ed. Clark, p. 252 n. 85. As Sharrock notes, this Indrābhiṣeka might have been Tantric, different from the ceremony later performed in Ayutthaya.

48 Provost-Roche, "Les derniers siècles", p. 88.

49 Claude Jacques, "The History and the Inscriptions," in Peter D. Sharrock, *Banteay Chhmar: Garrison-temple of the Khmer Empire*, Bangkok: River Books, 2015, pp. 141–4.

50

Dufour	Provost-Roche	Roveda	Between towers
133–35	8.43–8.45	XXVIII	37 & 22
124	8.4	XXVIb	36 & 37
119/120	8.5	XXIVb	35 & 36

Dufour: Henri Dufour *et al.*, *Le Bayon d'Angkor Thom: Bas-reliefs publiées par les soins de la Commission Archéologique de l'Indochine*, 2 vols., Paris: E. Leroux, 1910–14. These plates can be viewed on the web site https://bayonrevealed. wixsite.com/bayon, maintained by Richard Thomas and Rhoda O'Higgins. Nearly all Provost-Roche's illustrations were taken from a 2004 survey. For Roveda, his "Reliefs of the Bayon". The Leper King story appears in Dufour, pls. 133–5. For discussions of the Leper King, Ashley Thompson, "The Suffering of Kings: Substitute Bodies, Healing, and Justice in Cambodia", in *History, Buddhism, and New Religious Movements in Cambodia* (Honolulu: University of Hawai'i Press, 2004), pp. 99–112, and the references therein. For the international spread of a legend of a leper king, Brice Vincent, "Nouvelle étude du Lokeśvara khmer du Musée national de Colombo (Sri Lanka)", *AA* 68 (2013): pp. 27–38.

51

Dufour	Provost-Roche	Roveda	Between towers
113	8.11, 8.11 ter	XXIVf	35 & 36

See Provost-Roche, pp. 94–95. According to Roveda the central image was originally a *liṅga*, not the Buddha.

52 This possibility is raised and then rejected by Provost-Roche, p. 93 n. 298.

53

Dufour	Provost-Roche	Roveda	Between towers
128	8.2 bis	XXVIa	36 & 37
118	8.6	XXIVc	35 & 36
27	8.33	Vb	24 & 25
3	8.52	Ib	22 & 23

Roveda identified the man standing on an elephant, pl. 27, as a Cham.

54 Provost-Roche, "Les derniers siècles", p. 112.

Dufour	Provost-Roche	Roveda	Between towers
108	8.54, 8.54 bis	XXIIg	34 & 35
44	8.79	VIIId	26 & 27
41	8.82	VIIIb	26 & 27
40	8.83	VIIIa	26 & 27

55 Here are two incidental identifications, by-products of this research and of correspondence with Richard Thomas of Western Sydney University in 2017. Dufour pls. 130 (paying homage to Shiva) and 131 (a boat scene; Provost-Roche, p. 102; Roveda XXVIc and XXVIIb) are quite probably the same two scenes depicted in the southwestern corner pavilion at Angkor Vat: Woodward,

"King Sūryavarman II and the Power of Subjugation," in *On Meaning and Mantras: Essays in Honor of Frits Staal*, ed. George Thompson and Richard K. Payne (Berkeley: Institute of Buddhist Studies and BDK America, 2017), pp. 483–502. Dufour pl. 99 (Roveda XXId) depicts Kāmadeva, having responded to Indra's request to visit Shiva, residing in a pavilion on the mountainside, the scenes of nature in the lower part of the relief reflecting the descriptions of the environment in the *Śiva Purāṇa* 2.3.18 ("the vast diffusions of Spring caused the display of emotions of love"). Jagadisalala Sastri, trans., *The Śiva-Purāṇa*, 4 vols. (Delhi: Motilal Banarsidass, 1970); online access http://dspace.wbpublibnet.gov.in:8080/jspui/handle/ 10689/21319.

56 Cœdès, "Etudes cambodgiennes XXXII: La plus ancienne inscription en Pāli du Cambodge", *BEFEO* 36, 1936: pp. 14–21. On the terminology of the inscription, Ashley Thompson, "Changing Perspectives: Cambodia after Angkor", in *Sculpture of Angkor and Ancient Cambodia: Millennium of Glory*, ed. Helen Ibbitson Jessup and Thierry Zéphir, Washington: National Gallery of Art, 1997, p. 27.

57 Dominique Soutif, "Organisation religieuse et profane du temple khmer du VIIe au XIIIe siècle", 3 vols., Thèse de Doctorat, Université Sorbonne nouvelle – Paris 3, 2009, vol. 1, pp. 264–5.

58 Martin Polkinghorne, Christophe Pottier, and Christian Fischer, "One Buddha Can Hide Another", *JA* 301, no. 2, 2013: pp. 575–624.

59 In bronze, Bangkok National Museum Lb 344, illustrated Theodore Bowie, ed., *The Arts of Thailand*, Bloomington: Indiana University, 1960, Fig. 43, p. 78. All this requires juggling the dates of the destruction and of the installation of the replacement. If the interval lasted any length of time, then it must be asked if a Hindu image was installed for a period. Claude Jacques proposed that the original central Buddha was replaced by an image of Harihara; he drew on the evidence of inscriptions ("Dharaṇī" and "Parvatī) in the adjacent chapels: "The Historical Development of Khmer Culture", p. 48. It is far more likely that the name Dharaṇī referred to the Buddhist Earth Goddess, and that the inscriptions pre-dated the removal of the central icon (points made in Vickery, "Bayon: New Perspectives Reconsidered"). It is hard to know what form these images took, but I suspect that they had an additional esoteric meaning, as standing for the side channels in Tantric meditation.

60 These discussions of stylistic development depend on Hiram W. Woodward, Jr. et al., *The Sacred Sculpture of Thailand*, Baltimore: Walters Art Gallery, 1997.

61 *Jinakālamālī*, ed. A. P. Buddhadatta, London: Pāli Text Society, 1962, p. 103 (*lavapaṭimākāraṃ*); cf. Hans Penth, *Jinakālamālī Index*, Oxford: Pāli Text Society and Chiang Mai: Silkworm Books, 1994, p. 152.

62 Polkinghorne, Pottier and Fischer, "One Buddha".

63 On this temple, see Chapter 6 by Yuni Sato in this volume.

64 Prasat Top West has antefixes that are so like those installed on Phra Prang Sam Yot in Lopburi that the Lopburi antefixes could have conceivably been carried from Cambodia, as pointed out in Woodward, "Thailand and Cambodia: The Thirteenth and Fourteenth Centuries".

65 Claude Jacques, "The Royal Square of Angkor Thom and Jayavarman VII".

66 In accordance with the legendary origins of King U Thong, as found also in the analysis of the oath by Jit Phumisak: Čhit Phumisak, *ʾŌngkān chǣng nam læ khǭ khit mai nai prawattisāt thai lum nam čhao phrayā* [The oath of allegiance and new considerations concerning the history of the Thai in the Chao Phraya River basin], Bangkok: Duang Kamon, 1981, (in Thai), e.g., pp. 138–40.

67 Hiram Woodward, "'The Characteristics of Elephants': A Thai Manuscript and
 its Context", in *From Mulberry Leaves to Silk Scrolls: New Approaches to the
 Study of Asian Manuscript Traditions*, eds. Justin McDaniel and Lynn Ransom,
 Philadelphia: Schoenberg Institute, University of Pennsylvania Libraries, 2015,
 pp. 15–41, and Woodward, "King Sūryavarman II and the Power of
 Subjugation", pp. 483–502.

68 I have used the numbers in Michael Wright, *'Ōngkān chǣng nam* [The Curse on
 the Water of Allegiance], Bangkok: Matichon, 2000. No numeration appears in
 the Thai text: *Photčhanānukrom sap wannakhadī Thai samai 'Ayutthayā Lilit
 'Ōngkān chǣng nam* [Dictionary of Thai literature, Ayutthaya period: Lilit
 'Ōngkān Chǣng Nam], Bangkok: Rātchabandittayasathān, 1997. Furthermore
 the verses appear in a different order in this edition, numbers 26–33 appearing
 after the invocation of all the witnesses (p. 49). Wright's translation was based
 upon a 1986 edition of the text, rather than the 1997 edition.

69 Wright, *'Ōngkān*, p. 119.

70 George Cœdès, "Études cambodgiennes IX: Le serment des fonctionnaires de
 Sūryavarman I", *BEFEO* 13, no. 6, 1913: pp. 11–7.

71 Judith M. Jacob, *The Traditional Literature of Cambodia: A Preliminary Guide*,
 Oxford: Oxford University Press, 1996, pp. 53–64.

72 This is also a Tamil notion. The devotee's relationship to god is modelled on
 such human relations as master-servant, child-parent, and beloved-lover. "In the
 Tamil context, *bhakti* is also frequently expressed in the idiom of the
 relationship between king and subject." See Norman Cutler, *Songs of Experience:
 The Poetics of Tamil Devotion*, Bloomington: Indiana University Press, 1987,
 p. 1. I thank Phillip Green for providing this reference.

73 For some discussion, Frank E. Reynolds, "The Holy Emerald Jewel", in *Religion
 and Legitimation of Power in Thailand, Laos, and Burma*, ed. Bardwell L.
 Smith, Chambersburg PA: Anima, 1978, pp. 175–93.

74 Wright, *'Ōngkān*, p. 104. Sixteen Brahma realms: *soḷasabrahmañāṇa. Soḷasa* is
 the Pāli word for sixteen, and *ñāṇa* (knowledge) is a mistake for *jhāna* (trance).

75 For this rebirth, Frank E. and Mani B. Reynolds, trans., *Three Worlds According
 to King Ruang* Berkeley: Asian Humanities Press, 1982, pp. 317–8.

76 This is a difficult stanza, and I have depended as much on the exegesis of the
 Thai editors (pp. 34–6) as on Wright (pp. 110–11).

77 Woodward, "The Characteristics of Elephants".

78 Woodward, "The Characteristics of Elephants", esp. p. 33; Woodward, "King
 Sūryavarman II and the Power of Subjugation".

79 Abridged English translation of *K. 292* in Lawrence Palmer Briggs, *The Ancient
 Khmer Empire*, Philadelphia: American Philosophical Society, 1951, p. 151.

80 *Thewa pāng* [Incarnation of the gods], Bangkok: Krom Sinlapakòn, 1970, p. 21,
 (the same text that contains the account of the subduing of the mad elephant).

81 Christophe Pottier, "La quatrième dimension du puzzle", *Seksa Khmer* N. S. 1,
 1998: pp. 101–11.

82 Cœdès, "Études cambodgiennes XIX: La date du Bàyon", *BEFEO* 28, 1928:
 pp. 81–112. In his guidebook, Claude Jacques has written, "The inscription on
 its base is 14th century, or later": Michael Freeman and Claude Jacques, *Ancient
 Angkor*, Bangkok: River Books, 2003, p. 110.

83 Cœdès, *Angkor: An Introduction*, p. 45.

84 B.-P. Groslier, "Angkor: Terrace of Leper King", *Nokor Khmer*, October/
 December 1969, pp. 18–33; Jacques Dumarçay, *The Site of Angkor*, New York:
 Oxford University Press, 1998, p. 57.

85 A diagnostic motif absent on the Leper King Terrace but present on the later Preah Pithu pediment in the Musée Guimet and the bronze sitting Shiva in the National Museum Bangkok is the cylindrical coiffure mounted by tassels. See Baptiste and Zéphir, *L'Art khmer dans les collections du musée Guimet*, pp. 388–90; and Woodward, *The Art and Architecture of Thailand*, pp. 226–7 and pl. 85.

86 As stated (indistinctly), in Groslier, "Angkor: Terrace of Leper King".

87 *Three Worlds*, trans. Reynolds and Reynolds, p. 219. In the Thai illustrated *Traiphum* of 1776, the *nāga* kingdom is shown in a section that appears subsequent to the *lokapāla*, but the text indicates that it is considered part of the realm of the Guardians. See *Samut phāp traiphūm krung Thonburī / Buddhist Cosmology Thonburi Version*, Bangkok: Khana kammakān phitčharanā..., 1982, pp. 62–3.

88 I thank Martin Polkinghorne for sharing with me photographs of the free-standing sculptures from the Leper King Terrace. Henri Mouhot (1868) did not note the presence of surrounding sculptures but exuberantly praised the beauty of the Leper King: "the head, a praiseworthy example of nobility, of proportion, with fine features, calm in its lordly bearing, the work of the most skillful of the sculptors in a period filled with many blessed by rare talent." (Henri Mouhot, *Voyage dans les royaumes de Siam de Cambodge, de Laos*, Geneva: Editions Olizane, 1999, pp. 197–8.) Garnier (1873) published an engraving (p. 70) showing two attendant sword-bearing figures and commented on the Leper King statue (p. 71), "the inflated praise Mouhot gave to this statue will perhaps give rise to disappointment among future viewers" (Francis Garnier, *Voyage d'exploration en Indo-Chine effectué pendant les années 1866, 1867 et 1868 par une Commission française*, 2 vols., Paris: Hachette, 1873, vol. 1.) Another engraving less successfully includes the two sword-bearers: Louis Delaporte, *Voyage au Cambodge: l'architecture khmer*, Paris: Ch. Delagrave, 1880, p. 100. Aymonier (1904) mentioned (p. 124) offerings brought to the Leper King but not the guardian figures, the arm and shoulder of one of which appears in his photograph, Fig. 18, p. 124. Etienne Aymonier, *Le Cambodge, III, Le groupe d'Angkor et l'histoire*, Paris: E. Leroux, 1904. Lunet de Lajonquière (1911) wrote (p. 58), "Some fragments of sculptures have been collected around its base" (Etienne Lunet de Lajonquière, *Inventaire descriptif des monuments du Cambodge*, vol. 3, Paris: E. Leroux, 1911) (my translations of the French texts).

89 The pre-Angkorian date was noted by Henri Parmentier, *L'Art khmèr primitif*, 2 vols., Paris: EFEO, 1927, text vol., pp. 269–70 and then forgotten. Hab Touch is the first contemporary scholar to re-assess the dating: "Yama", in *Angkor: göttliches Erbe*, ed. Wibke Lobo, Bonn: Kunst- und Ausstellungshalle, 2006, p. 114.

90 Cœdès, "La date du Bàyon", pp. 83–4.

91 Quoted in the Wikipedia entry for Chitragupta.

92 Cœdès, *Inscriptions du Cambodge*, vol. 3, pp. 229–30; Michael Vickery, *Cambodia and Its Neighbors in the 15th Century*, Asia Research Institute, Working Paper Series, No. 27, National University of Singapore, June 2004, p. 19 (Vickery suspects that this king might have been a king of Ayutthaya).

93 Woodward, "The Buddha Images of Ayutthaya", p. 58.

94 E. Forchhammer, *The Jardine Prize: An Essay*, Rangoon: Government Press, 1885, p. 94. For more on Mahāsammata, Steven Collins and Andrew Huxley, "The Post-canonical Adventures of Mahāsammata", *Journal of Indian Philosophy* 224, 1996: pp. 623–48; Ashley Thompson, *Engendering the*

Buddhist State: Territory, Sovereignty, and Sexual Difference in the Inventions of Angkor, London and New York: Routledge/Taylor & Francis, 2016, p. 53.

95 *The Palace Law of Ayutthaya and the Thammasat: Law and Kingship in Siam*, trans. and eds. Chris Baker and Pasuk Phongpaichit, Southeast Asia Program Publications, Ithaca: Southeast Asia Program, Cornell University, 2016, pp. 37–8. Also Andrew Huxley, "Thai, Mon & Burmese Dhammathats Who Influenced Whom?", in *Thai Law: Buddhist Law: Essays on the Legal History of Thailand, Laos and Burma*, ed. Andrew Huxley, Bangkok: White Orchid, 1996, pp. 81–131.

96 It should be pointed out that the royal procession described by Zhou Daguan presumably passed by the Leper King Terrace on its way to one of the Buddhist terraces but did not terminate there: Chou Ta-Kuan, *The Customs of Cambodia*, trans. Paul Pelliot and J. Gilman d'Arcy Paul, Bangkok: The Siam Society, 1987, chap. 40.

97 Hiram Woodward, "Foreword", in *Bayon: New Perspectives*, ed. Clark, p. 8.

98 On this topic, Franklin Huffman, "Thai and Cambodian: A Case of Syntactic Borrowing?", *Journal of the American Oriental Society* 93, 1973: pp. 488–509.

References

Aymonier, Etienne. *Le Cambodge, III, Le groupe d'Angkor et l'histoire*. Paris: E. Leroux, 1904.

Baker, Chris and Pasuk Phongpaichit, trans. and eds. *The Palace Law of Ayutthaya and the Thammasat: Law and Kingship in Siam*. Southeast Asia Program Publications. Ithaca: Southeast Asia Program, Cornell University, 2016.

Baptiste, Pierre and Thierry Zéphir. *L'Art khmer dans les collections du musée Guimet*. Paris: Réunion des musées nationaux, 2008.

Bergaigne, Abel. *Inscriptions sanscrites de Campā et du Cambodge*. Paris: Imprimerie nationale, 1893.

Boisselier, Jean. *La statuaire khmère et son évolution*, 2 vols. Paris: EFEO, 1955.

———. *Le Cambodge*. Manuel d'archéologie d'Extrême-Orient, 1st part, Asivol. 1. Paris: A. & J. Picard, 1966.

Bowie, Theodore, ed. *The Arts of Thailand*. Bloomington: Indiana University, 1960.

Briggs, Lawrence Palmer. *The Ancient Khmer Empire*. Philadelphia: American Philosophical Society, 1951.

Brown, Robert L. *The Dvāravatī Wheels of the Law and the Indianization of Southeast Asia*. Leiden: Brill, 1996.

Chandler, David P. "Folk Memories of the Decline of Angkor in Nineteenth-Century Cambodia: The Legend of the Leper King". *JSS* 67, pt. 1, January 1979: pp. 54–62.

Čhit Phumisak [Jit Phumisak]. *'Ōngkān čhēng nam læ khò khit mai nai prawattisāt thai lum nam* čhao *phrayā* [The oath of allegiance and new considerations concerning the history of the Thai in the Chao Phraya River basin]. Bangkok: Duang Kamon, 1981.

Chou Ta-Kuan. *The Customs of Cambodia*, trans. Paul Pelliot and J. Gilman d'Arcy Paul. Bangkok: The Siam Society, 1987.

Clark, Joyce, ed. *Bayon: New Perspectives*. Bangkok: River Books, 2007.

Cœdès, George. *Angkor: An Introduction*. Hong Kong: Oxford University Press, 1963.

———. "Etudes cambodgiennes IX.—Le serment des fonctionnaires de Sūryavarman I". *BEFEO* 13, no. 6, 1913: pp. 11–7.

———. "Etudes cambodgiennes XIX—La date du Bàyon". *BEFEO* 28, 1928:

pp. 81–112.

———. "Etudes cambodgiennes XXXII—La plus ancienne inscription en Pāli du Cambodge". *BEFEO* 36, 1936: pp. 14–21.

———. *Inscriptions du Cambodge*, 8 vols. Hanoi and Paris: EFEO, 1937–66.

———. "Nouvelles données épigraphiques sur l'histoire de l'Indochine centrale". *JA* 246, 1958: pp. 125–42.

———. *Recueil des inscriptions du Siam Deuxième Partie: inscriptions de Dvāravatī, de* Çrīvijaya *et de Lavo*. Bangkok: Siam Society, 1961.

Collins, Steven and Andrew Huxley. "The Post-canonical Adventures of Mahāsammata". *Journal of Indian Philosophy* 224, 1996: pp. 623–48.

Conti, Pia. "Tantric Buddhism at Prasat Hin Phimai: A New Reading of Its Iconographic Message". In *Before Siam: Essays in Art and Archaeology*, eds. Nicolas Revire and Stephen A. Murphy. Bangkok: River Books and the Siam Society, 2014, pp. 374–95.

Cort, Louise Allison and Paul Jett, eds. *Gods of Angkor: Bronzes from the National Museum of Cambodia*. Washington: Arthur M. Sackler Gallery, Smithsonian Institution, 2010.

Cousins, L. S. "Aspects of Esoteric Southern Buddhism". In *Indian Insights: Buddhism, Brahmanism and Bhakti: Papers from the Annual Spalding Symposium on Indian Religions*, eds. Peter Connolly and Sue Hamilton. London: Luzac, 1997, pp. 185–207.

Crosby, Kate. "Tantric Theravada: A Bibliographical Essay on the Writings of François Bizot and Others on the Yogāvacara Tradition". *Contemporary Buddhism* 1, 2000: pp. 141–98.

Cutler, Norman. *Songs of Experience: The Poetics of Tamil Devotion*. Bloomington: Indiana University Press, 1987.

Dagens, Bruno. "Étude sur l'iconographie du Bàyon (frontons et linteaux)". *AA* 19, 1969: pp. 123–68.

———. *Les Khmers*. Paris: Les Belles Lettres, 2003.

Delaporte, Louis. *Voyage au Cambodge: l'architecture khmer*. Paris: Ch. Delagrave, 1880.

Dufour, Henri et al. *Le Bayon d'Angkor Thom: Bas-reliefs publiées par les soins de la Commission Archéologique de l'Indochine*, 2 vols. Paris: E. Leroux, 1910–14.

Dumarçay, Jacques. *The Site of Angkor*, New York: Oxford University Press, 1998, p. 57.

Dumarçay, J. and Paul Corbin. *Documents graphiques de la Conservation d'Angkor 1963–1973* and *La fouille de Sras-Srang*. Paris: EFEO, 1988.

Finot, Louis. "Les études indochinoises". *BEFEO* 8, 1908: pp. 221–33.

Forchhammer, E. *The Jardine Prize: An Essay*. Rangoon: Government Press, 1885.

Freeman, Michael and Claude Jacques. *Ancient Angkor*. Bangkok: River Books, 2003.

Garnier, Francis. *Voyage d'exploration en Indo-Chine effectué pendant les années 1866, 1867 et 1868 par une Commission française*, 2 vols. Paris: Hachette, 1873.

Gaston-Aubert, Pierre. "Nāga Buddhas in the Dvāravatī Period: A Possible Link between Dvāravatī and Angkor". *JSS* 98, 2010: pp. 116–50.

Gosling, Betty. *Sukhothai: Its History, Culture, and Art*. Singapore: Oxford University Press, 1991.

Groslier, Bernard-Philippe. "Angkor: Terrace of Leper King". *Nokor Khmer*, October–December 1969, pp. 18–33.

———. *The Art of Indochina*. New York: Crown, 1962.

Harris, Ian. *Cambodian Buddhism: History and Practice*. Honolulu: University of Hawai'i Press, 2005.

Huffman, Franklin. "Thai and Cambodian: A Case of Syntactic Borrowing?". *Journal of the American Oriental Society* 93, 1973: pp. 488–509.

Huntington, Susan L. and John C. Huntington. *Leaves from the* Bodhi *Tree*. Seattle: University of Washington Press, 1990.

Huxley, Andrew. "Thai, Mon & Burmese Dhammathats: Who Influenced Whom?". In *Thai Law: Buddhist Law: Essays on the Legal History of Thailand, Laos and Burma*, ed. Andrew Huxley. Bangkok: White Orchid, 1996, pp. 81–131.

Ishizawa, Yoshiaki, ed. "Special Issue on the Inventory of 274 Buddhist Statues and the Stone Pillar Discovered from Banteay Kdei Temple", 2 vols. *Renaissance culturelle du Cambodge* 21, 2004.

Jacob, Judith M. *The Traditional Literature of Cambodia: A Preliminary Guide*. Oxford: Oxford University Press, 1996.

Jacques, Claude. "The Historical Development of Khmer Culture", in *Bayon: New Perspectives*, ed. Joyce Clark, Bangkok: River Books, 2007, pp. 28–49.

———. "The History and the Inscriptions", in Peter D. Sharrock, *Banteay Chhmar: Garrison-temple of the Khmer Empire*, Bangkok: River Books, 2015, pp. 135–50.

———. "The Royal Square of Angkor Thom and Jayavarman VII". In *Southeast Asian Archaeology 1998: Proceedings of the 7th International Conference of the European Association of Southeast Asian Archaeologists, Berlin, 31 August–4 September 1998*, eds. Wibke Lobo and Stefanie Reimann. Hull: Centre for South-East Asian Studies and Berlin: Ethnologisches Museum, 2000, pp. 77–83.

Jinakālamālī, ed. A. P. Buddhadatta. London: Pāli Text Society, 1962.

Lobo, Wibke, ed. *Angkor: göttliches Erbe*. Bonn: Kunst- und Ausstellungshalle, 2006.

Lunet de Lajonquière, Etienne. *Inventaire descriptif des monuments du Cambodge*, vol. 3. Paris: E. Leroux, 1911.

Marchal, Henri. *Le décor et la sculpture Khmers*. Paris: Vanoest, 1951.

———. "Note sur la forme du stūpa au Cambodge". *BEFEO* 44, no. 2, 1951: pp. 581–90.

Mouhot, Henri. *Voyage dans les royaumes de Siam de Cambodge, de Laos.* Geneva: Editions Olizane, 1999.

Nandana Chutiwongs. *The Iconography of Avalokiteśvara in Mainland South East Asia*. Proefschrift, Rijksuniversiteit, Leiden, 1984.

Parmentier, Henri. *L'Art khmèr primitif*, 2 vols. Paris: EFEO, 1927.

Penth, Hans. *Jinakālamālī Index*. Oxford: Pāli Text Society and Chiang Mai: Silkworm Books, 1994.

Photčhanānukrom sap wannakhadī Thai samai ʻAyutthayā Lilit ʻŌngkān chǣng nam [Dictionary of Thai literature, Ayutthaya period: Lilit ʻŌngkān Chǣng Nam]. Bangkok: Rātchabandittayasathān, 1997.

Polkinghorne, Martin, Christophe Pottier and Christian Fischer. "One Buddha Can Hide Another". *JA* 301, no. 2, 2013: pp. 575–624.

Pottier, Christophe. "La quatrième dimension du puzzle". *Seksa Khmer* N. S. 1, 1998: pp. 101–11.

Provost-Roche, Ludivine. *Les derniers siècles de l'époque angkorienne au Cambodge [environ 1220–environ 1500]*, 2 vols. PhD dissertation, Université de Paris 3, 2010.

Revire, Nicolas. "Dvāravatī and Zhenla in the Seventh to Eighth Centuries: A Transregional Ritual Complex". *Journal of Southeast Asian Studies* 47, 2016: pp. 393–417.

———. "Glimpses of Buddhist Practices and Rituals in Dvāravatī and Its Neighboring Cultures". In *Before Siam: Essays in Art and Archaeology*, eds. Nicolas Revire

and Stephen A. Murphy. Bangkok: River Books and the Siam Society, 2014, pp. 240–71.

Reynolds, Frank E. "The Holy Emerald Jewel". In *Religion and Legitimation of Power in Thailand, Laos, and Burma*, ed. Bardwell L. Smith. Chambersburg PA: Anima, 1978, pp. 175–93.

Reynolds, Frank E. and Mani B. Reynolds, trans. *Three Worlds According to King Ruang*. Berkeley: Asian Humanities Press, 1982.

Roveda, Vittorio. *Images of the Gods*. Bangkok: River Books, 2005.

———. "Reliefs of the Bayon". In *Bayon: New Perspectives*, ed. Joyce Clark. Bangkok: River Books, 2007, pp. 286–311.

Samœchai Phunsuwan (Samerchai Poolsuwan). *Chittrakam phutthasatsana samai Phukam* [Buddhist Painting of the Bagan Period], 2 vols. Bangkok: Mahawitthayalai Thammmasat, 2016.

Samut phāp traiphūm krung Thonburī/Buddhist Cosmology Thonburi Version. Bangkok: Khana kammakān phičharanā læ Čhatphim ʻĒkkasān thāng Prawattisāt, Samnak Nāyok Ratthamontrī, 1982.

Sanderson, Alexis. "The Śaiva Religion among the Khmers (Part 1)". *BEFEO* 90, 2003: pp. 349–462.

Sharrock, Peter D. "The Nāga-enthroned Buddha of Angkor". In *Khmer Bronzes: New Interpretations of the Past,* eds. Emma C. Bunker and Douglas Latchford. Chicago: Art Media Resources, 2011, pp. 481–92.

Southworth, William A. "The Alteration and Destruction of Buddhist Images at Angkor during the Thirteenth and Fourteenth Centuries". In *In the Shadow of the Golden Age: Art and Identity in Asia from Gandhara to the Modern Age*, ed. Julia A. B. Hegewald. Berlin: EB-Verlag, 2014, pp. 197–225.

Soutif, Dominique. "Organisation religieuse et profane du temple khmer du VIIe au XIIIe siècle." 3 vols. PhD dissertation, Université Sorbonne nouvelle – Paris 3, 2009.

Stern, Philippe. *Les monuments khmers du style du Bàyon et Jayavarman VII*. Paris: Presses Universitaires de France, 1965.

Thewa pāng [Incarnation of the gods]. Bangkok: Krom Sinlapakòn, 1970.

Thompson, Ashley. "Changing Perspectives: Cambodia after Angkor". In *Sculpture of Angkor and Ancient Cambodia: Millennium of Glory*, eds. Helen Ibbitson Jessup and Thierry Zéphir. Washington: National Gallery of Art, 1997, pp. 22–32.

———. *Engendering the Buddhist State: Territory, Sovereignty, and Sexual Difference in the Inventions of Angkor*. London and New York: Routledge/Taylor & Francis, 2016.

———. "The Suffering of Kings: Substitute Bodies, Healing, and Justice in Cambodia". In *History, Buddhism, and New Religious Movements in Cambodia*, eds. John A. Marston and Elizabeth Guthrie, Honolulu: University of Hawaiʻi Press, 2004, pp. 99–112.

Tun Puthpiseth. "Bouddhisme Theravāda et production artistique en pays khmer: Étude d'un corpus d'images en ronde-bosse du Buddha (xiiie–xvie siècles)", 3 vols. PhD dissertation, Université Paris-Sorbonne, 2015.

Vickery, Michael. "The *2/k. 125 Fragment*, a Lost Chronicle of Ayutthaya". *JSS* 61, pt. 1, January 1973: pp. 1–80.

———. "Bayon: New Perspectives Reconsidered". *Udaya* 7, 2006: pp. 101–58.

———. *Cambodia and Its Neighbors in the 15th Century*. Asia Research Institute, Working Paper Series, No. 27. Singapore: National University of Singapore, June 2004.

Vincent, Brice. "Nouvelle étude du Lokeśvara khmer du Musée national de Colombo (Sri Lanka)". *AA* 68, 2013: pp. 27–38.

Woodward, Hiram W., Jr. *The Art and Architecture of Thailand From Prehistoric Times through the Thirteenth Century*. Leiden and Boston: Brill, 2005. First published 2003.

———. "Aspects of Buddhism in Tenth-Century Cambodia". In *Buddhist Dynamics in Premodern and Early Modern Southeast Asia*, ed. d. Christian Lammerts. Singapore: Institute of Southeast Asian Studies, 2015, pp. 218–60.

———. "The Buddha Images of Ayutthaya". In *The Kingdom of Siam*, ed. Forrest McGill. San Francisco: Asian Art Museum, 2004, pp. 47–59.

———. "Cambodian Images of Bhaisajyaguru". In *Khmer Bronzes: New Interpretations of the Past*, eds. Emma C. Bunker and Douglas Latchford. Chicago: Art Media Resources, 2011, pp. 497–502.

———. "'The Characteristics of Elephants': A Thai Manuscript and its Context". In *From Mulberry Leaves to Silk Scrolls: New Approaches to the Study of Asian Manuscript Traditions*, eds. Justin McDaniel and Lynn Ransom. Philadelphia: Schoenberg Institute, University of Pennsylvania Libraries, 2015, pp. 15–41.

———. "Dvaravati, Si Thep, and Wendan," *Bulletin of the Indo-Pacific Prehistory Association* 30, 2010: pp. 87–97.

———. "Image and Text in Eleventh-Century Burma". In *India and Southeast Asia: Cultural Discourses*, eds. Anna L. Dallapiccola and Anila Verghese. Mumbai: K R Cama Oriental Institute, 2017, pp. 97–124.

———. "The Jayabuddhamahānātha Images of Cambodia". *Journal of the Walters Art Gallery* 52/53, 1994/95: pp. 105–11.

———. "King Sūryavarman II and the Power of Subjugation". In *On Meaning and Mantras: Essays in Honor of Frits Staal*, eds. George Thompson and Richard K. Payne. Berkeley: Institute of Buddhist Studies and BDK America, 2017, pp. 623–42.

———. "Some Buddha Images and the Cultural Developments of the Late Angkorian Period". *Artibus Asiae* 42, 1980: pp. 155–74.

———. "Stylistic Trends in Mainland Southeast Asia, 600–800". In *Lost Kingdoms: Hindu-Buddhist Sculpture of Early Southeast Asia*, ed. John Guy. New York: Metropolitan Museum of Art, 2014, pp. 122–9.

———. "Tantric Buddhism at Angkor Thom". *Ars Orientalis* 12, 1981: pp. 57–67.

———. "Thailand and Cambodia: The Thirteenth and Fourteenth Centuries". In *Rūam bot khwām thāng wichākān 72 phansā thān āčhān Sātsatrāčhan Mòm Čhao Suphattradit Ditsakun/Studies & Reflections on Asian Art History and Archaeology: Essays in Honour of H. S. H. Professor Subhadradis Diskul*. Bangkok: Silpakorn University, 1995, pp. 335–42.

Woodward, Hiram W., Jr. et al. *The Sacred Sculpture of Thailand*. Baltimore: Walters Art Gallery, 1997.

Wright, Michael. '*Ōngkān chēng nam* [The Curse on the Water of Allegiance]. Bangkok: Matichon, 2000.

Wyatt, David K. "Relics, Oaths, and Politics in Thirteenth-Century Siam". *Journal of Southeast Asian Studies* 32, 2001: pp. 3–66.

READING AND INTERPRETING *JĀTAKA* TALES DURING THE ANGKORIAN PERIOD

Tuy Danel

INTRODUCTION

Among Buddhists, especially of the Theravāda school, *jātaka*, or stories of the previous lives of the Gotama Buddha, are of primary importance. Indeed, besides providing moral edification to Buddhist devotees, *jātaka* constitute a legitimation of the Buddha himself, an undeniable testimony of his efforts in his countless existences during which he sought Perfection or *pāramitā*, the indispensable quality that one needs in order to attain Buddhahood. First appearing in Indic visual art, *jātaka* clearly gained their greatest popularity in Sri Lanka and in Southeast Asia. In this latter part of Asia, early visual representations of *jātaka* tales date back as far as the first millennium of the Common Era, in the kingdom or more correctly the so-called culture of Dvāravatī (6th to 11th centuries). Several *jātaka* scenes have been found on terracotta reliefs of *stūpa* and boundary stones or *sīmā* in different places associated with this culture that had its principal political and cultural centres located in what is present-day Thailand.[1] The popularity of this Buddhist theme also spread to the centre of Java, in contemporary Indonesia, where, between the eighth and ninth centuries, the Buddhist dynasty of Sailendra erected the massive Borobudur, a Buddhist temple containing numerous reliefs related to the life of the Śākyamuni Buddha and to his previous existences.[2] However, it was primarily during the period of Pagan (9th to 13th centuries) that extended representations of *jātaka* tales were attested in the ancient capital of present-day Myanmar at several Buddhist temples, in particular the Ananda temple.[3]

In Cambodia, when *jātaka* scenes seemingly suddenly, and increasingly, appeared on temple reliefs during the Angkorian period (9th to 15th centuries) one may, with regard to the context of this volume, ask this question: Were these *jātaka* related to an expansion of practices of

Theravāda Buddhism during that time? Given the current state of our knowledge, it is difficult to find a definitive answer. Since both archaeological and epigraphical evidence tend to affirm the fact that Mahāyāna Buddhism was for a long time more present and manifest than Theravāda Buddhism in ancient Cambodia – this was furthermore confirmed with the adoption of Mahāyāna Buddhism as the mainstream religious institution by the end of the 12th century – it is tempting to consider *jātaka* representations as part of an iconographic programme belonging to a Mahāyāna context. In this chapter, however, my principal goal is not to discuss the history of Buddhism and its complex evolution in ancient Cambodia, a task that would go beyond my expertise, but, rather, to draw the reader's attention to the importance of representations of *jātaka* as a physically significant source, in other words, a possible indicator of religious tendency.

Like Khmer Buddhism during the Angkorian period more generally, studies of visual representations of *jātaka* in ancient Cambodia have been, for a long time, neglected or eclipsed by diversified research regarding Brahmanism whose dominating presence is attested in both archaeological and literary domains, and which seems to inspire scholarly fascination. Nevertheless, a few scholars have been interested in *jātaka* as part of temple iconographic programmes. The 1960s saw the publication of the first papers dedicated to reliefs with *jātaka* scenes, although most of these studies remained essentially descriptive.[4] Mireille Bénisti was, in this generation, the first scholar who raised questions concerning the

Fig. 3.1 *Vessantara-jātaka*, the gift of the children. Thommanon temple, first half of 12th century. Photograph by author, 2018.

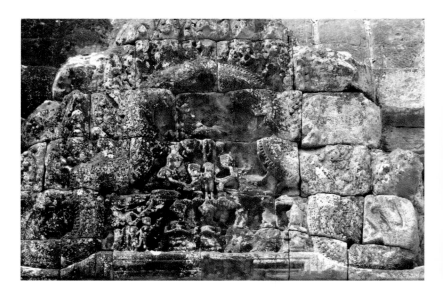

3.1

problem of identification of *jātaka* scenes in the Angkorian period.[5] A few years later, Bruno Dagens published a detailed study on the iconography of the Bayon temple in which he identified several reliefs illustrating *jātaka* tales.[6] In studying the iconography of Thommanon temple, Lan Sunnary also mentioned a *jātaka* scene on one of the pediments.[7] However, it was within the works carried out by Vittorio Roveda that a substantial number of *jātaka* figuring on Khmer temple reliefs were revealed.[8]

The present chapter is divided into two principal parts. First, I undertake the work of identification of *jātaka* and the chronological evolution of their representation during the Angkorian period, from their earliest days to the time when they appear to attain their highest point of popularity. In doing this, I also wish to demonstrate which stories were depicted most frequently and what this choice could have signified. Second, in order to find out from where and in what circumstances *jātaka* had arrived in Cambodia, a comparative study with the neighbouring states and cultures, where the *jātaka* illustrations have been largely attested in artistic and historical context, will be carried out. Seeking the answer to this question will lead us subsequently to further understand which Buddhist tradition – either Mahāyāna or Theravāda – would have provided the textual narratives of *jātaka* to the Khmer illustrators at Angkor.

Fig. 3.2 *Vessantara-jātaka*, Chau Say Tevoda temple, c. third quarter of 12th century. Photograph by author, 2018.

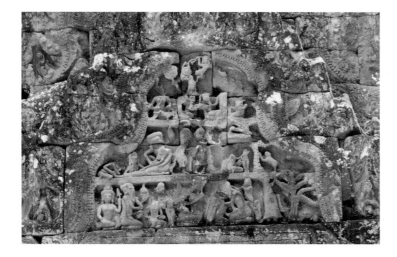

3.2

EARLY VISUAL REPRESENTATIONS: THE BUDDHIST DYNASTY OF MAHĪDHARAPURA

In Cambodia, since early in its history, Buddhism with both of its principal aspects, Mahāyāna and Theravāda, has certainly always been practiced simultaneously with Brahmanism, which for centuries was given the place of honour by Khmer kings. However, when Buddhist King Jayavarman VI (r. 1080/81–1107/08) came to the throne, he founded the dynasty of "Mahīdharapura", and it was under this period that Khmer Buddhism, supported by royal family members belonging to this dynasty, experienced a new stage of development.[9] More interestingly, the first visual representations of *jātaka* in Khmer art are found during this time.

In the first half of the 12th century, at the beginning of the reign of Sūryavarman II (r. 1113/14–c. 1150)[10], Thommanon, a temple probably dedicated to Vaishnavism, was erected, offering evidence of religious coexistence in a Khmer iconographic programme.[11] Indeed, among 59 iconographic themes studied by Lan at Thommanon[12], most related to Hindu deities, a scene depicts the *Vessantara-jātaka*, the last existence of the Gotama Buddha as a bodhisattva, also the most popular *jātaka* story celebrating the Perfection of generosity, on the northern pediment of the Eastern *gopura*[13] (Fig. 3.1). Two episodes of the tale occupy the whole of the pediment divided into two separate registers. The gift of the two children of Vessantara, seen as the most significant act of generosity of the story, is illustrated in the upper register. In a classical way, the two children, Jāli and Kaṇhājinā, find themselves in the middle of the scene, with their father on the right[14] and the brahman, Jūjaka, on the left. The

Fig. 3.3 *Vessantara-jātaka*, the gift of the children, Banteay Samre temple, c. third quarter of 12th century. Photograph by author, 2018.

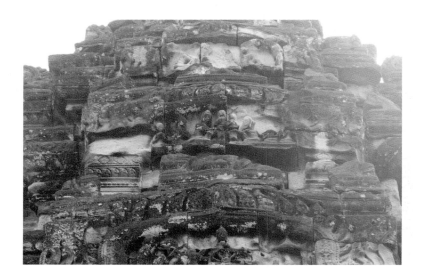

3.3

latter presents both his hands to receive the water poured down by the bodhisattva, a sign of his gift being approved. Another chapter of the tale is represented on the left side of the lower register. This scene likely tells of the moment when Jūjaka, after having taken Jāli and Kaṇhājinā from their father, would spend a night in the forest sleeping in a tree, with the children tied to the tree trunk. The brahman is seen lying on the top of the tree, but the two children are absent. In their place, on the left side, an animal is about to attack the sleeping brahman, while two human figures of different sizes, on the right, act in two different postures.[15] More than half of the lower register is filled by the presence of five praying figures, two of them totally eroded, who are here to celebrate and to witness the great act of generosity of the bodhisattva.

The following monuments with illustrations of *jātaka* tales belong to the so-called "Angkor Wat style" (c. 1080–1175), although in the absence of epigraphic records, their exact dates of foundation remain unknown. In the present study, I will consider four such temples: Chau Say Tevoda, Banteay Samre, Beng Mealea and Preah Khan of Kampong Svay. Located along the eastern road that links Angkor to Preah Khan of Kampong Svay (presently Preah Vihear province), these temples might be attributed to the reign of Tribhuvanādityavarman (r. 1165/66–c. 1177) who appears to be another Buddhist king of the Mahīdharapura dynasty, according to a recently discovered inscription *K. 1297* in a French private collection.[16] Furthermore, this stele contains a stanza in which the term *jātaka* is evoked.[17] Based on this latest evidence, it is, therefore, obvious that *jātaka*

Fig. 3.4 *Sibi-jātaka*, Sibi giving his flesh, Banteay Samre temple, c. third quarter of 12th century. Photograph by author, 2018.

had gained a certain popularity under the Mahīdharapura dynasty, with Tribhuvanādityavarman being one of the first kings of this dynasty whose Buddhist faith was marked by the definitive inclusion of new Buddhist themes which are, in this case, stories of the Buddha's previous lives. At Chau Say Tevoda, several episodes of the *Vessantara-jātaka* can be seen on the western pediment of the southern library (Fig. 3.2). The narrative reliefs are divided into three separate registers. In the upper register is the most significant moment of the story, the giving away of the two children, identifiable here with the figuration of Jāli and Kaṇhājinā placed between Vessantara on the right and Jūjaka on the left, resembling the relief seen at Thommanon mentioned earlier. The story continues to the middle register with, on the left side, Maddī lying down in the hands of Vessantara who would wake her up from her fainting caused by the loss of the children. To the right side of the same register, due to the stone damage, it is difficult to identify with precision which episode is depicted. Nevertheless, by comparing the reliefs from Thommanon, and noting an animal grabbing onto a tree, a symbol of the forest, it might be possible that this scene is related to the moment when Jūjaka sleeps in a tree inside the forest, leaving the children on the ground. This hypothesis is strengthened by the figure of a child being comforted by another male figure who, in this case, could be related to one of the two deities. The following episodes are depicted on the lower register divided into two sequences. On the left, Jūjaka meets King Sañjaya, father of Vessantara, to whom he returns the children. The reliefs at the right side of the register, although damaged, seem to depict the family reunification through imagery of Vessantara and Maddī.[18] It is interesting to emphasise that Chau Say Tevoda is one of only a few monuments where several scenes of the *Vessantara-jātaka* are depicted in one pediment. In the majority of cases, as seen below, the story is most commonly represented by the episode of the giving away of the children.

The other three temples located on the eastern road also deliver representations of *jātaka*. At Banteay Samre temple, two illustrations of

Fig. 3.5 Different episodes of the life of the Buddha and *jātaka*? Sasar Sdam temple, first half of 12th century. Photograph courtesy Brice Vincent, 2018.

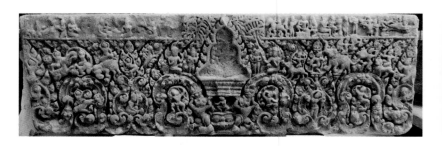

the *Vessantara-jātaka* are seen on the western pediment of the central tower and on another pediment left on the ground (Fig. 3.3). Both depict the episode of the gift of the children with iconographic aspects close to the reliefs described above. In addition to the *Vessantara-jātaka*, a scene of the *Sibi-jātaka*[19] is probably depicted on the northern pediment of the first level of the central tower (Fig. 3.4). The story tells of a generous king named Sibi, or Sivi,[20] who offers his own flesh in order to save a pigeon's life. The episode illustrated at Banteay Samre seems to relate the moment when the king, sitting on a pedestal in the middle of a group, put his flesh on the scale held by a man. However, the absence of a pigeon in the scene is problematic. In another similar version of the story, which is the *Sivi-jātaka*, the god Indra takes the appearance of an old blind man and comes to ask Prince Sivi, the bodhisattva incarnation, for his eyes as he wishes to test the prince's generosity. This tale might be associated with another group of characters figured on the right side of the pediment, in particular a male figure holding a walking stick who probably represents Indra from the *Sivi-jātaka*. Therefore, one question could be asked: Does the Banteay Samre pediment depict the two versions of the tale? Unfortunately, there are no other similar cases in Khmer temple reliefs with which we may make comparisons.[21]

Beng Mealea and Preah Khan of Kampong Svay are two important temple complexes which, in a poor state of conservation, deliver only a few narrative scenes related to either Hinduism or Buddhism.[22] Nevertheless, at least two scenes illustrating the gift of the children from the *Vessantara-jātaka* can be identified at Beng Mealea.[23] At Preah Khan of Kampong Svay, a temple complex and probably an ancient centre of Buddhism built in the tenth century,[24] which became an important centre under several reigns, including that of Jayavarman VII, a scene of the *Sibi-jātaka* is depicted on the southern pediment of the northern *gopura* situated in the first gallery.[25] The principal iconographic element enabling the identification of the story relies on the presence of the pigeon placed on a scale held by a man at the left side of the bodhisattva whose figure was erased. This tale appears to become one of the most popular stories to be illustrated on temples built during the reign of Jayavarman VII as I will discuss below. In the present chapter, only four principal temples located on the eastern road are mentioned. However, in the future, it would be worth studying the iconographic programme of the eight "temples d'étape" located on this ancient network.[26] With identical plans and architecture, it is very likely that other scenes from *jātaka* were represented on these temples.

Another site located in the Greater Angkor region, not far from the actual town of Damdaek, Siem Reap province, outside of the group of temples associated with the eastern road and with a very particular

architectural structure, is Prasat Sasar Sdam. Built certainly during the first half of the 12th century, perhaps under the reign of Sūryavarman II,[27] this monument has strong Buddhist aspects attested essentially by its monolithic *stūpa* found in the centre of the sanctuary, one of the earliest forms, if not the first, of Khmer *stūpa*. Usually associated with Theravāda Buddhism,[28] the intriguing *stūpa* of Prasat Sasar Sdam is reminiscent of the *stūpa*-shrines popular in the traditional Buddhist architecture of Sri Lanka.[29] This temple also catches our attention for its lintel, once placed at the eastern doorway of the sanctuary and now conserved at the Angkor Conservation Depot, on which a series of Buddhist reliefs are illustrated (Fig. 3.5). The central part undoubtedly depicts the *māravijaya*[30], whereas a frieze of characters in miniature occupy the upper level of the lintel. At least two episodes, including the Great Departure and the *mahāparinirvāṇa,* of the life of the Buddha can be identified on the right side of the frieze. For the left side, given that the reliefs are largely damaged, it is difficult to identify with precision which stories were illustrated. Nevertheless, it seems possible that a small number of human figures remaining intact could be associated with *jātaka* tales. Indeed, it seems that an episode of the *Sāma-jātaka* related to the death of young Sāma, the bodhisattva, caused by the poisoned arrow of King Piliyakkha might have been represented. However, though the idea of illustrating *jātaka* in parallel with scenes from the life of the Buddha appears logical,[31] one might ask which *jātaka* were chosen in this case? For what reason? It would be risky, in any case, to see in this frieze an illustration of a series of *jātaka* according to a specific order, that is, for instance, the *jātaka* from the *Mahānipāta*, a collection of the last ten *jātaka* of the Pāli version, which later became one of the most pre-eminent subject matters in Buddhist murals in Cambodia.[32] Considering the organisation of the reliefs, evidently in separated groups, and the available space, it is likely that five scenes from five *jātaka* were represented. Whatever the case may be, this lintel appears to be interestingly unique by the choice of the illustrated themes and their spatial organisation. Analysis of the relief structure suggests that this frieze might have been added in a later period.[33] If so, such an addition would have been done in a time when Buddhist images reached their highest point of popularity, viz. under the reign of Jayavarman VII, or perhaps even after.[34]

A pediment in the Musée Guimet, in Paris, originating from Preah Khan of Kampong Svay and dated to the third quarter of the 12th century, depicts a Buddhist narrative with several details alluding, in my opinion, to an episode of the *Vessantara-jātaka*.[35] For Pierre Baptiste and Thierry Zéphir, the figured subject matter of the pediment was, however, from episodes of the life of the Historical Buddha, although a potential figuration of a *jātaka* – the *Vessantara-jātaka* – remained, for the authors,

debatable.[36] The second assumption appears to be more convincing for several reasons. Baptiste and Zéphir associated this scene with the visits of Indra as described in the life of the Buddha, which means that the central character in the lower register is supposed to represent this Hindu god. Yet, as noted by the authors, the presence of the two brahmans cannot be associated with any sequence regarding this divine visit.[37] Furthermore, the god of gods, Indra, is represented here seated on the ground and not on his mount, the elephant Airāvata, as generally seen in Khmer art. On the other hand, there seem to be reliable arguments to believe that this central character was meant to represent Vessantara. Indeed, the bodhisattva appears to hold an object in his right hand, which he is about to put onto the right hand of one of the two brahmans seated before him. This gesture reminds us of one of the principal episodes of the *Vessantara-jātaka*, the gift of the elephant whose figure is seen on the right side of the scene. More interestingly, although the text does talk about eight brahmans sent by the king of Kāliṅga to ask for the elephant, often only two (or three) of them are figured, as seen on the terracotta plaque at the Ananda temple, at Pagan,[38] but also on the relief at Borobudur,[39] in central Java. In Cambodia, this episode was depicted on a sculptured stele found at Angkor Wat where only two of the eight brahmans were represented. This iconographic composition is certainly related either to lack of space in the panel or desire for symmetry, or both. Finally, the Khmer sculptor wished to draw the attention of the viewer to the remarkable humility of Vessantara towards inferior beings, one of the most important Buddhist outlooks, by representing him seated on the ground, on the same level as the brahmans. This attitude was also expressed, most of the time, in the episode of the gift of the children found at numerous temples dated to the

Fig. 3.6 *Vessantara-jātaka*, the gift of the children and the gift of the chariot, Ta Prohm temple, third quarter of 12th century. Photograph courtesy Vicheth Tiev, 2018.

Fig. 3.7 Scene probably illustrating the *Vessantara-jātaka*, the gift of the elephant, Ta Prohm temple, third quarter of 12th century. Photograph courtesy Vicheth Tiev, 2018.

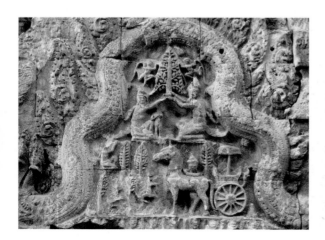

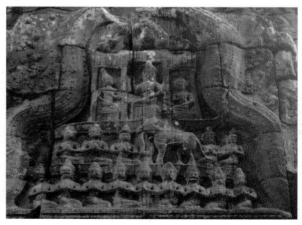

3.6 3.7

Angkorian period. As for the erased figure in the upper register, which was originally that of the Buddha, it could probably be understood not as in any direct link to the storyline of the lower register,[40] but rather as the prediction of the future existence of Vessantara who, because of the perfection of his generosity in his present life, will achieve Buddhahood. This iconographic feature can be also seen on a lintel at the Bayon, which represents the *Sāma-jātaka* (see below).

JAYAVARMAN VII AND THE MULTIPLICATION OF *JĀTAKA* IMAGES

The religious iconography under the reign of King Jayavarman VII (r. 1182/83–c. 1220) is of remarkable diversity and complexity, reflecting the cohabitation of different religious orientations in the ancient Khmer kingdom.[41] During this period, illustrations of *jātaka* tales were more frequent with a particular concentration found at principal temples located in the capital of Yaśodharapura (Angkor). Among these monuments, the architectural triad – the Bayon, Ta Prohm (Rājāvihāra) and Preah Khan (Jayaśrī) – are grouped the majority of *jātaka* reliefs represented during that time. Dedicated respectively to the king himself,

Fig. 3.8 *Vessantara-jātaka*, the gift of the elephant and the exile of the royal family, Ta Prohm of Tonle Bati, third quarter of 12th century. Photograph courtesy Brice Vincent, 2018.

Fig. 3.9 *Vessantara-jātaka*, the three principal gifts, found in Angkor Wat temple, National Museum of Cambodia, late 12th to early 13th centuries. Photograph by author, 2018.

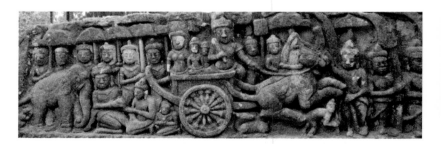

3.8

3.9

to his mother, Jayarājacūḍāmaṇī, and to his father, Dharaṇīndravarman (II), these important royal foundations contain representations of *jātaka* (some scenes being still unidentified) on their pediments, semi-pediments and lintels. Several provincial foundations of the same reign also provide evidence of familiarity with the *jātaka* far from the Angkor area. Two good examples are offered by the temple of Ta Prohm at Tonle Bati, Takeo province, and Vat Nokor, Kampong Cham province.[42]

The most represented *jātaka* tale in this period is the *Vessantara-jātaka*, a story that had already found it place in the earlier illustrations of Buddhist themes in ancient Cambodia. Also, it is the gift of the children which was, in general, chosen to evoke the virtue of great generosity, the principal message conveyed in the story. The iconographic aspects of this sequence remained almost analogous with early representations. However, other episodes from the same tale have also been identified. For instance, at Ta Prohm temple, on the northern pediment of the Southeastern tower, located between the second and the third gallery, two scenes of the *Vessantara-jātaka* were depicted (Fig. 3.6). While the gift of the children occupies the upper register of the pediment, the lower register was reserved for a scene probably related to an episode of the third chapter recounting the moment when four deities, taking the appearance of four stags, replace the horses that Prince Vessantara had just donated to a group of brahmans. On the left side of the frame, two stags appear to run towards the chariot

Fig. 3.10 *Sibi-jātaka*, King Sibi giving his flesh, Ta Prohm temple, third quarter of 12th century. Photograph by author, 2018.

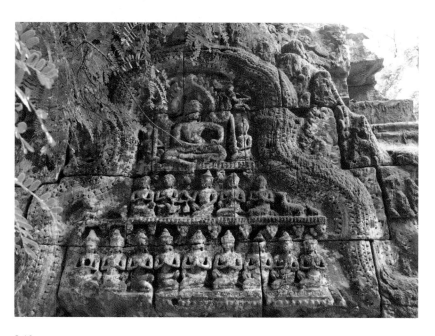

pulled by a horse that they will replace. Also at Ta Prohm, another episode of the *Vessantara-jātaka* was probably illustrated on the northern pediment of a western *gopura* located between the second and the third gallery (Fig. 3.7). An elephant is depicted below a central male figure sitting inside his palace and assisted by two subjects. Given the sacred characteristics of the scene, accentuated by a group of praying figures, it is likely that this relief renders two principal figures of the story: Vessantara himself and the white elephant Peccaya who is thought to bring rain and prosperity wherever he goes. Giving away this sacred animal, seen as a courageous act of generosity by Buddhists, would provoke great fury from the people, who demanded the banishment of Vessantara to the forest, as described in the second chapter of the story. Outside the Angkor area, an interesting lintel from Ta Prohm at Tonle Bati figures several episodes from the story of Vessantara (Fig. 3.8). The narration starts on the left side of the composition with the gift of the white elephant; Vessantara, on the ground with the elephant behind him, is depicted pouring water into the hands of the brahmans to indicate the act of giving. The consequence of this act is immediately presented in the middle of the panel with the exile of the family. Here, the couple and their two children were represented sitting on a chariot drawn by a pair of horses. On the right side, the journey is interrupted by a group of brahmans to whom Vessantara would give the horses and then the chariot. The great generosity of the bodhisattva is celebrated by a frieze of characters holding parasols and flags.[43]

Exceptionally, a stele found in Angkor Wat temple, currently conserved at the National Museum of Phnom Penh, illustrates successive episodes of the *Vessantara-jātaka* which are the three principal gifts made by the bodhisattva (Fig. 3.9). On the left side, Vessantara, seated on a pedestal, appears to pour water onto a brahman's hand to indicate the gift of the elephant depicted on the right side of the

Fig. 3.11 *Sāma-jātaka*, the death of Sāma, the Bayon, late 12th to early 13th centuries. Photograph courtesy Vicheth Tiev, 2018.

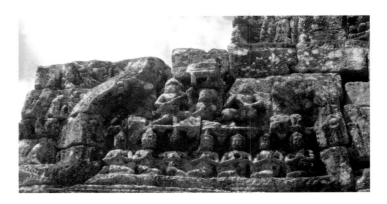

3.11

prince. The following scene relates clearly the gift of the children as Jālī and Kaṇhājinā are figured seated on each side of their father's thighs. The latter, as in the previous episode, pours the water from his right hand onto Jūjaka's hand to express his consent. This symbolic act of giving is repeated in the next panel which illustrates the gift of Maddī who appears behind Vessantara before whom is figured the old brahman, Indra, in disguise. These episodes of the *Vessantara-jātaka* seem to have originally been part of a series of narrative reliefs as shown in the following relief, regrettably in a fragmentary state, which possibly depicts another *jātaka* tale.[44] Stylistically, the stele dates between the late 12th and early 13th centuries,[45] viz. during the reign of Jayavarman VII.

Fig. 3.12 *Temiya-jātaka*? Bayon, late 12th to early 13th centuries. Photograph courtesy Vicheth Tiev, 2018.

Fig. 3.13 *Nārada-jātaka*? Bayon, late 12th to early 13th centuries. Photograph courtesy Vicheth Tiev, 2018.

3.12

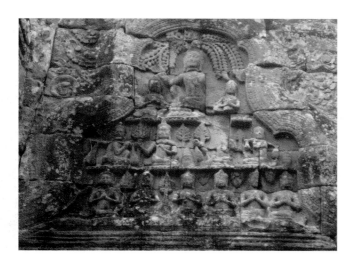

3.13

This iconographic theme would later inspire the modern Buddhist murals on which 13 panels, representing the 13 chapters of the story, are frequently illustrated.

In addition to the *Vessantara-jātaka*, there are other scenes from the previous lives of the Buddha depicted such as the *Sibi-jātaka* and possibly *jātaka* of the *Mahānipāta*. The story of King Sibi was represented twice at Angkor's Ta Prohm temple, on the northern pediment of the northeastern tower located between the second and the third gallery and on the northern pediment of the eastern *gopura* of the first wall (Fig. 3.10). The essential iconographic elements allowing a quick identification of the tale were present in both cases: a figure holding a scale with a pigeon on it and King Sibi cutting off his flesh with a blade. Moreover, the relatively important place of the story in the iconographic programme during this period was accentuated by the large scale of the pediments divided into two or three registers and a great number of worshippers and flying celestial beings. Two sequences of the *Sāma-jātaka* were depicted on the northern pediment of tower 40 of the Bayon temple (Fig. 3.11). The principal sequence is found in the lower register illustrating the death of Sāma. On the left side, the bodhisattva is figured lying between his parents who lament the tragic death of their child, whereas the huntsman, King Piliyakkha, on the other side, appears to have just shot an arrow that will soon run through Sāma's abdomen. Following the textual narration, the sculptor depicted in the centre of the group a standing stag towards which the king shot an arrow that missed its target. In the upper register, the bodhisattva is represented sitting on a pedestal and surrounded by two worshippers, a sequence that is probably supposed to illustrate Sāma reborn as the bodhisattva in the gods' realm, after his earthly passage. Also at the Bayon, at least two other *jātaka* of the *Mahānipāta* are illustrated. On the northern pediment of the eastern *gopura* of tower 35 is a scene of the *Temiya-jātaka*[46] related to one of the ordeals experienced by the bodhisattva Prince Temiya (Fig. 3.12). Assisted by the usual images of praying beings in the lower register, the principal episode takes place in the upper register where Temiya, sitting in the centre, appears to be threatened by two men who hold a blade or a serpent.[47] This scene also presents remarkable similitudes with the story of Temiya illustrated in later Cambodian Buddhist murals. Perhaps an episode of the *Nārada-jātaka*[48] could be identified on the northern pediment of tower 48 of the Bayon temple (Fig. 3.13).[49] The interpretation of this tale is based essentially on the presence of two male figures carrying a flail on their shoulders, a characteristic feature of the story painted on modern Buddhist murals. However, the suggested figure of King Aṅgati in the upper register of the pediment is problematic by its dominating size,

which is not in accordance with the iconographic rules of that time; that is the principal characters (the bodhisattva, in this case) generally had to be depicted larger than other figures. Several reliefs from different temples, for example at Banteay Kdei and Ta Prohm where three pediments are concerned, are likely to figure the *Bhūridatta-jātaka*, one of the last ten *jātaka* that tells the story of the bodhisattva born as a *nāga*. The fundamental features permitting the identification of the story rely on the *nāga*-headed figures, which have been associated with the *nāgī* mentioned in the text, and a *garuḍā*, all praying towards the bodhisattva (none of the images survived the supposed iconoclastic reaction in the second half of the 13th century). At Neak Pean temple, the previously proposed identification of a narrative scene on the lower pediment of the northern false door of the central tower as a representation of the *Mahājanaka-jātaka* is to be rejected.[50] If the presence of boats could vaguely suggest the sea crossing episode, the main figure sitting in a shrine cannot be associated with the bodhisattva, or the sea goddess, since this image, even though largely erased, must have been originally illustrated with four arms.[51] Bruno Dagens has suggested a possible representation of the *Vidhurapaṇḍita-jātaka*[52] on a semi-pediment of the tower 15 of the Bayon. However, the lack of the essential features of this tale make such an assumption difficult.

In addition to sculptural representations, there is other evidence suggesting familiarity with the *jātaka* during the Angkorian period: an inscription dated to the reign of Jayavarman VII.[53] The term *jātaka* is evoked in the stele of Phimeanakas (*K. 485*) written in Sanskrit prose by Jayavarman VII's second spouse, Indradevī. As part of the *praśasti* of Jayavarman VII's first spouse and Indradevī's elder sister, Jayarājadevī, a stanza of the stele mentions theatrical representations based on *jātaka* and commissioned by the queen. Here is the passage in question: "[...] and her vow, having obtained the Buddhist fruit [...] she ordered her own dancers to perform, to stage shows based on the Jātaka."[54]

This interesting citation, as short as it may appear, inscribes Angkorian Cambodia into a long tradition of dramatic performances of *jātaka* attested all over Asia.[55] According to the text, representations of the *jātaka* were part of a long list of meritorious deeds that the queen accomplished in order to express her Buddhist faith. However, it is unknown which *jātaka* stories were chosen to be interpreted here, and whether these performances were accessible to audiences of different social ranks, in other words, in public open spaces or only exclusively reserved for the elite.[56] Whatever the case may be, this citation of *jātaka* brings further weight – apart from the temples reliefs – to the argument that the *jātaka* were part of royal occupations.

THE EMERGENCE OF *JĀTAKA* IN ANCIENT CAMBODIA:
A REGIONAL INFLUENCE?

Dvāravatī

In the fifth century , the Indian monk Nāgasena was sent by Kauṇḍinya Jayavarman, the King of Funan, to the Liu Song court. During this visit, Nāgasena presented, among other items, a written report of Funan to the Chinese Emperor, which contained a passage evoking the praise of the bodhisattva who practices meritorious deeds during his numerous lives.[57] Peter Skilling, through this historical account, suggests a "*jātaka* ideology" in Funan.[58] However, apart from this thin textual testimony, there is practically no archaeological evidence related to *jātaka* tales in Cambodia during this period, viz. the first millennium of the Common Era.

Therefore, I shall focus my attention on the external relationship between ancient Cambodia and its neighbouring states where Buddhism occupied a major position, and where *jātaka* illustrations were of considerable importance. In doing so, I firstly, and naturally, start my research with the earliest representation of *jātaka* tales found in the context of so-called "Dvāravatī" (6th to 11th centuries), a Theravāda Buddhist kingdom or culture of the Mon-speaking people with principal centres regrouped in the central and northeastern regions of present-day Thailand. Two principal supports belonging to this culture bear several *jātaka* scenes: terracotta and stucco reliefs, and Buddhist boundary stones or *sīmā*. At Chula Pathon Cetiya, in Nakhon Pathom province, numerous terracotta and stucco reliefs have been brought to light, some of them depicting *jātaka* tales. According to Krairiksh, certain of these *jātaka* scenes were inspired from the Pāli text, the *Jātaka-aṭṭhakathā*, and the others by Sanskrit sources belonging to the Sarvāstivāda tradition, a Hīnāyana sect whose canonical scriptures are written in Sanskrit.[59] For Chutiwongs, it is, on the other hand, imprudent to consider *jātaka* at Chula Pathon Cetiya as the exclusive work of a specific Buddhist tradition. In her critical study focusing on the previous work of Krairiksh, she presented the universal characteristic of *jātaka* in Buddhist worlds; in other words, a number of stories are shared by various texts belonging to different Buddhist schools.[60]

Is there any connection between the *jātaka* found at Dvāravatī sites and *jātaka* at Angkor? No definite answer can be given to this with the current state of our knowledge. In fact, although relationships between the Khmer and the Mon in Dvāravatī have been proven since an early date, as attested, for example, in statuary,[61] the religious inclination of the two states during the period in question was significantly different. In Cambodia, during the pre-Angkorian period, no Buddhist foundations, as seen at Dvāravatī sites, have been attested until now; this is not surprising since Brahmanism was

primarily followed by the Khmer kings at that time. Therefore, the absence of *jātaka* reliefs during this period can be explained by the nonexistence of Buddhist temples or *stūpa*, traditional Buddhist architecture bearing Buddhist narrative reliefs – the life of the Buddha and his previous lives as principal themes – as seen in India and throughout Southeast Asia. However, this does not exclude the possibility that the popularity of *jātaka* strongly proven in Dvāravatī "culture" might have penetrated Khmer religious thought over the centuries, especially during the time when the Angkorian kingdom spread its political power over the previously principal centres of Dvāravatī. One of the earliest evidences of this contact may be seen at the Phnom Kulen site or Mahendraparvata, cradle of Angkorian civilisation, where numerous Buddhist boundary stones have been found.[62] Of these *sīmā*, most of which are decorated with Buddhist motifs – principally the stylised *dharmacakra* or the Wheel of the Law[63] and *kumbha-stūpa* images – and probably dated to the eighth century,[64] one depicts a scene from the *Vessantara-jātaka*: the gift of Maddī.[65] A *sīmā* from Muang Fa Daet (Northeast Thailand) and dated to the eighth to ninth centuries,[66] presents the same episode with striking similarity with the *sīmā* at Kulen, suggesting a cultural influence from this Mon region located in the North of Angkor and marked by the presence of Theravāda doctrine. Indeed, it has been suggested that the Buddhist boundary stones at Phnom Kulen are evidence of the presence of Buddhists originating from Northeast Thailand, more precisely from Mueng Fa Daed, a Dvāravatī site.[67] At any rate, these *sīmā* indicate the existence of a Buddhist community, apparently of Theravāda tradition and likely in relation with those known at Dvāravatī centres in Thailand, who might have played a significant role in development of Theravāda Buddhism in Cambodia later during the Angkorian period, and, in particular, the emergence of *jātaka* illustrations at that time.

Several other *jātaka* tales figured in the earlier Dvāravatī period also found their place on Angkorian reliefs of the 12th century. More notably, some of these *jātaka* as seen at numerous sites impregnated by Dvāravatī culture, such as Muang Fa Daet, the most important site where a great number of Buddhist boundary stones has been discovered,[68] present artistic influences from the Angkorian sculptural canons. This is related to the period when the Khmer empire reached its peak, that is from the 11th to 13th centuries, dominating the present territory of Thailand and Laos. Numerous *sīmā* from Northeast Thailand, dated to the 11th century, testify clearly to the influence of Khmer art. Indeed, two *sīmā* illustrating an episode of the *Vidhurapaṇḍita-jātaka*, dated to the 10th to 11th centuries,[69] are indications of Khmer artistic style. Another *sīmā* from Nong Khai province, in Northeast Thailand, depicting the *Sibi-jātaka*, also attests to this influence. Dated likely to the 11th century, this *sīmā*

catches our attention by its central character whose costume is apparently inspired by the Baphuon style.[70] More interestingly, the visual content of this relief – King Sibi who is shown cutting his flesh in order to save the pigeon seated on a scale held in his left hand[71] – appears to refer to the same textual source used by the Khmer illustrators at Angkor. Other testimony of the impact of Khmer stylistic elements can be seen on a *sīmā* with a scene from the *Sāma-jātaka*[72] dated to the 11th to 12th centuries[73]. A later lintel in the Bayon temple depicts this story in a more tragic and sensitive manner (see Fig. 3.12).

These *sīmā* from the northeastern region of Thailand could presumably be the sources for the rise of *jātaka* in reliefs during the Angkorian period. However, the precise circumstances of such transmission are uncertain: it is unknown whether the stone carvers of the *sīmā* were also responsible for the *jātaka* reliefs executed at Angkor. The imperial project of constructions in Angkor would have naturally required a large number of craftsmen coming from different parts of the kingdom. Or it could be that the popularity of these Buddhist stories gradually flowed into the capital through people in circulation between Angkor and the northern region, before being definitively adopted in the iconographic programme from the third quarter of the 12th century. Nevertheless, the first hypothesis seems to be less convincing given that several significant factors tend to demonstrate true divergences between the *jātaka* on *sīmā* from Northeast Thailand and *jātaka* from Angkor. In fact, while the *jātaka* from the *Mahānipāta* were all illustrated on *sīmā* – except the *Nimi-jātaka*[74] – only a few of this group have been, at the present stage of our knowledge, identified at Angkor, with the *Vessantara-jātaka* being the most represented. Moreover, the Angkorian sculptors clearly appear to give priority to the episode of the gift of the children, regarded as the most important exemplar of renouncement in the story, whereas only one example of this scene was found on a *sīmā* from Northeast Thailand.[75] The iconographic features also suggest certain differences in the manner in which this episode was perceived by the inhabitants in these two regions. In fact, on the *sīmā* in question, one of the two children whom Vessantara is about to give to Jūjaka appears to show resistance, which is, in this case, in accordance with the textual content.[76] At Angkor, on the contrary, the children were figured in an attitude of unshakeable resignation. In doing so, the sculptors seemed to honour the righteousness of the act of the bodhisattva whose extreme generosity was also approved by the children themselves.

For the *Sibi-jātaka*, this tale seemed to have been more appreciated among the Khmer at Angkor and beyond, since several representations of this tale were found in separate locations (Banteay Samre, Ta Prohm, Preah Khan of Kampong Svay, etc.), the same story being found on one single *sīmā* in Northeast Thailand. Furthermore, the simplicity of the sculptural

treatment of the latter contrasts with the rich composition of the Angkorian examples. In this case, could it be reasonable to suggest that the story of Sibi was first known in the Angkor region before being introduced later in Northeast Thailand? Such a hypothesis is further supported by the fact that the supposedly Buddhist *Sibi-jātaka* found in both regions also exists in the *Mahābhārata*, the timeless Hindu epic represented continuously in Khmer art, with a remarkable example from Angkor Wat.

In addition to the northeast sites, it is important to mention the centre of Thailand, in particular, Lopburi, previously a Dvāravatī town of considerable importance, which became an active region under Khmer patronage during our period of study. In the artistic field, there is evidence of stylistic influence in Buddha images between Lopburi and Angkor.[77] Discussion of this topic would however go beyond the scope of this chapter dedicated to *jātaka* study.

Pagan

From the beginning of the Pagan period, narratives scenes of *jātaka* became one of the principal elements of the artistic repertoire illustrated at Buddhist temples.[78] Of these early visual representations are the terracotta plaques figuring *jātaka* tales from both east and west Hpet-leik pagodas (c. mid 11th century), inspired by the Sri Lankan recension revisited by the Mon from Lower Burma.[79] For that matter, it has been attested that it was presumably the Mon of Thaton (Lower Burma) who introduced *jātaka* in Pagan, since there is no evidence, either textual or visual, prior to the date of Hpet-leik temple, to suggest that *jātaka* narratives were known in this ancient capital of present-day Myanmar.[80] Indeed, like Dvāravatī sites in Thailand, *jātaka* narratives were depicted on Buddhist boundary stones or *sīmā* found not far from the ancient Mon capital of Thaton, some of them dating as early as the 11th century.[81] In sum, in mainland Southeast Asia,[82] *jātaka* ideology was, first of all, one of the favourite Buddhist iconographic themes among the Mon populations, who included these stories in the decoration of their *stūpa*, dated to the sixth to seventh centuries, and shortly after on the Buddhist boundary stones, the earliest of which date to the 9th century.[83] As discussed above, these carved Buddhist boundary markers, found in great number in Northeast Thailand, could probably have been responsible for the emergence of *jātaka* scenes at Angkor. If such is the case, what could have been the role of Pagan, where *jātaka* scenes have had a role of great importance, in the rise of *jātaka* during the Angkorian period?

Political and religious relations between Angkor and Pagan during the 12th century need to be taken into consideration in order to answer this question. Generally speaking, a few historical events tend to attest the relationship between Cambodia and Burma during the late Angkorian

period. The Burmese *Glass Palace Chronicle*[84] mentioned the ordination in Sri Lanka of a group of Buddhist monks originating from Southeast Asia in the second half of the 12th century. Among these monks was a certain Tāmalinda, who has been thought to be a son of King Jayavarman VII.[85] Surprisingly, this event of great importance does not exist in any Cambodian records, either of contemporary epigraphs dated to the reign of Jayavarman VII or later textual sources. This anomaly calls into question the reliability of the Burmese record, which was actually written as late as in 1829 under the reign of King Bagyidaw of Burma[86]. Indeed, according to recent studies, the identity of Tāmalinda, as well as that of his travel companions associated with the Khmer court, could have been invented by the Burmese seeking to draw a religious map representing the presence of Theravāda Buddhism in South and Southeast Asia in the late 12th century.[87] Furthermore, Tāmalinda, if he really existed, seems to have died in Burma, never returning to Cambodia, so it is unknown whether his journey in Sri Lanka, during the great reform of Theravāda Buddhism on the island in the second half of the 12th century, provoked any consequences in the development of this Buddhist doctrine in his homeland.[88] Another religious relation between the two kingdoms was attested under the reign of Jayavarman VII who is thought to have had a court brahman (*purohita*) from Burma.[89] If the latter seemed to have brought changes in religious practices at Angkor, it is natural that his principal function would have consisted in the preparation of Brahmanical rites; a ceremony of consecration called "Indrābhiṣeka", which possibly had Burmese origins was undertaken by the king.[90] It is in this case unknown whether this Burmese chaplain could have, in parallel, contributed to the spread of Theravāda in Cambodia at that time.

What about stylistic grounds? Certain *jātaka* tales depicted in terracotta plaques at Pagan also exist on Angkorian reliefs. Of particular interest is the *Vessantara-jātaka*, the most illustrated *jātaka* in ancient Cambodia. At Pagan, this tale was generally figured in explicit detail by a succession of episodes, given its unique status and great prestige comparing to other *jātaka* stories of the Pāli recension. More than 134 terracotta plaques were dedicated to the *Vessantara-jātaka* at Ananda temple, a privileged position found nowhere else during this period.[91] In parallel, the story also appeared on stone reliefs in the cross passages at Ananda where two sculptures in niches illustrate the episode of the gift of the children.[92] Besides these two images, there is seemingly no other evidence suggesting the pre-eminent place accorded to this scene in Pagan art, given that the terracotta plaques depict the *Vessantara-jātaka* in its integrality without according preference to any specific episode. At Angkor, on the contrary, this episode was, as seen earlier in this chapter, by far the most appreciated moment becoming subsequently an absolute

icon of the *dāna-pāramīta* or the Perfection of giving. The popularity of this episode is attested by its figuration on diverse architectural elements, namely pediments, lintels and pilasters. The desire to prioritise illustration of this scene can be seen in early representations of the *Vessantara-jātaka*, at Thommanon and Chau Say Tevoda, where the gift of the children, depicted in both cases in the upper register, presides over the following sequences. Also, significant divergences in iconographic features regarding this episode exist between Angkor and Pagan. At Angkor, Vessantara was most of the time represented kneeling down before Jūjaka who, in the same position and size, receives the water poured by the bodhisattva. This striking attitude of humility from a high rank character – Vessantara being a prince and the Buddha-to-be – contrasts with the sculptures at Pagan where the figure of the bodhisattva was associated with the status of a superior either by his dominant size (the cross passages of Ananda), or by his higher position in the scene relative to other characters (terracotta plaques at Ananda, for example). Apart from the *Vessantara-jātaka*, there is also a remarkable divergence regarding the *Sibi-jātaka*. This tale was depicted on a terracotta plaque at the West Hpet-leik temple where the king is represented offering his eyes to the old blind brahman,[93] which corresponds to the Pāli version. It was another variant of the story that was chosen by the Khmer sculptor, apparently the Sanskrit version,[94] in which the bodhisattva gives his flesh to save a pigeon's life. Finally, the *Valāhassa-jātaka*, the story of the flying horse who through compassion saves 500 sea merchants from being devoured by female demons, was illustrated in the round at Neak Pean temple (Jayavarman VII), an intriguing monument representing Lake Anavatapta, which is believed to have miraculous curative powers to heal human sins.[95] Unlike the Ananda temple where the story, figured on a simple terracotta plaque, was based on the Pāli version,[96] the Khmer illustrator undoubtedly drew inspiration from the Sanskrit Mahāyāna text, the *Kāraṇḍavyūha-sūtra*, according to which the bodhisattva Avalokiteśvara is born as a flying horse named Balāha.[97] At Angkor, this *jātaka* tale was, thus, a strong symbol of the compassion of Avalokiteśvara following Mahāyāna ideology, whereas the same story illustrated at Pagan was apparently there to complete, first of all, the whole collection of the *jātaka* tales in the Pāli canon.[98]

JĀTAKA IN ANGKOR: A MANIFESTATION OF THERAVĀDA BUDDHISM?

There is a tendency to automatically associate *jātaka* with Theravāda practices. In reality, *jātaka* have been shared by both Theravāda and Mahāyāna traditions. It is difficult to know, in the absence of

uncontestable indications, whether the illustration of a *jātaka* tale is to be associated with either one of these two principal schools. However, certain factors exist and can be used in order to identify which Buddhist tradition is at the origin of *jātaka* representations. First, a specific number of *jātaka* tales depicted in one place can efficiently indicate the collection to which the stories belong. In this case, an excellent example can be seen at the Ananda temple (early 12th century) at Pagan where 547 *jātaka* from the whole Pāli recension of the *Tipiṭaka*, or the fundamental books of Theravāda Buddhism, were illustrated, with a special place accorded to the last ten stories, the *jātaka* of the *Mahānipāta*. Second, identification might also be possible by comparing the textual and the visual contents of the depicted story. However, this can only work with *jātaka* scenes offering sufficient details enabling such procedure, as is the case of the Borobudur temple on which the complete number of *jātaka* taken from Ārya-Śūra's *Jātakamālā* was identified.

In ancient Cambodia, no such possibilities are available for the Angkorian period. Likewise, relative to Pagan or Borobudur, it is obvious that *jātaka* at Angkor occupied only a secondary place. Other iconographic themes dominated at that time – images of the Buddha and narratives reliefs depicting his final life, the images of bodhisattva belonging to the Mahāyāna pantheon,[99] and traditional Hindu gods and heroes. Also, it seems that the concept of the illustration of the last ten *jātaka* as a set was unknown during this period. Nevertheless, there are a few elements that might shed light on our understanding about *jātaka* as an indicator of religious tendency for the period in question. In doing this, I will essentially focus my attention on two *jātaka* tales that were frequently figured in temple reliefs and contain interesting visual content deserving of closer observations. These are the *Vessantara-jātaka* and the *Sibi-jātaka*. For the former, two details catch my attention. The first observation comes from Thommanon where several scenes of the *Vessantara-jātaka* are seen on a pediment. In the lower register, below the gift of the children in the upper register, the relief seems to depict the episode in which Jūjaka is told to sleep in a tree. This sequence, regarded as one of the moving moments of the tale, does not exist, for example, in the *Jātakamālā* book, one of the most famous *jātaka* texts written in Sanskrit that inspired, inter alia, the sculptors of the Mahāyāna Buddhist temple of Borobudur. As far as I know, this sequence is only found in the canonical Pāli version which gives the story in its longest version. Given that, in general, stories are firstly transmitted orally before being fixed in textual form, this Pāli version of the story of Vessantara might have been known to the Khmers at that time,[100] who were supposed to recognise it on temple reliefs without great difficulty.[101] Another similar case comes from Chau Say Tevoda.

Here, the *Vessantara-jātaka* was illustrated in its most explicit manner compared to other temples mentioned in this study. Like at Thommanon, two episodes figured at Chau Say Tevoda probably correspond to the Pāli version. One of them relates the same moment mentioned above at Thommanon. The other one tells of the reunion between Vessantara and his children and wife. This sequence is also not mentioned in the *Jātakamāla* since, in the Chau Say Tevoda version, the story ends with the encounter between Jūjaka and King Sañjaya to whom the brahman returns the two children. It is always possible that the original textual version was modified by the sculptor himself who, following his own imagination, could have added an epilogue to generate a greater feeling of a happy ending of the story.

Let us focus now on the *Sibi-jātaka*, one of the first *jātaka* tales to be depicted on Khmer temples dated to the Angkorian period. This famous story that narrates the extreme generosity of King Sibi can be found in both Pāli and Sanskrit texts. In the Angkorian period, it appears that the textual sources that might have inspired the sculptural representations of this tale were not that of Pāli, but rather of Sanskrit tradition. Indeed, according to the Pāli versions, including the *Jātaka-aṭṭhakathā* [102] or in the *Cariyāpiṭaka*,[103] both belonging to Theravāda tradition, King Sivi is said to donate his own eyes to an old blind man,[104] while, in Sanskrit sources, the *Buddha-carita*, for example, he is said to give his flesh.[105] This version corresponds therefore to the Angkorian reliefs as discussed above. However, in this Sanskrit text, the generosity of King Sibi is cited only as a brief reference; in other words, the story's content is not given, making it impossible for the illustrators to use it as a guideline. On the contrary, another textual source belonging to the Hindu tradition offers more details that would have been beneficial for the artist's imagination. It is in the *Mahābhārata* where King Sivi is said to cut off his flesh to save a pigeon from being eaten by a hawk.[106] The two birds are actually Agni and Indra in disguise who are desirous to test the goodness and virtue of the king. That this textual content has likely inspired Khmer sculptors is strengthened by the popularity of the *Mahābhārata* attested in ancient Cambodia. Also, in the Angkorian period context, it appears to be unnecessary to determine to which Buddhist school this *jātaka* could have been related since such a story belongs, first of all, to a common collection of folklore tales from which both Mahāyāna and Theravāda Buddhism drew inspiration.[107]

Finally, as discussed above, the stele of Phimeanakas indicates that *jātaka* tales were performed by court dancers, even though it is unknown which stories were interpreted and in what circumstances these plays were made. Further understanding of the principal modes

of diffusion of *jātaka* in ancient Cambodia might help to determine the context in which the illustration of this Buddhist theme emerged during the Angkorian period. In fact, in Buddhist Southeast Asia, it is undeniable that the *Vessantara-jātaka* appears to be particularly popular within Theravādin traditional spheres compared to Mahāyāna tradition because of one specific reason. According to the *Māleyya-sutta*, the story of the legendary Buddhist monk named Māleyya who is said to visit heaven and hell, one who listens to the recitation of the *Vessantara-jātaka* may be guaranteed rebirth at the time of the next Buddha, Metteyya. The recitation of this text, composed by a Sri Lankan monk in the Pāli language in 1153,[108] followed by the reading of the *Vessantara-jātaka,* was mentioned in an inscription from Pagan dated to 1201.[109] Such an important practice, the final aim of which is to incite lay people to be generous in their lives in general and, also, to make donations of their time and properties for the smooth functioning of the *saṅgha*, could have been introduced within the Theravāda Buddhist community in Cambodia during the period of study. It is tempting to imagine that such an intercourse regarding the diffusion of Buddhist texts and rituals could have been assured by the monks sharing the same Buddhist doctrine who would have tried to come into contact and exchange writings and teachings. The diffusion of the Buddhist scriptures has always been regarded as an objective among Buddhist communities.[110] However, this intercourse appears to be most evident for Sri Lanka and Burma.[111] Therefore, in the future, fully understanding the place of Cambodia within this regional Theravāda network during the late Angkorian period[112] appears to be crucial to determine the dynamic of the proliferation of Buddhist scriptures belonging to this school in Khmer Buddhist communities.

It might be interesting to mention that during the Middle Period, when Theravāda doctrine became the principal cult of the Khmer, the obvious popularity of *jātaka* is evidenced in the "Inscriptions Modernes d'Angkor", which record numerous reproductions of the texts of the last ten *jātaka* offered to Buddhist monasteries,[113] as well as the ceremonial reading of these tales among which the recitation of the *Vessantara-jātaka* appears to be the most appreciated.[114] In addition, citations related to the principal characters of the *jātaka*, particularly of the last ten lives, are found. A dignitary, for instance, compares his children to Jālī and Krisnā, the two children of Vessantara who participated in the accomplishment of the perfect generosity of their father.[115] These practices related to *jātaka*, regarded as highly meritorious by Buddhists, were made on the occasion of Buddhist celebrations such as the erection or restoration of Buddha images, the construction of new buildings belonging to the monastery complex, or the release of slaves.[116]

One question might be raised: whether or not the *jātaka* known in the post-Angkorian period are a direct heritage of the *jātaka* dated to the Angkorian period. Such an idea could be worth considering given that strong Angkorian artistic sensibilities, in particular the Bayon style, have played an important role in the configuration of the art style of the Middle Period, at least in its beginning phase.[117] However, the absence of any surviving artistic productions related to *jātaka* during the more than three centuries following the decline of Angkor challenges the notion of continuity. To date, we know only of a set of wooden sculptures originating from the region of Babor, Kampong Chhnang province, and dated between the 17th and 18th centuries, as the only surviving artefacts from this period to illustrate scenes from *jātaka* tales.[118] Later, in modern Cambodia, Buddhist murals – the oldest ones dated to the late 19th century – have definitively adopted *jātaka*, in particular the last ten *jātaka*, as one of the principal themes to be represented in *vihāra*. Here, the ten *jātaka* have been depicted in detail, that is from the beginning of the story until the end, according to the Sri Lankan recension which is now shared by the Therāvada Buddhist countries of Southeast Asia. However, the fascination with the story of Vessantara has always been there and this can still be seen in contemporary mural paintings where the entirety of this tale is figured in 13 separate panels, whilst a single panel is typically used to represent each of the other nine *jātaka* tales of the *Mahānipāta*.

CONCLUSION

In Cambodia, the earliest depiction of *jātaka* is attested on a *sīmā* at a Phnom Kulen site, dated to the 8th to 9th centuries. Then, there was a long period of silence on this Buddhist theme in both epigraphy and art. It was then, during the first half of the 12th century, that *jātaka* reappeared again, this time on a pediment of Thommanon temple, probably dated to the reign of King Sūryavarman II. This sudden apparition of a *jātaka* tale at a temple apparently dedicated to Vaishnavism concretises the idea of the religious syncretism – Brahmanism and Buddhism – established earlier at Phimai (Thailand). However, the rarity of *jātaka* in sacred art reflects incontestably a secondary position of this Buddhist ideology in the religious conceptions of the Khmer at that time. In the third quarter of the 12th century, at the time of the ascension of King Tribhuvanādityavarman, one of the Buddhist monarchs belonging to the "Mahīdharapura" dynasty, *jātaka* seemed to be definitively adopted in the iconographic repertoire as attested by the "temples d'étape" located on the east road that links Angkor to Preah Khan of Kampong Svay. Of these early representations of *jātaka*, only two stories have been identified, the *Vessantara-jātaka* and the

Sibi-jātaka. The former, by its nature as the most celebrated *jātaka* among Buddhists in general, could be depicted in several episodes, whereas the latter was limited to one characteristic episode inspired by the iconographic patterns of ancient Buddhist art. When Jayavarman VII came to the throne, and established a new principal religious order in favour of Mahāyāna Buddhism, there was considerable enrichment of Buddhist imagery; here we see the *jātaka* theme expand. Numerous *jātaka*, certain scenes still unidentified, were illustrated in reliefs at different temples, in the capital as well as in the provinces. Still, the *Vessantara-jātaka* and the *Sibi-jātaka* remained the two most represented tales during this period. Also, the valorisation of these *jātaka* probably had a specific signification. One would note that in Buddhism, "generosity" and "self-renouncement" are two foremost virtues that have been highly celebrated over centuries, especially in Theravāda Buddhism. In fact, the perfection of generosity, perfectly embodied by the story of Prince Vessantara, continues to inspire Buddhists of different social backgrounds who, by the act of giving, can expect in return to gain merits for next lives. In a more socio-economic perspective, the *saṅgha* strongly depends on the generosity of the Buddhist community that supplies daily food and material needs to the monks prohibited from any lucrative activities.

In Southeast Asia, with the notable exception of the Mahāyāna Buddhist temple of Borobudur in central Java, the development of *jātaka* in the iconographic field are attested in those kingdoms or cultures where Theravāda Buddhism prospered. Based on the comparative study with the neighbouring Dvāravatī sites, especially those located in the northeast part of present-day Thailand, it seems that the Khmer were introduced to *jātaka* tales through the interactions that followed their conquest of these centres, which had been inhabited by Mon-speaking people who appeared to have particularly appreciated this Buddhist iconographic theme since an early date. In fact, this contact dates back as early as the beginning of the Angkorian period, as attested by a Buddhist boundary stone or *sīmā* found at the Phnom Kulen site, a stone which presents remarkable iconographic similarity with a contemporary *sīmā* from the Dvāravatī site of Muang Fa Daet. However, it was during the peak of the territorial and political expansion of the Khmer kingdom, between the 11th and 12th centuries, to the centre and the northeast of present-day Thailand, that *jātaka* tales seemed to have largely spread into certain zones occupied by the Khmer who, henceforth, would have lived alongside or within native communities. During this period of mutual artistic inspiration several *sīmā* marked by Khmer stylistic sensibilities were erected. For instance, in Northeast Thailand, two *sīmā* depict the *Vidhurapaṇḍita-jātaka*, whereas another *sīmā* illustrates the *Sibi-jātaka*, all of them presenting influences from the Khmer aesthetic canon, which was, therefore, probably the

consequence of cultural and political interactions between Angkor and former Dvāravatī sites. In parallel, a comparative study has revealed that there are divergences between the *jātaka* scenes on the *sīmā* and those depicted in reliefs during the Angkorian period. Indeed, at Angkor, the *Vessantara-jātaka* and the *Sibi-jātaka* appeared to have occupied an important position, whereas the same tales are rarely found on *sīmā* in Thailand. Furthermore, for the *Vessantara-jātaka*, the episode of the gift of the children was the most illustrated at Angkor, while the same sequence has been attested on only one single *sīmā*.

On the other hand, there is no clear evidence proving that the exceptional popularity of the *jātaka* at Pagan could have had any significant influence on the emergence of *jātaka* at Angkor. There are two principal arguments that support this. First, I have insisted on the fact that the religious relationship between Angkor and Pagan during the late Angkorian period, which would have enabled the introduction in Cambodia of the Buddhist scriptures containing *jātaka* narratives as known at Pagan, remains both scantily documented and confused. The reliability of the identity of Tāmalinda, the presumed Khmer monk thought to have received ordination under Theravāda tradition in Sri Lanka some time at the end of the 12th century, remains controversial to this day. Second, the *jātaka* depicted at Angkor did not follow the specific rules established at Pagan, that is the illustration of the complete collection of *jātaka* tales as it is known in the Sri Lankan Pāli version and the figuration in explicit detail of the last ten *jātaka* with the *Vessantara-jātaka* occupying the most extended space. At Angkor, the *Vessantara-jātaka* was generally represented by one evocative scene, which is the episode of the gift of the children, although a few more sequences could sometimes be added. By choosing this episode, the Khmer seemed to have intended to draw the viewer's particular attention towards the most exemplary act of generosity of the bodhisattva in the whole story. Humanly speaking, this episode is also known as the most moving and tragic moment.[119] Other evidence also seems to demonstrate that the *jātaka* at Angkor, at least some of them, were not drawn from the same Buddhist textual tradition attested at Pagan. Indeed, the *Sibi-jātaka* depicted at Angkor clearly belongs to the Sanskrit texts, probably the *Mahābhārata*, while the same story at West Hpet-leik temple was inspired from the Pāli version of the Sri Lankan recension. Another case concerns Neak Pean temple at Angkor where the illustration of the *Valāhassa-jātaka* confirmed the access of Khmer illustrators to the Mahāyāna Sanskrit text of *Kāraṇḍavyūha-sūtra* in which the story is given.

As discussed above, due to the lack of reliable historic data and the considerable divergences in the iconographic field between the two capitals, one can argue that the extended popularity of *jātaka* at Pagan did

not have a significant influence on the illustration of *jātaka* at Angkor.

In sum, there seem to be, during the late Angkorian period, not one but several Buddhist textual traditions that would have provided artistic inspirations for the illustration of *jātaka* tales. While certain stories were clearly taken from Sanskrit texts such as the *Kāraṇḍavyūha-sūtra* (*Vālahassa-jātaka*), a Mahāyāna text, and probably the *Mahābhārata* (*Sibi-jātaka*), the *Vessantara-jātaka* as seen at Thommanon and Chau Say Thevoda contained the episodes that are developed in the Pāli text of the Theravāda tradition. At any rate, these two *jātaka* tales, the most depicted during this period, although apparently belonging to different textual traditions, delivered a single message of extreme generosity and the renouncement of self, the most celebrated virtue in Buddhism, particularly, in Theravāda Buddhism. This may well have reflected the politico-religious philosophy of the king who acts as the unifier of his nation. Whatever the case may be, this plurality of Buddhist scriptures belonging to different traditions seems to reflect the complex and evolutive aspects of the religious system established under the reign of Jayavarman VII, a king also known for his devotion to the bodhisattva Avalokiteśvara, symbol of compassion in the Mahāyāna context, the virtue of whom was represented by the *Vālahassa-jātaka* at Neak Pean temple.

Notes

1 For *jātaka* illustrations from Dvāravatī culture see Pierre Dupont, *L'archéologie mône de Dvāravatī*, 1959, 2 vols.; Jean Boisselier, "Récentes recherches à Nakhon Pathom", *JSS* 58, no. 2, July 1970, pp. 55–65; Piriya Krairiksh, *Buddhist Folk Tales Depicted at Chula Pathon Chedi*, 1974; "Semas with scenes from the *Mahānipāta-Jātaka* in the National Museum at Khon Kaen", in *Art and Archeology in Thailand*, Fine Arts Department, 1974, pp. 35–65; and *The Chula Pathon Cedi: Architecture and sculpture of Dvāravatī*, PhD dissertation, 1975; Nandana Chutiwongs, "Review article on the Jātaka reliefs at Cula Pathon Cetiya", *JSS* 66, no. 1, 1978, pp. 133–51.

2 For *jātaka* reliefs at Borobudur see Sheila L. Weiner, "Notes on Buddhist Art", *Journal of the American Oriental Society* 18, 1897, pp. 196–201; Jan Fontein, "Notes on the Jātakas and Avadānas of Barabuḍur", in *Barabudur: History and Significance of a Buddhist Monument*, eds. Louis O. Gomez and Hiram W. Woodward, 1981, pp. 85–108; Louis Frédéric, with Jean-Louis Nou, *Borobudur*, 1984.

3 For *jātaka* illustrations during the Pagan period see Edouard Huber, "Études indochinoises", *BEFEO* 11, 1911, pp. 1–5; Charles Duroiselle, "Pictorial Representations of Jātakas in Burma", *Archaeological Survey of India* 1912–3, pp. 87–116; and "The Talaing Plaques on the Ananda Temple at Pagan", *Epigraphica Birmanica being Lithic and Other Inscriptions of Burma* 2, pt. 1, 1920; Gordon H. Luce, "The 550 Jatakas in Old Burma", *Artibus Asiae* 19, no. 3–4, 1956, pp. 291–307; and (partly repeated) *Old Burma-Early Pagan,* vol. 1, 1969; Lu Pi Win, "The Jātakas in Old Burma", *Artibus Asiae* 2, 1966, pp. 94–108.

4 Contrary to the artistic context, *jātaka* tales in Cambodian literature drew the attention of French scholars since the end of the 19th century (cf. Auguste Pavie, *Mission Pavie. Indochine. 1879–1895: Études diverses, I, Recherche sur la littérature du Cambodge, du Laos et du Siam*, 1898; and *Contes du Cambodge*, 1921; Adhémard Leclère, *Le livre de Vésandâr: Le roi charitable*, 1902; *Les livres sacrés du Cambodge*, 1906; and *Cambodge: Contes, légendes et jâtaka,* 1912).

5 Mireille Bénisti, "Notes d'iconographies khmère: I. Deux scènes nautiques", *BEFEO* 51, 1963, pp. 95–8.

6 Bruno Dagens, "Étude sur l'iconographie du Bayon (frontons et linteaux)", *AA* 19, 1969, pp. 123–67.

7 Lan Sunnary, "Étude iconographique du temple khmer de Thommanon (Dhammānanda)", *AA* 25, 1972, pp. 155–98.

8 Vittorio Roveda, *Khmer Mythology*, 1997; and *Images of the Gods: Khmer Mythology in Cambodia, Thailand and Laos*, 2006.

9 For new data concerning the rise of Buddhism during this period, see Arlo Griffith and Brice Vincent, "Un vase khmer inscrit de la fin du xie siècle (K. 1296)", *AA* 69, 2014, pp. 115–28.

10 Jean Boisselier, based on his stylistic study, thought that Thommanon was possibly erected slightly before Angkor Wat (see Jean Boisselier, "Běng Mālā et la chronologie des monuments du style d'Angkor Vat", *BEFEO* 46, 1952, pp. 187–226).

11 Such religious syncretism in Khmer sacred arts was also attested with the impressive temple of Phimai in actual Northeast Thailand. Founded during the reign of Jayavarman VI, at the end of the 11th century, or at the beginning of the 12th century, and dedicated to Buddhism in its Tantric form, the monument does not, however, include *jātaka* tales in its iconographic program as noted by Bruno Dagens in his "Autour de l'iconographie de Phimai", in *Actes du Premier Symposium franco-thaïlandais: La Thaïlande des origines de son histoire au XVème siècle. Bangkok juillet 1988,* Bangkok 1995, pp. 17–37.

12 Lan Sunnary, "Étude iconographique du temple khmer de Thommanon", *BEFEO* 25, 1972, pp. 155–98.

13 In 2006, Siyonn Sophearith, another Khmer scholar, published a short article in which he presents the iconographic feature of the pediment: "Camlak rūp tā jūjak' nau prāsād dhammnand" [Jūjak's relief at Thommanon temple], in *KhmeRenaissance*, vol. 1, December 2005–December 2006, pp. 102–3.

14 The figure of Vessantara is seriously damaged.

15 According to the Pāli canon, while Jūjaka falls asleep, two deities, having pity for the children, take the appearance of Vessantara and his wife, Maddī, then feed and comfort them during that night. It is unlikely that the two figures mentioned above can be associated with these gods. Nevertheless, the female figure could be related to one of the several gods of the forest who are touched by the children's pain, and are mentioned in the text.

16 Arlo Griffiths and Brice Vincent, personal communication.

17 Ibid.

18 According to the Pāli version, the family reunion takes place as a procession conducted by his father, King Sañjaya, arrives at the exile site of Vessantara. To indicate that the sequence happens in the forest, the sculptor shows a female figure (Maddī) collecting fruit from a tree.

19 Vittorio Roveda (*Images of the Gods*, 2005, p. 249) mistakenly identified this relief as extracted from the *Kapota-jātaka* (No. 275 in the Pāli version), another *jātaka* tale in which the bodhisattva was born as a pigeon.

20 Depending on different versions, the king is sometimes called Sibi, sometimes Sivi.

21 But, an example, although far in time and space, comes from the Magao Cave 275 (fifth century) where the two versions found their place in the same panel (Wu Ming-Kuo, *The Jataka Tales of the Mago Caves: China in Anthropological Perspective*, PhD dissertation, 2008, p. 428).

22 For the iconography of Beng Mealea: George Cœdès, "Note sur l'iconographie de Bĕng Mālā", *BEFEO* 13, pp. 23–8; and Jean Boisselier, "Bĕng Mālā et la chronologie des monuments du style d'Angkor Vat", *BEFEO* 46, 1952, pp. 187–226; from the same author, *Le Cambodge*, 1966.

23 Vittorio Roveda, *Images of the Gods*, 2005, p. 256, ph. 6.101.

24 For the different stages of architectural evolution of Preah Khan of Kampong Svay see Bernard-Philippe Groslier, *Le Preah Khan de Kompong Svay*, PhD dissertation, 1967. Also, for a discussion of the temple as a new Buddhist centre, see Brice Vincent, *Saṃrit: Étude de la Métallurgie du Bronze dans le Cambodge angkorien (fin du xie–début du xiiie siècle)*, PhD dissertation, 2012, pp. 57–61.

25 Bruno Bruiguier and Juliette Lacroix have mistakenly associated this episode with the *Kapota-jataka* (*Preah Khan, Koh Ker et Preah Vihear: les provinces septentrionales*, 2013, p. 111, ph. 116).

26 The eight "temples d'étape" are Chau Say Tevoda, Banteay Samre, Banteay Ampil, Beng Mealea, Prasat Chrei, Prasat Pram, Prasat Sup Tiep B, and Prasat Chambok (see Mitch Hendrickson, *Arteries of Empire: An Operational Study of Transport and Communication in Angkorian Southeast Asia (9th to 15th centuries CE)*, PhD dissertation, 2007, Fig. 8.22b). For some iconographic aspects of these temples see Bruno Dagens, "Autour de l'iconographie de Phimai", in *La Thaïlande des débuts de son histoire jusqu'au XVe siècle: Actes du 1er symposium franco-thaï, Bangkok, Université de Silpakorn, juillet 1988*, p. 27; and Bruno Bruguier and Juliette Lacroix, *Guide archéologique du Cambodge, Vol. V: Preah Khan, Koh Ker et Preah Vihear: Les provinces septentrionales,* 2013.

27 For brief studies on Prasat Sasar Sdam, see "Chroniques", *BEFEO* 37, 1937, p. 636; Henri Marchal, "Note sur la forme du stūpa au Cambodge", *BEFEO* 44, 1951, pp. 581–90; Jean Boisselier, *Le Cambodge*, 1966, p. 94. For a recent study, see Ludivine Provost-Roche, *Les derniers siècles de l'époque angkorienne au Cambodge (env. 1220–env. 1500)*, PhD dissertation, 2010, pp. 114–5.

28 However, Ludivine Roche-Provost associated the temple with Mahāyāna Buddhism (ibid., p. 115).

29 See Senake Bandaranayake, *Sinhalese Monastic Architecture: The Vihāras of Anurádhapura*, 1974, pp. 139–60.

30 Cf. "Chroniques", *BEFEO* 37, 1937, p. 636.

31 The life of the historical Buddha and *jātaka* tales are two Buddhist principal themes that are frequently depicted together in one place since an early age. In Cambodia, regarding mural painting in pagodas, it is customary to paint episodes from the life the Buddha in the upper register, whereas the lower register is occupied by *jātaka* tales.

32 In Southeast Asia, the *jātaka* of the *Mahānipāta* were depicted as a whole for the first time in the Thaton kingdom of the Mons, located in Lower Burma. For this topic, see Gordon H. Luce, "The 550 Jātakas in Old Burma", *Artibus Asiae* 19, no. 3–4, 1956, p. 292.

33 "Chroniques", *BEFEO* 37, 1937, p. 636; Ludivine Provost-Roche, *Les derniers siècles de l'époque angkorienne au Cambodge (env. 1220–env. 1500)*, PhD dissertation, 2010, p. 115.

34 In place of the presumed *jātaka* scenes, a frieze of erased Buddha images could

be also evoked. Friezes of erased Buddha images assisted by worshippers are known from the same temple (see Ludivine Provost-Roche, 2010, Figs. 103–6).

35 See Pierre Baptiste and Thierry Zéphir, *L'Art khmer dans les collections du musée Guimet*, 2008, cat. 106.

36 Ibid.

37 Ibid.

38 Lilian Handlin, "A Man for All Seasons: Three *Vessantaras* in Premodern Myanmar", in *Readings of the Vessantara Jātaka*, ed. Steven Collins, 2016, Fig. 6.1.

39 Louis Frédéric with Jean-Louis Nou, *Borobudur,* p. 313, Fig. 37.

40 Baptiste and Zéphir feel that, in the case where the gift of the elephant was figured in the lower register, the erased Buddha seated in the upper register would have probably been illustrated here as the narrator of his own previous life.

41 For further understanding of aspects of Buddhism during this period see Hiram Woodward, "Esoteric Buddhism in Southeast Asia in the Light of Recent Scholarship", *Journal of Southeast Asian Studies* 35, pp. 329–52 and *The Art and Architecture of Thailand*, 2005, p. 166 sq.; Brice Vincent, *Saṃrit: Étude de la Métallurgie du Bronze dans le Cambodge angkorien (fin du xie–début du xiiie siècle)*, PhD dissertation, 2012, p. 52 sq.

42 For a detailed study of the iconographic programme under Jayavarman VII see Christine Hawixbrock, *Population divine dans les temples: Religion et Politique sous Jayavarman VII*, PhD dissertation, 1992.

43 This frieze may also have represented the journey of the people of Sivi in the direction of the Vaṁka hill, Vessantara's site of exile, in order to present their apologies to the royal family and to ask them to return to the capital, the final chapter marking a happy ending of the story. If so, this narrative relief would be a sort of summarised version regrouping some symbolic sequences of the story.

44 The nautical features of this scene, attested by a fish figure within the ocean, catches our attention by the seeming goddess figure whose divine characteristic is accentuated by the halo behind her head. The deity appears very close to another male character whose fragmentary state makes him difficult to identify. However, accepting the idea that another *jātaka* tale might have been represented here, this relief is not without reminding us of one of the most famous *jātaka* included in the *Mahānipātaka* book, the *Mahājanaka-jātaka*. In Southeast Asia, the most evocative scene of this tale appears to be related to the sequence when the bodhisattva is saved, from his wrecked ship, by the sea goddess. This episode was, for example, depicted at Hpetleik (Luce, *OBEP*, pl. 115.b) and at Ananda temples, Pagan (ibid., pl. 324. d).

45 See Madeleine Giteau, *Guide du musée national de Phnom Penh: I. Sculpture*, 1960, pp. 85–6.

46 Or *Mūgapakkha-jātaka*.

47 Bruno Dagens, "Étude sur l'iconographie du Bayon (frontons et linteaux)", *AA* 19, 1969, pp. 132, 142; Vittorio Roveda, *Images of the Gods*, 2005, p. 245, ph. 6. 85.

48 Or *Mahānāradakassapa-jātaka*.

49 Bruno Dagens, ibid, pp. 135, 143; Vittorio Roveda, ibid, p. 255.

50 Vittorio Roveda, ibid, p. 251, ph. 6. 92.

51 Ibid.

52 Bruno Dagens, ibid, p. 126.

53 Another recently discovered inscription, *K. 1297*, dated to the reign of King

Tribhuvanādityavarman, also refers to *jātaka* as the perfection of wisdom that possessed one of the disciples of the king (Arlo Griffiths and Brice Vincent, personal communication).

54 George Cœdès, *Inscriptions du Cambodge*, vol. II, 1942, pp. 170, 178.

55 Peter Skilling, "Jātaka and Paññāsa-jātaka in South-East Asia", *Journal of the Pāli Text* Society 27, 2006, pp. 119–20.

56 Such an event was not mentioned in the description of the Chinese ambassador Zhou Daguan who visited Angkor at the end of the 13th century. See Paul Pelliot, "Mémoires sur les Coutumes du Cambodge", *BEFEO* 2, 1902, pp. 123–79 and *Mémoires sur les coutumes du Cambodge de Tcheou Ta-kouan*, 1951.

57 Paul Pelliot, "Le Fou-nan", *BEFEO* 3, 1903, p. 260.

58 Peter Skilling, ibid., p. 123.

59 Krairiksh, *Buddhist Folk Tales Depicted at Chula Pathon Chedi*, 1974.

60 Nandana Chutiwongs, "Review article on the Jātaka reliefs at Cula Pathon Cetiya", *JSS* 66, no. 1, 1978, pp. 133–51.

61 Artistic influences from Dvāravatī style can be, for example, seen in *nāga*-protected Buddha images dated to the Angkorian period. See Jean-Pierre Gaston Aubert, "Nāga-Buddha Images of the Dvāravatī Period: A Possible Link between Dvāravatī and Angkor", *JSS* 98, 2010, pp. 116–50.

62 Jean Boulbet and Bruno Dagens, "Les sites archéologiques de la région de Bhnaṃ Gūlen (Phnom Kulen)", *AA* 27, 1973, pp. 43–7.

63 However, Jean Boulbet and Bruno Dagens saw in this motif a representation of a "royal chariot" (ibid., for example, p. 47, ph. 133: face A).

64 See Hiram Woodward, "Dvaravati, Si Thep, and Wendan", *Bulletin of the Indo-Pacific Prehistory Association* 30, 2010, pp. 87–97; *The Art and Architecture of Thailand*, 2005, (1st ed. 2003), pp. 104–5.

65 See Jean Boulbet and Bruno Dagens, ibid., ph. 134.

66 See Krairiksh, "Semas with scenes from the *Mahānipāta-Jātaka*", p. 57; see also Stephen A. Murphy, *The Buddhist Boundary Markers of Northeast Thailand and Central Laos, 7th–12th Centuries CE: Towards an Understanding of the Archaeological, Religious, and Artistic Landscapes of the Khorat Plateau*, PhD dissertation, 2010, p. 250 and Fig. 5.47.

67 Jean Boulbet and Bruno Dagens, ibid., pp. 51–2.

68 Stephen A. Murphy, ibid., pp. 157–60.

69 Arunsak Kingmanee, "Baisema Paap salak Witon-jaduk jaak Jangwat Nong Khai" [A Boundary Marker of the *Vidhurapaṇḍita-jātaka* from Nong Khai], *Muang Boran* 24, no. 3, 1998, p. 112.

70 Woodward, H., personal communication. Rungrot Phiromanukun assigns this *sīmā* to the Angkor Wat style (c. 1080–1175): "Bai sema rioeng sibijataka: rongroy buddhasasana mahayana nai phak dawan ook chiang nioeo don pan" [A Sema of the *Sibi-jātaka*: Traces of Mahāyāna Buddhism in the Upper Northeast Region], *Muang Boran* 28, no. 3, 2002, pp. 102–7; "Les bornes rituelles du nord-est de la Thaïlande", in *Dvāravatī: aux sources du bouddhisme en Thaïlande*, Musée Guimet, Fig. 3.

71 Rungrot, "Les bornes rituelles", Fig. 3.

72 Murphy, *The Buddhist Boundary Markers*, p. 230, Fig. 5.16.

73 Stephen A. Murphy, ibid., p. 230.

74 Cf. Stephen A. Murphy, ibid., p. 217.

75 Ibid., Fig. 5.49.

76 Edward Cowell, *The Jātaka, or Stories of the Buddha's Former Births*, Vol. 6, 1907, pp. 281–2.

77 Cf. Hiram Woodward, "Some Buddha Images and the Cultural Developments of the Late Angkorian Period", *Artibus Asiae* 42, 1980, pp. 155–74.

78 Cf. Charlotte Galloway, "Buddhist Narrative Imagery During the Eleventh Century at Pagan, Burma: Reviewing Origins and Purpose", in *Rethinking Visual Narratives from Asia: Intercultural and Comparative Perspectives*, ed. Alexandra Green, 2013, pp. 159–74.

79 See Gordon H. Luce, "The 550 Jātakas in Old Burma", *Artibus Asiae* 19, no. 3–4, 1956, pp. 291–307.

80 Gordon H. Luce, *Old Burma-Early Pagan*, vol. 1, 1969, p. 241.

81 Donald M. Stadtner, *Ancient Pagan: Buddhist Plain of Merit*, 2005, p. 129.

82 Scenes of *jātaka* were also illustrated in relief at the Buddhist temple of Borobudur, in central Java, dated to the eighth to ninth centuries.

83 Jean Boisselier, "Travaux de la mission archéologique française en Thaïlande (juillet–novembre 1966)", *AA* 25, 1972, p. 50.

84 Pe Maung Tin and Gordon H. Luce, trans., *The Glass Palace Chronicle of the Kings of Burma*, 1960, (1st ed. 1923).

85 George Cœdès, *Les États hindouisés d'Indochine et d'Indonésie*, 1964, p. 323.

86 Pe Maung Tin and Gordon H. Luce, *The Glass Palace Chronicle*, p. ix.

87 Tilman Frasch, "Die Welt des Buddhismus im Jahre 1000", in *Asiem im Jahre 1000*, ed. Kulke Hermann, 2000, pp. 104–5.

88 Ian Harris, *Cambodian Buddhism: History and Practice*, 2005, p. 23.

89 George Cœdès, *The Indianized States of Southeast Asia*, trans. Sue Brown Cowing, 1968, p. 173.

90 Hiram Woodward, "Tantric Buddhism in Angkor Thom", *Ars Orientalis* 12, 1981, pp. 62–3.

91 Later, in Southeast Asia (Cambodia, Thailand and Laos), with regards to pre-modern and modern Buddhist mural paintings, the artist appears to have usually painted this *jātaka* in 13 sequences referring to the 13 chapters of the textual content. On the other hand, the narration of the *Vessantara-jātaka* on the painted scrolls in northeast Thailand and Laos has been mostly composed of more than 13 scenes – the tale of *Braḥ Mālay*, the legendary monk, and the dedication panel related to the merit made by the scroll's donation precede the episodes (Leedom Lefferts and Sandra Cate, "Narration in the Vessantara Painted Scrolls of Northeast Thailand and Laos", in *Readings of the Vessantara Jātaka*, ed. Steven Collins, 2016, p. 129).

92 Gordon H. Luce, ibid., vol. 3, pl. 322: e, f. Another carving stele, also at the cross passages, probably figures Prince Vessantara with his wife and mother giving away horses and elephants (ibid., pl. 322: d; Gordon H. Luce, ibid., vol. 2, pp. 147–8).

93 Gordon H. Luce, ibid., vol. 3, pl. 110: b.

94 As in the discussion above, it might have been in the *Mahābhārata* text, or in Buddhist common folk tales, that the Khmer illustrator extracted this story.

95 Louis Finot and Victor Goloubew, "Le symbolisme de Nak Pan", *BEFEO* 23, 1923, pp. 401–5. See also Jean Boisselier, "Pouvoir royal et symbolisme architectural: Neak Pean et son importance pour la royauté angkorienne," *AA* 21, 1979, pp. 91–108.

96 No. 196 (Edward Cowell, *The Jātaka or The Jātaka, or Stories of the Buddha's Former Births*, vol. 2, pp. 89–91. In the Pāli version, the marvellous horse is the Buddha himself in his previous existence.

97 Cf. Peter Alan Roberts with Tulku Yeshi, trans., *The Basket's Display: Kāraṇḍavyūha*, 2013, pp. 46–9, (PDF version).

98 It has been attested that one of the principal purposes of the Burmese king Kyanzittha in figuring the whole of Pāli *jātaka* at Ananda temple might have been related to his desire of purity and completeness of the Buddhist texts as known in the Theravāda Buddhism of Ceylon (Robert L. Brown, "Narrative as Icon: The Jātaka Stories in Ancient Indian and Southeast Asian Architecture", in *Sacred Biography in the Buddhist Traditions of South and Southeast Asia*, ed. Juliane Schober, 1997, p. 89).

99 During the reign of Jayavarman VII, the figure of Avalokiteśvara, the bodhisattva of compassion largely worshipped in Mahāyāna Buddhism, had an important role as the king seemed to favour this Buddhist sect, in particular.

100 In Southeast Asia, the use of certain Pāli sources in the illustration of *jātaka* tales has been attested since the second half of the first millennium of the Common Era, including the so-called Dvāravatī culture and Borobudur. For the former, see Piriya Krairiksh, *Buddhist Folk Tales Depicted at Chula Pathon Chedi*, 1974. For the latter, see Padmanabh Jaini, "The Story of Sudhana and Manoharā: An Analysis of Texts and the Borobudur Reliefs", in *Collected Papers on Buddhist Studies*, ed. Padmanabh S. Jaini, 2001, pp. 207–329.

101 In the absence of legends inscribed to identify the story, the artist ought to ensure that significant details from the oral or textual content can be quickly captured by the reader. In Cambodia, the same procedure was largely and efficiently developed in modern Buddhist murals which were addressed to a mostly illiterate population.

102 No. 499 (Edward B. Cowell, *The Jātaka or Stories of the Buddha's Former Births*, vol. 4, 1901, pp. 250–6).

103 P. S. Dhamarama with André Bareau, "Les récits canoniques du Cariyāpiṭaka et les Jātaka pāli", *BEFEO* 51, 1963, pp. 335–6.

104 But, this same story is also found in the *Jātakamālā* of Ārya-Śūra (J. S. Speyer, *Jātakamālā or Garland of Birth-Stories*, 1895, pp. 13–27).

105 Cf. Charles Willemen, trans., *Buddhacarita: In Praise of Buddha's Acts*, 2009, p. 100.

106 Pratap Chandra Roy, *The Mahabharata of Krishna-Dwaipayana Vyasa*, vol. 3, 1974, pp. 425–6.

107 Such an idea might be found, for example, in the context of the so-called Dvāravatī culture as Chutiwongs has described regarding the *jātaka* stories figured at Cula Pathon *stūpa*: "Jātaka stories in general are non-sectarian and timeless motifs in Buddhist art, and each and every tale depicted at Cula Pathon displays such characteristics" (Nandana Chutiwongs, "Review Article on the Jātaka Reliefs at Cula Pathon Cetiya", *JSS* 66, no. 1, 1978, pp. 141–2).

108 Paul Schweisguth, *Étude sur la littérature siamoise*, 1951, p. 128. It is also important to add the fact that the Pāli version of the *Vessantara-jātaka* offers the longest version of the story (1,000 verses), also the longest comparing with other *jātaka* of the same recension, while the Sanskrit texts, especially the *Jātaka-mālā*, do not seem to accord any particular status to this tale.

109 See Than Tun, "History of Buddhism in Burma A.D. 1000–1300", *Journal of the Burma Research Society* 61, no. 1–2, 1978, pp. 85–6.

110 Tilman Frasch, "A Buddhist Network in the Bay of Bengal", in *From the Mediterranean to the China Sea: Miscellaneous Notes*, eds. Claude Guillot, Denys Lombard and Roderich Ptak, 1998, p. 85.

111 Ibid.

112 The real existence of Tāmalinda, thought to be a son of Jayavarman VII, remains contestable.

113 Cf. *IMA* 34 (Saveros Pou, "Inscriptions Modernes d'Angkor 34 et 38", *BEFEO* 62, 1975, pp. 284–93).

114 Cf. *IMA* 37 (Saveros Pou, "Inscriptions Modernes d'Angkor 35, 36, 37 et 39", *BEFEO* 61, 1974, pp. 308–18). In Buddhist Southeast Asia, the textual recitation of the *Vessantara-jātaka* could last several days and necessitates the participation of the whole village. Sometimes this reading could also be accompanied by a spectacular theatrical *mise-en-scène* as seen in Northeast Thailand. There, the Thai-Lao community celebrates each year the Festival of the Reading of the *Vessantara-jātaka*, the most important merit-making ceremony, during which villagers and monks perform certain episodes of the story. For this topic, see cf. Bernard Formoso, "Le bun pha Wet des Lao du nord-est de la Thaïlande", *BEFEO* 79, 1992, pp. 233–260; Leedom Lefferts, "The "Bun Pha Wet" Painted Scrolls of Northeastern Thailand in the Walters Art Museum", *The Journal of the Walters Art Museum* 64/65, 2006/07, pp. 149–170; Leedom Lefferts and Sandra Cate, "Constructing Multiple Narratives in Theravada Buddhism: The Vessantara Painted Scrolls of Northeast Thailand and Lowland Laos", in *Rethinking Visual Narratives from Asia: Intercultural and Comparative Perspectives*, ed. Alexandra Green, 2013, pp. 229–43.

115 *IMA* 5 (Saveros Pou, "Inscriptions Modernes d'Angkor 4, 5, 6 et 7", *BEFEO* 58, 1971, pp. 105–23).

116 Saveros Pou, "Inscriptions Modernes d'Angkor".

117 Madeleine Giteau, *Iconographie du Cambodge post-angkorien*, 1975.

118 Ibid., pp. 207–14.

119 In Cambodia, at the beginning of the 20th century, during recitations of the *Vessantara-jātaka*, sobbing could be heard from women and children in the audience (see Adhémard Leclère, *Le livre de Vésandâr. Le roi charitable*, 1902).

References

Arunsak Kingmanee. "Baisema Paap salak Witon-jaduk jaak Jangwat Nong Khai" [A Boundary Marker of the *Vidhurapaṇḍita-jātaka* from Nong Khai]. *Muang Boran* 24, no. 3, 1998: pp. 107–12. (In Thai with English summary.)

Bandaranayake, Senake. *Sinhalese Monastic Architecture: The Viháras of Anurádhapura*. Leiden: Brill, 1974.

Baptiste, Pierre and Thierry Zéphir. *L'Art khmer dans les collections du musée Guimet*. Paris: Éditions de la Réunion des musées nationaux, 2008.

Bénisti, Mireille. "Notes d'iconographies khmère: I. Deux scènes nautiques". *BEFEO* 51, 1963: pp. 95–8.

Boisselier, Jean. *Asie du Sud-Est, I. Le Cambodge*. Paris: Picard, Manuel d'Archéologie d'Extrême-Orient, 1966.

———. "Běng Mālā et la chronologie des monuments du style d'Angkor Vat". *BEFEO* 46, no. 1, 1952: pp. 187–226.

———. "Pouvoir royal et symbolisme architectural. Neak Pean et son importance pour la royauté angkorienne". *AA* 21, 1979, pp. 91–108.

———. "Récentes recherches à Nakhon Pathom". *JSS* 58, no. 2, July 1970, pp. 55–65.

———. "Travaux de la mission archéologique française en Thaïlande (juillet–novembre 1966)". *AA* 25, 1972: pp. 27–90.

Boulbet, Jean, and Bruno Dagens. "Les sites archéologiques de la région de Bhnaṃ Gūlen (Phnom Kulen)". *AA* 27, 1973, numéro spécial.

Brown, Robert L. "Narrative as Icon: The Jātaka Stories in Ancient Indian and Southeast Asian Architecture". In *Sacred Biography in the Buddhist Traditions*

of South and Southeast Asia, ed. Juliane Schober. Honolulu: University of Hawai'i Press, 1977, pp. 64–109.

Bruguier, Bruno and Juliette Lacroix. *Guide archéologique du Cambodge, Vol. 5: Preah Khan, Koh Ker et Preah Vihear: les provinces septentrionales.* Phnom Penh: Japan Printing House Co. Ltd., 2013.

Chutiwongs, Nandana. "Review article on the Jātaka reliefs at Cula Pathon Cetiya". *JSS* 66, no. 1, 1978: pp. 133–51.

Cowell, Edward B. *The Jātaka, or Stories of the Buddha's Former Births*, 6 vols. Cambridge: Cambridge University Press, 1895–1907.

Cœdès, George. *Inscriptions du Cambodge*, vol. 2. Paris: EFEO, 1942.

———. *Les États hindouisés d'Indochine et d'Indonésie*. Paris: De Boccard, 1964.

———. "Note sur l'iconographie de Běng Mālā". *BEFEO* 13, 1913: pp. 23–8.

Dagens, Bruno. "Autour de l'iconographie de Phimai". In *Actes du Premier Symposium franco-thaïlandais: La Thaïlande des origines de son histoire au XVème siècle. Bangkok juillet 1988*. Bangkok, 1995, pp. 17–37.

———. "Étude sur l'iconographie du Bayon (frontons et linteaux)". *AA* 19, 1969: pp. 123–67.

Dhamarama, P. S. and André Bareau. "Les récits canoniques du Cariyāpiṭaka et les Jātaka pāli. Traduction du Cariyāpiṭaka". *BEFEO* 51, no. 2, 1963: pp. 321–90.

Dupont, Pierre. *L'archéologie mône de Dvāravatī*, 2 vols. Paris: EFEO, 1959.

Duroiselle, Charles. "Pictorial Representations of Jātakas in Burma". *Archaeological Survey of India*, 1912–13, pp. 87–116.

———. "The Talaing Plaques on the Ananda Temple at Pagan". *Epigraphia Birmanica being Lithic and Other Inscriptions of Burma* 2, 1920, part 1.

Finot, Louis and Victor Goloubew. "Le symbolisme de Nak Pan". *BEFEO* 23, 1923: pp. 401–5.

Fontein, Jan. "Notes on the Jātakas and Avadānas of Barabuḍur". In *Barabudur: History and Significance of a Buddhist Monument*, eds. Louis O. Gomez and Hiram W. Woodward. Berkeley: Asian Humanities Press, 1981, pp. 85–108.

Formoso, Bernard. "Le bun pha We:t des Lao du nord-est de la Thaïlande". *BEFEO* 79, 1992: pp. 233–60.

Frasch, Tilman. "A Buddhist Network in the Bay of Bengal". In *From the Mediterranean to the China Sea: Miscellaneous Notes*, eds. Claude Guillot, Denys Lombard and Roderich Ptak. Wiesbaden: Harrassowitz Verlag, 1998, pp. 69–92.

———. "Die Welt des Buddhismus im Jahre 1000". In *Asiem im Jahre 1000*, ed. Kulke Hermann. 2000, pp. 56–72.

Frédéric, Louis and Jean-Louis Nou. *Borobudur*. Paris: Imprimerie nationale, 1984.

Galloway, Charlotte. "Buddhist Narrative Imagery During the Eleventh Century at Pagan, Burma. Reviewing origins and purpose". In *Rethinking Visual Narratives from Asia: Intercultural and Comparative Perspectives*, ed. Alexandra Green. Hong Kong: Hong Kong University Press, 2013, pp. 159–74.

Gaston-Aubert, Jean-Pierre. "Nāga-Buddha Images of the Dvāravatī Period: A Possible Link between Dvāravatī and Angkor". *JSS* 98, 2010: pp. 116–50.

Giteau, Madeleine. *Guide du musée national de Phnom Penh. I. Sculpture*. Phnom Penh: Office national du tourisme, 1960.

———. *Iconographie du Cambodge post-angkorien*, Paris: EFEO, 1975.

Griffith, Arlo and Brice Vincent. "Un vase khmer inscrit de la fin du xie siècle (K. 1296)". *AA* 69, 2014: pp. 115–28.

Groslier, Bernard-Philippe. *Le Preah Khan de Kompong Svay*, 3 vols. PhD dissertation, Paris: École du Louvre, 1967.

Handlin, Lilian. "A Man for All Seasons: Three *Vessantaras* in Premodern Myanmar". In *Readings of the Vessantara Jātaka*, ed. Steven Collins. New York: Columbia University Press, 2016.

Harris, Ian. *Cambodian Buddhism: History and Practice*. Hawai'i: University of Hawai'i Press, 2005.

Hawixbrock, Christine. *Population divine dans les temples. Religion et Politique sous Jayavarman VII*, 2 vols. PhD dissertation, Paris: Université de la Sorbonne Nouvelle-Paris 3, 1994.

Hendrickson, Mitch. *Arteries of Empire: An Operational Study of Transport and Communication in Angkorian Southeast Asia (9th to 15th Centuries CE)*. PhD dissertation, Sydney: University of Sydney, 2007.

Huber, Edouard. "Études indochinoises". *BEFEO* 11, 1911: pp. 1–5.

Jaini, Padmanabh S. "The Story of Sudhana and Manoharā: An Analysis of Texts and the Borobudur Reliefs". In *Collected Papers on Buddhist Studies*, ed. Padmanabh S. Jaini. Delhi: Motilal Banarsidass Publishers, 2001, pp. 207–329.

Krairiksh, Piriya. *Buddhist Folk Tales Depicted at Chula Pathon Chedi*. Bangkok: Prachandra Printing Press, 1974a.

———. *The Chula Pathon Cedi: Architecture and Sculpture of Dvāravatī*. PhD dissertation, Cambridge, Massachusetts: Harvard University, 1975.

———. "Semas with scenes from the *Mahānipāta-Jātaka* in the National Museum at Khon Kaen". In *Art and Archeology in Thailand*, Fine Arts Department, 1974b, pp. 35–65.

Lan Sunnary. "Étude iconographique du temple khmer de Thommanon (Dhammānanda)". *AA* 25, 1972: pp. 155–98.

Leclère, Adhémard. *Le livre de Vésandâr. Le roi charitable*. Paris: Ernest Leroux, 1902.

Lefferts, Leedom. "The 'Bun Pha Wet' Painted Scrolls of Northeastern Thailand in the Walters Art Museum". *The Journal of the Walters Art Museum* 64/65, 2006/07: pp. 149–70.

Lefferts, Leedom and Sandra Cate. "Constructing Multiple Narratives in Theravada Buddhism: The Vessantara Painted Scrolls of Northeast Thailand and Lowland Laos". In *Rethinking Visual Narratives from Asia: Intercultural and Comparative Perspectives*, ed. Alexandra Green. 2013, pp. 229–43.

Lu Pi Win. "The Jātakas in Old Burma". *Artibus Asiae* 2, 1966: pp. 94–108.

Luce, Gordon H. "The 550 Jatakas in Old Burma". *Artibus Asiae* 19, no. 3–4, 1956: pp. 291–307.

———. *Old Burma-Early Pagan*, 3 vols. New York: J. J. Augustin, 1969.

Marchal, Henri. "Note sur la forme du stūpa au Cambodge". *BEFEO* 44, 1951: pp. 581–90.

Murphy, Stephen A. *The Buddhist Boundary Markers of Northeast Thailand and Central Laos, 7th–12th Centuries CE: Towards an Understanding of the Archaeological, Religious, and Artistic Landscapes of the Khorat Plateau*. PhD dissertation, London: SOAS University of London, 2010.

Pe Maung Tin and Gordon H. Luce. *The Glass Palace Chronicle of the Kings of Burma*. Rangoon, Rangoon University Press, 1960. First edition, 1923.

Pelliot, Paul. "Le Fou-nan." *BEFEO* 3, 1903. (Extract.)

———. "Mémoires sur les Coutumes du Cambodge". *BEFEO* 2, 1902: pp. 123–79.

———. *Mémoires sur les coutumes du Cambodge de Tcheou Ta-kouan*. Paris: Adrien Maisonneuve, 1951.

Pou (aka Lewitz), Saveros. "Inscriptions Modernes d'Angkor 4, 5, 6 et 7". *BEFEO* 58, 1971: pp. 105–23.

————. "Inscriptions Modernes d'Angkor 35, 36, 37 et 39". *BEFEO* 61, 1974: pp. 301–37.

————. "Inscriptions Modernes d'Angkor 34 et 38". *BEFEO* 62, 1975: pp. 283–353.

Provost-Roche, Ludivine. *Les derniers siècles de l'époque angkorienne au Cambodge (env. 1220–env. 1500)*. PhD dissertation, Paris: Université de la Sorbonne Nouvelle-Paris 3, 2010.

Roberts, Peter Alan and Tulku Yeshi. *The Basket's Display: Kāraṇḍavyūha*, 84000, 2013. (PDF version, translated.)

Roveda, Vittorio. *Images of the Gods: Khmer Mythology in Cambodia, Thailand and Laos*. Bangkok: River Books, 2006.

————. *Khmer Mythology*. Bangkok: River Books, 1997.

Roy, Pratap Chandra. *The Mahabharata of Krishna-Dwaipayana Vyasa: Translated into English Prose from the Original Sanskrit Texts*, 3 vol. Calcutta: Oriental Publishing Co., 1974.

Rungrot Phiromanukun. "Bai sema rioeng sibijataka: rongroy buddhasasana mahayana nai phak dawan ook chiang nioeo don pan" [A Sema of the *Sibi-jātaka*: Traces of Mahāyāna Buddhism in the Upper Northeast Region]. *Muang Boran* 28, no. 3, 2002: pp. 102–7. (In Thai.)

————. "Les bornes rituelles du nord-est de la Thaïlande". In *Dvāravatī: aux sources du bouddhisme en Thaïlande*. Paris, Réunion des musées nationaux, Musée Guimet, 2009, pp. 97–104.

Schweisguth, Paul. *Étude sur la littérature siamoise*. Paris: Imprimerie Nationale, 1951.

Siyonn, Sophearith. "Caṃlak rūp tā jūjak' nau prāsād dhammnand" [Jūjak's relief at Thommanon temple]. In *KhmeRenaissance* 1, December 2005–6: pp. 102–3. (In Khmer.)

Skilling, Peter. "Jātaka and Paññāsa-jātaka in South-East Asia". *Journal of the Pāli Text Society* 28, 2006: pp. 113–73.

Speyer, J. S. *Jātakamālā or Garland of Birth-Stories*. Paris: Imprimerie Nationale, 1895.

Stadtner, Donald M. *Ancient Pagan: Buddhist Plain of Merit*. Bangkok: River Books, 2005.

Than Tun. "History of Buddhism in Burma A.D. 1000–1300". *Journal of the Burma Research Society* 61, no. 1–2, 1978: pp. 1–266.

Vincent, Brice. *Saṃrit: Étude de la Métallurgie du Bronze dans le Cambodge angkorien (fin du xie–début du xiiie siècle)*, 2 vol. PhD dissertation, Paris: Université Sorbonne Nouvelle-Paris 3, 2012.

Weiner, Sheila L. "Notes on Buddhist Art". *Journal of the American Oriental Society* 18, 1897: pp. 196–201.

Willemen, Charles. *Buddhacarita: In Praise of Buddha's Acts*. Berkeley: Numata Center for Buddhist Translation and Research, 2009. (Translated.)

Woodward, Hiram W., Jr. *The Art and Architecture of Thailand*. Leiden & Boston: Brill, 2005.

————. "Dvaravati, Si Thep, and Wendan". *Bulletin of the Indo-Pacific Prehistory Association* 30, 2010: pp. 87–97.

————. "Esoteric Buddhism in Southeast Asia in the Light of Recent Scholarship". *Journal of Southeast Asian Studies* 35, no. 2, June 2004: pp. 329–54.

————. "Some Buddha Images and the Cultural Developments of the Late Angkorian Period". *Artibus Asiae* 42, 1980: pp. 155–74.

————. "Tantric Buddhism in Angkor Thom". *Ars Orientalis* 12, 1981: pp. 57–67.

Wu Ming-Kuo. *The Jataka Tales of the Mago Caves: China in Anthropological Perspective*. PhD dissertation, Washington: Washington State University, 2008.

THE BUDDHA SCULPTURES OF THAM PHRA (BUDDHA CAVE): IMPLICATIONS FOR UNDERSTANDING THE COMPLEX RELIGIOUS ATMOSPHERE OF WESTERN THAILAND DURING THE EARLY SECOND MILLENNIUM CE

Samerchai Poolsuwan

INTRODUCTION

Situated about 30 metres above ground level on the eastern slope of a low mountain range – lying approximately on the northwest–southeast axis in Don-sai sub-district, Pak-tho district, Ratchaburi province, western Thailand (N: 13.367; E: 99.800) – is Tham Phra (Buddha Cave), a sacred landmark after which the mountain is also named (Map 4.1, p. 168). Now easily reached by car, the cave is located only a few kilometres down a side road from the main Phetchakasem highway. Enshrined in a wooden pavilion situated in the cave's hall are Buddha sculptures of various sizes and ages. For generations, they have been much venerated, and thus watched over, by local people in the area. Identified ethnically as "Khmer-Lao" (a mixture of Khmer and Lao), these locals speak a Lao dialect into which a considerable number of Khmer loanwords have been incorporated. The ancestors of the group were prisoners of war, forced to move from Cambodia to inhabit the Ratchaburi area during the Thonburi period (second half of the 18th century).[1] The Tham Phra shrine would have already been in existence at the time of the arrival of these newcomers, thus leaving its history unknown to them.

The shrine comprises a group of old wooden sculptures, currently 14 in number, which is a focus of this study, together with several original

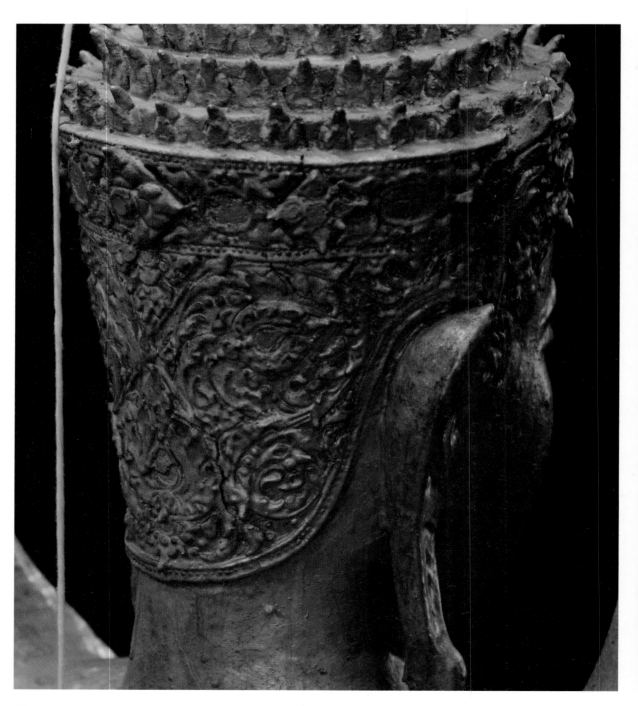

4.1

sandstone sculptures of the seated Buddha dating from the Ayutthaya period (c. 15th to 17th centuries). Other Buddha images made of brass and wood were added to this cave-shrine at much later times. Located in front of the wooden pavilion is a seated sculpture of the bejewelled Buddha made in situ of brick and stucco. Although having been much renovated in later times, the image still maintains some of its original stucco motifs, particularly on the back of the Buddha's crown and on his richly decorated pedestal, which are definitely of the 17th-century Ayutthaya style (Fig. 4.1). They provide solid proof for the cave's function as a Buddhist shrine at least since that time.

Although of different sizes and styles, the majority of Tham Phra's wooden sculptures of focus here form a coherent group that share some common characteristics: a particular style of lotus pedestal, the unique facial characteristics of several images, and the flat unfinished back side – implying that they were intended to be viewed mainly from the front. The shared characteristics suggest that most, if not all, of the images were contemporaneous and probably carved by the same group of sculptors for enshrinement with their backs set against a blind wall of the cave. A similar degree of weathering observed on the lower part of the sculptures suggests their previous placement in a damp place, probably on the cave's earthen or brick floor, for a considerable period of time. Each of these images, ranging from slightly less than half to about twice life-size, was carved of a single block of teak wood, a material readily available in the vicinity of the site. Accumulation in a single place of a considerable number of sizeable Buddha sculptures, made of locally available material and sharing some outstanding common characteristics, favours interpretation of the images' production by a single local workshop for the Tham Phra shrine.

The wooden sculptures can be classified stylistically in four groups:

Group I: A set of four sculptures of the bejewelled Māravijaya Buddha showing strong affiliation with the original Pāla prototype of northeastern India and its derivatives widely discovered in Southeast Asia.

Group II: A pair of standing figures of the bejewelled Buddha, both hands raised in *abhayamudrā*, in close association with the 12th-century Khmer Angkor Wat style.

Group III: A set of four standing Buddha figures, both hands raised in *abhayamudrā*, with their style probably inspired by both Khmer and Pagan arts.

Group IV: A set of four seated figures of the Māravijaya Buddha, showing mixed Khmer and Pagan characteristics.

Fig. 4.1 Original stucco decoration of the 17th-century style on the bejewelled Buddha sculpture in Tham Phra. Photograph by author.

Being puzzled by the unconventional combination of their styles – related to various ancient Buddhist arts during the late first and early second millennia – one might question the authenticity of these enigmatic images. The exact history of the wooden sculptures, now dominating Tham Phra's shrine as its central objects of worship, is practically unknown. The shrine itself is an ancient one, with its existence already proven to at least since the 17th century. In later history, the wooden sculptures of Tham Phra were mentioned in *Samut Rātchaburī* (a book describing Ratchaburi), published in 1925,[2] as being of ancient age; they had been much venerated, so kept undisturbed, by local people. The document certainly confirms that Tham Phra's wooden images were not modern forgeries and had been enshrined there since long before the 20th century.

Whether the images might be a product of a later period, that is, long after the early centuries of the second millennium but certainly pre-dating the 1900s, is another matter of concern. One can reasonably doubt the possibility of anyone in old Siam, before advances in the modern disciplines of archaeology and art history, having simultaneous access to the much older sculptural prototypes of various schools of Buddhist art in order to faithfully reproduce or combine them in a fashion such that is found among the Tham Phra wooden images. Included in the cave-shrine are also a number of traditional Ayutthaya-period Buddha sculptures of styles truly distant from the set of wooden sculptures of concern. Comprising several sandstone sculptures, one of a colossal size, and the in situ constructed brick-and-stucco bejewelled image already mentioned, they confirm that the Ayutthaya sculptors of Tham Phra adopted conventional styles of their period, from the 15th to 17th centuries, for creation of the sacred sculpture of the group; it is thus unlikely that they were also responsible for creation of the wooden images in question.

On these logical bases, Tham Phra's wooden sculptures could be genuinely old, with their date and styles broadly contemporaneous. Provided in this chapter is a detailed stylistic analysis of this significant group of wooden images. The complex cultural and religious milieus of Western Thailand in which they were created, probably during the third quarter of the 12th century, are also discussed.

THAM PHRA BUDDHA SCULPTURES

Siam's Fine Arts Department announced its first list of the country's registered archaeological sites, categorised by province, in 1935. Representing Ratchaburi in the list[3] – along with the other three significant sites of the province: Wat Mahāthāt,[4] Tham Ruesi (Hermit Cave)[5] and Phong Tuek[6] – was Tham Phra. According to local

informants, Luang Wichitwāthakān, the first director general of the department, visited the site, probably shortly after his appointment in 1934. Guided to the cave-shrine by local people, he was astonished by the wooden Buddha sculptures, which he believed to be of great antiquity and archaeological significance. However, neither descriptive details nor photographs of the site and its Buddha images were found in the department's records from that time.

A later photograph of the Tham Phra shrine, taken some time during the mid 20th century (Fig. 4.2), shows several Buddha images assembled together in a tiered-roof pavilion made of wood, with only some of the currently known wooden sculptures of our focus shown. The other wooden sculptures of the group, as well as several Ayutthaya-style sandstone sculptures, could have been placed elsewhere in the cave at that time. The bejewelled Buddha sculpture of the late Ayutthaya style seen on the pavilion's front still maintained much of its original form and decoration, it would be considerably altered in subsequent renovations. According to local informants, the wooden pavilion was constructed for the cave's shrine during the 1950s by Luangpho Son, a senior monk said to come from Cambodia. This monk also established a monastery, now named Wat Tham Phra Manimongkhon, to be associated with the cave;

Fig. 4.2 The mid 20th century photograph of the Tham Phra shrine, showing Buddha images assembled in a wooden pavilion (duplicated from the miniature photo made as an amulet by the Tham Phra monastery during the 1950s, property of the author).

4.2

this was shortly before his renovation of the cave's shrine and restoration of its damaged Buddha sculptures, including the wooden ones. Before Luangpho Son's time, Tham Phra was an isolated place in the jungle. In one instance at the site, a nun who was in retreat there for meditation was killed by a tiger. The difficult access to the site during the rainy season was emphasised in *Samut Rātchaburī*.

Shown in the photograph, taken soon after the completion of the wooden pavilion, are six of the seated images and the same number of the standing ones of the wooden group, together with some Ayutthaya-period sandstone sculptures of the Buddha. The standing image to the far left of the composition has disappeared and one of a pair of the bejewelled Buddha sculptures in standing pose, now placed in the pavilion, is not shown. This means Tham Phra's wooden images in standing posture numbered at least seven during the mid 20th century. All the old sculptures of the Tham Phra shrine have been, during past decades, repaired and repeatedly coated with synthetic gold paint, thus creating the modern-looking appearance of the group now.

Group I Sculptures

Tham Phra's Group I includes sculptures of varying sizes: a colossal one that is 1.85 metres high (Fig. 4.3; Sculpture 1.1); two medium-sized sculptures approximately 1 metre in height (Figs. 4.4 & 4.5; Sculptures 1.2 & 1.3); and the smallest one with a height of about 80 centimeters (Fig. 4.6; Sculpture 1.4). They show stylistic similarities with the Pāla prototype from Northeastern India and the Bengal area, dating from the 8th to 12th centuries, and also with its derivatives found in Upper Burma at Pagan, Lower Burma and Haripunjaya in Northern Thailand, all broadly dating from the early second millennium.

The Buddha of this group has angled eyebrows that join over a sharp small nose, the tip of which is slightly pointing down. The eyes, mildly slanted and protruding, are half-closed and downcast. The Buddha has an oval-shaped face, broad forehead, prominent cheekbones, projecting chin and elongated earlobes. The mouth, showing a gentle smile, has a much fuller lower lip than upper lip. These characteristics yield a facial appearance of the Buddha basically similar to the early Pagan type typical of the late 11th and early 12th centuries. Comparable early Pagan examples can be seen among stone sculptures of the Buddha in high relief from the Patho-hta-mya, Ananda, Myinkaba Kubyauk-gyi and Nagayon temples, in Pagan.[7] A major difference between the Tham Phra and Pagan examples concerns the more V-shaped mouth observed in the Pagan sculptures.

The Buddha is seated in a typical *vajrāsana* pose on a tall pedestal shaped as a blooming lotus flower. The lotus petals point both upwards

Fig. 4.3 Sculpture 1.1 (centre of back row), a bejewelled Māravijaya Buddha of the Pāla-related type. Photograph by author.

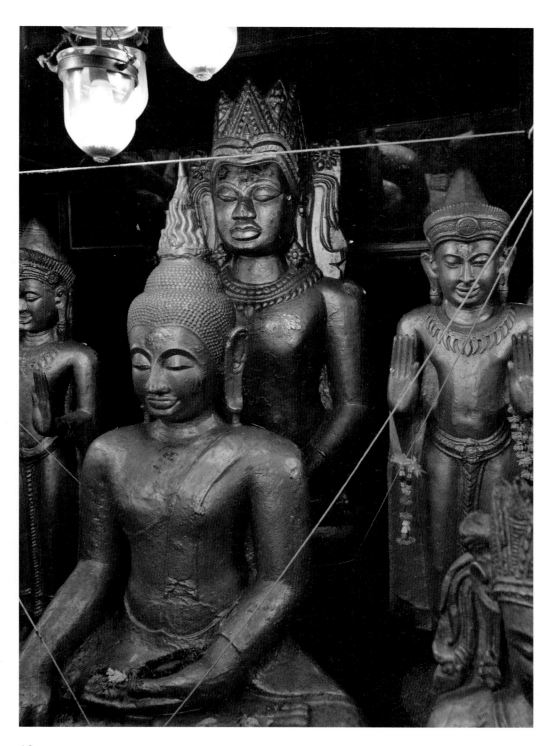

4.3

and downwards and are alternately arranged in two laminated rows. Contained in each lotus petal is an incised line running parallel to the external outline; its top part is curved on both sides to form a V-shape in between them. A row of stamens, protruding from the row of upward pointing lotus petals, adorns the pedestal's upper rim. The recessed waist of each pedestal in the group is either left plain (Sculpture 1.4) or decorated (Sculptures 1.1–1.3). In the latter case, it comprises a single prominent V-shaped ring (Sculptures 1.1 & 1.2) or a series of horizontal bands symmetrically arranged to highlight the central ring (Sculpture 1.3). This type of pedestal, with the exception of its waist decoration, conforms to the typical style widely adopted in the Buddhist arts of South and Southeast Asia during the late first and early second millennia. Decorating the recessed waist of a lotus pedestal with a protruding ring is a characteristic also observed in some Khmer bronzes of the late 12th and early 13th centuries,[8] and in the Haripunjaya votive tablets probably dating from the early 13th century.[9] Sculpture 1.1's pedestal shows another modification of the style. Its upper part contains three laminated rows of upward pointing lotus petals; there is no incised line running parallel to the external outline of each petal (Fig. 4.7). The lower part of Sculpture 1.4's pedestal has been partially cut off, probably due to wood decay.

Fig. 4.4 Sculpture 1.2, a bejewelled Māravijaya Buddha of the Pāla-related type. Photograph by author.

Fig. 4.5 Sculpture 1.3, a bejewelled Māravijaya Buddha of the Pāla-related type. Photograph by author.

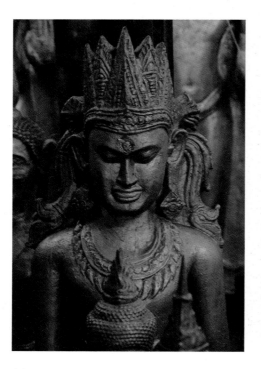

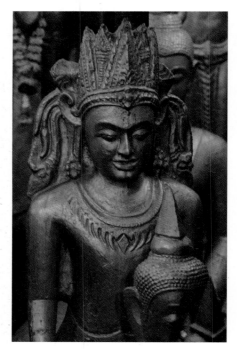

4.4 4.5

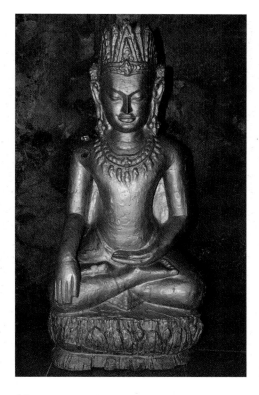

4.6

Fig. 4.6 Sculpture 1.4, a bejewelled
Māravijaya Buddha of the
Pāla-related type.
Photograph by author.

Fig. 4.7 Lotus pedestal of Sculpture
1.1. Photograph by author.

4.7

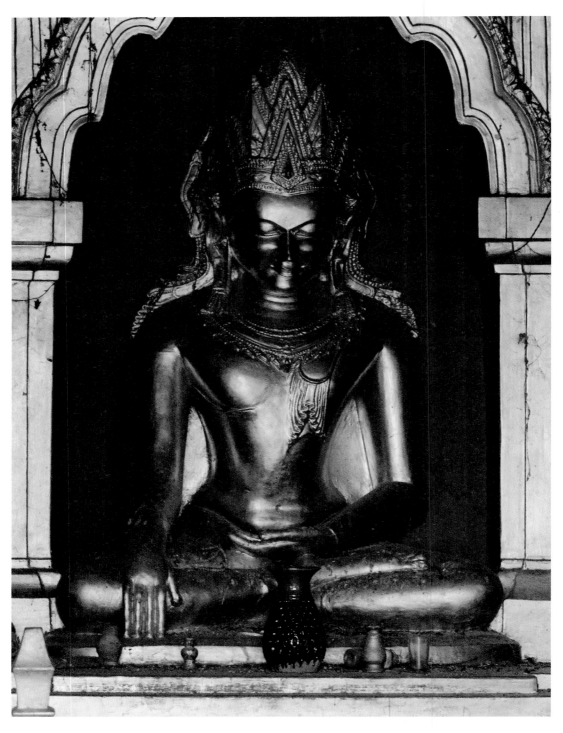

4.8

The Buddha wears a pointed crown of the Indian-Pāla or Burmese-Pagan type, broadly dating from the late first to early second millennia. His diamond rosette earrings also conform to the mentioned prototypes. The Buddha's crown comprises a diadem supporting five wide decorative triangles that are symmetrically arranged, three in front and two behind. The diadem, with a diamond rosette at its centre, is richly decorated with repeated motifs of the type frequently seen on Khmer bronze sculpture of the bejewelled Buddha from the 12th and 13th centuries.[10] Bordering the richly decorated triangular parts of the Buddha's crown is a row of repeated bud-like motifs, which can find its exact parallel, in the same decorative context, on the early 12th-century Pagan stone sculpture of the bejewelled Māravijaya Buddha now at the Ananda Temple (Fig. 4.8). Tied to the Buddha's crown at its back are ribbon knots, the upper parts of which protrude symmetrically behind the Buddha's temples, while the lower parts fall naturally over the shoulders. These ribbon knots are not fully shown, however, on Sculpture 1.4. The Buddhas of Sculptures 1.2 and 1.4 wear necklaces with central bands decorated with repeated motifs of the same type as that found on the Buddha's diadem. Dangling from the lower rim of the necklaces is a row of curved conical pendants, which are comparable to both the early 12th-century Khmer and the contemporary Pagan prototypes. Cruder decoration is observed on the Buddhas' necklaces of Sculptures 1.1 and 1.3.

Fig. 4.8 Bejewelled Māravijaya Buddha of the Pāla-related type, Ananda-gu-hpaya-gyi temple, Pagan. Photograph by author.

Fig. 4.9 Bejewelled Māravijaya Buddha of the Pāla-related type, Shwezayan Pagoda Museum, Thaton. Photograph courtesy Donald M. Stadtner.

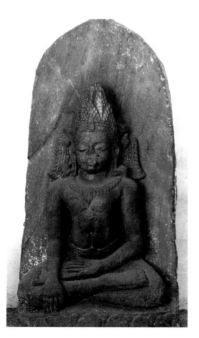

4.9

Unlike the Pāla and Pagan examples, in which a crowned Buddha in the *māravijaya* pose usually wears a monastic garment covering the left shoulder but leaving the right shoulder bare, Tham Phra's crowned Buddha wears a monastic garment that completely covers both shoulders. Lying on the plinth between the Buddha's crossed legs are the overlapping hems of his garments, which create a V-shaped form. The upper edge of the Buddha's lower garment, usually suggested by the depression outlined around the Buddha's waist below a slightly bulging lower abdomen in the Pāla and Pagan prototypes, is, in the Tham Phra examples, clearly raised without the natural feature of the Buddha's bulging abdomen. The Buddha's stiffer body and the draped form of his monastic garment, as described, suggest the similarity of the Tham Phra sculptures to other groups of the Māravijaya Buddha wearing a pointed crown of the Pāla type found in Haripunjaya, northern Thailand,[11] and the Mon country, Lower Burma (Fig. 4.9). The Pāla type has been tentatively dated from the early centuries of the second millennium.

Group II Sculptures

Tham Phra's Group II comprises two crowned images in standing posture, with both hands raised in *abhayamudrā* (Figs. 4.10 & 4.11; Sculptures 2.1 & 2.2). Both images are of approximately the same size, about 1.6 metres in height including the pedestal. They show characteristics clearly inherited from the Khmer Angkor Wat style, during the first half of the 12th century. The Buddha wears a crown with a broad diadem splaying around its tall conical top part, protecting the Buddha's *uṣṇīṣa*. The upper part of the diadem is decorated with tidily arranged motifs, each a slender vertical column with pointed tip. A band constituting the lower part of the diadem is decorated with three large medallions, one at the centre and the other two symmetrically located above the Buddha's temples.[12] The Buddha wears bud-like earrings and a necklace with pendants (Sculpture 2.1), or pendant-like motifs (Sculpture 2.2), dangling from its lower rim. However, neither armlets nor bracelets, commonly seen in Khmer sculptures of the bejewelled Buddha, are worn by the Buddhas of the group.

Sculptures 2.1 and 2.2 have different facial characteristics. In conformity with the 12th-century Khmer style, the Buddha of Sculpture 2.1 has angled eyebrows that join over the small sharp nose, and wide-open almond-shaped eyes, each with an incised line above and below. Sculpture 2.2's facial characteristics are less conventional according to the typical Khmer style: the Buddha has more arched eyebrows with half-closed eyes. Cruder decoration is also observed on the diadem and necklace of Sculpture 2.2 in comparison with Sculpture 2.1. Some common characteristics found to be shared by Group I and Group II

Fig. 4.10 Sculpture 2.1, a bejewelled standing Buddha of the Khmer-related type. Photograph by author.

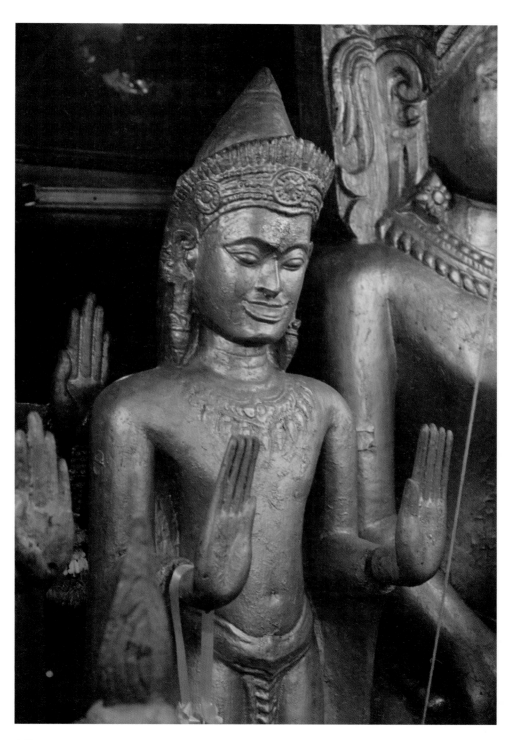

4.10

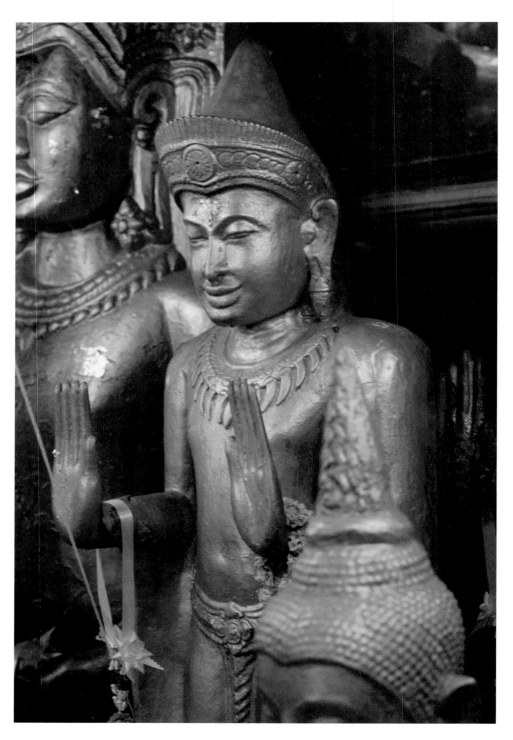

4.11

sculptures – the Buddha's gently smiling face, prominent cheekbones, full lower lip and pointed chin – suggest that both groups could be products of the same workshop, albeit intended to represent different artistic styles.

The Buddhas of Sculptures 2.1 and 2.2 wear monastic robes in the covering mode. Adorning the belt and the central pleat of the lower garment are repeated motifs serially connected to form a row. The lower hems of the outer and inner garments are stylised to be curvilinear with the point of the lower hem located between the Buddha's legs. All these characteristics conform to the classic Khmer pattern of the 12th and 13th centuries. They are comparable to several Khmer bronzes – representing the standing Buddha, probably produced in the Lopburi area, an outpost of the Khmer empire – dating from the first half of the 12th century.[13] The Buddhas' hands, with elongated fingers of equal length, were separately carved and then attached to Sculptures 2.1 and 2.2. This construction is more compatible with the late Ayutthaya style than the older Khmer style, and they could be a later replacement for the originals that were probably lost or damaged. The replacement could have taken place during the 17th century, when the shrine was refurbished and one seated bejewelled Buddha, already described, was sculpted – in situ for the shrine, out of brick and stucco – in conformity with the style of the period.

Fig. 4.11 Sculpture 2.2, a bejewelled standing Buddha of the Khmer-related type. Photograph by author.

Fig. 4.12 Lotus pedestal of Sculpture 2.2. Photograph by author.

4.12

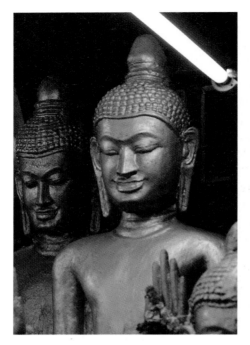

4.13

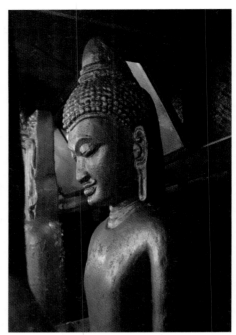

4.14

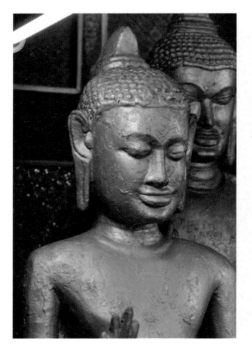

4.15

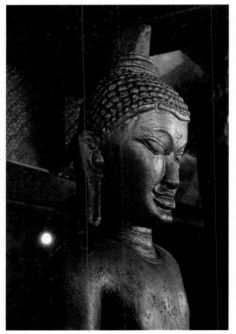

4.16

The lotus pedestals of Sculptures 2.1 and 2.2 are basically of the same type as those of Group I. The recessed waist of each comprises a prominent central V-shaped ring, and a series of lesser bands symmetrically and horizontally arranged to highlight the ring (Fig. 4.12). The pointed lotus petals observed on the pedestals, with each containing an incised line running parallel to its external outline, is of the type only rarely encountered in the realm of Khmer art during the Angkor period. More frequently found in the Khmer counterpart is a different type in which a lotus petal is outlined into trefoil shape. It is likely that Sculptures 2.1 and 2.2 were not genuine products of an imperial Khmer workshop, but rather were less strict imitations done by local craftsmen in Western Thailand.

Group III Sculptures

Tham Phra's Group III constitutes four standing sculptures of the Buddha with both hands performing *abhayamudrā* (Figs. 4.13–4.16; Sculptures 3.1–3.4). The Buddha's hands, with fingers of natural length, were crudely executed and could possibly be a later replacement made during the 1950s restoration of the shrine. The images are of approximately the same size as those of Group II. All share similarities with Group II in terms of the type of pedestal (Fig. 4.17) and the Khmer-style decorations on the Buddha's belt and the central pleat of his lower

4.17

Fig. 4.13 Sculpture 3.1, a standing Buddha image with a series of concentric rings supporting the Buddha's radiance, shaped as a lotus bud. Photograph by author.

Fig. 4.14 Sculpture 3.2, a standing Buddha image with a series of concentric rings supporting the Buddha's radiance, shaped as a lotus bud. Photograph by author.

Fig. 4.15 Sculpture 3.3, a standing Buddha image with a series of concentric rings supporting the Buddha's radiance, of a shape similar to the Pagan style. Photograph by author.

Fig. 4.16 Sculpture 3.4, a standing Buddha image with a series of concentric rings supporting the Buddha's radiance, of a shape similar to the Pagan style. Photograph by author.

Fig. 4.17 Lotus pedestals of Sculptures 3.1 (*left*) and 3.2 (*right*). Photograph by author.

garment. Also conforming to the Khmer type are the curvilinear rims of the Buddha's outer and inner garments, with the pointed lower hem located between the Buddha's legs. The group shows facial characteristics of the Buddha that are common to the Tham Phra wooden sculptures in general: angled eyebrows that join over the sharp small nose, the tip of which is slightly pointing down; protruding eyes, half-closed and downcast; prominent cheekbones and chin; and smiling face with a much fuller lower lip. The Buddha's hair curls are knob-like and tidily arranged in rows that run parallel to the hairline. The latter, bordering the forehead, is slightly concave at the middle. No clear sign of the *uṣṇīṣa* protruding from the top of the skull can be observed. Instead, there is a series of concentric rings supporting the Buddha's large radiance, shaped

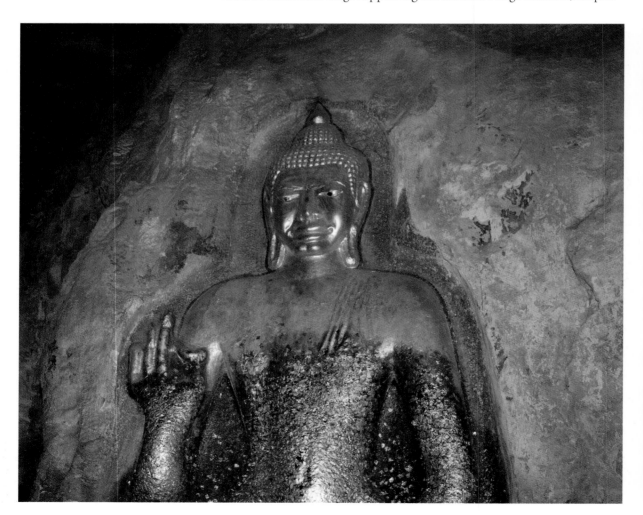

4.18

either as a lotus bud (Sculptures 3.1 & 3.2) or as an asymmetric obtuse cone with its flat anterior side slightly projecting forwards (Sculptures 3.3 & 3.4). The latter type of Buddha's radiance could have been derived from the older Pagan prototype, dating from the mid 11th to the early 12th centuries. The relatively large lotus-bud-shaped radiance of the Buddha, adopted in some images of the group, could have found its immediate root in the old "Mon" Buddhist art, evidenced in both western Thailand and Lower Burma. Examples can be seen on a Dvāravatī relief of the leg-pendant seated Buddha from Tham Ruesi, Ratchaburi, dating from the late first millennium (Fig. 4.18), and a relief plaque depicting the Buddha in standing pose from the Shwezayan Pagoda, Thaton, broadly dating from the early second millennium (Fig. 4.19).[14] On the other hand, the presence of concentric rings supporting the Buddha's radiance seems to be a local characteristic unique to the Tham Phra Buddha sculptures. Probably its closest relative is a tiara or decorative concentric ring(s) protecting the Buddha's *uṣṇīṣa* and supporting his radiance, which are occasionally encountered in Khmer sculptures of the Buddha during the late 12th and 13th centuries.[15]

Fig. 4.18 Buddha's big radiance shaped as a lotus bud, Dvāravatī relief sculpture of the Buddha in leg-pendant seated pose, Tham Ruesi, Ratchaburi. Photograph by author.

Fig. 4.19 Buddha's big radiance shaped as a lotus bud, Mon relief sculpture of the Buddha in standing pose, Shwezayan Pagoda Museum, Thaton, possibly early second millennium. Photograph courtesy Donald M. Stadtner.

Group IV Sculptures

Group IV contains four images (Figs. 4.20–4.23; Sculptures 4.1–4.4), each approximately one metre high. They represent the Māravijaya Buddha seated in *vajrāsana* on a tall lotus pedestal. Sculptures 4.1–4.3

4.19

share common facial characteristics with the majority of the Tham Phra wooden images. Sculpture 4.3 lacks the decorative rings on the pedestal's waist. The lotus petals and stamens are not shown on the pedestal of Sculpture 4.2. The Buddhas of Sculptures 4.3 and 4.4 wear earrings of the Khmer type. Located above the Buddha's shaved head, adorned with hair curls, is a series of concentric rings or bands supporting his large radiance, shaped either as a lotus bud (evident in Sculpture 4.1 and probably the damaged Sculpture 4.4) or a slightly obtuse cone with its tip inclining forwards (Sculptures 4.2 & 4.3). The sculptures of this group could be

Fig. 4.20 Sculpture 4.1, a Māravijaya Buddha. Photograph by author.

Fig. 4.21 Sculpture 4.2, a Māravijaya Buddha. Photograph by author.

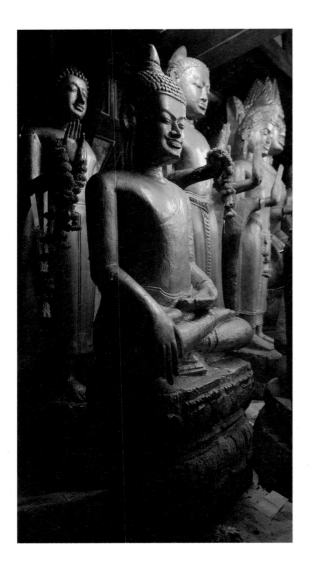

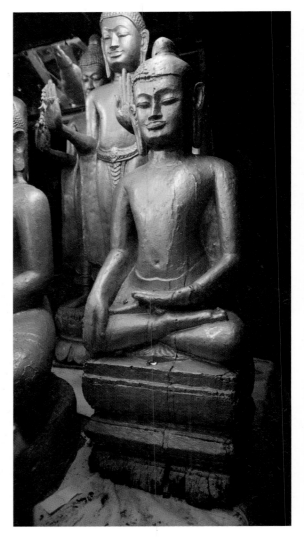

4.20 4.21

recognised as early examples of the *Sihing* type, where the Māravijaya Buddha is seated in *vajrāsana*. This type became prevalent in various parts of Thailand from the 14th or 15th centuries.

The monastic robe worn on the Buddha's stiff body leaves the right shoulder bare. The upper edge of the lower garment is clearly shown around the waist. The overlapping hems of the garments protrude in the V-shaped form between the crossed legs. There is no sign of fabric worn on the Buddha's left shoulder, neither in the form of the *saṃghāṭī*, normally encountered in the Khmer prototypes, nor of the outer

Fig. 4.22 Sculpture 4.3, a Māravijaya Buddha. Photograph by author.

Fig. 4.23 Sculpture 4.4, a Māravijaya Buddha. Photograph by author.

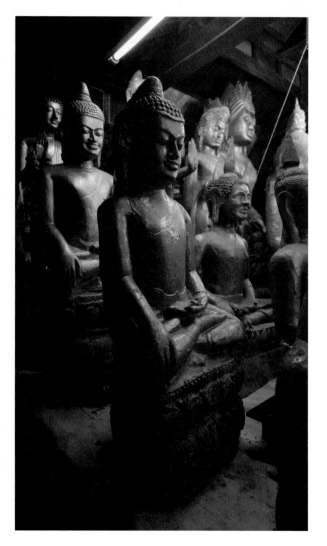

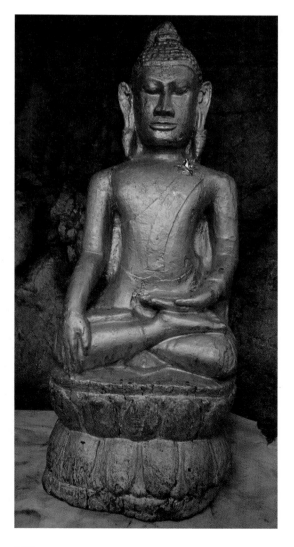

4.22 4.23

garment's hem, normally seen in the Pāla prototypes. This type of drapery, without a piece of fabric on the left shoulder of the Buddha, is one of the ancient characteristics observed in various schools of Buddhist art in Southeast Asia during the first and early second millennia: Dvāravatī in Central and Northeastern Thailand, Mon in Lower Burma, Pyu in Upper Burma, and Haripunjaya in Northern Thailand.

Sculpture 4.4 shows some unusual characteristics not shared with others of the same group, which suggests an intrusive status and probably a slightly later date. The Buddha's nose and mouth are not as well shaped as those of the other sculptures in the group. He wears the *saṃghāṭī* on his left shoulder. The lotus pedestal's (Fig. 4.23) upper and lower parts are complete mirror images of each other; the decorative ring(s) between them and the row of stamens adorning the pedestal's upper rim are absent. The lotus petals are more elongated without incised-line decorations. Similar elongated lotus petals can be seen adorning the pedestal of some Khmer Buddha sculptures of the 12th and 13th centuries.[16] The Buddha's *uṣṇīṣa* is subtly suggested by a row of hair curls located immediately below a series of concentric rings that support the Buddha's large radiance.

BROADER GEOGRAPHICAL AND HISTORICAL SETTINGS

Along the middle terrace zone and old alluvial fan bordering the lower central plain of Thailand[17] on its western fringe, early human settlements of the urban type were located, dating from the second half of the first millennium. From north to south, the main archaeological sites representing these comprise U-Thong, Kamphaeng Saen,[18] Phong Tuek,[19] Nakhon Pathom and Khu Bua (see Map 4.1). They normally shared the following four characteristics: a typical town plan with earthen works and moat that were not strictly geometric in pattern; a likely common faith in Buddhism which, based on evidence of Pāli usage, could have been somehow related to "old Theravāda" (or "Hinayāna") belief(s);[20] the adoption of old Mon language in inscriptions; and the introduction of styles and iconographies of the Buddhist art from various sources in South Asia (North and South India, and probably Sri Lanka), only to be combined and perceived in the local context of aesthetics and meaning. All these characteristics coincided well under the broad general term of "Dvāravatī",[21] named for an early Indianised culture of Southeast Asia prevailing on the elevated border of Central and parts of Northeastern Thailand during the first millennium .[22]

Urban settlement along the elevated border of Central Thailand in the first millennium was geographically strategic in that it avoided the marshy area of the lower central plain that was prone to seasonal flooding during the marine transgressions of the period.[23] It also provided easy access for

the communities in the area to maritime contact with the outside world. The contacts allowed the exchange of goods and the spread of Indic cultures and religions into the area, a phenomenon found to be prevalent along the entire coastline of mainland Southeast Asia during the first millennium.[24] Interconnection among these early urban settlements in the western zone of Central Thailand was facilitated by their close geographic proximity and inland routes frequently running along the elevated border of the lower central plain. Ancient passes across the Tenassarim Range, to the west of the area, also allowed these Dvāravatī-phase communities to access their contemporaneous counterparts in the so-called "Mon land" of Lower Burma.

These "western-zone" Dvāravatī communities would have given rise, either directly or indirectly, to several polities that subsequently emerged in the area during the early second millennium, that is Suphanburi, Śambūkapaṭṭana,[25] Ratchaburi and Phetchaburi. As suggested by epigraphic and archaeological records these second-phase urban communities experienced the political and cultural expansion of the Khmer empire, heavily dominated by the religious faiths of Hinduism and Mahāyāna Buddhism, and centred at Angkor from the early 9th to early 14th centuries. Found in Lopburi, to the northeast of the area, is an inscription dated 1022 that records an edict of Sūryavarman I, the king of Angkor at that time, ordering ascetics and Mahāyāna Sthavira monks (supposed to live in Lopburi) to offer the meritorious fruit of their meditation (*tapas*) to him.[26] This probably corresponded with the early phase of Khmer domination over the northern part of Central Thailand, where Lopburi is located.[27] The Khmer expansion extended to cover the whole area of Central Thailand during the last quarter of the 12th century.

Dated 1191, the Preah Khan inscription of King Jayavarman VII provides a list of 23 towns, probably integrated into the imperial Khmer network, in which the king had sent images named Jayabuddhamahānātha for enshrinement; a special ceremony was held annually at Angkor for the assemblage of these sacred images, temporarily transported to the capital for the event.[28] Among these towns, six have been identified for their locations in the northern and western zones of Central Thailand: Lavodayapura (Lopburi), Svarṇapura (Suphanburi),[29] Śambūkapaṭṭana, Jayarājapurī (Ratchaburi), Srī Jayasiṃhapurī (Muang Sing in Kanchanaburi), and Srī Jayavajrapurī (Phetchaburi). Khmer-style monuments dating from Jayavarman VII's reign are evident in some of these towns – that is Phra Prang Sam Yot in Lopburi, Prasat Muang Sing on the Khwae Noi River in Kanchanaburi province, Wat Kampaeng Lang in Phetchaburi province, and the old foundation and the Buddha arcade on top of the enclosing laterite wall of Wat Mahāthāt Ratchaburi. Also,

an undated inscription from Phimeanakas in Angkor provides information that one of Jayavarman VII's sons was sent to rule Lavodayapura (Lopburi).[30] Closer geographically to the Khmer's centre of power in lowland Cambodia, the eastern part of Central Thailand, where Prachinburi is located, would have long been integrated into the Khmer domain before Jayavarman VII's reign, as confirmed by archaeological evidence related to Khmer influence found in situ in the area, dating from the late first millennium onwards.[31] Combining these pieces of evidence brings about a more complete picture of the Khmer dominion in Central Thailand for its gradual expansion from the eastern part of the area to cover the northern part, at least since the first half of the 11th century, and then finally to the western part during the last quarter of the following century.

Remote control by Khmer power from the capital at Angkor over parts of Central Thailand would have demanded substantial military and diplomatic efforts on the part of the Khmer kings; it, thus, would have been far from consistent and stable. According to Chinese sources, there was a diplomatic mission sent from Lopburi to China in 1155, separate from a mission from Angkor at the same time.[32] Since sending an envoy to

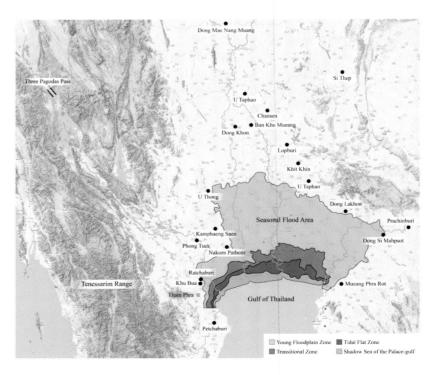

Map 4.1 The location of Tham Phra in relation to ancient communities around the Gulf of Thailand during the late first and early second millennia. (Based on maps and information provided in Trongjai Hutangura, "Reconsidering the Palaeo-shoreline in the Lower Central Plain of Thailand" and https://maps.google.com). Map courtesy Issarachai Buranaaj.

4.1

the China court conventionally implied independence of the state, this could suggest a period of Lopburi's liberation, albeit brief, after the city had been subordinate to Angkor for most of the preceding century and a half. It probably corresponded with weakness of Angkor, during the period from Sūryavarman II's death in 1150 to the beginning of Jayavarman VII's reign in 1181, when the kingdom experienced insurgencies and several wars with Champa.[33] Khmer sovereignty was resumed at Lopburi during the last quarter of the 12th century, following consolidation of the Khmer empire by Jayavarman VII who sent one of his sons to rule there.[34]

Also recorded in Chinese sources is a brief series of diplomatic missions sent to the Sung court during the years 1200–1205 from the state named Chen-li-fu,[35] most likely located near a seaport on the western fringe of Central Thailand. Its centre could have been either Ratchaburi or Nakhon Chaisi, or even Suphanburi.[36] The polities on the western fringe of Central Thailand, thus, would have enjoyed a certain degree of autonomy even during the peak of Jayavarman VII's domination. They probably had accumulated wealth and power, to the extent that they were able to challenge Angkor by controlling trade routes, both overseas up the Mae Klong and Tha Chin rivers, to more inland principalities and inland across the Tenassarim Range to areas around the Gulf of Martaban.[37] Abundant Chinese ceramics, dating from the Sung and Yuan dynasties, recently discovered sunk in the bed of the Mae Klong River, in Ratchaburi province, certainly attest to involvement of this riverine route in a network of maritime trade, at least with China, during the early centuries of the second millennium.[38]

Also supported by archaeological evidence is the east–west connection between urban communities in the western part of Central Thailand and their contemporaneous counterparts in areas around the Gulf of Martaban in Lower Burma during the first and early second millennia. The main route providing this interconnection could have been the "Three Pagodas Pass", up the Mae Klong and then the Khwae Noi rivers from Ratchaburi. Archaeological discoveries during recent years in the areas of Lower Burma around the Gulf of Martaban have yielded much evidence of urban settlements dating from the first millennium.[39] Major sites include, for example, Kyaikkatha, Winka, Zothoke and Thaton, all located along the eastern coast of the Gulf. Evidence found includes brick and laterite religious structures (monasteries and *stūpa*), artefacts, inscriptions and walled cities. A number of characteristics and types of artefacts have been found to have been shared between urban communities in Lower Burma and those in Central and Northeastern Thailand, suggesting their cultural intercourse during the first millennium. These include usage of old Mon language in inscriptions, a

particular type of coin not found among Pyu sites in Upper Burma,[40] distribution of certain types of Buddhist votive tablets,[41] and probably the tradition of erecting carved *sīmā*.[42]

Parallel to the Khmer expansion in Central Thailand during the early centuries of the second millennium, contemporaneous Lower Burma, inhabited by the ethnically Mon people, also experienced the extension of political power of the first Burmese Kingdom, centred at Pagan in the Central Dry Zone. Easy communication between Pagan and the Mon communities of Lower Burma could be facilitated along the Irrawaddy River.

According to some later chronicles, King Anawratha of Pagan (c. 1044–1078) conquered the Mon territory of Lower Burma, with its capital located at Thaton, in the mid 11th century.[43] The presence of Anawratha's authority in Lower Burma is archaeologically confirmed by Buddhist votive tablets, with his signed inscription on their back, found at numerous sites in the area.[44] Left at Mergui in Lower Burma is an inscription of Anawratha's son, Sawlu, who reigned at Pagan for a short period after his father.[45] His successor, Kyanzittha, also left two Mon inscriptions in Thaton and his votive tablets at numerous places in Lower Burma.[46] Listed in the Dhammayazika inscription of 1196–1198 are vassal states that came under Pagan during Narapatisithu's reign, some located as far south as Tavoy and Thandok (near Mergui) in Lower Burma and Ligor (Nakhon Si Thammarat) in Southern Thailand.[47]

Although, evidence of Pagan's dominance over Lower Burma is ample as stated above, its controlling power over the area would have been far from consistent. Proof of this is the attack of Pagan by a rebel troop led by the Pegu ruler in the late 11th century, resulting in the death of Sawlu.[48] The rebel troop was soon driven back to Lower Burma by Sawlu's successor, Kyanzittha. Again, several political upheavals occurred in Lower Burma during the mid 12th century, associated with a few acts of rebellion and a Sinhalese raid that captured two Gulf of Martaban seaports, Bassein and Martaban, and one inland site, Ukkama, thought to be located about 30 kilometres north of Yangon.[49]

In terms of religious faith, Western Thailand and its interconnecting areas west and northwest of the Tenasserim Range in Central and Lower Burma would have been, at least since the middle of the first millennium, a repository of beliefs in Pāli-based Buddhism.[50] Collectively and deliberately perceived here as belonging to "old Theravāda", they shared in common Pāli usage and probably the majority of their textual references. The term is to be distinguished from the Theravāda-Mahāvihāra orthodoxy reformed in Sri Lanka during the third quarter of the 12th century and prevailing in Southeast Asia from the 14th century onwards.[51] The continuum of old Theravāda in Western Thailand and its Burma

counterparts pre-existed expansion of Khmer power in the former area, most thoroughly during Jayavarman VII's reign in the late 12th and early 13th centuries, and conquest of Pagan over the latter area during the mid 11th century. The Khmer and Pagan expansions, however, would have affected the religious atmospheres of their corresponding areas differentially.

Implantation of the Khmer Vajrayāna Buddhism in an area where old Theravāda had long been firmly established and where earlier Khmer influence was minimal, that is the western zone compared with the other parts of Central Thailand, would have been more or less by force under Jayavarman VII. The diffusion of this particular form of Buddhist faith and its related artistic style ceased abruptly beyond Jayavarman VII's political sphere, as there has been so far no evidence suggesting its presence in Lower Burma, another stronghold of old Theravāda, also connected with Western Thailand since long before Jayavarman VII's reign. Since Khmer power waxed and waned in Western Thailand, even during the peak of Jayavarman VII's power, it is probable that old Theravāda survived in the area, although its associated art and iconography would have been much influenced by that of Jayavarman VII's reign. Another source of Khmer artistic inspiration in the Buddhist art of Central Thailand during the 12th century could have come from Phimai in Northeastern Thailand, where another form of Khmer Vajrayāna Buddhism flourished.[52] The surviving "Hinayāna" beliefs (perceived here as being included in the array of "old Theravāda"), a continuum of the Dvāravatī Buddhist faiths in Central Thailand extended well into the period of Khmer domination, between the 11th and 13th centuries, has been broadly termed by Hiram Woodward the "Ariya sect", after the name used in the 15th-century Kalyani Inscription of King Dhammaceti of Pegu for the pre-Sinhalese Theravāda monasticism existing in Burma since long before the mid 11th century.[53]

Probably the oldest definite evidence confirming existence of the Ariya Buddhism in Central Thailand during the period of concern is an important inscription, dated 1168, found in the 1950s at Dong Mae Nang Muang, Nakhon Sawan province, on the northern fringe of central Thailand.[54] This is a site where Dvāravatī tradition was maintained until a late period and contact with Haripunjaya is evident.[55] On a stone slab, using Pāli on one side and Khmer on the other, the inscription essentially records an order of *mahārājādhirāja* (the Great King-of-Kings) named Asokamahārājā for the ruler of Dhanyapura to provide donations to the holy relics. As suggested by Cœdès and others, this *mahārājādhirāja* could have been the king of Lopburi, at that time enjoying temporary independence from Angkor, after the death of Sūryavarman II.[56] Either he or his predecessor on the throne at Lopburi would have been responsible

for sending a tribute mission to China in 1155. While Khmer influence is evident at least in linguistic form in the inscription, the use of Pāli could have somehow been affiliated with old Theravāda in the political sphere of Lopburi during the mid 12th century. Woodward has identified some iconographic characteristics of the Buddhist art found in Central Thailand which had come under Khmer influence to be associated with his Ariya Buddhism.[57] These comprise, for example, Buddha images in the earth-touching pose, images with pointed crowns related to the Pāla prototype, Buddhas holding a hand in front of the chest, and groups of three Buddhas.

The religious landscape of the areas to the west and northwest of the Tenassarim Range, that is Lower and Central Burma, seemed to be far less heterogeneous than that already described for Central Thailand, to the east of the same mountain range. Archaeological evidence and later chronicles suggest that Pāli-based Buddhism, probably belonging to the "old Theravāda" array, existed in Lower Burma during the first and early second millennia.[58] It is also beyond doubt that the Pagan kingdom was a stronghold of this Pāli-based Buddhism since its inception in the mid 11th century. According to later chronicles, Pagan originally received Theravāda Buddhism from the Mons of Lower Burma, during the reign of Anawratha in the mid 11th century.[59] Soon after, in the same century, it established a diplomatic relationship with Sri Lanka, through which the introduction of Sinhalese Buddhism into the kingdom was expected.[60] It is noteworthy that the incident preceded the Buddhist reform in Sri Lanka during the third quarter of the 12th century, which resulted in hegemony of the strict Mahāvihāra orthodoxy on the island. Subsequent contacts between Pagan and Sri Lanka were also numerous, until the end of its dynastic period in the late 13th century.[61]

The Buddhist art of Pagan, from the mid 11th to the late 13th century, was characterised by stylistic and iconographic affiliations with older and contemporaneous Pāla prototypes from Northeastern India and the Bengal area, strongly subject to Mahāyāna influence. This is partly explicable by close geographic proximity, allowing easy contacts, between Upper Burma and Bengal. The other main reason for establishment of this relationship could be related to Pagan's perception of the supremacy of Bodhgaya, the place of the Buddha's enlightenment, located in the Pāla realm of Northeastern India. This is attested by the generous sponsorship of restorations of Bodhgaya's main sanctuary provided by several Pagan kings.

However, adoption of Pāla Buddhist iconography at Pagan was truly selective, with modifications for compatibility with Pāli texts in the Theravāda realm observed in most cases.[62] The Pāla-related Buddhist

iconography and artistic style of Pagan were, therefore, largely Theravāda in essence, regardless of their original affixation to the Northern Indian Mahāyānism. Pagan could have since then been substantially responsible for dissemination of the Theravāda-based iconography and art style, under strong Pāla influence, which would become widespread within its religious network in Southeast Asia during the early second millennium. One obvious example could be the bejewelled Buddha wearing a pointed crown found in Haripunjaya, Northern Thailand, and the Mon country in Lower Burma, both with strong Theravāda affiliations. Other related examples, also subject on the other hand to Khmer artistic influence,[63] found largely in Central Thailand and probably produced there, could be considered in the same context.

CONCLUSION

Tham Phra's wooden sculptures could have been a local product of 12th-century Western Thailand, before the extension of Jayavarman VII's political power into the area during the last quarter of the century. None of the indisputable characteristics of the yet to come Bayon style of Jayavarman VII's reign is evidenced in this group of images. The wooden sculptures are stylised in accordance with forms observed in various schools of Buddhist art, whether older than or contemporaneous with the proposed date, that is Pāla from Northeastern India and the Bengal area most likely through Pagan; Khmer probably from Lopburi; and Mon from Lower Burma and Haripunjaya.

The wide acceptance in Southeast Asia, since the first millennium, of the Pāli-based Buddhism, so-called "old Theravāda" (which also included Woodward's Ariya sect), would have given rise to a network of cultural relationships among different Buddhist centres sharing the religious faith(s), extending well into the early centuries of the second millennium. It could have resulted in the combination of artistic styles observed among the wooden sculptures of focus. Although the original Buddhist art of the Pāla school, in which the iconography of the Buddha wearing a pointed crown originated, was affixed to the Mahāyāna belief and cults of Northeastern India, its Southeast Asian derivatives, particularly those derived from the Pagan prototypes, could have been essentially Theravāda in affiliation.

The meanings of this Buddha imagery could have been amply varied in the world of Buddhist art.[64] However, they shared a common value that cut across Buddhist sects that emphasised the supremacy of the Buddha, here symbolised by his manifestation as the Universal King. Occasionally depicted in the Pagan-period murals of the 13th century

was the Buddha of this imagery; seated in the *māravijaya* pose, he is normally flanked symmetrically by devotees, sometime dressed in exotic costume (Fig. 4.24). Few instances of the case, found in temple no. 101 at Sale (about 50 kilometres south of Pagan, in the Chauk township of the Magwe Division) (Fig. 4.25) and temple no. 13 at Sarle (at the border between Chauk and Yenan-Chaung township in the Magwe Division) (Fig. 4.26) dating from the period, are with original epigraphic records confirming their representation of the Buddha's encounter with a king named Maha Kappina (temple no. 101, Sale) or Maha Kappain (temple no. 13, Sarle), which in one place is spelt as "Kapain".[65] Although the story is not further detailed in these mural inscriptions, the iconography of the bejewelled Buddha and the king's name appearing in this case could naturally link it to a narrative originating in the old Sanskrit source, the *Kapphiṇa-avadāna* included in the *Avadānaśataka* series.[66] Although it could have been of Sarvāsativāda origin, the story has been proven to be known later in the Mahāyāna context of Northern India during the Pāla dynasty.[67] It could have been transferred to Pagan from there, together with the Buddhist iconography of the bejewelled Buddha and others of the Pāla type.

The Buddha of the story disguised himself as the incomparable universal monarch to tame Kapphiṇa, an arrogant king of the southern country (Dakṣiṇāpatha).[68] For its Sanskrit origin, the depicted story stands out in Pagan murals, amidst an abundance of Buddhist narratives based on Pāli canonical and commentarial sources. The phenomenon could, thus, suggest integration of this Buddha imagery and its associated narrative, probably mainly to illuminate the Buddha's supremacy, into the Theravāda norm of Pagan. Although a secondary Pāli source of the story, which could have served as an immediate reference for the murals, is not yet known, it is worth noting that absorption of original Sanskrit narratives into later Pāli-based literature might not be unusual at all in the old Theravāda context of Southeast Asia. Another prominent example is the integration of a story extracted from the *Aśokāvadāna*, also of the Sanskrit *avadāna* series, into Pāli literature said to be composed in Burma, the *Lokapaññatti*. Dealing with an episode of King Aśoka, in a previous existence, as a child donating a handful of dust for alms to the Buddha Gotama, the story was also given material form amidst other narratives based primarily on the Pāli commentarial sources in the murals of temple no. 585 at Pagan, dating from the 13th century (Fig. 4.27).[69]

The Māravijaya Buddha wearing a pointed crown of the Pāla type found among the Tham Phra wooden sculptures, which shows clear stylistic associations with the Pagan prototype on one hand and with those from the Mon countries in Lower Burma and Haripunjaya on the

other, suggests the existence of a network of relationships among these Buddhist centres during the course of the 12th century. This type of Buddha wearing a pointed crown is among the major characteristics suggested by Woodward to demonstrate the survival of the old Hinayāna belief(s) in Southeast Asia during the early second millennium.[70]

Western Thailand during the 11th and 12th centuries saw the rise of several polities, developed in situ probably from their late Dvāravatī progenitors, that would have actively engaged in maritime trading with China and inland exchanges with the Mon communities in Lower Burma. A series of envoys sent to China from Deng-lui-mei, a state thought to be located in Western Thailand during a period from the late 10th to late 11th centuries, suggests the presence of an autonomous state in the area at that time.[71] Another series of tribute missions sent to China from the state named Chen-li-fu, located near a seaport in Western Thailand, in the years 1200–1205, confirms Chen-li-fu's relative independence even at the zenith of Jayavarman VII's domination in Central Thailand.

Fig. 4.24 A 13th-century mural scene at Pagan depicting the Māravijaya Buddha wearing a pointed crown of the Pāla prototype; he is attended by devotees dressed in exotic costume suggesting their foreign origin (Pagan monument 1077, photograph by author).

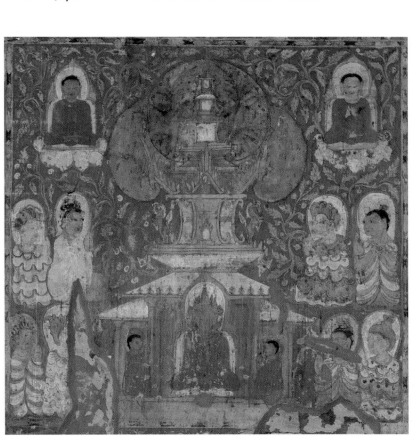

4.24

It is beyond doubt that, under such circumstances, the principalities in Western Thailand could have maintained their old Theravāda beliefs more or less continuously, with its supremacy soon resumed after the cessation of the Khmer domination under Jayavarman VII. Probably attesting this was also the establishment of the main brick sanctuary of Mahāthāt Ratchaburi, most likely during the course of the 14th century, to dominate the older laterite complex of Jayavarman VII's Mahāyāna temple.[72]

It is important to note that old Theravāda belief(s) had also been maintained in the northern sphere of Central Thailand during the early centuries of the second millennium, although it was here constrained to a certain degree by strong Khmer influence. Major evidence is the Dong Mae Nang Muang inscription, dated 1168, in which both Pāli and Khmer languages were used to describe the religious affairs of the king, most likely from Lopburi. Usage of Pāli language in the inscription could suggest a revival of old Theravāda in Lopburi's dominion during this period, probably corresponding with temporary cessation of Khmer power after the death of Sūryavarman II, in 1150. Before that time, Lopburi had been

4.25 4.26

an outpost of the Khmer empire for almost a century and a half, during which its religious belief(s) and artistic style would have been heavily dominated by the imperial Khmer ideology and art form.

Religious contact between Lopburi and Western Thailand during the 12th century could have resulted in the creation of the two standing bejewelled Buddha sculptures found at Tham Phra; they show a strong influence of the Khmer Angkor Wat style. To be compatible with the religious atmosphere of Western Thailand, dominated by the old Theravāda belief(s) until the advent of Jayavarman VII's power in the area, this could have happened during the period of Lopburi's temporary independence from Khmer sovereignty and of the Theravāda revival suggested by the Dong Mae Nang Muang inscription, that is the third quarter of the 12th century. Observed in this pair of Khmer-style sculptures are several local characteristics, also shared with other sculptures of the Tham Phra group, suggesting that the pair was locally produced. They were probably among the earliest sculptures of the Khmer type ever produced in Western Thailand, however, as imitations rather than genuine products of the imperial Khmer workshop.

Fig. 4.25 Being of the Pagan style and dating from the 13th century, the mural scene depicts a Māravijaya Buddha wearing a pointed crown of the Pāla prototype; an ink gloss, not totally legible, associates the scene with the Buddha and the "Mahā Kappina" king (Sale monument 101, inscription read by Saya Minbu Aung Kyaing, photograph by author).

Fig. 4.26 Of the 13th-century Pagan style, the mural depicts a Māravijaya Buddha wearing a pointed crown of the Pāla prototype; it bears two ink-glosses: one located below the Buddha describing his episode of admonishing King Kappain, and the other explaining a seated devotee, located above it, to be the very king, however with his name spelt as "Kapain" (Sarle monument 13, inscription read by Saya Minbu Aung Kyaing, photograph by author).

Fig. 4.27 A 13th-century inscribed mural from Pagan illustrating a child, King Aśoka in his previous existence, donating a handful of dust for alms to the Buddha Gotama, probably based on the *Lokapaññatti* account (Pagan monument 585, inscription read by Saya Minbu Aung Kyaing, photograph by author).

4.27

The Dvāravatī characteristics observed on some of the Tham Phra Buddha sculptures demonstrate a stylistic continuum in the Buddhist art of Western Thailand until well into the early centuries of the second millennium, probably coinciding with persistence of old Dvāravatī Theravāda belief(s) in the area. As a counter-response to Khmer influence, some local characteristics observed in the group, that is a series of concentric rings supporting the Buddha's radiance located on the top of his skull and the protruding central ring adorning the recessed waist of the Buddha's lotus pedestal, could have served as prototypes for comparable characteristics evident in Khmer Buddhist art during the late 12th and early 13th centuries; the latter set of Khmer characteristics comprises a tiara protecting the Buddha's *uṣṇīṣa* and supporting his radiance, and a decorative ring on the recessed waist of the Buddha's pedestal.

As this chapter has so far suggested, the historical and archaeological landscapes of Central Thailand during the early centuries of the second millennium were complicated. The area comprised several parts – the eastern, northern and western zones, bordering the marshy lower central plain – each characterised by its own political and cultural dynamics, albeit being culturally tied to each other. The imperial Khmer network into which polities in the area were integrated had protracted and contracted in a truly dynamic fashion. Being a part of the wider Theravāda network, also incorporating other parts of Thailand and both Upper and Lower Burma, Central Thailand experienced disturbances with the expansions of Khmer Hinduism and Mahāyāna Buddhism.

Compared with other parts of Central Thailand, that is the northern and eastern zones, the western zone had remained on the margins of Khmer domination until advancement of Jayavarman VII's power in the last quarter of the 12th century. The wooden sculptures of Tham Phra provide us a clue for understanding the religious and cultural atmospheres of Western Thailand during the decades immediately preceding his reign. On the one hand, Khmer cultural influence, probably diffusing from the Lopburi area rather than directly from Angkor, was not at all alien to the area and probably started to have its earliest artistic manifestation materialised in situ; on the other, the area had not yet been truly dominated by Khmer sovereignty. The continuous existence of the old Theravāda belief(s) in the area since long before that time would have brought Western Thailand into a wider Theravāda network of Southeast Asia, into which Pagan in Upper Burma and the Mon communities in both Lower Burma and Haripunjaya were also integrated.

Notes

1 Chao Phraya Thipākorawong, *Phrarātcha-pongsāwadān Krung Rattanakosin, Ratchakān Thī Nung* [The Royal Chronicle of Bangkok, First Reign], Bangkok: Rong-phim Bamrungnukunkit, 1903, pp. 21–2.

2 Phrayā Kathāthornbodī, *Samut Rātchaburī* [A Book Describing Ratchaburi], published for the occasion of the 1925 CE exhibition "Sayāmrattha-phiphitthaphan", Bangkok: Rongphim Nangsuethai, 1925, pp. 161–3.

3 *Rātchakijjānubeksā* [Royal Siam Government Gazette], 52, sec. 75, 8 March 1935, p. 3696.

4 Presiding over this "Temple of the Great Relic" is a brick tower of the Khmer-related type, probably erected during the 14th century (for dating the Mahāthāt-Ratchaburi tower no earlier than the 14th century, see Hiram W. Woodward Jr., *Studies in the Art of Central Siam, 950–1350 A.D.*, vol. 2, PhD dissertation, Yale University, 1975, pp. 21–3). A recent excavation at the site, however, has revealed older complicated foundations of a Khmer Mahāyāna temple dating from Jayavarman VII's reign, in the late 12th or early 13th centuries.

5 The Dvāravatī cave site where a relief of the leg-pendant seated Buddha in preaching gesture is located.

6 The Phong Tuek sub-district where this Dvāravatī archaeological site is located is now under the administration of Kanchanaburi province.

7 Gordon H. Luce, *Old Burma-Early Pagan*, vol. 3, New York: J. J. Augustin Publisher, 1969, pp. 278–317.

8 See the Khmer examples in Hiram W. Woodward Jr., *The Art and Architecture of Thailand*, Leiden: Brill, 2003, plate 80b; Piriya Krairiksh, *Rāk Ngao Haeng Sinlapa Thai* [The Roots of Thai Art], Bangkok: River Books, 2010, pl. 2.250 & 2.252; Heidi Tan, ed., *Enlightened Ways: The Many Streams of Buddhist Art in Thailand*, Singapore: Asian Civilisations Museum, 2012, p. 94.

9 See Piriya, *Rāk Ngao*, pl. 2.395.

10 For example, the decorative pattern is seen on the belt and central pleat of the lower garment of the bejewelled standing Buddha published in Louise Allison Cort and Paul Jett, eds., *Gods of Angkor: Bronzes from the National Museum of Cambodia*, Chiang Mai: Silkworm Books, 2010, pp. 56–7.

11 See illustrations of some typical Haripunjaya seated sculptures of the Buddha wearing a pointed crown in Carol Stratton, *Buddhist Sculpture of Northern Thailand*, Chicago: Buppha Press, 2004, Figs. 5.70–5.72.

12 A Khmer example with three medallions adorning the Buddha's diadem can be seen in Piriya, *Rāk Ngao*, pl. 2.239.

13 See Cort and Jett, eds., *Gods of Angkor*, pp. 56–7.

14 For dating the Shwezayan example see: Luce, *Old Burma*, vol. 1, pp. 140–1; Hiram W. Woodward Jr., "Some Buddha Images and the Cultural Developments of the Late Angkorian Period", *Artibus Asiae,* 42, no. 2/3, 1980: pp. 155–74.

15 See examples in Woodward, *Art and Architecture*, pl. 74b, 76, 84, 86a & 86b.

16 See an example in Piriya, *Rāk Ngao*, pl. 2.380.

17 The term "lower central plain of Thailand" refers, in a geological sense, to the flooded area, a part of the paleo-gulf of Thailand, during the Holocene Maximum Transgression around 6,500–6,400 BCE (Trongjai Hutangkura, "Reconsidering the Palaeo-shoreline in the Lower Central Plain of Thailand", in *Before Siam: Essays in Art and Archaeology,* eds. Nicolas Revire and Stephen A. Murphy, Bangkok: The Siam Society, 2014, pp. 32–67). It had been a wetland zone not suitable for human occupation until around the middle of the second

 millennium CE.

18 See a recent account on this archaeological site in Matthew D. Gallon,
 "Monuments and Identity at the Dvāravatī Town of Kamphaeng Saen", in
 Before Siam: Essays in Art and Archaeology, eds. Nicolas Revire and Stephen A.
 Murphy, Bangkok: The Siam Society, 2014, pp. 330–51.

19 For a recent archaeological study on Phong Tuek see Wesley Clarke, "The
 Skeletons of Phong Tuek: Human Remains in Dvāravatī Ritual Contexts", in
 Before Siam: Essays in Art and Archaeology, eds. Nicolas Revire and Stephen A.
 Murphy, Bangkok: The Siam Society, 2014, pp. 311–29.

20 Peter Skilling, "The Advent of Theravada Buddhism to Mainland South-east
 Asia", *Journal of the International Association of Buddhist Studies,* 20, no. 1,
 1997: pp. 83–107; the term "old Theravāda" is coined here to account for the
 form(s) of Pāli-based Buddhism in existence prior to the major Buddhist
 unification in Sri Lanka during the reign of King Parakramabahu I in the second
 half of the 12th century; based on the Mahāvihāra tradition, the reform set a
 new standard for "Theravāda" orthodoxy in Sri Lanka, to be subsequently
 widespread in Southeast Asia from the 14th century onwards (Samerchai
 Poolsuwan, "Buddhist Murals Illustrating Unusual Features in Temple 36 at
 Sale and Their Cultural Implications", *Journal of Burma Studies,* 19, no. 1,
 2015: pp. 145–97).

21 See discussions on various aspects of the Dvāravatī culture in: Peter Skilling,
 "Dvāravatī: Recent Revelations and Research", in *Dedications to Her Royal
 Highness Princess Galyani Vadhana Krom Luang Naradhiwas Rajanagarindra
 on Her 80th Birthday,* ed. Chris Baker, Bangkok: The Siam Society, 2003,
 pp. 87–112; Nicolas Revire, "Glimpses of Buddhist Practices and Rituals in
 Dvāravatī and its Neighboring Cultures", in *Before Siam: Essays in Art and
 Archaeology,* eds. Nicolas Revire and Stephen A. Murphy, Bangkok: The Siam
 Society, 2014, pp. 240–71.

22 See Woodward, *Art and Architecture,* Chapter 2.

23 Trongjai, "Reconsidering the Palaeo-shoreline in the Lower Central Plain of
 Thailand".

24 See reviews in Donald M. Stadtner, "The Mon of Lower Burma", *JSS* 96, 2008,
 pp. 193–215; John Guy, ed., *Lost Kingdoms: Hindu-Buddhist Sculpture of Early
 Southeast Asia*, New York: The Metropolitan Museum of Art, 2014.

25 The name first appeared in the Preah Khan inscription of King Jayavarman VII.
 Its location has been identified as Kosinarai in Ban Pong district, Ratchaburi
 province (Woodward, *Art and Architecture,* p. 211).

26 Paul Mus, "George Cœdès: Recueil des Inscriptions du Siam, 2e partie.
 Inscriptions de Dvāravatī, de Çrīvijaya et de Lăvo", *BEFEO,* 29, no. 1, 1929:
 pp. 446–50.

27 Woodward, *Art and Architecture,* p. 140.

28 George Cœdès, "La stèle du Práh Khằn d'Ankor", *BEFEO* 41, no. 1, 1941:
 pp. 255–302.

29 Could have been Noen Thang Phra in Sam Chuk district, Suphanburi province
 (Woodward, *Art and Architecture,* p. 211).

30 George Cœdès, *Inscriptions du Cambodge,* vol. 2, Hanoi and Paris: EFEO, 1942,
 p. 161.

31 See a discussion in Woodward, *Art and Architecture,* pp. 140–1.

32 David K. Wyatt, "Relics, Oaths and Politics in Thirteenth-Century Siam",
 Journal of Southeast Asian Studies, 32, no. 1, 2001: pp. 3–66.

33 Ibid.

34 Ibid.

35 Ibid.

36 Ibid.

37 Ibid.

38 See a discussion on ancient Chinese ceramics found in the Mae Klong River in Piriya, *Rāk Ngao*, pp. 147–56.

39 Stadtner, "The Mon of Lower Burma"; Elizabeth Moore and San Win, "The Gold Coast: Suvannabhumi? Lower Myanmar Walled Sites of the First Millennium A.D.", *Asian Perspectives* 46, no. 1, 2007: pp. 202–32; Elizabeth Moore, "Sampanago: City of Serpents" and "Muttama (Martaban)", in *Before Siam: Essays in Art and Archaeology,* eds. Nicolas Revire and Stephen A. Murphy, Bangkok: The Siam Society, 2014, pp. 216–37.

40 Stadtner, "The Mon of Lower Burma".

41 For the shared types of Buddhist votive tablets found in both Lower Burma and Western Thailand see Stadtner, "Demystifying Mists: The Case for the Mon", a paper presented at the conference *Discovery of Ramanya Desa: History, Identity, Culture, Language and Performing Arts*, Chulalongkorn University, Bangkok, 10–13 October 2007.

42 Piriya Krairiksh, "Semas with Scenes from the Mahānipāta-Jātakas in the National Museum of Khon Kaen", in *Art and Archaeology in Thailand*, Bangkok: Fine Arts Department, 1974, pp. 35–100; for a different view, see Stephen A. Murphy, "*Sema* Stones in Lower Myanmar and Northeast Thailand: A Comparison", in *Before Siam: Essays in Art and Archaeology,* eds. Nicolas Revire and Stephen A. Murphy, Bangkok: The Siam Society, 2014, pp. 353–71.

43 See a discussion in Luce, *Old Burma,* vol. 1, chapter II.

44 Ibid.; Than Tun, "Buddhism in Burma, AD 1000–1300", *Journal of the Burma Research Society* 61, 1978: pp. 1–266; Tilman Frasch, "Coastal Peripheries During the Pagan Period", in *The Maritime Frontier of Burma: Exploring Political, Cultural and Commercial Interaction in the Indian Ocean World,* eds. Jos Gommans and Jacques Leider, Leiden: KITLV Press, 2002, pp. 59–78; Stadtner, "The Mon of Lower Burma".

45 Frasch, "Coastal Peripheries During the Pagan Period".

46 Stadtner, "The Mon of Lower Burma".

47 U Tin Htway, "The First Burmese Royal Inscription", in *Vorträge des 18. Deutschen Orientalistentages*, ed. Wolfgang Voigt, Wiesbaden: Harrassowitz, 1974, (cited in Frasch, "Coastal peripheries During the Pagan Period").

48 Frasch, "Coastal Peripheries During the Pagan Period".

49 Ibid.

50 Nihar-Ranjan Ray, "Early Traces of Buddhism in Burma", *Journal of the Greater India Society* 6, no. 1, January 1939: pp. 1–52; Gordon H. Luce, "The Advent of Buddhism to Burma", in *Buddhist Studies in Honour of I. B. Horner*, eds. L. Cousins, A. Kunst and K. R. Norman, Boston: P. Reidel Publishing Company, 1974, pp. 119–38; Janice Stargardt, "The Oldest Known Pāli Text, 5th–6th Century: Results of the Cambridge Symposium on the Pyu Golden Pāli Text from Śrī Kṣetra, 18–19 April 1995", *Journal of the Pāli Text Society* 21, 1995: pp. 199–213; Skilling, "The Advent of Theravāda Buddhism to Mainland South-east Asia"; a stone inscription recording *paṭiccasamuppāda* from the Pāli *Mahāvagga* is also known from Pegu (ibid.; Stadtner, "The Mon of Lower Burma").

51 Poolsuwan, "Buddhist Murals".

52 Woodward, *Art and Architecture*, pp. 146–59.

53 Hiram W. Woodward Jr., *The Sacred Sculpture of Thailand*, Bangkok: River Books, 1997, pp. 115–16; Woodward, *Art and Architecture*, pp. 166–71.

54 George Cœdès, "Nouvelles données épigraphiques sur l'histoire de I'Indochine centrale", *JA* 246, 1958: pp. 125–42.

55 Woodward, *Art and Architecture*, p. 145.

56 Wyatt, "Relics Oaths and Politics in Thirteenth-Century Siam"; Woodward, *Art and Architecture,* pp. 163–5.

57 Woodward, *Sacred Sculpture*, pp. 115–6; Woodward, *Art and Architecture*, pp. 166–71.

58 Luce, *Old Burma,* vol. 1, chapter II; there is also a stone inscription recording *paṭiccasamuppāda* from the Pāli *Mahāvagga*, probably dating from the mid first millennium CE, found in Pegu (Skilling, "The Advent of Theravāda Buddhism to Mainland South-east Asia"; Stadtner, "The Mon of Lower Burma").

59 See a discussion in Luce, *Old Burma*, vol. 1, chapter II.

60 Ibid.

61 W. M. Sirisena, *Sri Lanka and South-East Asia*, Leiden: E. J. Brill, 1978, pp. 58–81; Tilman Frasch, "A Buddhist Network in the Bay of Bengal: Relations Between Bodhgaya, Burma and Sri Lanka, c. 300–1300", in *From the Mediterranean to the China Sea: Miscellaneous Notes*, eds. Claude Guillot, Denys Lombard and Rodenrich Ptak, Weisbaden: Harrassowitz Verlag, 1998, pp. 69–92; Tilman Frasch, "The Buddhist Connection: Sinhalese-Burmese Intercourse in the Middle Ages", in *Explorations in the History of South Asia: Essays in Honour of Dietmar Rothermund*, eds. Georg Berkemer, Tilman Frasch, Hermanh Kulke and Jurgen Lütt, Delhi: Manohar, 2001, pp. 85–97.

62 Samerchai Poolsuwan, "After Enlightenment: Scenes of the Buddha's Retreat in the Thirteenth Century Murals at Pagan", *Artibus Asiae* 72, no. 2, 2012: pp. 377–97; Samerchai Poolsuwan, "The Buddha's Biography: Its Development in the Pagan Murals vs.the Later Vernacular Literature, in the Theravādin Buddhist Context of Southeast Asia", *Journal of the Royal Asiatic Society* 27, no. 2, 2017: pp. 255–94.

63 See examples in Woodward, *Sacred Sculpture*, Figs. 133–5; Woodward, *Art and Architecture*, pl. 82 & 83; Piriya, *Rāk Ngao,* pl. 2.377–2.380, 2.383 & 2.384.

64 For a review of the iconographies of the bejewelled Buddha and probably their associated meanings in Indian and Kashmir Buddhist arts see Claudine Bautze-Picron, *The Bejewelled Buddha: From India to Burma*, Delhi: Sanctum Books, 2010; for the Burmese and Mon examples see Luce, *Old Burma*, vol. 1, chapter X; Pamela Gutman, "A Burmese Origin for the Sukhothai Walking Buddha", in *Burma: Art and Archaeology*, eds. Alexandra Green and T. Richard Blurton, London: The British Museum, 2002, pp. 35–43.

65 Inscription readings provided to the author by Saya Minbu Aung Kyaing, Former Deputy Director General, Department of Archaeology, Myanmar.

66 P. L. Vaidya, ed., *Avadāna-śataka*, Dabhanga: The Mithila Institute of Post-Graduate Studies and Research in Sanskrit Learning.

67 Peter Skilling, "Pieces in the Puzzle: Sanskrit Literature in Pre-Modern Siam", in *Buddhism and Buddhist Literature of South-East Asia: Selected Papers*, ed. Claudio Cicuzza, Bangkok and Lumbini: Fragile Palm Leaves Foundation, Lumbini International, Research Institute, 2009, pp. 27–45.

68 P. L. Vaidya, ed., *Avadāna-śataka*.

69 Poolsuwan, "Buddha's Biography".

70 Woodward, *Sacred Sculpture,* pp. 115–6.

71 Piriya, *Rāk Ngao,* p. 139.

72 See note 4.

References

Bautze-Picron, Claudine. *The Bejewelled Buddha: From India to Burma*. Delhi: Sanctum Books, 2010.

Chao Phraya Thipakorawong. *Phrarātcha-pongsāwadān Krung Rattanakosin, Ratchakān Thī Nung* [The Royal Chronicle of Bangkok, First Reign]. Bangkok: Rong-phim Bamrungnukunkit, 1903.

Clarke, Wesley. "The Skeletons of Phong Tuek Human Remains in Dvāravatī Ritual Contexts". In *Before Siam: Essays in Art and Archaeology*, eds. Nicolas Revire and Stephen A. Murphy. Bangkok: The Siam Society, 2014, pp. 311–29.

Cœdès, George. *Inscriptions du Cambodge*, vol. 2. Hanoi and Paris: EFEO, 1942.

———. "La stèle du Práh Khǎn d'Ankor". *BEFEO*, 41, no. 1, 1941: pp. 255–302.

Cort, Louise Allison and Paul Jett, eds. *Gods of Angkor: Bronzes from the National Museum of Cambodia*. Chiang Mai: Silkworm Books, 2010.

Frasch, Tilman. "A Buddhist Network in the Bay of Bengal: Relations Between Bodhgaya, Burma and Sri Lanka, c. 300–1300". In *From the Mediterranean to the China Sea: Miscellaneous Notes*, eds. Claude Guillot, Denys Lombard and Rodenrich Ptak. Weisbaden: Harrassowitz Verlag, 1998.

———. "The Buddhist Connection: Sinhalese-Burmese Intercourse in the Middle Ages". In *Explorations in the History of South Asia: Essays in Honour of Dietmar Rothermund,* eds. Georg Berkemer, Tilman Frasch, Hermann Kulke and Jurgen Lütt. Delhi: Manohar, 2001.

———. "Coastal Peripheries During the Pagan Period". In *The Maritime Frontier of Burma: Exploring Political, Cultural and Commercial Interaction in the Indian Ocean World*, eds. Jos Gommans and Jacques Leider. Leiden: KITLV Press, 2002.

Gallon, Matthew D. "Monuments and Identity at the Dvāravatī town of Kamphaeng Saen". In *Before Siam: Essays in Art and Archaeology*, eds. Nicolas Revire and Stephen A. Murphy. Bangkok: The Siam Society, 2014, pp. 330–51.

Gutman, Pamela. "A Burmese Origin for the Sukhothai Walking Buddha". In *Burma: Art and Archaeology*, eds. Alexandra Green and T. Richard Blurton. London: The British Museum, 2002, pp. 35–43.

Guy, John, ed. *Lost Kingdoms: Hindu-Buddhist Sculpture of Early Southeast Asia*. New York: The Metropolitan Museum of Art, 2014.

Luce, Gordon H. "The Advent of Buddhism to Burma". In *Buddhist Studies in Honour of I. B. Horner*, eds. by L. Cousins, A. Kunst and K. R. Norman. Boston: P. Reidel Publishing Company, 1974.

———. *Old Burma-Early Pagan*, vols. 1 & 3. New York: J. J. Augustin Publisher, 1969.

Moore, Elizabeth. "Sampanago: 'City of Serpents' and Muttama (Martaban)". In *Before Siam: Essays in Art and Archaeology*, eds. Nicolas Revire and Stephen A. Murphy. Bangkok: The Siam Society, 2014, pp. 216–37.

Moore, Elizabeth, and San Win. "The Gold Coast: Suvannabhumi? Lower Myanmar Walled Sites of the First Millennium A.D.". *Asian Perspectives* 46, no. 1, 2007: pp. 202–32.

Murphy, Stephen A. "Sema Stones in Lower Myanmar and Northeast Thailand: A Comparison". In *Before Siam: Essays in Art and Archaeology*, eds. Nicolas Revire and Stephen A. Murphy. Bangkok: The Siam Society, 2014, pp. 353–71.

Mus, Paul. "George Cœdès: Recueil des Inscriptions du Siam, 2e partie. Inscriptions

de Dvāravatī, de Çrīvijaya et de Lăvo". *BEFEO* 29, no. 1, 1929: pp. 446–50.

Phrayā Kathāthornbodī. *Samut Rātchaburī* [A Book Describing Ratchaburi]. Published for the occasion of the 1925 CE Exhibition "Sayāmrattha-phiphitthaphan". Bangkok: Rongphim Nangsuethai, 1925. (In Thai.)

Piriya Krairiksh. "Semas with Scenes from the Mahānipāta-Jātakas in the National Museum of Khon Kaen". In *Art and Archaeology in Thailand*. Bangkok: Fine Arts Department, 1974.

Piriya Krairiksh. *Rāk Ngao Haeng Sinlapa Thai* [The Roots of Thai Art]. Bangkok: River Books, 2010.

Rātchakijjānubeksā [Royal Thai Government Gazette], vol. 52, section 75, 8 March 1935, p. 3696.

Ray, Nihar-Ranjan. "Early Trace of Buddhism in Burma". *Journal of the Greater India Society* 6, no. 1, January 1939: pp. 1–52.

Revire, Nicolas. "Glimpses of Buddhist Practices and Rituals in Dvāravatī and Its Neighboring Cultures". In *Before Siam: Essays in Art and Archaeology*, eds. Nicolas Revire and Stephen A. Murphy. Bangkok: The Siam Society, 2014, pp. 240–71.

Samerchai Poolsuwan. "After Enlightenment: Scenes of the Buddha's Retreat in the Thirteenth-Century Murals at Pagan". *Artibus Asiae* 72, no. 2, 2012: 377–97.

———. "The Buddha's Biography: Its Development in the Pagan Murals vs. the Later Vernacular Literature, in the Theravādin Buddhist Context of Southeast Asia". *Journal of the Royal Asiatic Society* 27, no. 2, 2017: pp. 255–94.

———. "Buddhist Murals Illustrating Unusual Features in Temple 36 at Sale and Their Cultural Implications". *Journal of Burma Studies* 19, no. 1, 2015: pp. 145–97.

Sirisena, W. M. *Sri Lanka and South-East Asia*. Leiden: E. J. Brill, 1978.

Skilling, Peter. "The Advent of Theravada Buddhism to Mainland South-east Asia". *Journal of the International Association of Buddhist Studies* 20, no. 1, 1997: pp. 83–107.

———. "Dvāravatī: Recent Revelations and Research". In *Dedications to Her Royal Highness Princess Galyani Vadhana Krom Luang Naradhiwas Rajanagarindra on Her 80th Birthday*, ed. Chris Baker. Bangkok: The Siam Society, 2003, pp. 87–112.

———. "Pieces in the Puzzle: Sanskrit Literature in Pre-Modern Siam". In *Buddhism and Buddhist Literature of South-East Asia: Selected Papers*, ed. Claudio Cicuzza. Bangkok and Lumbini: Fragile Palm Leaves Foundation, Lumbini International, Research Institute, 2009.

Stadtner, Donald M. "Demystifying Mists: The Case for the Mon". A paper presented at the conference *Discovery of Ramanya Desa: History, Identity, Culture, Language and Performing Arts*, Chulalongkorn University, Bangkok, 10–13 October 2007.

———. "The Mon of Lower Burma". *JSS* 96, 2008: pp. 193–215.

Stargardt, Janice. "The Oldest Known Pāli Text, 5th–6th Century: Results of the Cambridge Symposium on the Pyu Golden Pāli Text from Śrī Kṣetra, 1 8–19 April 1995". *Journal of the Pāli Text Society* 21, 1995: pp. 199–213.

Stratton, Carol. *Buddhist Sculpture of Northern Thailand*. Chicago: Buppha Press, 2004.

Tan, Heidi, ed. *Enlightened Ways: The Many Streams of Buddhist Art in Thailand*. Singapore: Asian Civilisations Museum, 2012.

Than Tun. "Buddhism in Burma, AD 1000–1300". *Journal of the Burma Research Society* 61, 1978, pp. 1–266.

Trongjai Hutangkura. "Reconsidering the Palaeo-shoreline in the Lower Central Plain

of Thailand". In *Before Siam: Essays in Art and Archaeology*, eds. Nicolas Revire and Stephen A. Murphy. Bangkok: The Siam Society, 2014, pp. 32–67.

U Tin Htway. "The First Burmese Royal Inscription". In *Vorträge des 18. Deutschen Orientalistentages*, ed. Wolfgang Voigt. Wiesbaden: Harrassowitz, 1974.

Woodward, Hiram W., Jr. *The Art and Architecture of Thailand*. Leiden: Brill, 2003.

———. *The Sacred Sculpture of Thailand*. Bangkok: River Books, 1997.

———. "Some Buddha Images and the Cultural Developments of the Late Angkorian Period". *Artibus Asiae,* 42, no. 2/3, 1980: pp. 155–74.

———. *Studies in the Art of Central Siam, 950–1350 A.D.*, vol. 2. PhD dissertation, Yale University, 1975.

Wyatt, David K. "Relics, Oaths and Politics in Thirteenth-Century Siam". *Journal of Southeast Asian Studies*, 32, no. 1, 2001: 3–66.

A BRIEF OVERVIEW OF KEY THERAVĀDA BUDDHIST STRUCTURES IN CENTRAL ANGKOR FROM THE 13TH TO 18TH CENTURIES

Ea Darith

INTRODUCTION

Two types and periods of Theravādin religious constructions are represented in early Middle Period Cambodia. The first type dates to approximately the 13th to 14th centuries. These structures are simple platforms or "terraces" devoid of massive architectural features or artistic embellishments.[1] This dramatically contrasts with the dominant, large-scale and ornate Brahmanic and Mahāyāna structures that preceded them (for example, Angkor Wat and Angkor Thom). The platforms likely supported a wooden structure housing a single central Buddha image. Roofs may have been covered with ceramic tiles. The second type consists of reworking Hindu and Mahāyāna structures to accommodate Theravāda preferences.[2] The scale of the central Buddha image and sacred space is much larger than the earlier Brahmanic or Mahāyāna inner sanctum. The prominent building period, however, begins in the latter part of the 16th century with King Ang Chan. Archaeological, art and architectural evidence demonstrate this pattern.

THERAVĀDA BUDDHIST STRUCTURES IDENTIFIED IN ANGKOR THOM: ARCHAEOLOGICAL SURVEY AND EXCAVATION

The stone platforms that once supported wooden structures for Buddhist religious practice were known in early scholarship as "Buddhist terraces". Theravāda Buddhism likely existed in a substantial way in the Angkor area from approximately the 13th to 14th centuries. The primary evidence comes from structures located in the capital city of Angkor, Angkor

Thom, dating to that period. Also of relevance, the first Pāli inscription appeared in the early 14th century.

Through surveying and mapping Angkor Thom, Cambodia's national Authority for the Protection and Safeguarding of Angkor and the Region of Angkor (APSARA) has identified 80 Buddhist platforms since 2002.[3] However, only 44 terraces have been recorded in detail (with technical descriptions and measurements). The other terraces were not recorded in detail because many were heavily looted, damaged and difficult to access. Others had not been properly cleared of vegetation and modern deposits, which prevented more detailed studies. The terraces were divided into four sections within Angkor Thom. There are 12 Buddhist terraces in the southeast section, 11 in the northeast section, 10 in the northwest section, and 11 in the southwest section.

There are five types of terraces based on size (planar dimensions):

Type I: 8 x 15–40 metres (9 terraces)
Type II: 10 x 20–25 metres (14 terraces)
Type III: 15 x 20–40 metres (8 terraces)
Type IV: 20 x 30–60 metres (12 terraces)
Type V: 40 x 60 metres (1 terrace)

Type II is the most common for smaller size structures, while Type IV is more common for larger size structures.

Most of the terraces face east. Three terraces in the southeast section face other directions: two face south and one faces north. One terrace in the northeast section faces west.

The terrace foundations were elevated differently. Artificial elevation is approximately one metre above the natural surface. Some simply include piled-up soil and fill. Others include arranged laterite or sandstone perimeters in a rectangular shape with added soil and fill inside the terrace. Three terraces in the northeast section have a second raised floor on the southern part of the terrace, about 30–50 centimetres higher than the lower floor. The higher floor at the southern section of the terrace was probably used by monks during ritual activities.[4] Modern ethnographic evidence shows that a raised platform at the southern section of the building is often reserved as a place for monks to eat. If a floor has only one level, a mat is placed at the southern section, enabling the monks to sit higher than the laypeople. The Buddha statue is usually placed at the western part of the terraces. Occasionally, there is an additional *stūpa* or older *prāsād* at the western end of the terraces.[5]

Two staircases made of sandstone or laterite leading to the eastern edge of the terrace are a common feature. However, there are no indications of stone pillars or walls. Most likely, wooden pillars were used to support superstructures and roofing. Some terrace pavements contain notches in

the stone or laterite for wooden pillar placement – generally spaced at three to four metre intervals. Brown glazed roof tiles are frequently scattered on the surface, having accumulated after the organic structures collapsed and decomposed.

Most terraces are bordered at the eight cardinal and inter-cardinal points by double *sīmā*. *Sīmā* have different styles and patterns.[6] Interesting artefacts around the terraces include stone coffins, Buddha statues, bricks, brown glazed stoneware roof tiles and other statues representing items such as cows, lions and deities.

Each of these terraces probably dates to approximately the 13th century or later. (For more on dating, see Chapter 6 and Chapter 8.) The famous 13th-century Chinese envoy, Zhou Daguan, mentioned what appear to be Buddhist terraces in Angkor.[7] The descriptions seem to align with the archaeological remains.

The largest Buddhist terraces were found in close proximity to the royal palace compound and the Bayon Temple in Angkor Thom.

Fig. 5.1 Preah Ang Kok Thlok terrace, Angkor Thom. Photograph by author, 2017.

Examples include Preah Palilay, Tep Pranam, Preah Vihear Prampir Lavaeng, Wat Tang Tok, Preah Ang Kok Thlok, Preah En Tep, Preah Si Ary Metrei and Kong Chhum. The larger Buddhist terraces are located near the royal palace. This may have made it more convenient for the king and high officials to practice their religion, and it may also have indicated status due to proximity to the palace. Many of the terraces are still used by local people today for Buddhist practices (Figs. 5.1–5.2).

Around some terraces, eight double *sīmā* were half buried at the cardinal points to define the boundaries of the *vihāra* (Fig. 5.3). Subsequently, a laterite wall was added around the terraces and double *sīmā*.

As noted, some terraces were constructed to the east of Angkorian Hindu temples (see images of Western Prasat Top in Chapter 6). This

Fig. 5.2 Tep Pranam terrace, Angkor Thom. Photograph by author, 2017.

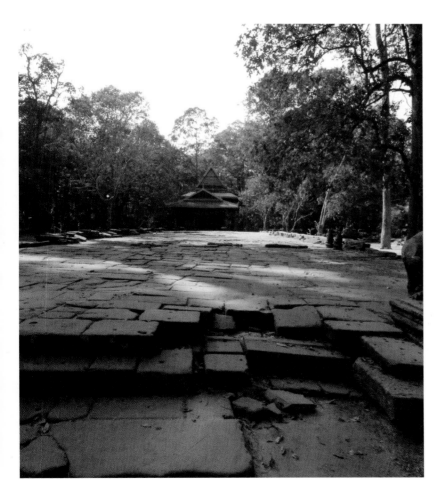

5.2

demonstrates that Buddhist structures probably shared borders with Hindu temples for a reason. It may relate to re-use or augmentation of sacred space and architecture. It could also represent a symbiotic religious relationship. The paired nature could relate to complementary sharing and use of sacred spaces, but such hypotheses remain speculative. However, the larger Hindu spaces and architecture could add to the Buddhist terrace for various practices, especially if the Hindu temple was defunct at the time the Buddhist terraces were created. In this case, the Hindu temple and space would have been transformed to accommodate Buddhist practices. These alternative hypotheses need further research and exploration. As stated, one hypothesis suggests a symbiotic, amalgamated or quasi-fused relation (common in Khmer culture); while the other hypothesis suggests re-use of defunct Hindu spaces and architecture for Buddhist practices. It cannot be denied, however, that sacred space in Khmer traditions may include a plethora of religious representations and practices despite being designated as following a specific religious doctrine. For example, a modern Theravāda pagoda may include, tolerate

Fig. 5.3 Preah Vihear Prampir Lavaeng, Angkor Thom, with double *sīmā*. Photograph by author, 2017.

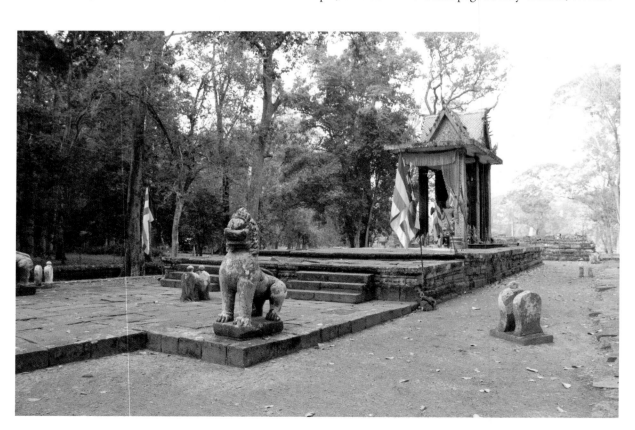

and even promote elements of traditional beliefs and art and architecture (for example, Neak Ta ancestor placation is often deemed to be semi-animistic), Hindu, Taoist and other beliefs. This type of syncretism is evident in historic and archaeological records and infused in many traditional practices and ethnographic records. The concept of mutual religious exclusion is possibly the exception rather than the norm.

Some terraces were constructed separate from the Angkorian Hindu temples. These can also have a structure at their western end, but in this case this structure appears to date to the same time as the terrace itself. What was the function of the building attached to the western part of the Buddhist terraces? These constructions were usually made of laterite. Only lower parts remain today. Careful observation around the laterite remains at Preah Ang Ngok shows what appear to be stone coffins arranged at the western sides of the laterite building[8] (Fig. 5.4). The stone coffins may have been associated with the building. It is possible the building may have served as housing for the coffins of high-level officials or kings. The other coffins around the building may belong to lower officials,

Fig. 5.4 Stone coffins at Preah Ang Ngok, Angkor Thom. Photograph by author, 2020.

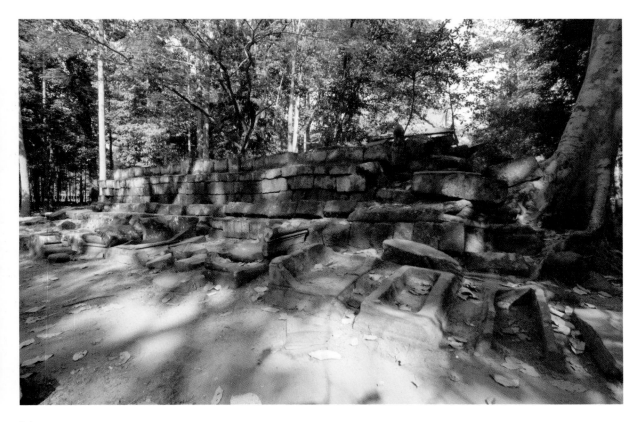

lower royalty or local people associated with the higher class. There are 14 stone coffins, all broken, made of sandstone, of different sizes and shapes with varying decoration. These coffins require further study.

If we observe the Hindu and Buddhist temples in the Angkorian period (pyramid or pyramid-like in form), some functioned as both a temple and tomb of the kings. George Cœdès suggested Angkor Wat was both a temple and a tomb. The Bayon temple was constructed for housing a large Buddha (a symbol of King Jayavarman VII) in the central tower with a *maṇḍapa* building attached at the eastern section. As previous scholars have questioned: Is there any similarity or connection between the Hindu and Mahāyāna Buddhist temples with the Buddhist structures during the later Theravāda time? The modern pagoda/temple is a place to bury or to store the ashes of deceased people, it is also a place to perform ceremonies. Now, there are many *stūpa* for housing ashes constructed inside pagoda complexes.

Excavations of a terrace at Western Prasat Top were conducted by the APSARA and Japanese Nara National Research Institute for Cultural Properties teams in 2004. Results indicated that terrace stones were placed along the terrace perimeter. Subsequently, surface soil was used to fill the interior. No internal lower terrace pavement, subsurface foundation or

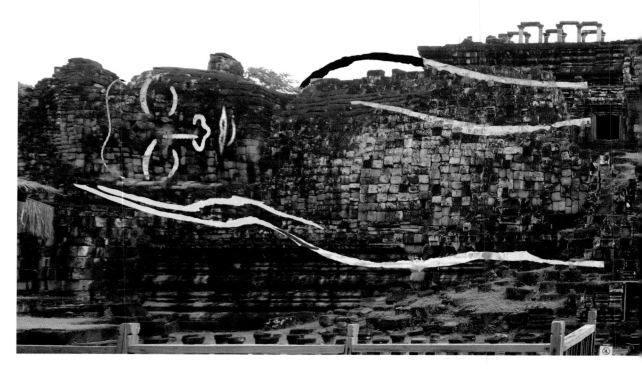

Fig. 5.5 Buddha entering *nirvāṇa* constructed on western façade of the Baphuon temple, outlined to better show the figure. Photograph and outline courtesy Lim Bunhong, 2020.

Fig. 5.6 Buddha entering *nirvāṇa*, Preah Palilay temple, Angkor Thom. Photograph by author, 2017.

5.6

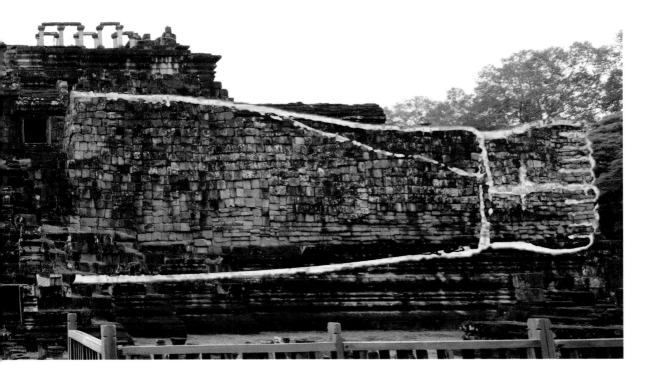

specialised fill was used. Only the upper surface had paved flooring (laterite and sandstone). Many types of archaeological objects were recovered such as brown glazed roof tiles, Khmer and Chinese ceramics, a bronze hook for a palanquin, jewellery, stones used for foundation or ritual ceremonies, and statues of Buddhas made of stone. Charcoal was also found and subjected to Accelerator Mass Spectrometry (AMS) radiocarbon analysis.'. The results indicate 13th- to 14th-century dates for the construction of the terrace.[9] Further research on this site is discussed in Chapter 6.

The overall design of these Buddhist terraces is simple. They were not intended to support large heavy structures. The design differs significantly from Hindu temple architecture – particularly the simplicity and lack of ornamentation. Simplicity may have represented Theravāda ideology (for example, impermanence in the physical realm and simplicity as opposed to ornate display of opulence and power). Also, simplicity may have related to economic and demographic factors, such as limited funding, support and patronage. Neither possibility is exclusive. The ideology coupled with lack of financial, organisational and labour support may have been equally important factors.

LARGER SCALE CONSTRUCTIONS AND MODIFICATIONS

In addition to Buddhist terraces, the early Middle Period also saw a re-emergence of more grandiose structures and representations. However, it appears the elite did not command the power, finances or resources to launch new megaprojects, such as those realised in previous Angkorian kingdoms under kings Sūryvarman II and Jayavarman VII. What is apparent is the re-use and reconfiguration of Hindu monuments to Buddhist ends – transformations. Interestingly, they did not transform the whole monument, only important aspects.

For example, the 11th-century Baphuon temple in Angkor Thom (originally Shaivite) was modified by dismantling stones from the galleries for the construction of a large reclining Buddha approximately 70 metres in length at the back of the temple (Fig. 5.5). The AMS radiocarbon dating of the four iron crampons from the head of the reclining Buddha at the western part of the Baphuon temple show evidence of the history of its foundation and modification. The new dating of the foundation of the Baphuon temple situates its main construction period during the reign of Sūryavarman I (1010–1050). However, the modifications date to the Theravāda Buddhist period related to the Ayutthayan occupation of Angkor in the 1430s.[10]

Dating the Preah Palilay temple remains difficult.[11] Hypotheses range from the mid 12th to 13th centuries. Preah Palilay has a cruciform plan

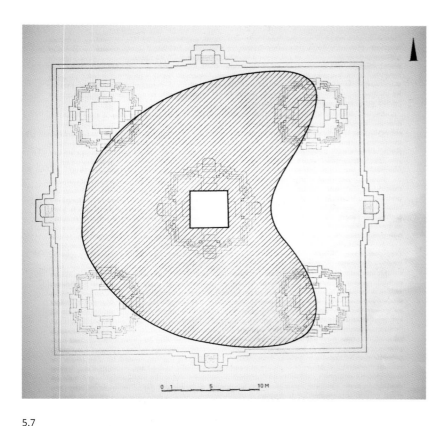

5.7

Fig. 5.7 Remains of seated Buddha atop Phnom Bakheng, Angkor. The shaded part of the diagram shows a seated Buddha incorporating elements of the original quincunx configuration at the mountain-temple summit. From Jacques Dumarçay, *Phnom Bakheng: Etude Archéologique du Temple, Mémoires Archéologiques VII*, 1971, p. 15. Reproduced with the permission of the EFEO.

5.8

Fig. 5.8 Phnom Bakheng seated Buddha. View from the southeast, showing portions of the Buddha body re-using stones from the original temple, with portion of an original sanctuary tower visible within. Photograph: Cliché EFEO, Fonds Cambodge réf. EFEO_CAM14118.

surrounded by enclosure walls with a single gate on the east wall. From the architectural plan and iconographic elements, it seems the main temple tower was built earlier, possibly as early as the middle of the 12th century. The east gate appears to have been added later during the 13th century. These two distinct phases are evident from the walls ending abruptly against the gables of the gate. On the lintel of the east gate is a representation of the Buddha entering *nirvāṇa*, lying on his left side, with disciples at his side (Fig. 5.6).

The early 10th-century Bakheng temple (originally Shaivite), located on Bakheng Mountain south of Angkor Thom, was later modified to form a large seated Buddha (Figs. 5.7–5.8). Stones from several pre-existing towers were used for construction. The colossal seated Buddha was likely built no later than the 16th century.[12]

The 12th-century Preah Khan temple located to the north of Angkor Thom was later reworked by adding a sandstone *stūpa* inside the central sanctuary, presumably making the whole area accommodate Theravādin practice (Fig. 5.9). The *stūpa* design appears to post-date the Angkor period but pre-date the modern period.[13]

Though possible, it is noted that some of these structural modifications and additional structures may not have been initiated in the

Fig. 5.9 *Stūpa* in central sanctuary, Preah Khan temple, Angkor. Photograph by author, 2017.

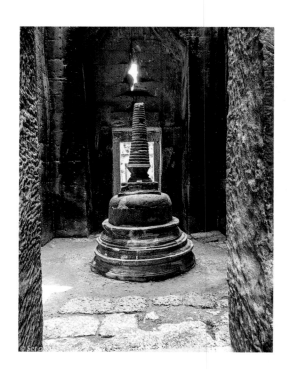

5.9

13th century. Many were probably undertaken in the late Middle Period but pre-date the modern period.

In the Middle Period, Angkor Wat temple appears to have contained only one Buddhist terrace in stone, which is located in the northwest section of the compound. The terrace was probably constructed in the 13th century, contemporaneous with the terraces in Angkor Thom – Stage 1. The double *sīmā* can still be seen around the terrace. However, the stones forming the terrace are degrading, eroding and falling out. Many have been displaced. On 3 October 1992, Buddhist devotees in Siem Reap province reconstructed a new *vihāra* (that they call Vihear Toch, or "Small Worship Hall" in Khmer) on the ancient Buddhist terrace by using old stones for the foundation (Fig. 5.10). A new platform and Buddha statue were erected on top. A wooden structure with a tiled roof was built to shelter the image. Although this is a new building, it respects the spirit of the ancient structure of the Buddhist terrace.

There were probably more Buddhist terraces inside the Angkor Wat complex in the past that did not use stone foundations. They were likely constructed of wood above the ground. Photographs of Angkor Wat taken in 1867 by John Thomson, a Scotsman who travelled from Bangkok, show wooden buildings and a Buddhist flagpole near the Grand Terrace (known in Khmer as *kdār paen*), west of the third enclosure. Thomson mentioned that the building on the left, close to the causeway, was the house of the head of a Buddhist monastery.[14] All these structures are now gone. Moreover, during the clearing process of the causeway in 1909, between the fourth and the third enclosures, two small cone-shaped mounds situated on either side (north and south) of the causeway, were unearthed just east of the western entrance of the fourth enclosure. Henri Marchal excavated the southern mound in June 1919, and found mainly built up earth mixed with sandstone chips and bricks that rose 3.9 metres above ground level and was limited on all sides by a 1.4-metre-high balustrade. He identified it as a recently added Buddhist structure, a *stūpa*.[15] The excavation also unearthed several hundred Thai coins that were still in use at the time of excavation and also three Japanese swords.[16]

Today there are two large pagodas located on either side of the main complex of Angkor Wat, to the north and south of the western entry causeway. The two pagodas were built approximately 100 years ago.

Within the main structure of Angkor Wat temple itself there are Buddhist traces and remains in many places in the form of Buddhist statues (see Chapter 8); more than 40 Khmer, Burmese and Thai inscriptions; ink inscriptions by Japanese and Chinese visitors or residents; a *stūpa* construction at the east of the third gallery; and some restoration works. It is also known that some Hindu bas-reliefs were carved in the galleries during the Middle Period. This practice appears to have served to

pay respect to the ancestors by finishing past projects in order to gain merit. Even though the carvings were Hindu, the practice itself was Buddhist. Combined, this evidence also demonstrates the connection between Angkor Wat, Buddhist practices and beliefs, and people from both local and foreign locations.[17]

Unfortunately, there is no clear, systematic documentation that elucidates in a definitive and thorough manner exactly what activities occurred in Angkor Wat and when the religion changed from Hinduism and Mahāyāna Buddhism to Theravāda Buddhism. For example, when were the "thousands" of Buddhist statues erected at the Cruciform Gallery (called "Preah Pean" or the Gallery of "A Thousand Buddhas") and the uppermost Bakan level? For how long did these activities take place? These questions remain largely unanswered, though the painstaking research I have cited has made progress and promises further elucidation on these issues.

We do know that in the 16th century a few Khmer kings, especially King Ang Chan, stepped up to strengthen and expand royal power after

Fig. 5.10 New *vihāra* on Middle Period terrace site in Angkor Wat temple grounds. Photograph by author, 2017.

the shift of the Khmer capital from Angkor. The Khmer capital had moved south by then – particularly spanning the Phnom Penh, Phnom Udong and Longvek areas on the west side of the Tonle Sap Lake, closer to modern-day Kampong Chhnang and Kandal provinces. The expansion primarily focused on the Angkorian heartlands rather than more distant places. King Ang Chan and his two successors visited Angkor to restore, reform and decorate structures and temples. Although it seems that the royal court itself never returned permanently to Angkor, royalty periodically returned to the area and established temporary residences for restoration and symbolic purposes. Angkor still remains the symbolic cultural heartland. Even today, there is a royal residence in Siem Reap despite the main palace being located in Phnom Penh.

Interestingly, as alluded to earlier, two galleries of the third enclosure of Angkor Wat, at the northeast corner, were left incomplete during the reign of King Sūryavarman II. An inscription records the context of their sculpting in the mid 16th century: "When His Majesty Braḥ Rāja Oṅkār Parama Rājādhirāja Rāmādhipatī Parama Cakravartirāja [Ang Chan], rose to the throne, he ordered Braḥ Mahīdhara and the royal artisans to continue sculpting the narrative panels ...". The new reliefs were made between 1546 and 1564.[18]

Following the restoration projects, we can assume that there was more information flow, knowledge transfer and advertisement about the area as an important place for Buddhist pilgrimage, hospitality and opportunity. Increased numbers of pilgrims likely visited Angkor. This is evident from many of the post-Angkor foreign inscriptions carved at Angkor Wat. Angkor became well known as a pilgrim centre for Buddhists, including the royal family.[19]

In summary, Theravāda Buddhist representations at Angkor appear to go through a basic two-stage evolutionary process. We do not yet know if there were abrupt changes or gradual changes. We do not fully understand the causes (both internal and external). It is unfortunate that there are few clues from the 14th and 15th centuries. However, a review of the inscriptions and other evidence from the 16th century onwards tells us about many practices that had evolved prior to the 16th century, as well as signifying important changes and efforts also beginning in the 16th century. It is important to increase research attention to this period of transformation. This includes further research on the chronology of the terraces; an inventory of items found at the terraces; establishment of the dating of these objects and of the *sīmā*; evidence in archaeology or text for specific rituals at the terraces; and how the terraces and other changes to Angkorian structures accommodated Theravāda in contrast to Mahāyāna or Brahmanic ceremonies.

Notes

1 Henri Marchal, "Monuments secondaires et terrasses bouddhiques d'Aṅkor Thom", *BEFEO* XVIII, no. 8, Hanoi, 1918; Ashley Thompson, "The Ancestral Cult in Transition: Reflections on Spatial Organization of Cambodia's Early Theravada Complex", in *Southeast Asian Archaeology 1996. Proceedings of the 6th International Conference of the European Association of Southeast Asian Archaeologists, Leiden, 2–6 September 1996,* eds. M. J. Klokke and T. de Brujin, Centre for Southeast Asian Studies, University of Hull, 1998, pp. 273–95; Ashley Thompson, *Mémoires du Cambodge*, PhD dissertation, Université de Paris 8, 1999, pp. 40–76.

2 Thompson, "The Ancestral Cult" and *Mémoires*, pp. 40–114.

3 APSARA, *Aṅgar Dhaṃ*, 2002. (Khmer-language publication for internal use.)

4 Marchal, "Monuments secondaires"; Thompson, "The Ancestral Cult" and *Mémoires*, pp. 47–8.

5 Thompson, "The Ancestral Cult" and *Mémoires*, pp. 40–114.

6 The most extensive study to date of Cambodian *sīmā* is in Madeleine Giteau, *Le bornage ritual des temples bouddhiques au Cambodge*, PEFEO VXVIII, 1969. For close consideration of the Middle Period *sīmā* in Angkor Thom, see Chapter 6 in this volume.

7 Zhou Daguan, *A Record of Cambodia: The Land and its People*, trans. Peter Harris, Silkworm Books, 2007.

8 George Cœdès, "Études cambodgiennes XXXIII: La destination funéraire des monuments khmers", *BEFEO* XL, no. 2, 1940, pp. 315–49.

9 Nara National Research Institute for Cultural Properties, Japan, *Western Prasat Top Site Survey Report on Joint Research for the Protection of the Angkor Historic Site*, Digital Advertising, Phnom Penh, 2012.

10 Stéphanie Leroy, Mitch Hendrickson, Emanuelle Delqué-Kolic, Enrique Vega and Philippe Dillmann, "First Direct Dating for the Construction and Modification of the Baphuon Temple Mountain in Angkor, Cambodia", *Plos ONE* 10, no. 11: e0141052. https://doi.org/10.1371/journal.pone.0141052.

11 For the most recent detailed reflections on the dating of this site, see Ludivine Provost-Roche, *Les derniers siècles de l'époque angkorienne au Cambodge (env. 1220–env. 1500)*, 2 vols., PhD dissertation, Université de la Sorbonne Nouvelle–Paris III, 2010, vol. 1: pp. 115–31; and Chapter 2 in this volume.

12 Jacques Dumarçay, *Phnom Bakheng: Étude architecturale du temple*, PEFEO, Paris, 1971; Ashley Thompson, "Pilgrims to Angkor: A Buddhist 'Cosmopolis' in Southeast Asia?", *Bulletin of the Students of the Department of Archaeology*, Royal University of Fine Arts, Phnom Penh, 2004, pp. 88–119; Nasir Abdoul-Carime and Grégory Mikaelian, "Angkor et l'Islam: note sur la stèle arabe du Bhnaṃ Pākhaeṅ (K.1081)", *Péninsule* 63, no. 2, 2011: pp. 5–59.

13 On early *stūpa* forms in Cambodia, including comments on this *stūpa*, see Henri Marchal, "Note sur la forme du *stupa au Cambodge*", *BEFEO* XLIV, no. 2: pp. 581–90; and Jean Boisselier, *Cambodge: Manuel d'archéologie d'Extrême-Orient*, tome I, ed. Picard, Paris, 1966, pp. 97–8.

14 Ang Choulean, Ashley Thompson and Eric Prenowitz, *Angkor: A Manual for the Past, Present and Future*, Phnom Penh: APSARA, 1995.

15 Henri Parmentier and Henri Marchal, *Angkor Vat: Rapport avril 1919–avril 1920, Rapport de la Conservation d'Angkor*, unpublished manuscript, Paris: EFEO, 1920.

16 See Nasir Abdoul-Carime, "Un vestige japonais au Cambodge: le *katana* du roi Sisowath", *Bulletin de l'AEFEK*, no. 22, December 2017, http://www.aefek.fr,

note 4; Till F. Sonnemann, *Angkor Underground: Applying GPR to Analyse the Diachronic Structure of a Great Urban Complex*, PhD dissertation, University of Sydney, 2011, pp. 137–8.

17 On the collection of Buddha images, see Chapter in this volume. On the 16th-century transformation of the central sanctuary into a *stūpa* with four colossal Buddha images, see Thompson, *Mémoires*, pp. 115–253; and Ashley Thompson, "Lost and Found: The Stupa, the Four-Faced Buddha and the Seat of Royal Power in Middle Cambodia", in *Southeast Asian Archaeology 1998. Proceedings of the 7th International Conference of the European Association of Southeast Asian Archaeologists, Berlin, 31 August to 4 September 1998*, eds. W. Lobo and S. Reimann, Centre for Southeast Asian Studies, University of Hull, 2000, pp. 245–63. On the inscriptions, see especially George Cœdès, "La date d'exécution des deux bas-reliefs tardifs d'Angkor Vat", *JA*, fasc. 2, 1962: pp. 235–43; Saveros Lewitz's corpus of critical editions in the *BEFEO* from 1970–75; and Yoshiaki Ishizawa, "Les inscriptions calligraphiques japonaises du XVIIe siècle à Angkor Vat et le plan du Jetavana-vihara", *Manuel d'épigraphie du Cambodge*, vol. I. ed. Yoshiaki Ishizawa, Claude Jacques and Khin Sok, Paris: EFEO/UNESCO, 2007, pp. 169–79.

18 Cœdès, "La date d'exécution"; Thompson, *Mémoires*, vol. I, pp. 172–79, vol. II, pp. 407–8; and Thompson, "Pilgrims to Angkor".

19 Thompson, "Pilgrims to Angkor".

References

Abdoul-Carime, Nasir. "Un vestige japonais au Cambodge: le *katana* du roi Sisowath". *Bulletin de l'AEFEK* 22, December 2017. http://www.aefek.fr.

Abdoul-Carime, Nasir and Grégory Mikaelian. "Angkor et l'Islam: note sur la stèle arabe du Bhnaṃ Pākhaeṅ (K.1081)". *Péninsule* 63, no. 2, 2011: pp. 5–59.

Ang Choulean, Ashley Thompson and Eric Prenowitz. *Angkor: A Manual for the Past, Present and Future*. Phnom Penh: APSARA, 1995.

APSARA. *Aṅgar Dhaṃ*. Publication for Internal Use, 2002. (In Khmer.)

Boisselier, Jean. *Cambodge: Manuel d'archéologie d'Extrême-Orient*, tome I. Paris: Éditions Picard, 1966.

Cœdès, George. "La date d'exécution des deux bas-reliefs tardifs d'Angkor Vat". *JA*, no. 2, 1962: pp. 235–43.

———. "Études cambodgiennes XXXIII. La destination funéraire des monuments khmers". *BEFEO* XL, no. 2, 1940: pp. 315–49.

Dumarçay, Jacques. *Phnom Bakheng: Étude architecturale du temple*. Paris: PEFEO, 1971.

Giteau, Madeleine. *Le bornage rituel des temples bouddhiques au Cambodge*. Paris: PEFEO VXVIII, 1969.

Ishizawa, Yoshiaki. "Les inscriptions calligraphiques japonaises du XVIIe siècle à Angkor Vat et le plan du Jetavana-vihara". In *Manuel d'épigraphie du Cambodge, Volume I,* eds. Yoshiaki Ishizawa, Claude Jacques and Khin Sok. Paris: EFEO/UNESCO, 2007, pp. 169–79.

Leroy, Stéphanie, Mitch Hendrickson, Emanuelle Delqué-Kolic, Enrique Vega and Philippe Dillmann. "First Direct Dating for the Construction and Modification of the Baphuon Temple Mountain in Angkor, Cambodia". *Plos ONE* 10, no. 11, 2015: e0141052. https://doi.org/10.1371/journal.pone.0141052.

Lewitz (Pou), Saveros. "Inscriptions modernes d'Angkor 2 et 3". *BEFEO* LVII, 1970: pp. 99–126.

———. "Inscriptions modernes d'Angkor 4, 5, 6 et 7". *BEFEO* LVIII, 1971: pp. 105–23.

———. "Inscriptions modernes d'Angkor 1, 8 et 9". *BEFEO* LIX, 1972: pp. 101–21.

———. "Inscriptions modernes d'Angkor 10, 11, 12, 13, 14, 15, 16a, 16b et 16c". *BEFEO* LIX 1972: pp. 221–49.

———. "Inscriptions modernes d'Angkor 17, 18, 19, 20, 21, 22, 23, 24 et 25", *BEFEO* LX, 1973: pp. 163–203.

———. "Inscriptions modernes d'Angkor 26, 27, 28, 29, 30, 31, 32, 33". *BEFEO* LX, 1973: pp. 205–42.

———. "Inscriptions modernes d'Angkor 35, 37 et 39". *BEFEO* LXI, 1974: pp. 301–37.

———. "Inscriptions modernes d'Angkor 34 et 38", *BEFEO* LXII, 1975: pp. 283–353.

Marchal, Henri. "Monuments secondaires et terrasses bouddhiques et monuments secondaires d'Aṅkor Thom". *BEFEO* XVIII, no. 8, 1918.

———. "Note sur la forme du *stupa au Cambodge*". *BEFEO* XLIV, no. 2, 1944: pp. 581–90.

Nara National Research Institute for Cultural Properties, Japan. *Western Prasat Top Site Survey Report on Joint Research for the Protection of the Angkor Historic Site.* Phnom Penh: Digital Advertising, 2012.

Parmentier, Henri and Henri Marchal. *Angkor Vat: Rapport Avril 1919–Avril 1920, Rapport de la Conservation d'Angkor.* Paris: EFEO, 1920. (Unpublished manuscript.)

Provost-Roche, Ludivine. *Les derniers siècles de l'époque angkorienne au Cambodge (env. 1220–env. 1500),* 2 vols. PhD dissertation, Université de la Sorbonne Nouvelle–Paris III, 2010.

Sonnemann, Till F. *Angkor Underground: Applying GPR to Analyse the Diachronic Structure of a Great Urban Complex.* PhD dissertation, University of Sydney, 2011.

Thompson, Ashley. "The Ancestral Cult in Transition: Reflections on Spatial Organization of Cambodia's Early Theravada Complex". In *Southeast Asian Archaeology 1996. Proceedings of the 6th International Conference of the European Association of Southeast Asian Archaeologists, Leiden, 2–6 September 1996,* eds. Marijke J. Klokke and Thomas de Brujin, Centre for Southeast Asian Studies, University of Hull, 1998, pp. 273–95.

———. "Lost and Found: The Stupa, the Four-Faced Buddha and the Seat of Royal Power in Middle Cambodia". In *Southeast Asian Archaeology 1998. Proceedings of the 7th International Conference of the European Association of Southeast Asian Archaeologists, Berlin, 31 August to 4 September 1998,* eds. Wibke Lobo and Stefanie Reimann, Centre for Southeast Asian Studies, University of Hull, 2000, pp. 245–63.

———. *Mémoires du Cambodge.* PhD dissertation, Université de Paris 8, 1999.

———. "Pilgrims to Angkor: A Buddhist 'Cosmopolis' in Southeast Asia?". *Bulletin of the Students of the Department of Archaeology, Royal University of Fine Arts.* Phnom Penh, 2004, pp. 88–119.

Zhou Daguan. *A Record of Cambodia: The Land and its People,* trans. Peter Harris. Chiang Mai: Silkworm Books, 2007.

NEW EVIDENCE AT WESTERN PRASAT TOP, ANGKOR THOM

Yuni Sato

INTRODUCTION

Western Prasat Top is a temple site located in the southwest quadrant of Angkor Thom. Western Prasat Top today consists of a central sanctuary flanked by southern and northern sanctuaries, with a "Buddhist terrace" to the east of the central sanctuary (Fig. 6.1). A laterite enclosure measuring 50 metres by 80 metres and seven double *sīmā* mark the temple grounds as though to enclose the sanctuaries (Fig. 6.2). In past studies, it was thought that Western Prasat Top was built in the ninth century, as inferred from inscriptions and the trace of modification to the central sanctuary[1], and remained in use into the post-Angkor period. However, no detailed archaeological studies had been made to support this

Fig. 6.1 Western Prasat Top (viewed from the east). Photograph by author, 2008.

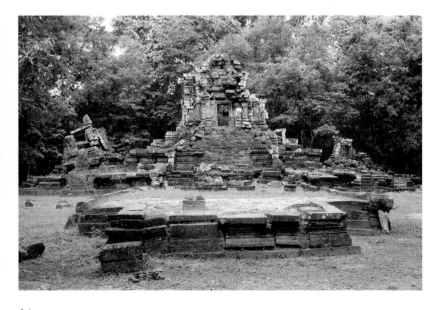

6.1

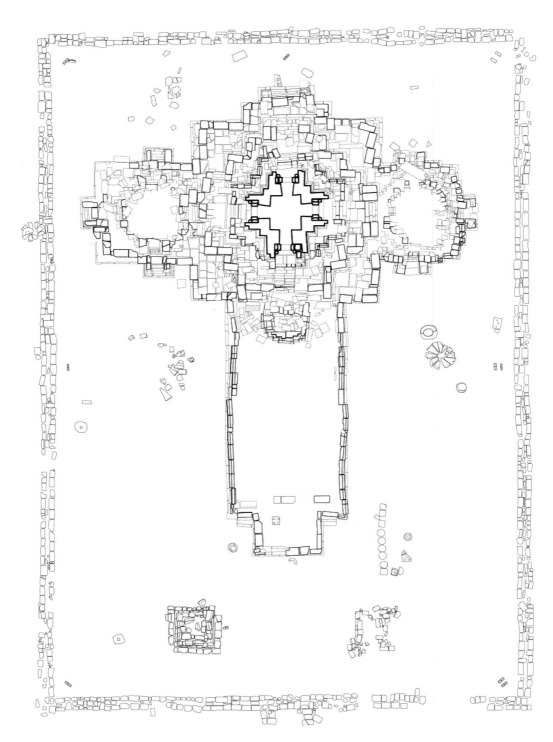

6.2

understanding. The monument deserves particular attention, as it includes buildings and architectural decorations that are associated with the 10th-century Banteay Srei style and the 13th- to 14th-century post-Bayon style. For example, seated Buddha images in *māravijaya* that are displayed on pediments and standing Buddha images depicted on the false doors of the northern sanctuary could be regarded as representative icons of Western Prasat Top that belong to the post-Bayon period.

PREVIOUS STUDY ON WESTERN PRASAT TOP

In 1918, Henri Marchal reported on the "Buddhist terraces" found in Angkor Thom district in his article "Monuments secondaires et terrasses bouddhiques d'Angkor-Thom".[2] Regarding the Western Prasat Top site, he discusses each sanctuary from an architectural point of view, and the artistic elements of the eastern face of the central sanctuary, concluding that the central sanctuary is a product of the Hindu religion that pre-dated Buddhism at Angkor. He also provides a rough definition of terrace remains based on observation of the terrace remains located throughout the Angkor Thom district. According to this definition, terrace remains are characterised by their relation to Buddhism; being

Fig. 6.2 Plan of Western Prasat Top. National Research Institute for Cultural Properties, Nara (NRICPN) 2012.

Fig. 6.3 Inscription *K. 576* (stored at the Angkor Conservation Depot). Photograph courtesy Inoue Tadao, 2010.

6.3

long narrow platforms running from east to west; and having architectural structures atop them.

In 1925, Marchal published an essay entitled "Notes sur le Monument 486 d'Angkor Thom" in which he discusses the Western Prasat Top site from artistic and architectural standpoints based on his observations in the previously mentioned article.[3] The 1925 article could be called the first full-fledged survey of the Western Prasat Top site. Firstly, Marchal takes note of the decorative lintels found in the central sanctuary. The north–south and east–west decorative lintels and colonettes in the central sanctuary resemble those found in the 10th-century Banteay Srei style, and some are trimmed down in an unnatural fashion and wedged into the central sanctuary, indicating that they may have been transferred there from elsewhere. An attempt at deciphering Inscription *K. 576* (Fig. 6.3.), discovered at the Western Prasat Top site, was made by Louis Finot.[4] This inscription, on a stone tablet 150 centimetres high, 40 centimetres wide and 15 centimetres thick, was discovered at the southeast corner of the northern sanctuary base during cleaning of the site. According to Finot, there are 23 lines engraved in Sanskrit and Old Khmer. They describe a statue of Vishnu offered in order to secure blessings for the ancestral hall, built for the maternal uncle of Yaśovarman I, and indicate that the hall was built between 889 and 908 for the enthronement of a prince.

After Marchal, from the 1940s through the 1960s, there was little scholarly investigation of or research on the Western Prasat Top site, and in general reference manuals on the broader Angkor site it was only mentioned as one of many ruins in the region. Maurice Glaize, for example, mentions the Western Prasat Top site briefly in his *Les monuments du groupe d'Angkor* but his observations do little more than reiterate the interpretations of Marchal.[5]

In the early 1970s, research on the Western Prasat Top site turned a corner with the work of Madeleine Giteau. She took an interest in the art of the post-Angkor period, and was one of the few experts studying this art from an iconographic standpoint. In particular, the iconographic analysis of post-Angkor Buddhist art and the decorative elements found at archaeological sites in *Iconographie du Cambodge Post-Angkorien* made her a well-known pioneering figure in the field.[6] Included in this study is an examination of Western Prasat Top as a site from the post-Bayon period, including an analysis of the Buddhist iconography, particularly of the pediments. The iconography of the site is attributed to several different periods, with the oldest pediments dating from the late 13th century, and, in Giteau's view, the newest of them not later than the end of the 14th century. She points out the resemblance of the *uṣṇīṣa* (protuberances on the heads of Buddha statues) to those of the Haripunjaya culture flourishing at the time in northern Thailand. The iconography of statues

at the Western Prasat Top site derives from Theravāda Buddhism, which in Giteau's view places them historically at the transition between Angkor and post-Angkor culture. This view has been highly influential on archaeological research not only at the Western Prasat Top site, but also on wider research relating to the Cambodian Middle Period.

In 1995, Hiram Woodward took note of the links between Thailand and Cambodia toward the end of the Angkor period, and delved into the formal evolution occasioned by the dissemination of Theravāda Buddhism through the study of a wide variety of materials from both countries from an architectural and artistic perspective.[7] In a 2002 paper, he discussed the back-and-forth influence between Thailand and Cambodia during the post-Bayon period, which he sees to be particularly notable on Thai art and architecture.[8] An example is the resemblance between standing Buddhist statues in the Western Prasat Top site northern sanctuary and the art of the Mon people of the Haripunjaya culture which flourished in northern Thailand between the 11th and 14th centuries. In addition, he notes the triple tower structure of the Western Prasat Top site, similar to temple structures seen in Lopburi, Central Thailand. During the post-Bayon period, Angkor came under increasing influence from regional Thai powers that were formerly under Khmer control, and Woodward suggests that these influences are visible in the spatial organisation of temples and decorative elements thereof.

Fig. 6.4 Northeast corner of the inner laterite base of Western Prasat Top's central sanctuary, with mouldings visible. Photograph by author, 2016.

In 1996, Ashley Thompson conducted a study of early Theravāda Buddhist architecture.[9] This study discusses the Western Prasat Top site, and acknowledges the importance of the site as both the last work of Angkor period architecture and the last temple to exhibit the triple tower structure. Thompson's doctoral dissertation of 1999 also refers to the Western Prasat Top site, and, while adhering fundamentally to the interpretations of Marchal and Giteau, places a strong emphasis on the triple tower structure of the site.[10] It notes that the triple towers in Cambodian Mahāyāna Buddhism generally represent Buddha, Avalokiteśvara, and Mahāprajnāpāramitā, while in Hinduism they represent Shiva, Vishnu and Brahma. Like Woodward, she describes the Western Prasat Top site as representative of the triple tower structure in Buddhist architecture, as also seen in Lopburi-period Thailand.

ARCHAEOLOGICAL EXCAVATIONS AND RESTORATION WORKS BY NARA NATIONAL INSTITUTE FOR CULTURAL PROPERTIES (NRICPN)

History of surveys by NRICPN

In 2001, Nara National Institute for Cultural Properties (NRICPN) launched an ongoing study of Western Prasat Top from the perspectives of archaeology, architectural history and conservation science.[11] Through our project new artefacts and evidence have been discovered.

On 26 May 2008, during the second mid-term phase surveys, about 40 gable stones on the eastern side of the central sanctuary were dislodged. It was learned that trees covering the top of the central sanctuary had been cut down two years prior, killing the roots that had held the stones in place. The destabilised stones fell as the tree roots decayed. As a consequence, all of the stonework on the upper part of the central sanctuary became unstable. This experience highlighted the urgent nature of the restoration of Western Prasat Top, which had been neglected for so long. Through discussions between NRICPN, APSARA (Authority for the Protection and Safeguarding of Angkor and the Region of Angkor) and other concerned parties, the decision was made to initiate restoration work under the third mid-term phase (2011–2015). Preparation for the restoration work started in 2011.

Archaeological excavations have been conducted at Western Prasat Top since 2003. As the excavation research focus was mainly limited to the Buddhist terrace and the periphery of the central sanctuary, it is difficult to infer the transformation of the site as a whole directly from the results of this research. However, some findings have been obtained through analysis of the artefacts' conditions when they were excavated.

Central Sanctuary

Previous studies pointed out three main points: an early laterite structure sits inside the central sanctuary; the decorative lintels and colonettes were adapted for installation in the central sanctuary; and pediments installed on the central sanctuary and southern and northern sanctuaries can be dated to the post-Bayon period. These three points must be well established in order to understand the transition of the central sanctuary.

Firstly, the central sanctuary consists of three major sections, a building frame, an upper base and a lower base. The outer tier of the bases is made from sandstone and has simple moulding. Due to the collapse of the outer sandstone tier, some parts of the inner laterite tier have been made visible. As Marchal mentioned, it is believed that the inner laterite base could be that of a former structure of Western Prasat Top, as this inner laterite base has mouldings.[12] During the partial restoration of the northeast corner of the upper base of the central sanctuary, we found that the inner laterite base retains original moulding (Fig. 6.4). That is, there is one laterite base with moulding inside the outer sandstone base of the central sanctuary which we can see today.

Secondly, as Marchal mentioned, the decorative lintels and colonettes of the central sanctuary are of the 10th-century Banteay Srei style. It became clear in our work however that only the south lintel was kept in its original position. The eastern and western lintels are today stored at the Angkor Conservation Depot; parts of the northern lintel had unfortunately fallen and scattered on the sanctuary floor.

Fig. 6.5 Pediment with the motif of Buddha in *māravijaya* seated on a pedestal. Photograph by author, 2016.

6.5

Thirdly, we were able to reconstruct some of the pediments and identify some of their iconography. Pediments in Western Prasat Top are characterised by images of the Buddha and other motifs depicted at the centre of the tympanum. These pediment images basically consist of three types:

Type One: A single seated Buddha with hands held in *māravijaya*. Type One is further broken down into two categories; Category One is made up of those with the Buddha seated on a pedestal decorated with lotus petals (Fig. 6.5), and Category Two refers to those without a pedestal.

Type Two: A seated Buddha in *māravijaya*, flanked by supplicants. The Type Two pediment images are all without pedestals. However, this type also consists of two categories. Category One includes pediment images in which the supplicants are wearing crowns (Fig. 6.6), and Category Two includes those in which they are not. In both categories, all the supplicants have their legs bent and are facing the Buddha with hands clasped in prayer.

Type Three: Flower or *kendi* imagery (Fig. 6.7).

For dating the central sanctuary, it is key to identify the unearthed ceramic sherds. During the seventh survey in the periphery of the central sanctuary, a white porcelain bowl was excavated. Because a sandstone masonry door sill of the central sanctuary was placed on this second layer, the current sandstone base exterior of the central sanctuary is believed to have been installed no earlier than the 14th century.

Fig. 6.6 Pediment with the motif of a crowned supplicant. Photograph by author, 2008.

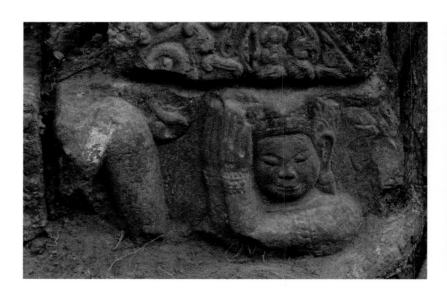

Buddhist Terrace
Structures

The survey of the artefacts of the lower layers of the Buddhist terrace revealed the transformation of artefacts in front of the pedestal at the eastern end of the terrace (Fig. 6.8). The survey discovered the laterite pavement. As Chinese ceramics excavated from the fifth layer are understood to belong to the 12th century, the first stage of construction is considered to date from around or after the 12th century. During a second stage, one posthole was dug, and a pillar likely related to the terrace was erected. The Carbon-14 date of the carbide, which is believed to be from a pillar, is from the late 13th century to the 14th century (Table 6.1), enabling us to date the second stage accordingly. During the third stage, pillars were abolished, the ground of the third and fourth layers was levelled, and the laterite floor was laid. Also, the currently conserved sandstone base exterior of the central sanctuary was built in this period. The fourth stage was when the second and the first layers were built on the laterite floor, and the Buddhist terrace that can be seen today was completed. The construction of the third and the fourth stages was carried out sequentially in the 14th century. The fifth stage, when wooden structures were built, can be identified by the production dates of the many roof tiles that were discovered. These roof tiles are brown glazed stoneware, the only discovery of the type thus far. The production time of the roofs will be studied as more similar case reports become available in the future.

Fig. 6.7 Pediment with *kendi* imagery. Photograph by author, 2016.

6.7

A small white porcelain jar was unearthed from the third layer during the 11th survey, and the head of a sandstone Buddha image, along with sandstone featuring Buddhist decoration were discovered in the adjacent area. A variety of artefacts made of gold and bronze were found inside the bowl and were confirmed to be objects used in ritual ceremonies.

Artefacts

The stone sculptures unearthed during excavations at the Buddhist terrace all depict the Buddha or are Buddhist-related. These unearthed artefacts do not appear to be stylistically uniform. For example, the Buddhist triad (Fig. 6.9) and the Buddha seated on a *nāga* represent motifs most often seen in Bayon-period sculpture. On the other hand, two Buddha heads and a niche have characteristics that place them in the post-Bayon period (Fig. 6.10). Moreover, the two Buddha heads differ in their treatment of different features, such as *uṣṇīṣa*, type of hair and shape of the face. The Buddha head with a flame-like *uṣṇīṣa* (Fig. 6.11) can be dated later than that with a simple *uṣṇīṣa* (Fig. 6.12).

Fig. 6.8 Plan of trench in front of pedestal on the terrace. NRICPN, 2012.

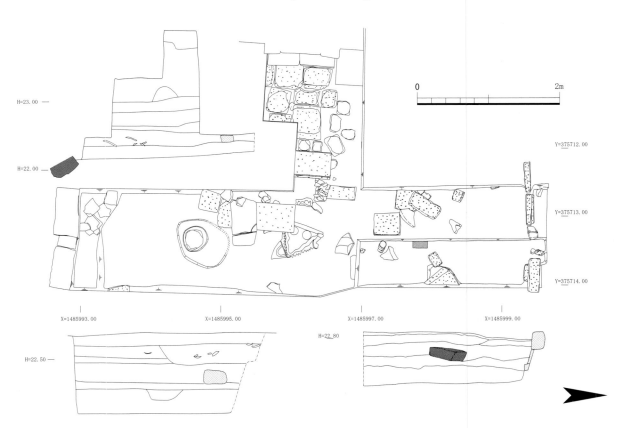

6.8

However, it must be noted here that while these artefacts display characteristics of different periods, they were all unearthed from around the same level on top of the eastern terrace. Most of them were found around the front of the Buddha pedestal, a point that requires additional discussion. We are however able to affirm that these Buddhist images were intentionally buried in the Buddhist terrace of Western Prasat Top. Considering the results of analysis of the accompanying Chinese ceramics and charcoal that were unearthed, the images from the vicinity of the pedestal were buried later than the 13th to 14th centuries.

Southern Sanctuary

The southern sanctuary consists of three major sections, a building frame, an upper base and a lower base. The upper section of the upper base of the southern sanctuary inclines toward the south at an angle of approximately 19 degrees. Because this incline made it impossible to reposition stones for reconstruction following disassembly, it was necessary to disassemble the lower base, add and compact soil, and then reconstruct the base.

Building frame

The building frame which consists of nine layers (N1–N9) is placed on the upper base. The roof was assumed to have been a simple arch; however, none of it remained. During dismantling, cuboid stones that may have been used for the roof were found. With regard to the building

Measurement	δ13C (‰)	Date for calendar year calibration (yrBP±1σ)	14C Date (yrBP±1σ)	Date range that 14C Date is calibrated into calendar year	
				1σ Calendar year range	2σ Calendar year range
PED-16760 No.S-1	-4.55±0.18	712±17	710±15	1270AD(68.2%)1290AD	1265AD(95.4%)1295AD
PED-16761 No.S-2	-4.60±0.15	737±17	735±15	1265AD(68.2%)1280AD	1255AD(95.4%)1290AD
PED-16762 No.S-3	-25.50±0.20	685±17	685±15	1275AD(68.2%)1300AD	1270AD(76.6%)1310AD 1360AD(18.8%)1390AD
PED-16763 No.S-4	-24.16±0.19	668±17	670±15	1285AD(40.6%)1300AD 1365AD(27.6%)1380AD	1270AD(54.2%)1310AD 1360AD(41.2%)1390AD
PED-16764 No.S-5	-24.73±0.25	718±19	720±20	1270AD(68.2%)1290AD	1260AD(95.4%)1295AD

Table 6.1: Radiocarbon dating results and calendar year calibration

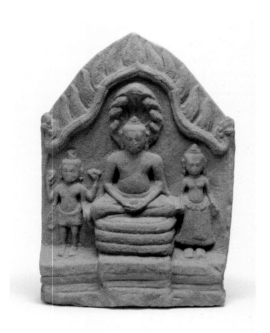

6.9

6.10

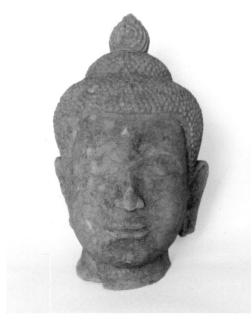

6.11

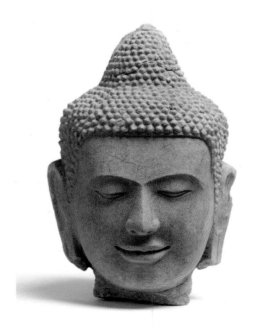

6.12

frame, on the eastern face, where the majority of the original stones remained, the beams under the gables of the roof, and one unit on the northern side among the *nāga* decorations that had been placed in pairs on both sides of the gables remained in their original positions; the eastern door was originally opened. On the other hand, on the northern, western and southern faces, where some parts of the original stones remained, each interior side door frame was filled in with stones, making these "false doors", well known in Angkorian architecture. Some of the sandstone comprising the building frame are re-used stones.

Unearthed *sīmā* at the upper base and lower base

The upper base consists of eight layers (N10–N17); the lower base consists equally of eight layers (N18–N25). The top layer of the lower base (N18) which is mainly composed of flat stones measuring approximately 12 centimetres thick could be the pavement layer of the lower base. During dismantlement, 14 *sīmā* were uncovered from the upper and lower bases. From the upper base, three *sīmā* were uncovered from N12, two from N14, two from N15 and five from N16. From the lower platform, two were found in N24 (Figs. 6.13 & 6.14). At first glance, the *sīmā* appear to have been stacked randomly, but they also seem to be placed mainly in positions that serve as gateways, such as near the stairways of platforms. This trend is especially conspicuous in N24. The *sīmā* found in N24 are clearly placed immediately below the bottom-most stairway of the lower platform stairways of the southern sanctuary and were probably placed in this position intentionally. At the southern sanctuary, although there is a diversion from the obvious use of these as "*sīmā*", that is sacred boundary stones, the sculpted blocks were likely placed and incorporated into the southern sanctuary with consideration of their ritualistic and religious meaning.

Comparative study of *sīmā* in Angkor Thom

Prior to her 1975 publication on Cambodian Middle Period iconography, Giteau published a study on the ritual use of *sīmā* in Cambodia.[13] Giteau's research provides the only available classification of *sīmā* in Cambodia, but it focuses mainly on highly decorative *sīmā* of Theravāda Buddhist temples built after the Middle Period, and does not provide a detailed classification of *sīmā* belonging to Buddhist terraces that were seen toward the end of the Angkor period and in Angkor Thom. Stephen Murphy has done significant work on *sīmā* not only in the Dvāravatī period/area but in other areas.[14] His work can support studies on *sīmā* generally, but the *sīmā* that were discovered in the southern sanctuary need to be considered in their specific context. Given this situation, the team decided to make a list of *sīmā* of major Buddhist terraces within

Fig. 6.9 Buddhist triad. Photograph courtesy Inoue Tadao, 2010.

Fig. 6.10 Sculpted niche. Photograph by author, 2011.

Fig. 6.11 Head of Buddha image (with flame-like *uṣṇīṣa*). Photograph by author, 2010.

Fig. 6.12 Head of Buddha image (with simple *uṣṇīṣa*). Photograph courtesy Inoue Tadao, 2010.

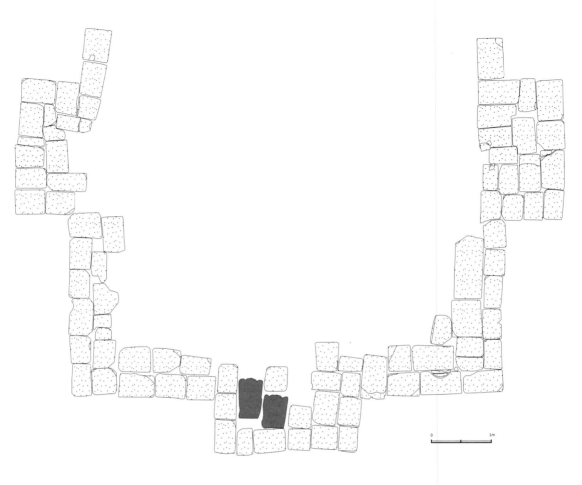

6.13

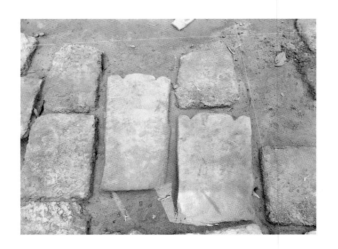

6.14

Angkor Thom, to compare them with the *sīmā* of Western Prasat Top. This was considered only a preliminary activity, feasible at the present stage. Though not all *sīmā* in Angkor Thom were verified, roughly on the whole, it seems they can be classified into two main types, each with their own sub-types, according to the shape of the stone exposed above ground. For convenience, they shall herein be referred to as Types A1 and A2, and Types B1, B2 and B3.

Type A1 has a tripartite head with no lotus bud; Type A2 has a tripartite head with a lotus bud at the top. Type B1 is shaped like a lotus petal and is minimally decorated; Type B2 has a lotus bud at the top and its body has a straight-edged form; Type B3 also has a lotus bud at the top, however, its side body shows a curved-edge form. It is too early yet to conclude at the present stage whether the differences between these types are due to differences in their year of construction. However, among the *sīmā* found at Western Prasat Top, the 14 stones found in the southern sanctuary correspond to Type A1, and those that were found in situ as boundary markers of the West Prasat Top Buddhist site correspond to Type B1. Among the Buddhist terraces of Angkor Thom we find:

> Type A1: Kok Thlok (Fig. 6.15)
> Type A2: Preah Pithu (Fig. 6.16)
> Type B1: Tep Pranam (Figs. 6.17 & 6.18)
> Type B2: Preah In Tep; Vihear Prambuon Lavaeng (Fig. 6.19)
> Type B3: Preah Ang Ngok; Vihear Prampir Lavaeng (Fig. 6.20)

The recent discovery of *sīmā* in the dismantling of the southern sanctuary of Western Prasat Top might provide important clues to revealing the process of formation of Theravāda Buddhist temples in Angkor Thom and the state of affairs during the transition into the Middle Period over the 13th and 14th centuries.

Northern Sanctuary

The northern sanctuary consists of three major sections: a building frame, an upper base and a lower base. The upper section of the upper base of the northern sanctuary inclines toward the south at an angle of approximately 14 degrees. The degree of incline is smaller relative to that of the southern sanctuary; however, sinkage at the centre of the base is significant, and has resulted in greater damage to the building frame. Additionally, the size of each sandstone block of the northern sanctuary is smaller than that of those used in the southern and central sanctuaries.

False door

According to previous studies and the École française d'Extreme-Orient (EFEO) photographic documentation, it has long been known that

Fig. 6.13 Locations of *sīmā* from N24 southern sanctuary. NRICPN, 2014.

Fig. 6.14 *Sīmā* from N24 southern sanctuary. Photograph by author, 2013.

Fig. 6.15 *Sīmā* at Kok Thlok, Angkor
Thom. Photograph by
author, 2013. (See Fig. 6.14
for comparator *sīmā* from
the southern sanctuary of
Western Prasat Top.)

Fig. 6.16 *Sīmā* at Preah Pithu (lotus
bud top missing).
Photograph by author,
2015.

Fig. 6.17. *Sīmā* at Tep Pranam.
Photograph by author,
2013.

standing Buddhas were sculpted on the western and southern false doors
of the northern sanctuary. Unfortunately, the building frame collapsed at
some point in the 20th century and many sandstone blocks have fallen to
the ground. The northern and eastern doors are entirely collapsed, leaving
only portions of the western and southern false doors in their original
positions. Fortunately, the upper part of the standing Buddha on the
western false door was stored at the Angkor Conservation Depot and has
now been reconstructed in its original position (Fig. 6.21). When
restoration work for the northern sanctuary started, the team
reconstructed the false doors. More than half of the southern false door
was found as scattered stones, and was reconstructed (Fig. 6.22).
Furthermore, the team found parts of the northern false door, which had
never been recorded in previous studies. It is interesting to note the subtle
differences in posture of these three Buddhas. While in previous studies

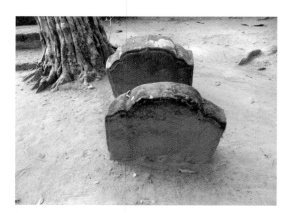

6.15

6.16

6.17

the southern and western door figures were interpreted as standing, there is a slight but important difference between them. The southern figure is fully frontal; the bent proper left knee of the western figure suggests walking. The figure on the northern door is shown veritably walking, with the whole body twisted in the direction the feet are headed (Fig. 6.23). We see here a specific style, like the walking Buddha known in northern Thai traditions. While the images on each of the three false doors depict the Buddha in a different stance, all show the *abhayamudrā*, with the right hand drawn up to the chest, and the left arm at the side.

Brick structure

Dismantlement of the building frame began in January 2016. It has become clear that while the inner tier of the lower base of the southern sanctuary is mainly composed of laterite, that of the northern sanctuary is

Fig. 6.18 *Sīmā* at Western Prasat Top in situ. Photograph by author, 2013.

Fig. 6.19 *Sīmā* at Vihear Prambuon Lavaeng. Photograph by author, 2010.

Fig. 6.20 *Sīmā* at Vihear Prampir Lavaeng. Photograph by author, 2012.

6.18

6.19

6.20

Fig. 6.21 Standing (or walking)
Buddha on the western
false door of the northern
sanctuary, Western Prasat
Top, Angkor Thom.
Photograph by author,
2019.

Fig. 6.22 Standing Buddha on the
southern false door of the
northern sanctuary,
Western Prasat Top, Angkor
Thom. Photograph by
author, 2019.

Fig. 6.23 Walking Buddha on the
northern false door of the
northern sanctuary,
Western Prasat Top, Angkor
Thom. Photograph by
author, 2019.

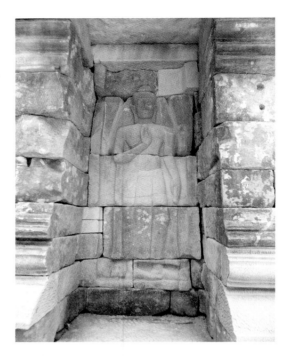

6.21

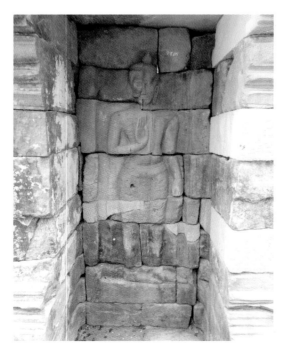

6.22

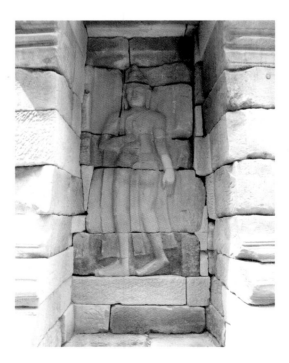

6.23

mainly composed of laterite and brick. Bricks are often used in temples of the pre-Angkor period or the early Angkor period; on the other hand, in the late Angkor period including the Bayon period, it was rare to use bricks for temple structures. From this point of view, it is assumed that bricks were used at the Western Prasat Top due to special circumstances.

After dismantlement of the lower base, an archaeological trench was set at the foundation in order to confirm the condition of the foundation soil and to confirm the soil bearing capacity. During this work a 2.2 metre square-shaped brick structure appeared in the centre of the foundation. The depth of the brick structure is 1.6 metres and the four walls are all lined with bricks (Fig. 6.24). It is particularly notable that the lower part of the walls is partially covered in soot. Additionally, a large number of valuable artefacts were unearthed from the area immediately above the brick-paved floor. All artefacts are broken into small sherds and all are burnt. There are 332 pieces in total, broken down into the following categories: 174 pieces of gold artefacts; 46 pieces of potash lead glass beads;

Fig. 6.24 Brick structure at the centre of the foundation of the northern sanctuary, Western Prasat Top, Angkor Thom, viewed from the south. Photograph by author, 2016.

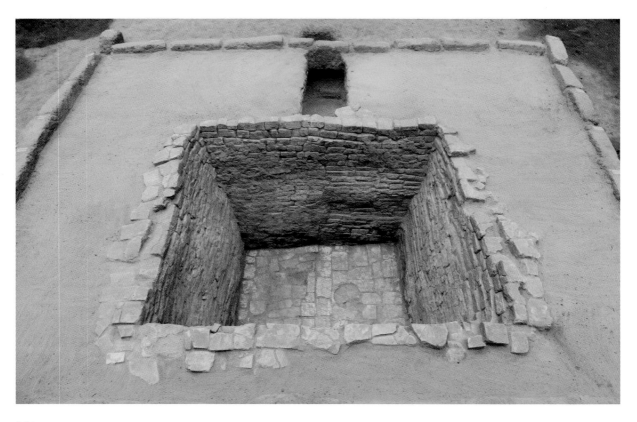

19 pieces of soda glass; 42 pieces of quartz; 19 pieces of bronze; 11 pieces of bone; and 21 pieces of unknown objects. Non-decorative gold plate items are the highest in number but many of these are small fragments. Gold balls count for the second highest number; this type is hollow and has a small hole through the axis. It seems that this type was used as a kind of bead for something like a bracelet or necklace. An unusual piece comprises two gold strings twisted into a thin strand (Fig. 6.25). The fragments of burnt bone and charcoal were analysed by scientific methods. The charcoal samples from the bottom of the brick floor show specific data.[15] Moreover, the burnt bone fragments were analysed through bone histological methods.[16] Judging from the charcoal pieces unearthed from the same level as these artefacts (Table 6.2), and the sooted walls, it is assumed that some form of ritual ceremony using fire was undertaken inside this brick structure.

Besides these valuable artefacts, a tiny sherd of ceramics was also unearthed from the same level. The ceramic is Chinese blue-and-white ware, which can be dated to the 14th century. This demonstrates that after ritual ceremonies had been accomplished after the 14th century, the brick structure was filled with sandy soil and the northern sanctuary was built on top of it.

It is unusual to find a structure underneath a sanctuary in Angkor. In the early 20th century, George Trouvé excavated the underground of the central tower of Angkor Wat and the central tower of the Bayon. He found shaft pits but there was no evidence of fire. The centre pit of Ak Yum was also excavated by Trouvé, however, the pit could be related to the *linga* placed inside the sanctuary. Although many archaeological missions have been undertaken since Trouvé's, there has never been mention of comparable underground structures in Angkor. It reminds us instead of Wat Mahāthāt in Ayutthaya where significant gold and otherwise valuable

Fig. 6.25 Gold strand excavated from the brick structure at the foundation of the northern sanctuary, Western Prasat Top, Angkor Thom. Photograph by Nakamura Ichiro, 2017.

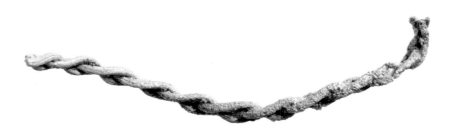

artefacts were unearthed from the space underneath the central tower. These may share the context of the ritual pit and valuable items, but Western Prasat Top has a decidedly different context with evidence of the use of fire. At this stage, two hypotheses can be considered. One hypothesis is that this was a part of funerary ceremony such as a cremation and the other is that it evidences a ritual fire ceremony in Hinduism and Buddhism as represented by *homa/havan/goma*. It is necessary to keep these hypotheses in mind as we continue our research.

DISCOVERY OF A DECORATIVE SANDSTONE BLOCK WITH AN INSCRIPTION

On 24 July 2012, a decorative sandstone block with an inscription was found while a new alignment marker was being installed in the course of restoration work. The decorative block was found in close proximity to the *sīmā* in the centre of the southern side, placed in an approximately

Measurement	Date range that 14C Date is calibrated into calendar year (1SD)	Date range that 14C Date is calibrated into calendar year (2SD)	Calibration data
WPT-C1	1315AD(51.7%)1356AD 1389AD(16.5%)1402AD	1299AD(67.9%)1370AD 1380AD(27.5%)1413AD	IntCal13
	1394AD(68.2%)1423AD	1322AD(13.8%)1347AD 1387AD(81.6%)1435AD	ShCal13
WPT-C2	1318AD(44.2%)1353AD 1390AD(24.0%)1409AD	1301AD(61.5%)1368AD 1382AD(33.9%)1420AD	IntCal13
	1398AD(68.2%)1427AD	1326AD(5.3%)1341AD 1390AD(90.1%)1442AD	ShCal13
WPT-C3	1329AD(14.0%)1340AD 1396AD(54.2%)1426AD	1316AD(30.9%)1355AD 1388AD(64.5%)1437AD	IntCal13
	1412AD(68.2%)1440AD	1400AD(95.4%)1450AD	ShCal13
WPT-C4	1315AD(50.0%)1356AD 1389AD(18.2%)1404AD	1299AD(67.1%)1370AD 1380AD(28.3%)1414AD	IntCal13
	1395AD(68.2%)1423AD	1323AD(11.6%)1345AD 1388AD(83.8%)1435AD	ShCal13
WPT-C5	1320AD(38.0%)1350AD 1391AD(30.2%)1414AD	1305AD(54.8%)1364AD 1384AD(40.6%)1425AD	IntCal13
	1402AD(68.2%)1430AD	1391AD(95.4%)1446AD	ShCal13
WPT-C6	1319AD(42.9%)1351AD 1391AD(25.3%)1410AD	1304AD(59.8%)1365AD 1383AD(35.6%)1420AD	IntCal13
	1400AD(68.2%)1426AD	1327AD(2.8%)1339AD 1390AD(92.6%)1443AD	ShCal13

Table 6.2: Estimated calibration age (cal BP)

10-centimetre-deep recess in the ground's surface. It has a decorative contour in the shape of lotus petals, and has a rectangular mortise at its centre (Fig. 6.26). When it was carefully picked up so that its opposing surface could be examined, a single inscribed line in the Pāli language in Khmer script was found (Fig. 6.27). The stone measures 66.3 centimetres at its longest point, 45.3 centimetres at its widest, it is 11.5 centimetres high and weighs approximately 40 kilograms. There is no consensus regarding its purpose, but it might have been an offering made with the inscription side facing up, or a pedestal for a wooden or stone object with the mortise side facing up. No other examples of similar decorative sandstone have been found so far from archaeological sites other than Western Prasat Top. The content of the inscription is interpreted as shown below.

Transliteration of original inscription: *dakkhiṇṇe kassapo buddho*
English translation: The Kassapa Buddha in the south

Judging by the character type, it is presumed to date from between the last years of the Angkor period and the Middle Period (Fig. 6.28). Kassapa Buddha is the sixth in the sequence of seven past Buddhas. In Buddhist traditions, multiple Buddhas appear over time. The first three Buddhas are of the *alamkarakalpa* era and the latter four are called Buddhas of the

Fig. 6.26 Decorative stone with mortise found at the centre of the southern side of the laterite enclosure of Western Prasat Top. Photograph courtesy Inoue Tadao, 2014.

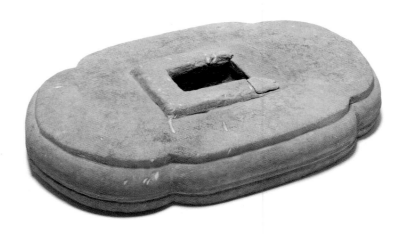

6.26

present *bhadrakalpa* era. The seventh Buddha is Sākyamuni, and an added eighth is Maitreya, the Buddha to come. The four past Buddhas of the present era, in particular, are frequently associated with the four directions and Kassapa Buddha is normally positioned in the south.[17] As mentioned above, this sandstone artefact was unearthed near *sīmā* situated in the central part of the south laterite enclosure; it might have been placed there with a conscious awareness of the south direction. With regard to the four past Buddhas, it is known that they were widely worshipped in Pagan, Burma (Myanmar). In Cambodia, however, no records or examples exist that indicate that the worship of the four past Buddhas flourished during the height of the Angkor period, but there is the possibility that such worship was widespread in the Cambodian Middle Period.[18]

The inscription "Kassapa Buddha in the south" found at Western Prasat Top might also suggest the possibility that the four-Buddha configuration was ingrained in Western Prasat Top. Fragments of sandstone with the same decorations as those recently discovered have been found (Figs. 6.29a & 6.29b) One of the fragments can be read as *pacca* and the other as *kyamuni*.[19] If additional fragments could be found in future surveys, it could lead to further understanding of the content of the inscriptions. In this respect, the recent discovery can be said to be an invaluable example that provides a vestige of early Theravāda Buddhism in

Fig. 6.27 Inscribed face of the decorative stone found at the centre of the southern side of the laterite enclosure of Western Prasat Top. Photograph courtesy Inoue Tadao, 2014.

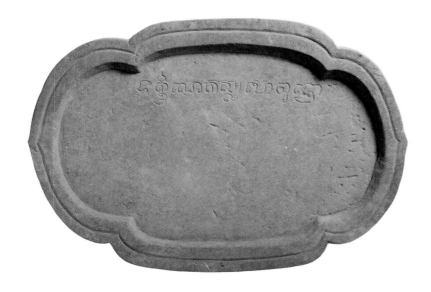

the early Cambodian Middle Period, and a new step toward an understanding of the overall picture of early Theravāda Buddhism in Cambodia.[20]

TRANSITION OF WESTERN PRASAT TOP

There appear to be more than four phases of transition at Western Prasat Top. At the first stage, the laterite base that can be seen inside the central sanctuary was constructed. As mentioned above, it is clear that the inner laterite base could be a former structure of Western Prasat Top because the inner laterite base has mouldings. At the second stage, the central sanctuary was built and decorated with a pediment featuring the seated Buddha in *māravijaya*, and a Buddha statue pedestal was constructed in front of the central sanctuary. However, the main Buddha statue of Western Prasat Top has yet to be found. At the third stage, the southern sanctuary and northern sanctuary were newly constructed and joined to the central sanctuary. During the dismantling process of the southern sanctuary, the southern lower stairway of the central sanctuary was excavated from the foundation soil of the lower platform of the southern sanctuary. This clearly showed that the southern sanctuary was built later than the central sanctuary. However, the period of the brick structure underneath the northern sanctuary must also be considered. At the fourth stage, the Buddhist terrace was constructed and connected with the eastern face of the central sanctuary; and the laterite enclosure and *sīmā* stones were arranged so as to enclose the sanctuaries. Regarding the sandstone with an inscription naming the Kassapa Buddha, there are two possible periods during which it could have been buried: one is the same time the *sīmā* were installed at Prasat Top, and the other is after the *sīmā* were installed.

According to the results of Carbon-14 dating of samples from the Buddhist terrace, the construction of the Buddhist terrace, which we can see today, can be dated after the 14th century. Also, based on the

Fig 6.28 Rubbing of a Pāli inscription *"dakkhiṇṇe kassapo buddho"* found at Western Prasat Top, Angkor Thom. NRICPN, 2015.

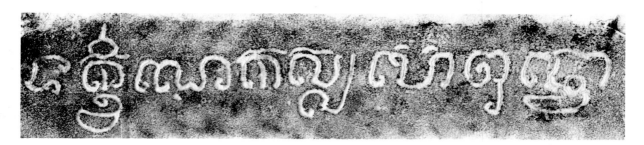

chronology of Chinese ceramics excavated from the southern and northern sanctuaries, both sanctuaries were also constructed around or after the 14th century to the early 15th century. The iconography of the northern false door of the northern sanctuary features a walking Buddha. All of this suggests that the major transformation of Western Prasat Top could have occurred around the 14th to the early 15th century.

6.29a

6.29b

Fig. 6.29a Rubbing of a fragmentary Pāli inscription, *pacca*, from Western Prasat Top, Angkor Thom.

Fig. 6.29b Rubbing of a fragmentary Pāli inscription from Western Prasat Top, *kyamuni*, from Western Prasat Top, Angkor Thom. NRICPN, 2015.

Notes

1 Henri Marchal, "Monuments secondaires et terrasses bouddhiques d'Aṅkor-
 Thom", *BEFEO* XVIII, 1918, pp. 1–40.
2 Henri Marchal, "Monuments secondaires".
3 Henri Marchal, "Notes sur le monument 486 d'Angkor Thom", *BEFEO* XXV,
 1925, pp. 411–6.
4 Louis Finot, "Inscriptions d'Angkor", *BEFEO* XXV, 1925, pp. 307–52.
5 Maurice Glaize, *Les monuments du groupe d'Angkor*, pp. 129–30.
6 Madeleine Giteau, *Iconographie du Cambodge Post-Angkorien*, Paris: PEFEO,
 1975. For an examination of Prasat Top, see pp. 113–6.
7 Hiram Woodward, "Thailand and Cambodia: The Thirteenth and Fourteenth
 Centuries", in *Ruam bot khwâm thâng 72 phansâ than âchân Sâstrâchan Môm
 Chao Suphattradit Ditsakun/Studies & Reflections on Asian Art History and
 Archaeology: Essays in Honour of H.S.H. Professor Subhadris Diskul,* Bangkok:
 Silpakorn University, 1995, pp. 335–42.
8 Hiram W. Woodward, *The Art and Architecture of Thailand*, Leiden/Boston:
 Brill, 2002.
9 Ashley Thompson, "The Ancestral Cult in Transition: Reflections on Spatial
 Organization in Cambodia's Early Theravāda Complex", in eds. Marijke J.
 Klokke and Thomas de Brujin, *Southeast Asian Archaeology 1996. Proceedings of
 the 6th International Conference of the European Association of Southeast Asian
 Archaeologists, Leiden, 2–6 September 1996*, Hull: Centre for Southeast Asian
 Studies, University of Hull, 1998, pp. 273–95.
10 Ashley Thompson, *Mémoires du Cambodge*, PhD dissertation, Université de
 Paris 8, 1999, pp. 51–3 ; see also Thompson, "The Ancestral Cult".
11 National Research Institute for Cultural Properties, Nara (NRICPN), *Western
 Prasat Top Site Survey Report on Joint Research for the Protection of the Angkor
 Historic Site.*
12 Marchal, "Notes sur le monument 486".
13 Madeleine Giteau, *Le bornage rituel des temples bouddhiques au Cambodge.*
 Paris: PEFEO, 1969.
14 Stephen Murphy, *The Buddhist Boundary Markers of Northeast Thailand and
 Central Laos, 7th–12th Centuries CE: Towards an Understanding of the
 Archaeological, Religious and Artistic Landscapes of the Khorat Plateau,* PhD
 dissertation, SOAS University of London, 2010.
15 See Table 6.1. The radiocarbon results are shown in Yuzuru Yoneda, Takayuki
 Omori, Harumura Ozaki, Yuni Sato and Hiroshi Sugiyama, "Radiocarbon
 dating", *Survey and Restoration of Western Prasat Top Interim Report 5 Brick
 Structure of Northern Sanctuary,* 2018, pp. 22–5. This analysis was conducted
 by the Laboratory of Radiocarbon Dating, The University Museum, Tokyo
 University. (See Table 6.2.)
16 The histological analysis was conducted by Dr Sawada Junmei of Niigata
 University of Health and Welfare. The results appear in Sawada, Junmei,
 "Species Identification by Bone Histomorphology of Burnt Bone Fragments
 Unearthed from a Brick Structure at Western Prasat Top", *Survey and
 Restoration of Western Prasat Top Interim Report 5 Brick Structure of Northern
 Sanctuary,* 2018, pp. 26–33. It shows that the excavated burnt bone fragments
 are of quite similar composition to human bone. However, it is necessary to
 conduct further comparative research on animals in Southeast Asia through the
 histological method.
17 See Chapter 7 in this volume.

18 See Thompson, *Mémoires du Cambodge*, pp. 115–253; and Ashley Thompson, "Lost and Found: The Stupa, the Four-faced Buddha and the Seat of the Royal Power in Middle Cambodia", in *Southeast Asian Archaeology 1998. Proceedings of the 7th International Conference of the European Association of Southeast Asian Archaeologists, Berlin, 31 August–4 September 1998*, eds. W. Lobo and S. Reimann, Hull: Centre for Southeast Asian Studies, University of Hull, 2000, pp. 245–63.

19 Keo Sovannara Sok, "The Western Top Temple's Stone Blocks (Preliminary Introduction to the Inscriptions, Graffiti, Marks and Sketched Designs)", *Annual Report on the Research and Restoration Work of the Western Prasat Top II: Dismantling Process of the Southern Sanctuary,* Nara National Research Institute for Cultural Properties, 2015, pp. 49–55.

20 For further reflections on these issues, see Chapter 7 in this volume.

References

Finot, Louis. "Inscriptions d'Angkor". *BEFEO* XXV, 1925: pp. 307–52.

Giteau, Madeleine. *Iconographie du Cambodge Post-Angkorien*. Paris: PEFEO, 1975.

———. *Le bornage rituel des temples bouddhiques au Cambodge*. Paris: PEFEO, 1969.

Glaize, Maurice. *Les monuments du groupe d'Angkor*. Paris: Librairie d'Amérique et d'Orient Adrien Maisonneuve, 1963.

Lunet de Lajonquière, Étienne. *Inventaire descriptif des monuments du Cambodge*, Tome 3. Paris: Ernest Leroux, 1911.

Marchal, Henri. "Monuments secondaires et terrasses bouddhiques d'Ankor-Thom". *BEFEO* XVIII, 1918: pp. 1–40.

———. "Notes sur le monument 486 d'Angkor Thom". *BEFEO* XXV, 1925: pp. 411–6.

Murphy, Stephen. *The Buddhist Boundary Markers of Northeast Thailand and Central Laos, 7th–12th Centuries CE: Towards An Understanding of the Archaeological, Religious and Artistic Landscapes of the Khorat Plateau*. PhD dissertation, SOAS University of London, 2010.

National Research Institute for Cultural Properties, Nara (NRICPN). *Western Prasat Top Site Survey Report on Joint Research for the Protection of the Angkor Historic Site*. 2012.

NRICPN. *Annual Report on the Research and Restoration Work of the Western Prasat Top: Dismantling Process of the Southern Sanctuary*. 2014.

Sato, Yuni. "A Perspective on Iconography in Late Angkor: Comparative Study of Artefacts from Western Prasat Top and Other Sites". In *A Study on Devaraja Cult and its Arts in South Asia and Southeast Asia,* ed. Koezuka Takashi. Osaka: Graduate School of Letters, Osaka University, 2013, pp. 99–105. (In Japanese.)

Sawada, Junmei. "Species Identification by Bone Histomorphology of Burnt Bone Fragments Unearthed from a Brick Structure at Western Prasat Top". *Survey and Restoration of Western Prasat Top Interim Report 5 Brick Structure of Northern Sanctuary,* 2018, pp. 26–33.

Sok, Keo Sovannara. "The Western Top Temple's Stone Blocks (Preliminary Introduction to the Inscriptions, Graffiti, Marks and Sketched Designs)". *Annual Report on the Research and Restoration Work of the Western Prasat Top II: Dismantling Process of the Southern Sanctuary,* Nara National Research Institute for Cultural Properties, 2015, pp. 49–55.

Thompson, Ashley. "The Ancestral Cult in Transition: Reflections on Spatial Organization in Cambodia's Early Theravāda Complex". In *Southeast Asian Archaeology 1996. Proceedings of the 6th International Conference of the*

European Association of Southeast Asian Archaeologists, Leiden, 2–6 September 1996, eds. Marijke J. Klokke and Thomas de Brujin. Hull: Centre for Southeast Asian Studies, University of Hull, 1998, pp. 273–95.

———. "Lost and Found: The Stupa, the Four-faced Buddha and the Seat of the Royal Power in Middle Cambodia". In *Southeast Asian Archaeology 1998: Proceedings of the 7th International Conference of the European Association of Southeast Asian Archaeologists, Berlin, 31 August–4 September 1998,* eds. Wibke Lobo and Stefanie Reimann. Hull: Centre for Southeast Asian Studies, University of Hull, 2000, pp. 245–63.

———. *Mémoires du Cambodge*, PhD dissertation, Université de Paris 8, 1999.

Woodward, Hiram W. "Thailand and Cambodia: The Thirteenth and Fourteenth Centuries". In *Ruam bot khwâm thâng 72 phansâ than* âčhân *Sâstrâčhan Mộm Čhao Suphattradit Ditsakun/Studies & Reflections on Asian Art History and Archaeology: Essays in Honour of H.S.H. Professor Subhadris Diskul.* Bangkok: Silpakorn University, 1995, pp. 335–42.

———. *The Art and Architecture of Thailand.* Leiden/Boston: Brill, 2002.

Yoneda, Yuzuru, Takayuki Omori, Harumura Ozaki, Yuni Sato and Hiroshi Sugiyama. "Radiocarbon dating". *Survey and Restoration of Western Prasat Top Interim Report 5 Brick Structure of Northern Sanctuary,* 2018, pp. 22–5.

BACK TO THE FUTURE: THE EMERGENCE OF PAST AND FUTURE BUDDHAS IN KHMER BUDDHISM

Nicolas Revire

INTRODUCTION

The enumeration of past (*atīta*) and future (*anāgata*) Buddhas may go back to the origins of Buddhism in India. Even if the number and names of Buddhas vary from one list to another in South Asian traditions,[1] what primarily matters in Pāli Buddhism is the idea of "serialisation", that is, that the Buddhas follow each other sequentially in different time periods and never encounter one another. The concept of multiple or infinite Buddhas of past and future times is indeed nicely embedded in a metaphor of today's Khmer language and recurrently appears in the Middle Period *Inscriptions modernes d'Angkor* (*IMA*), that is, *braḥ buddh aṁmpāl khsāc* or "Buddhas as numerous as [grains of] sand".[2]

The earliest occurrence of past Buddhas in the Tipiṭaka is found in the *Mahāpadānasutta* (D II 1–54) which lists only the six former Buddhas preceding Gotama.[3] The seven Buddhas of the past are of course also well known and worshipped in other Buddhist traditions preserved, for example, in Sanskrit and Tibetan.[4] In mainland Southeast Asia, however, it is the grouping of the 24 or 27 past Buddhas immediately preceding Gotama, according to the *Buddhavaṁsa* and its commentary,[5] and that of the five Buddhas of the present age or "good eon" (*bhaddakappa*) that are the most important. These latter five consist of four past Buddhas, that is, Kakusandha, Koṇāgamana, Kassapa and Gotama, to which the next future Buddha, Metteyya, is added.

These series of past and future Buddhas are well evidenced in local Pāli and vernacular literature. Many ancient painted or sculpted examples, as well as architectural forms, also exist. The earliest artistic and epigraphic traces appear in Burma (Myanmar) and Siam (Thailand), first at Śrīkṣetra and Dvāravatī, as well as, later, in Pagan, Sukhothai and Lanna, from

approximately the 6th century up to the present.[6] The separate worship of Metteyya, often combined with the four past Buddhas seems also to have been popular in premodern Cambodia as we shall see. This configuration of four or five Buddhas became prominent, for example, at Wat Nokor (Kampong Cham province) or Wat Tralaeng Kaeng in Longvek, that is, after the development of Theravāda Buddhism as the most widely practised religion in the kingdom.[7] Later, a rare list of ten future Buddhas, beginning with Metteyya, was further elaborated and extolled in the same religious context.

This chapter aims to chronologically survey the artistic, epigraphic, textual and premodern ritual evidence for the emergence of the cult of past and future Buddhas in Cambodia proper and its bordering regions. It also briefly compares these lists with material from Sri Lanka and other neighbouring countries, and examines their importance in understanding the advent and uniqueness of Theravāda across the region.

FROM ESOTERIC JINAS TO CANONICAL BUDDHAS (11TH TO 13TH CENTURIES)

This question, of the distinction between the five esoteric and the canonical Buddhas, is key in understanding the advent of Theravāda in Cambodia during the late Angkorian period. One hypothesis is that Mahāyānic and tantric conceptions of the five Jinas were rejected and indeed anathema to the five Historical Buddhas unequivocally associated with the *bhaddakappa*. But does the material actually demonstrate this? To address this question is to look into the possible origins of the so-called esoteric Theravāda practices well documented in later periods.

Possibly the first known Khmer representation of five Buddhas seated together is seen on the stone *stūpa*[8] or *caitya* from Kbal Sre Yeay Yin mound (late 10th century; Musée Guimet inventory no. 17487). In the context of this period, they probably represent the five cosmic Buddhas or Jinas, not the past Buddhas. Esoteric Jinas are also depicted in the north interior lintel at Prasat Hin Phimai (11th to 12th centuries), where they are associated with dancing *yoginī*,[9] and may equally be represented in another stele from Prasat Phnom Kambot (early 12th century) depicting five "serpent-enthroned" Buddhas kept today at the Angkor Conservation Depot.[10] The earliest epigraphic reference to a similar esoteric pentad is from the Sap Bak inscription (*K. 1158*) from Northeast Thailand, dated 1066, which states as follows:

> I. *śrīpañcasugatā yādau śrīghanānāṃ vibhāvakāḥ*
> *śrīghanāś ca sudebānāṃ śrīpradātṝn namāmi tān* ||
> II. *bajrasatvas tu ṣaṣṭhaḥ sadvodhisatvaprabhur varaḥ*
> *ādhāraḥ sarvavuddhānāṃ tan namāmi vimuktaye* ||[11]

1. In the first instance, the glorious five Sugatas are the
originators of the Śrīghanas, and the Śrīghanas of the
excellent gods. I bow to them, the givers of glory.
2. But Vajrasattva is the sixth (as) the pre-eminent lord of the
existing Bodhisattvas, (and) the repository (or foundation)
of all the Buddhas. I bow to him for the sake of deliverance[12]

This inscription clearly reflects the growing importance of esoteric
Buddhism in this area at least around the middle of the 11th century. In
the same inscription appears the epithet *śrīghana* and the term
pañcasugata in reference to the five cosmic Jinas (*pañcajina*) and to which
Vajrasattva, the sixth primordial one, is added.[13] These five transcendental
Buddhas or Jinas are a common subject of Vajrayāna *maṇḍala* and are
usually identified as Vairocana, Akṣobhya, Ratnasambhava, Amitābha and
Amoghasiddhi. There are many variant systems and lists known across
time and space in Buddhist Asia, as well as an expansive number of
associations with these five Buddhas that has developed over many
centuries. The most common listing includes the following "five families"
or *pañcakula* as arranged in Table 7.1.

In addition to being assigned a direction, an element, a colour, a *bīja*
or seed syllable, and an animal throne, each of the five transcendental
Buddhas represent the purified manifestations of the five aggregates, sense
organs and sensory perceptions.[15] These five Buddhas also correspond to
the five main *cakra* of the subtle body, with white Vairocana at the crown,
red Amitābha at the throat, blue Akṣobhya at the heart, yellow
Ratnasambhava at the navel, and green Amoghasiddhi at the sexual centre.

Some lintels from Phimai or other Angkorian temples from the Bayon
period (prominently at Preah Khan of Kompong Svay) represent, or at

Jina	Family	Direction	Aggregate	Element	Colour	Bīja	Vehicle
Vairocana	*Tathāgata* (Buddha)	centre	form (*rūpa*)	space	white	OṀ	lion
Akṣobhya	*Vajra* (diamond)	east	consciousness (*vijñāna*)	air	blue	HŪṀ	elephant
Ratnasambhava	*Ratna* (jewel)	south	feeling (*vedanā*)	fire	yellow	TRAḤ	horse
Amitābha	*Padma* (lotus)	west	perception (*saṁjñā*)	water	red	HRĪḤ	peacock
Amoghasiddhi	*Karma* (action)	north	formation (*saṁskhāra*)	earth	green	AḤ	*garuḍa*

Table 7.1: Diagram of the Five Buddha Families[14]

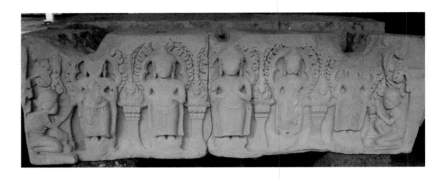

Fig. 7.1a Lintel representing five standing Buddhas, Phimai National Museum. Inventory number: 7/2520, Nakhon Ratchasima province, Thailand, 11th to 12th centuries.

7.1a

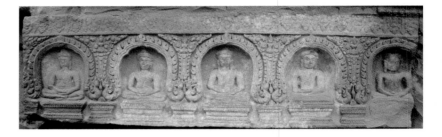

Fig. 7.1b Lintel representing five seated Buddhas, Preah Khan of Kompong Svay, Preah Vihear province, Cambodia, 12th to 13th centuries. Photographs by author, 2011 & 2015.

7.1b

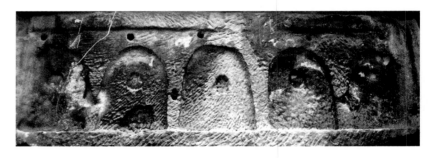

7.2a

Fig. 7.2a Empty niches, presumably for five seated Buddhas, Preah Khan of Kompong Svay, Preah Vihear province, Cambodia, 13th century.

Fig. 7.2b Defaced niches of five (tantric?) deities, Wat Nokor, Kompong Cham province, Cambodia, 13th century. Photographs by author, 2015.

7.2b

least once represented, five standing or seated Buddhas and may refer to these "glorious Sugatas" or "Śrīghanas", that is, the esoteric Jinas (Figs. 7.1a & 7.1b).[16] Some of these niches are, however, empty or defaced and evidently suffered an iconoclastic crisis (Figs. 7.2a & 7.2b). The late Ian Harris, following others before him, indeed argued that "the anti-Buddhist iconoclasm was rather more selective than has sometimes been thought". The explanation he gives is that "the reaction was directed at images of a syncretic or tantric nature representing concepts quite recently imported into the country [...]. The opposition, then, was to alien ideas and practices rather than to long-standing Buddhist traditions [...]."[17] In other words, perhaps it was not so much about an anti-Buddhist iconoclasm at Angkor in the 13th century but more correctly an anti-tantric reaction. A lintel with five seated Buddhas at Ta Prohm Kel, a Bayon-period "hospital" sanctuary in Angkor, may be a good example of this trend since three-dimensional scanning imagery shows that the five meditating Buddhas we see today in situ actually replaced an equal number of four-armed original (tantric?) Buddhist deities (Figs. 7.2c & 7.2d).[18]

In the same vein, several other lintels with rows of seven Buddhas from Phimai, often in royal dress, are equally difficult to interpret depending on which kind of Buddhism was practised in the Khmer empire at the time (Figs. 7.3a–7.3c). They could represent different groupings of Buddhas,

Fig. 7.2c Lintel with five seated Buddhas, Ta Phrom Kel "Hospital" sanctuary, Angkor, Siem Reap province, Cambodia, 13th century.

Fig. 7.2d Same lintel with chiseled-out arms highlighted. Photogrammetric images by Olivier Cunin, 2015.

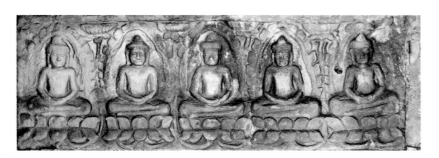

7.2c

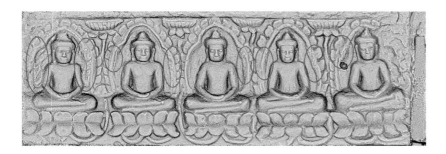

7.2d

Figs. 7.3a–c Lintels with rows of
seven Buddhas, Phimai
National Museum.
Inventory Numbers:
12/1–4/2520, 15/2520,
39/2/2529, Nakhon
Ratchasima province,
Thailand, 11th to 12th
centuries. Photographs
by author, 2011.

either those of the past and present, the transcendental Jinas, or even
perhaps the seven emanations of Bhaiṣajyaguru, the "Master of Healing"
or Buddha of medicine, who is thought to have also had some impact and
popularity in Cambodia and Northeast Thailand during the Bayon period
under King Jayavarman VII.[19] The *Sūtra on the Merits of the Fundamental
Vows of the Seven Buddhas of Lapis Lazuli Radiance, the Masters of
Healing* (Chinese: *Yaoshi liuliguang qifo benyuan gongde jing*, T. vol. 14,
no. 451; *Prabhāsasaptabuddhapūrvapraṇidhānasūtra*), translated from
the Sanskrit by Yijing in 707, includes not only the multiple vows of the

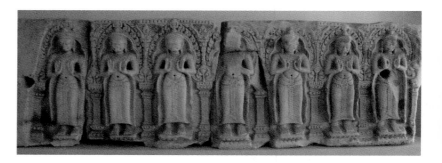

7.3a

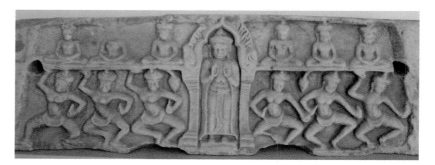

7.3b

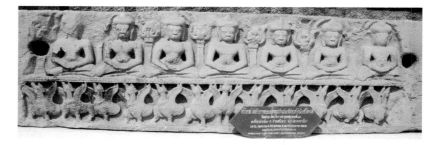

7.3c

Medicine Buddha, but also those of six other Buddhas who are distinguished by the distance their realms lie to the east of our world.[20] In Tibetan Buddhism, these Buddhas are referred to as "brothers". In Chinese Buddhist art, Bhaiṣajyaguru and the six other Buddhas are frequently presented together as a group.[21]

Some Khmer bronzes similarly represent a group of four, five, seven or eight Buddha images.[22] Of particular interest, two miniature *stūpa/caitya* in bronze depicting two rows of four seated Buddhas, one on each side of the base, are known from Lopburi.[23] Because of the Khmer religious transition operating during the 13th to 14th centuries, it is not always clear whether these could represent separate groupings of the four past Buddhas, plus the future one conceptually embedded inside the *stūpa/ caitya*, and the esoteric Jinas. However, must we necessarily think that

Fig. 7.4a Five-sided miniature *caitya*, bronze, from Lopburi province, National Museum of Bangkok. Inventory number: LB 343. Photograph courtesy Brice Vincent, 2009.

Fig. 7.4b Five-sided miniature *caitya*, stone, found at Bang Rachan, Singburi province, Thailand, 12th to 13th centuries. Photograph by Alexander B. Griswold, 1951. Courtesy The Walters Art Museum, Baltimore, no. 472.4001, neg. 51.111.10.

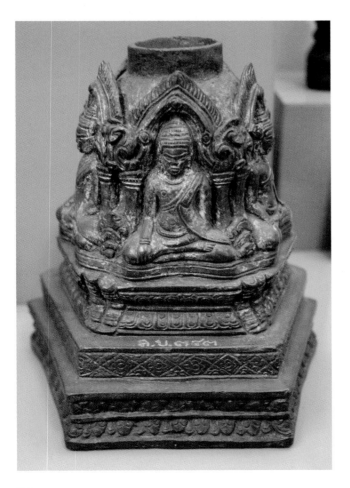

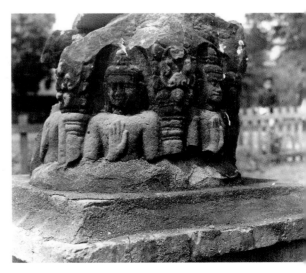

these two concepts of the five Buddhas – esoteric vs exoteric – ought to be conceptually distinguished in the Khmer context? We might as well conceive of a new paradigm that emphasises conceptual continuity and amalgamation rather than rupture and distinction. Five-sided miniature *stūpa/caitya*, in bronze or stone, are also puzzling in this regard. They have been found in Lopburi and Singburi provinces in Thailand and remain unpublished (Figs. 7.4a & 7.4b). These examples, where the five Historical Buddhas may have mirrored the esoteric concept of the *pañcajina* already well established in the Angkor period, call for direct comparison with pentagonal monuments found in Burma during the Pagan period and which were similarly interpreted as a cosmic metaphor and an architectural manifestation of the five Buddhas.[24]

DIRECTIONAL BUDDHAS IN THE CAMBODIAN MIDDLE PERIOD

Possibly one late Angkorian *stūpa/caitya* at Preah Khan of Kompong Svay where four standing Buddha figures are arranged so that they face out is known by some today as Preah Chatomukh (see Fig. 1.8 & Fig. 7.5).[25] This layout may conceptually recall the popular Indian architectural and sculptural tradition known as *sarvatobhadra* or *sarvatobhadrikā*, that is, "all-auspicious" or "auspicious on all sides". Such depictions of quadruple sculptures in India are especially well suited for dedication to one particular deity in his four different aspects (*caturvyūha*), as in the case of the Vishnu temple at Deogarh,[26] or else to different gods.

In the context of Theravāda Buddhism, this arrangement may be more directly related to the cult of the Historical Buddha Gotama or the four

Fig. 7.5 Plan of the Preah Khan Chatomukh. Cliché EFEO, Fonds Cambodge, réf. EFEO_CAM10729_2. (See also Fig. 1.8, p. 33.)

past Buddhas of this eon. Depictions of four Buddhas seated or standing back-to-back were indeed also common in Lower Burma and Northern Thailand during the 14th to 15th centuries, for example at Kyaik Pun in Pegu,[27] or Wat Phra Yuen in Lamphun.[28] Ashley Thompson[29] further suggested that the central figure hidden between the other four must be Metteyya, the future Buddha, especially worshipped during the Middle Period in his princely and messianic capacity. We learn of this cult to Metteyya from Pāli inscription *K. 82* of Wat Nokor dated 1566[30] and from some Khmer Middle Period inscriptions such as *IMA 2* (stanzas 29–41) written in Khmer and dated 1577.[31]

A short Pāli inscription recently discovered on decorative sandstone at Western Prasat Top in Angkor Thom (Monument 486), paleographically datable to the late 14th or early 15th century,[32] during the Cambodian Middle Period, provides tantalising new evidence for the tradition of directional Buddhas of the past (Figs. 6.27 & 6.28, pp. 225 & 226). It reads *dakkhiṇe kassapo buddho*, that is, "Buddha Kassapa, in the South".[33] We would expect that, on the same logical ground, the other three past canonical Buddhas of this eon, viz. Kakusandha, Koṇāgamana, and Gotama, were similarly assigned different cardinal directions. Indeed, other fragmentary inscriptions found previously at the site, and where only a few *akṣara* are still legible, seem to read *pacch* […], presumably for *pacchime*, "in the West", and […] *yamuni*, probably for Sākyamuni, another name for Buddha Gotama.[34] A claim could thus legitimately be made that these inscriptions refer to only the four past Buddhas placed respectively in the east, south, west and north, while the future Buddha Metteyya would symbolically occupy the centre. However, I do not think this is what we see here; at least no textual basis for this specific arrangement is known to my knowledge in Pāli Buddhism. This is assuming, of course, that a text, whether in a written form or recited orally, preceded ritual and iconographic practice in this context.

Intriguingly, however, one post-canonical collection of Pāli liturgical texts refers to the Buddhas of the ten directions representing not only the four cardinal points, but also the four intermediate points, the zenith, and the nadir. It is known as the *Mahādibbamanta*, a compendium of *paritta* or protective chants, equally known in Cambodia and Siam since the premodern period.[35] The earliest epigraphic mention of this family of texts in Cambodia appears in *IMA 12*, dated 1629 (line 13, *sūt dibbhamun*).[36] It may also be alluded to in *IMA 34*, dated 1697 (line 22, *sūt braḥ dibvamuntr*).[37] During the late Ayutthaya period in Siam, the *Mahādibbamanta* is said to have been recited by monks when the troops set out for the battlefield.[38] The relevant verses 21–23 that are also found almost verbatim in the *Cūlajinapañjara* (verses 2b–5a), a short *paritta*

hymn also found in Sri Lanka, read as follows:

> *Padumuttaro ca pubbāyaṁ āgaṇeyye ca Revato*
> *dakkhiṇe Kassapo buddho neharatīye Sumaṅgalo,*
> *pacchime Buddhasikkhī ca bāyabbe ca Medhaṅkaro*
> *uttare Sākyamunī*[39] *c'eva isāne Saraṇaṁkaro,*[40]
> *pathaviyaṁ Kakusandho ākāse ca Dīpaṅkaro*[41]
> *ete dasadisā buddhā rājadhammassa pūjitā*[42]

My translation:

> Padumuttara, in the East, and Revata, in the Southeast;
> Buddha Kassapa, in the South; Sumaṅgala, in the
> Southwest; Buddha Sikhī, in the West, and Medhaṅkara, in
> the Northwest;
> Sākyamuni, in the North, and Saraṇaṅkara, in the
> Northeast;
> Kakusandha, in the Earth, and Dīpaṅkara in the Sky.
> These Buddhas of the ten directions are worshipped on the
> part of their royal virtue(s).[43]

This list of ten Buddhas is best envisioned in Table 7.2.

As we can see, exactly the same verse found inscribed at Western Prasat Top (that is, *dakkhiṇe kassapo buddho*) is found today in the *Mahādibbamanta* and it can thus logically be deduced that at least seven other directional Buddhas, if we leave aside the nadir and zenith, were conceptually intended to be present as well. Accordingly, the spatial arrangement of these eight directional Buddhas at Western Prasat Top, originally flanking the set of eight *sīmā*, which decisively marked the temple ground, would have appeared as shown in Fig 6.2 in Chapter 6 (p. 204).

Medhaṅkara (northwest)	Sākyamuni (north)	Saraṇaṅkara (northeast)
Sikhī (west)	Dīpaṅkara (sky = zenith)	Padumuttara (east)
	Kakusandha (earth = nadir)	
Sumaṅgala (southwest)	Kassapa (south)	Revata (southeast)

Table 7.2: Diagram of the Ten Directional Buddhas

This tradition of the Buddhas of the ten directions (Sanskrit: *daśadigbuddha*; Pāli: *dasadisabuddha*), implicitly positing the existence of several world systems, is an old concept already attested in several early Mahāyāna *sūtra* such as the *Saddharmapuṇḍarika* or *Lotus Sūtra*,[44] although no names or details are provided for this list. At first glance, the existence of several and coeval Buddhas appearing in the world at any given time seems to go against Theravāda doctrine. In the above reference from the *Mahādibbamanta*, however, all ten Buddhas are directly (randomly?) excerpted from the list of 28 past Buddhas according to the *Buddhavaṁsa*.[45] Strictly speaking, this group of ten Buddhas is indeed arranged both chronologically and spatially, and thus it does not exactly infringe on the basic tenets of the Theravāda school which holds that only one such figure can exist at a time and place. How these particular successive Buddhas were selected and later attributed a specific cardinal direction, however, is not known.

Here, we could tentatively surmise that the likely spatial arrangement of these eight Buddhas as a magical diagram in conjunction with the set of eight twin *sīmā* found at Western Prasat Top (see Fig. 6.2, p. 204) probably served specific protective and symbolic functions. Admittedly, we have to date only one clearly identified epigraph with the name of "Kassapa Buddha, in the South" to support this hypothesis; while the two other fragments show only the "west" and "[Sāk]yamuni" and may refer to two different associations. According to the *Mahādibbamanta*, indeed, the "west" is associated with "Buddha Sikhī" and the "north" with "Sākyamuni". There is no clear inter-cardinal epigraphic evidence discovered yet, but future excavations at Western Prasat Top may yield more material and confirm this interpretation. At any rate, the *sīmā* are definitely there and using them as indication of the as yet missing or fragmentary epigraphic material seems not too far-fetched.

A strong case can thus be made that the above protective chant excerpted today from the *Mahādibbamanta*, and also known separately as the *Sabbadisabuddhamaṅgalaparitta*, actually circulated earlier and independently in Cambodia since an uncertain period;[46] it is also popular in the Mon-Burmese tradition to this day.[47] In addition, in contemporary visual art, only eight Buddhas are represented in the cardinal and inter-cardinal directions. For obvious reasons, the Buddhas of the zenith and nadir, which would make a total of ten, cannot be represented when laid out on a two-dimensional plan such as at the temple ground of Western Prasat Top or in certain modern murals found on temple ceilings (Fig. 7.6). Furthermore, according to the *Cūlasabbadisabuddhamaṅgalaparitta*, drawn today from the same liturgical collection,[48] an additional eight chief disciples (*aggasāvaka*) also surround the central Buddha and can be similarly arranged in a

"magic circle" as a *maṇḍala* or *yantra*. This ritual practice is again known in modern Burma.[49] In the traditional *kammaṭṭhān* system of Khmer Buddhism, the eight Buddhas and eight disciples may likewise be related to the practice of the eight moralities or *aṭṭhasīla*, also mentally connected to the eight *sīmā*, the eight cardinal or inter-cardinal directions, the eight "boundary vowels" known as *akkharasīmā* (that is, A, Ā, I, Ī, U, Ū, E, O), and a physical part of the body.[50]

A similar exercise of visualisation that invokes and assigns the past Buddhas and the eight chief disciples to a specific bodily portion is found embedded as well in the *Jinapañjaragāthā*, "Verses of the Conqueror's Cage", possibly first composed in premodern Northern Thailand,[51] but likewise found in modern Sri Lanka as an expanded *pirit* or *paritta*.[52] Some scholars have argued that such rituals may be reminiscent of the medieval Hindu and Buddhist tantric practice of imposing *mantra* on the body (*nyāsa*) in order to transform the ordinary body of the practitioner into a subtle body of ultimate reality.[53] Whatever the case may be, just as in the Khmer texts belonging to the *kammaṭṭhān* tradition, the ritual boundaries (*baddhasīmā*) of the eight directions are also symbolically associated with the eight external orifices or "gates" (*dvāra*) of the human body (viz. the two eyes, the two ears, the two nostrils, the mouth, and the anus) in the *Saddavimala*, another

Fig. 7.6 Eight directional Buddhas on a modern mural found on the ceiling of Wat Prei Bang, Kandal province, Cambodia, 21st century. Photograph by author, 2016.

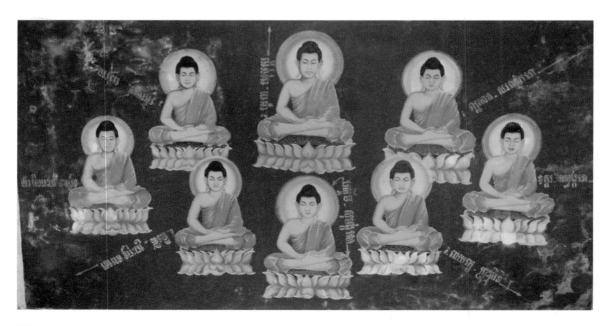

premodern text of a cognate tradition found in Northern Thailand and Laos.[54] According to this yogic tradition, it is as if the human body with its specific inner boundaries (*sīmā khluon*) was perceived as the true "sanctuary" (*vihāra*).

Naturally, there are also strong similarities between the concept of the Buddhas of the eight or ten directions and that of the Dikpāla(ka)s or Lokapālas, the guardian deities who rule the specific directions of space and are traditionally invoked in temple consecration rituals since they are associated with protective functions.[55] According to Corinna Wessels-Mevissen who did a detailed study of the Dikpālas in ancient India:

> These gods, some of whom were also worshipped
> independently, were given the task of guarding particular
> parts of a temple. This protection against external evil forces
> functions within an intricate system of religious beliefs and
> ritual practices. During the early development of stone
> temple architecture in India, *c.* 5th through 8th centuries
> A.D., the probably already existing invisible, ritually invoked
> presence of directional guardians at building sites was
> complemented by the visual representation of the deities in
> the form of stone panels in high relief. Apart from the
> depiction of *dikpālas* on temple exteriors, which is largely
> restricted to North India, the directional guardians can also
> be found on ceilings and other parts of the temple
> structure.[56]

In India, moreover, the installation of these directional guardians in a Buddhist context or monument is not uncommon.[57] Interestingly, Madeleine Giteau also reports the frequent invocation of "*devatā*" of the cardinal and intermediate directions during the modern ceremonies of implanting *sīmā* in Khmer temples.[58] Among the various lists of *devatā* she gives, one corresponds exactly to the guardians of the eight directions or *aṣṭadikpāla*.[59] She thus logically concludes,

> It is quite certain that the Buddhist ceremonies embraced
> old cults rendered to the divinities of the cardinal points.
> These divinities have sometimes even been assimilated. Thus
> at Vatt Braḥ Canda Rājā, the divinities of the cardinal points
> have been replaced by Buddhas.[60]

In addition, Giteau refers to the following text in Pāli which must be recited three times at the end of the invocation of Kruṅ Bāli, that is, the land spirit who is also worshipped during similar consecration rituals,[61] *Padumuttaro ca pūribāyaṁ aggaṇiye ca revato dakkhiṇe ca kassapo buddho.*

As we can see, this formula is nearly exactly the same as that found in the ancient inscription from Western Prasat Top and embedded today in the *Mahādibbamanta*,[62] although it is given here only in partial form. Could it be taken as residual evidence for the early circulation of this compendium, either in whole or in part, in ancient Cambodia? Be that as it may, it is actually possible to find the etymology of all these cardinal and intermediate directions given above in pseudo-Pāli in working our way back to the original Sanskrit terms. In cases of the intermediate directions, we can even associate these spellings with the names of the corresponding deities underlying the equivalents found for example in the *Mahādibbamanta*. A summary of the data drawn from these correspondences is presented in Table 7.3.

In this light, a strong case can be made that the *Mahādibbamanta* collection with its large astrological and cosmological contents – or at least some of its source texts such as the *Sabbadisabuddhamaṅgalaparitta* – was already known in Cambodia to some extent, either in written form or orally, and recited there since the early Middle Period. Perhaps it became established there soon after Ayutthayan influence began to make its presence felt following the fall of Angkor in 1431–1432, as attested by other material, epigraphic and textual evidence,[63] unless it is the other way around. In Siam, we know that the *Mahādibbamanta* collection in one form or another circulated since at least the late Ayutthaya period and could have thus been brought earlier from Cambodia. At any rate, it was still used in Siamese court rituals and Brahmanical consecration ceremonies up to the modern period.[64]

Direction in English	Direction in Pāli (cf. *Mahādibbamanta*)	Direction in Sanskrit	Directional Deity	Directional Buddha
east	*pubbā*	*pūrva*	Indra	Padumuttara
southeast	*āganeyya*	*āgneya*	Agni	Revata
south	*dakkhiṇa*	*dakṣiṇa*	Yama	Kassapa
southwest	*neharatīya*	*nairṛta*	Nirṛti	Sumaṅgala
west	*pacchima*	*paścima*	Varuṇa	Sikhī
northwest	*bāyabba*	*vāyavya*	Vāyu	Medhaṅkara
north	*uttara*	*uttara*	Kubera	Sākyamuni
northeast	*isāna*	*īśāna*	Īśāna	Saraṇaṅkara

Table 7.3: Cardinal and Intermediate Directions & Related Deities/Buddhas

THE FIVE BUDDHAS FROM THE LATE MIDDLE PERIOD
(C. 17TH CENTURY ONWARDS)

At a point that is difficult to date with precision but which can at present hardly be pushed back before the 17th century on textual or epigraphic evidence, the five Buddhas (*pañcabuddha*) of this eon were also equated with each of the five syllables (*kāra* or *akkhara*) *NA MO BU DDHĀ YA* that comprise the *gāthā* of "Hommage to the Buddha(s)". The *NAMO BUDDHĀYA* formula – comparable to the *pañcakṣara* or five sacred syllables of the Śaiva *mantra NAMAḤ ŚIVĀYA*[65] – is a common trope in the so-called *yogāvacar* or *kammaṭṭhān* meditation tradition and texts of Thai-Khmer Buddhism studied by François Bizot, Olivier de Bernon, and others.[66] The formula is therein broken down into five sacred syllables, which are further sanctified by the fact that they are given new associations.[67] Perhaps one of the earliest pieces of textual evidence for such correlations appears in the *Aphitham chet khamphi ruam*

Syllable	NA	MO	BU	DDHĀ	YA
Buddha	Kakusandha	Koṇāgamana	Kassapa	Gotama	Metteyya
Location in Ordinary Being	right eye	left eye	back[70]	navel	forehead
Precept	abstention from taking life (*sīlapāṇā*)	abstention from theft (*sīla-adinnā*)	abstention from adultery (*sīlakāme* or *sīla-abrahma*)	abstention from falsehood (*sīlamusā*)	abstention from intoxicants (*sīlasurā*)
Cyclic Age	"accomplished" (*kitti*)	"triad" (*tetā*)	"pair" (*dvāpara*)	"dark" (*kali*)	"granary" (*kosa*)
Aggregate	form (*rūpakhandha*)	feeling (*vedanākhandha*)	perception (*saññākhandha*)	formation (*saṅkhara-khandha*)	consciousness (*viññāṇakhandha*)
Element	earth[71] (*paṭhavidhātu*)	water[72] (*āpodhātu*)	fire (*tejodhātu*)	wind (*vāyodhātu*)	atmosphere (*ākāsadhātu*)
Subtle Body's Light	purple[73]	blue	yellow[74]	red[75]	white crystal (transparent)
Location in Subtle Body	nose	epiglottis	neck	sternum	Navel

Table 7.4: Groups of Five according to the Thai-Khmer *Kammaṭṭhān* Tradition[76]

("A Summary of the Seven Books of the *Abhidhamma*"), a text composed in Northern Thailand.[68] In due course, the five "heart syllables" were thus also equated in Thai-Khmer Buddhism with the groups of five precepts, five elements, five colours and lights, and so on, in a manner that is not unlike that of the Vajrayāna concept of the "five Buddha-families" (Table 7.1),[69] as shown in Table 7.4.

A similar homage correlating the five syllables with the five Buddhas of this eon can equally be seen in the modern Khmer-Pāli liturgical tradition, which reads as follows:

> *Thvāy paṅgaṁ braḥ buddh 5 braḥ aṅg*
> *Ukāsa na karo braḥ kukkasandho nāma bhagavā ahaṁ vandāmi sabbadā*
> *Ukāsa mo karo braḥ konāgamano nāma bhagavā ahaṁ vandāmi sabbadā*
> *Ukāsa bu karo braḥ kasapo buddho nāma bhagavā ahaṁ vandāmi sabbadā*
> *Ukāsa ddhā karo braḥ sirī sakyamunī gotamo nāma bhagavā ahaṁ vandāmi sabbadā*
> *Ukāsa ya karo braḥ sira-ārya meteyyo nāma bhagavā ahaṁ vandāmi sabbadā*
> *Thvāy paṅgaṁ mṭaṅ*

Fig. 7.7 Modern mural painting depicting the five Buddhas, each being associated with their animals and the five syllables *NA MO BU DDHĀ YA*. Wat Prei Bang, Kandal province, Cambodia, 21st century. Photograph by author, 2016.

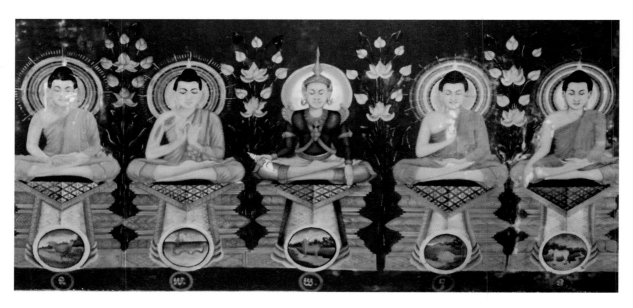

My translation:

> Bowing to the Five Buddhas
> Please [permit me]. The syllable *NA* denotes the Blessed
> One Kakusandha. I salute [him?] at all times.
> Please [permit me]. The syllable *MO* denotes the Blessed
> One Koṇāgamana. I salute [him?] at all times.
> Please [permit me]. The syllable *BU* denotes the Blessed One
> Buddha Kassapa. I salute [him?] at all times.
> Please [permit me]. The syllable *DDHĀ* denotes the Blessed
> One Sākyamuni-Gotama. I salute [him?] at all times.
> Please [permit me]. The syllable *YA* denotes the Blessed One
> Metteyya. I salute [him?] at all times.
> One bow.[77]

In addition, the mystical formula *NAMO BUDDHĀYA* often appears to
this day as magical diagrams (*yantra*), generally written in Khom/Khmer
script,[78] although examples written in Tham or Yuan (northern Thai)
script are also known.[79] There are innumerable examples of modern mural
paintings from Cambodia that depict the five Buddhas, sometimes even
associated with the five syllables *NA MO BU DDHĀ YA* (Fig. 7.7). Preah
Bo (*braḥ pat'*) or cloth paintings with the five Buddhas and their symbolic
animals (on which see *infra*) were also popular in Cambodia up to the
20th century.[80]

THE TEN FUTURE BUDDHAS FROM THE MIDDLE PERIOD
(C. 17TH CENTURY ONWARDS)

We have seen that the separate worship of Metteyya, sometimes combined
with the four past Buddhas, was somewhat popular in premodern
Cambodia since the final advent of Theravāda Buddhism, approximately
in the 14th century onwards. However, since at least the 17th century a
rare list of ten future Buddhas (*dasabodhisatta*), beginning with Metteyya,
emerged in the same religious context.

A brief Khmer epigraphic reference to this concept appears in a
Middle Period inscription (*IMA 31*, stanza 26), dated 1684, where the
donor wishes to become the 11th Buddha to come.[81] But the notion is
more fully developed in a popular text known as the *Dasabodhisatta-
uddesa*, found primarily in Siam and to a lesser extent in Cambodia. It is
known in several vernacular languages, including in Khmer as *Dasavaṅs*,[82]
but for which English translations are still a desideratum even though it
has already been translated into French from Pāli.[83] To my knowledge, no
complete versions of this text in Pāli are extant in Cambodia, which raises

the question of whether it was originally produced or even copied there. The oldest Pāli manuscripts are in fact all kept in Thailand at the National Library of Bangkok and date from the reign of Rama III (1824–1851). These are all written in Khom script and, for this reason, scholars generally thought they were of Khmer origin. This is doubtful since, on the one hand, this script was widely used in Siam for Pāli scriptures since the Ayutthaya period. On the other, the literacy of the canonical Pāli language has always been very low in traditional Khmer Buddhism, to the point that it literally became an "esoteric" language.[84]

The *Dasabodhisatta-uddesa* was thus probably much in vogue during the late Ayutthaya and early Rattanakosin periods (18th century onwards) in Siam and, for reasons I develop elsewhere,[85] a strong argument can be made that the *Dasabodhisattuppattikathā*, found today in Sri Lanka,[86] may be a later sanitised version of the former text, possibly brought to the island in the course of the 18th-century revival of Theravāda Buddhism from Siam. In the same vein, it is also my assumption that this Pāli text was only introduced recently into Cambodia from Siam, possibly in the 19th or early 20th centuries. Interestingly, short-format palm-leaf manuscripts in Pāli paying homage to the ten future Buddhas do exist in very low numbers in Cambodia to this day.[87] In this contracted liturgical text, it is said that a person who worships these ten Buddhas will not be reborn in hell for 100,000 eons. But two points are worth mentioning here. First, the list of the ten bodhisattvas found in these short-format manuscripts differs slightly from that given in the main stories of the *Dasabodhisatta-uddesa* and so it cannot be simply considered as an abbreviated version. Yet, exactly the same liturgy is found appended in the colophon of the latter text,[88] and it may be surmised that this is either a later addition or else that it represents another variant regional tradition. It is worth giving the text in full which reads as follows:

> *Metteyyo Uttaro Rāmo Paseno Kosalo 'bhibhu |*
> *Dīghajaṅghi ca Soṇo ca Subho Todeyyabrāhmaṇo ||*
> *Nālāgirī Pālileyyo bodhisattā ime dasa |*
> *anukkamena sambodhim pāpuṇissanti anāgate ||*
>
> *Metteyyo Metteyyo nāma Rāmo ca Rāmasambuddho |*
> *Kosalo Dhammarājā ca Mārarājā Dhammasāmi ||*
> *Dīghajaṅghī ca Nārado Soṇo Raṅsimuni tathā |*
> *Subho ca Devadevo ca Todeyyo Narasīhako ||*
> *Tisso nāma Dhanapālo Pālileyyo Sumaṅgalo |*
> *etedasa buddhā nāma bhavissanti anāgate ||*

Metteyyo nāgarukkho ca Rāma-buddho pi candanaṁ |
Dhammarājā nāgarukkho sālarukkho Dhammasāmi ||
Nārado candarukkho ca Raṅsīmuni ca pipphali |
Devadevo ca campako pātalī Narasīho ca ||
Nigrodho Tissasambuddho Sumaṅgalo nāgarukkho |
ete dasa rukkhā bodhī bhavissanti anāgate ||

ime dasa ca sambuddhe yo naro pi namassati |
kappasatasahassāni nirayaṁ so na gacchatī—ti ||[89]

My translation of which is:

Metteyya, Uttara Rāma, Pasena the Kosalan, Abhibhū,
Dīghajaṅghi, Soṇa, Subha, Todeyya the Brahmin, Nālāgirī
and Pālileyya – these are the ten bodhisattvas who will, in
times yet to come, reach enlightenment.

Metteyya as Metteyya, Rāma as the Perfect Buddha Rāma,
the Kosalan as Dhammarāja, King Māra as Dhammasāmi,
Dīghajaṅghi as Nārada, Soṇa as Raṅsimuni, likewise Subha
as Devadeva, Todeyya as Narasīha, Dhanapāla as Tissa and
Pālileyya as Sumaṅgala – these are the ten who will, in times
yet to come, become Buddhas.

Metteyya the *nāga*-tree, the Buddha Rāma the *candana*
[-tree], Dhammarāja the *nāga*-tree, Dhammasāmi the
sāla-tree, Nārada the *canda*-tree, Raṅsimuni the *pipphali*
[-tree], Devadeva the *campaka*[-tree], Narasīha the *pātalī*
[-tree], the Perfect Buddha Tissa the *nigrodha*[-tree] and
Sumaṅgala the *nāga*-tree – these ten will, in times yet to
come, be the ten Bodhi-trees.

And the man who pays homage to the ten Perfect Buddhas
will not go to hell for 100,000 eons.[90]

In contrast to the textual and epigraphic evidence, artistic traces of the ten
future bodhisattvas are extremely scarce in mainland Southeast Asia, but
not totally absent. In fact, the earliest examples identified at present are
still found in Sri Lanka, albeit only in Siamese *nikāya*-lineage temples, and
date from the late 18th century onwards.[91] In modern Thailand, mural
paintings including these ten future bodhisattvas have only been recently
identified at Wat Nai Klang, Phetchaburi province, and are dated to the
late 19th century.[92] As for Cambodia, the scheme of the ten future
bodhisattvas is virtually unknown. However, I have successfully identified

Fig. 7.8 Modern mural representing an episode of the *Dasabodhisatta-uddesa* in which King Mahāpadāna cuts off his own head in front of Buddha Kakusandha who predicts his future Buddhahood as Buddha Sumaṅgala, Wat Sithor, Kandal province, Cambodia, 21st century. Photograph by author, 2016.

on a recent trip to the Srei Santhor region a unique mural from Wat Sithor which represents an episode of the last story of the *Dasabodhisatta-uddesa*. In this final chapter, the tenth Buddha of the future named Sumaṅgala was previously the Great King Mahāpanāda under the dispensation of Buddha Kakusandha. We can see in this panel the past Buddha who pronounces a very evocative phrase – *mahāpurisa nibbānagamanadhammaṁ vicāresī ti*, "O Mahāpurisa, you should investigate that Dhamma leading to *nibbāna*" – a sentence that is written down as a caption and is also found verbatim in the textual source. Upon hearing these powerful words, King Mahāpanāda makes a firm resolution

to become a Buddha in the future and to sacrifice his life towards this goal. The modern painting depicts the poignant moment immediately after he beheaded himself, by means of his own fingernails, and presented his head in offering to the sermon of the Buddha (Fig. 7.8).[93] Meanwhile, the head continues to utter the sacred verse *Iti pi so bhagavā arahaṁ*.[94]

ESOTERIC BUDDHISM IN THERAVĀDA GUISE?

From the previous discussion, it appears that the concept of past and future Buddhas gradually emerged in the Khmer archaeological record rather late in the second millennium, only to become mainstream in the later centuries. By this time, the second "wave" of Pāli Buddhism in mainland Southeast Asia arrived from Sri Lanka in the wake of the Mahāvihāra ascendency. It may well be the case, therefore, that this form of Khmer Theravāda may have reinterpreted or assimilated some older Mahāyāna or esoteric modes of Buddhist practice that had been performed in Cambodia since the Angkor period,[95] just like the Abhayagiri and the Jetavana (also Theravāda) *vihāra* did in medieval Sri Lanka.[96] That is also to say that, for example, the emergence of the *pañcabuddha* in ancient Cambodia was likely the local answer to the earlier esoteric *pañcajina*.

Today, the cult of past and future Buddhas is completely appropriated and integrated into local Southeast Asian legends, chronicles, and certain rituals, and often plays an integral part in the iconography of temple decoration (paintings, sculptures, architecture, etc.). Several legends, liturgies, and narratives have been composed, expanded, translated and rearranged over many centuries and continue to develop to this day. For example, the elaboration of such stories as that of the ten future bodhisattvas clearly emphasised the ten perfections (*dasapāramī*) which were identified as part of the path of the bodhisattva. It may also be loosely linked to the concept of the ten avatars of Vishnu (*daśāvatāra*), the Hindu god of preservation, who is said to descend to earth from time to time to restore cosmic order. Incidentally, the second future Buddha after Metteyya is known as Rāma in the *Dasabodhisatta-uddesa*, likely named after the famous seventh avatar of Vishnu. Similarly in the Khmer *Rāmayāṇa*, known as the *Reamker* (*Rāmakerti*), Rāma's divine nature, whose mission is to lead all creatures to deliverance, is simultaneously perceived as an aspect of Vishnu, the Buddha, and a bodhisattva.[97] Interestingly, esoteric interpretations of the *Reamker* have also been studied by Bizot[98] who breaks down the allegory of Rām(a) overcoming obstacles in the way of his union with Setā into a number of stages representing the path of initiation that leads to full enlightenment.

Another popular myth found throughout the region is that of the white or albino crow, said to be the "Mother of the Five Bodhisattvas". The folk legend known in Cambodia as *rīoeṅ ka-aik sa*, the "Legend of the White Crow", attempts to explain the origin of the five Buddhas of this eon by going back to a bygone period when the five bodhisattvas were still siblings and raised by different kinds of female animals, viz. a hen for the future Buddha Kakusandha, a snake for Koṇāgamana, a tortoise for Kassapa, a cow for Gotama, and a lion for Metteyya.[99] Some modern paintings from Cambodia nicely illustrate this folktale, the only minor difference being that the lion is generally replaced by a tiger.[100]

Could this legend be a faint echo of some older Mahāyāna or Vajrayāna beliefs that were firmly established in the Bayon period with the worship of the five cosmic Buddhas or Jinas[101] and of the Prajñāpāramitā goddess, equally referred to as "Mother of all Buddhas"?[102] The parallels and correspondences I have tentatively drawn in this chapter between the emergence of the five esoteric Buddhas during the Angkor period and their canonical counterparts found in later Khmer Buddhism (Tables 7.1 & 7.4), as well as between the Buddhas of the ten directions and the Dikpālas (Tables 7.2 & 7.3), are avenues that need to be further explored with great caution so as to avoid overgeneralisation. As a prime example, the *Mahādibbamanta* collection – perhaps already attested in Cambodia since the early Middle Period at Western Prasat Top,[103] and definitely by the late Middle Period – was traditionally considered "Mahāyānist" by Padmanabh S. Jaini[104] and others, in view of the fact that "its obvious concern with *maṇḍala*, *mantra*, and a highly syncretic pantheon of divinities certainly does look rather tantric".[105] Yet, it must be added that "the work is not uncharacteristic of the Pali Theravāda literature that had circulated in Cambodia for several centuries".[106] At the same time, Prapod Assavavirulhakarn has cautiously indicated that many Thai-Buddhist contemporary users of such liturgical texts do not see these as derived from earlier Mahāyānist or even tantric traditions and that "they fit perfectly into the Theravāda context".[107]

In this light, the label "Tantric Theravāda" first promoted by Bizot[108] in his various writings on Thai-Khmer Buddhism is probably a misnomer since it cannot be established with certainty that the so-called *kammaṭṭhān* tradition that he describes directly derives its practices and manuals from an earlier stratum of Indian Buddhist *tantra* that may or may not have once circulated in the region.[109] It is true, however, that its esoteric character for the practitioner (*yogāvacar*) can only be properly understood through initiation or when provided with the oral guidance of a skilled master (*grū*), often difficult to obtain nowadays in Cambodia.[110] Is it possible, furthermore, as Harris asked, that "we are looking at an indigenous Southeast Asian tradition that may have come under ill-

defined external influences in the course of its development"?[111] At any rate, only further detailed research in these various cultic and liturgical expressions, corpora of texts, inscriptions, and artistic manifestations throughout the ages in Cambodia and its neighbouring cultures will shed more light on their likely sources of inspiration as well as on the peculiarities of premodern Khmer Buddhism.

Notes

1 Vincent Tournier, "Buddhas of the Past: South Asia", in *Brill's Encyclopedia of Buddhism*, Vol. II: Lives, eds. Jonathan Silk et al, Leiden: Brill, 2019, pp. 95–107.

2 Saveros Pou, "Inscriptions modernes d'Ankgor 4, 5, 6 et 7", *BEFEO* 58, 1971: pp. 108, 114; "Inscriptions modernes d'Angkor 35, 36, 37 et 39", *BEFEO* 61, 1974: pp. 302–3, 310, 315; Olivier de Bernon, "'Des buddha aussi nombreux que les grains de sable' : Note sur une métaphore figée dans la langue khmère", Institut National des Langues et Civilisations Orientales, 2 vols, Paris, 2001: pp. 13–7.

3 Richard Gombrich, "The Significance of Former Buddhas in the Theravādin Tradition", in *Buddhist Studies in Honour of Walpola Rahula*, eds. Walpola Rahula et al, London: Gordon Fraser, 1980, pp. 62–72.

4 Leo Both, "The *Saptabuddhastotra* and the *Saptatathāgatastotra*, Two Hymns Praising the Seven Previous Buddhas", in *Glimpses of the Sanskrit Buddhist Literature (Volume 1)*, ed. Kameshwar Nath Mishra, Sarnath: Central Institute of Higher Tibetan Studies, 1997, pp. 57–73.

5 I. B. Horner, *Buddhavaṃsa (Chronicle of Buddhas) and Cariyāpiṭaka (Basket of Conduct)*, London: The Pāli Text Society, 1975; *The Clarifier of the Sweet Meaning (Madhuratthavilāsinī): Commentaries on the Chronicle of Buddhas (Buddhavaṃsa)*, London: The Pāli Text Society, 1978.

6 Nicolas Revire, "Buddhas of the Past and of the Future: Southeast Asia", in *Brill's Encyclopedia of Buddhism*, Vol. II: Lives, eds. Silk, Jonathan et al., Leiden: Brill, 2019, pp. 109–120.

7 In this chapter, I use the term "Theravāda" as pure convention in the modern and broad sense of a Buddhist "monastic school" (*nikāya*) that draws its scriptural inspiration mainly from the Tipiṭaka or Pāli canon and its commentaries, and traces its sectarian lineage back to the "Elders" (Sanskrit: *sthavira*; Pāli: *thera*) from which the Mahāsāṃghika monks broke away during the Second Buddhist council. Evidently, the Theravāda school (and sub-schools) was not a monolithic movement and has much evolved in the course of its development. As we shall see here, the so-called Theravādins of Southeast Asia were also capable of original compositions in both Pāli and vernacular languages (usually dubbed by scholars as post- or non-canonical or even "apocryphal"). For recent discussions on the artificial category of Theravāda and its complex modern history, see Peter Skilling et al, *How Theravāda is Theravāda?: Exploring Buddhist Identities*, Chiang Mai: Silkworm Books, 2012; also Grégory Kourilsky, "Le 'bouddhisme *theravāda*', cette autre invention de l'Occident", *BEFEO* 100, 2014: pp. 361–8.

8 In historical scholarship, the Sanskrit term *stūpa* generally indicates any in-filled structure that is supposed to contain collected material, textual or corporeal

relics of the Buddha or other high dignitaries. Other structures generally called *caitya* are simply commemorative monuments having no relics. This distinction is blurred, however, in Cambodia where, for modern Khmers, the term *stūpa* designates a non-funerary object, usually a monolith, and vice-versa, a relic-containing/funerary object a *caitya*, see Ashley Thompson, "Lost and Found: The *Stupa*, the Four-faced Buddha, and the Seat of Royal Power in Middle Cambodia", in *Proceedings of the 7th International Conference of the European Association of Southeast Asian Archaeologists, Berlin, 31 August–4 September 1998*, eds. Wibke Lobo and Stephanie Reimann, 2000, pp. 245–63.

9 Pia Conti, "Tantric Buddhism at Prasat Hin Phimai: A New Reading of Its Iconographic Message", in *Before Siam: Essays in Art and Archaeology*, eds. Nicolas Revire and Stephen A. Murphy, Bangkok: River Books & The Siam Society, 2014, pp. 386–7, Figs. 12a–b.

10 Bruno Bruguier et al, *Banteay Chhmar et les provinces occidentales. Tome III : Guide archéologique du Cambodge,* Phnom Penh: Éditions Reyum, 2015, pp. 134–5, Fig. 191; Peter D. Sharrock, "Serpent-enthroned Buddha of Angkor", *Marg* 67, no. 2 [Special Issue *Art of Cambodia: Interactions with India*, ed. Swati Chemburkar], 2016: p. 31, Fig. 9.

11 Julia Estève, *Étude critique des phénomènes de syncrétisme religieux dans le Cambodge angkorien*, doctoral dissertation, École Pratique des Hautes Études, Paris, 2009.

12 Conti, "Tantric Buddhism at Prasat Hin Phimai", appendix 1; translated by Skorupski. For two earlier readings and translations, see Chirapat Prapandvidya, "The Sab Bāk Inscription. Evidence of an Early Vajrayana Buddhist Presence in Thailand", *JSS* 78, no. 2, 1990: pp. 11–4; and Claude Jacques, "The Buddhist Sect of Śrīghana in Ancient Khmer Lands", in *Buddhist Legacies in Mainland Southeast Asia: Mentalities, Interpretations and Practices*, eds. François Lagirarde and Paritta Chalermpow Koanantakool, Bangkok: Princess Maha Chakri Sirindhorn Anthropology Centre, 2006, p. 73.

13 The Sanskrit terms *śrīghana* ("dense with glory"), *sugata* ("one gone to bliss"), and *jina* ("conqueror") are all epithets and names for a buddha ("awakened one"). Only the context will tell us if these epithets refer to transcendental or Historical Buddhas.

14 Adapted from Alice Getty, *The Gods of Northern Buddhism: Their History and Iconography*, New York: Dover Publications, 1988.

15 Benoytosh Bhattacharyya, *The Indian Buddhist Iconography,* Calcutta: Mukhopadhyay, 1968, p. 42ff.

16 We should be wary, however, of Jacques' interpretation (2006) of what he calls the "Śrīghana sect" as an esoteric movement in ancient Cambodia. Skilling (2004) has written an article refuting this interpretation of the epithet of the Buddha "*śrīghana*" as necessarily tantric. The term decidedly had no special school affiliation. See also Pitchaya Soomjinda, "Khamwa 'srikhana' nai charuek kampucha: 'nikai' rue 'nimankai' ['Śrīghana' in Cambodian Inscriptions: 'Buddhist Sect' or 'Buddha's Transformation Body']", *Thai Khadi Sueksa: The Journal of the Thai Khadi Research Institute* 11, 2557 BE/2014: pp. 175–217. Having said that, it is interesting to note that the spellings in the inscription *K. 888*, a homage to the "Triple Gem" (*triratna*) written on a bar held above the head of a divinity and discovered in the vicinity of the Chatomukh site at Preah Khan of Kompong Svay (on which see also *infra*), are now thought to be all Sanskritic, not Pāli as previously published (cf. Pou, *Nouvelles inscriptions du Cambodge*, Vol. 1. Paris: EFEO, 1989: pp. 14–5; Ludivine Provost-Roche, *Les*

derniers siècles de l'époque angkorienne au Cambodge (env. 1220–env. 1500), doctoral dissertation, Université Paris 3–Sorbonne Nouvelle, 2010: pp. 42–3, 304; Skilling, "Namo Buddhāya Gurave (K. 888): Circulation of a Liturgical Formula Across Asia", *JSS* 106, 2018: pp. 109–28.). In addition, a textual source for the formula in this inscription could have been the *Kudṛṣṭinirghātana*, the first text on initiation contained in the collection of works known as the *Advayavajrasaṅgraha* and composed in northern India – today's Nepal – in the 11th century (Teun Goudriaan and Christiaan Hooykaas, *Stuti and Stava (Bauddha, Śaiva and Vaiṣṇava) of Balinese Brahman Priests*, Amsterdam & London: North-Holland Publishing Company, 1971: pp. 306–7; Glenn Wallis, "Advayavajra's Instructions on the Adikarma", *Pacific World: Journal of the Institute of Buddhist Studies*, Third Series, no. 5, 2003: p. 214). An English translation of the *Pañcākāra*, another short text on the five Jinas from the same collection, appears in Conze et al. 2007: pp. 249–52. From the foregoing, it is possible to infer that the numerous five-Jina panels found at the main temple of Preah Khan might possibly have been loosely connected with this latter section of the *Advayavajrasaṅgraha*. At least, the citation of *K. 888* suggests that other portions of the *Advayavajrasaṅgraha* might have been known in the late Angkor period. I would like to acknowledge Hiram Woodward and Trent Walker for providing me with helpful bibliographical information on this.

17 Ian Harris, *Cambodian Buddhism: History and Practice*, Honolulu: University of Hawai'i Press, 2005, p. 24.

18 I am grateful to Olivier Cunin for drawing this lintel to my attention and for sharing his three-dimensional images.

19 Rethy Chhem, "Bhaiṣajyaguru and Tantric Medicine in Jayavarman VII Hospitals", *Siksacakr* 7, 2007: pp. 8–19; Hiram Woodward, "Cambodian Images of Bhaiṣajyaguru", in *Khmer Bronzes: New Interpretations of the Past*, eds. Emma Bunker and Douglas Latchford, Chicago: Art Media Resources, 2011, pp. 497–502; Sharrock, "Berlin's 1182–86 CE Bodhisattva 'Sunlight' or 'Moonlight'", *Indo-Asiatische Zeitschrift* 15, 2011: pp. 31–40.

20 Raoul Birnbaum, *The Healing Buddha*. Boulder: Shambhala, 1979, pp. 69ff, 173ff.

21 Ibid., p. 92ff, pl. 7; Jing Anning, "The Yuan Buddhist Mural of the Paradise of Bhaiṣajyaguru", *Metropolitan Museum Journal* 26, 1991: pp. 147–66.

22 Subhadradis Diskul M. C., *Sinlapa Samai Lopburi* [Lopburi Period Art], Bangkok: Fine Arts Department, 2510 BE/1967, Figs. 76 & 77.

23 Phuthorn Bhumadhon, "Buddhist Artifacts Recently Unearthed in Lopburi", in *Interpreting Southeast Asia's Past: Monument, Image and Text*, eds. E. A. Bacus, I. C. Glover and P. D. Sharrock, Singapore: NUS Press, 2008, pp. 156–64.

24 Pierre Pichard, *The Pentagonal Monuments of Pagan*, Bangkok: White Lotus, 1991.

25 Recent excavations at Preah Khan of Kompong Svay led by Mitch Hendrickson were unable to get a radiocarbon date for the construction of the structure known by some today as Preah Chatomukh. A ceramic analysis that might yield further dating information for the site is still ongoing (Mitch Hendrickson, Pers. Comm.).

26 Alexander Lubotsky, "The 'Sarvatobhadra' Temple of the Viṣṇudharmottarapurāṇa and the Viṣṇu Temple at Deogarh", in *Ritual, State and History in South Asia: Essays in Honour of J.C. Heesterman*, eds. A. W. van

der Hoek et al., Leiden: Brill, 1992, pp. 199–221.

27 Donald M. Stadtner, *Sacred Sites of Burma: Myth and Folklore in an Evolving Spiritual Realm*, Bangkok: River Books, 2011, pp. 139–40.

28 Alexander B. Griswold, *Wat Pra Yün Reconsidered*, Bangkok: The Siam Society, 1975. An earlier example can be seen at Wat Phra Men in Nakhon Pathom where four colossal enthroned Buddhas are each assigned a different cardinal direction, see Nicolas Revire, "Iconographical Issues in the Archeology of Wat Phra Men, Nakhon Pathom", *JSS* 98, 2010: pp. 75–115.

29 Thompson, "Lost and Found", pp. 245–63; and "The Future of Cambodia's Past: A Messianic Middle-period Cambodian Royal Cult", in *History, Buddhism, and New Religious Movements in Cambodia*, eds. John Marston and Elizabeth Guthrie. Chiang Mai: Silkworm Books, 2006, pp. 13–39.

30 Jean Filliozat, "Une inscription cambodgienne en pāli et en khmer de 1566 (K 82 Vatt Nagar)", *Comptes rendus des séances de l'Académie des Inscriptions et Belles-Lettres*, 113e année, no. 1, 1969: pp. 93–106.

31 Saveros Pou, "Textes en kmer moyen. Inscriptions modernes d'Angkor 2 et 3", *BEFEO* 57, 1970: pp. 103, 105–6.

32 Paleographical estimates were provided by U-tain Wongsathit and Santi Pakdeekham in private communications.

33 Yuni Sato, "New Elements of Theravada Buddhism Found at Western Prasat Top", in *Annual Report on the Research and Restoration Work of the Western Prasat Top. II: Dismantling Process of the Southern Sanctuary*, eds. Hiroshi Sugiyama and Yuni Sato, Nara: Nara National Research Institute for Cultural Properties, 2015, pp. 62–4; also Chapter 6 in this volume.

34 See Sato in this volume and Sok Keo Sovannara, "The Western Top Temple's Stone Blocks", in *Annual Report*, eds. Hiroshi Sugiyama and Yuni Sato, p. 51.

35 Padmanabh S. Jaini, "*Mahādibbamanta*: A *Paritta* Manuscript from Cambodia", *BSOAS* 28, no. 1, 1965; Prapod Assavavirulhakarn, "Mahādibbamanta: A Reflection on Thai Chanting Tradition", in *Jainism and Early Buddhism: Essays in Honor of Padmanabh S. Jaini,* ed. Olle Qvarnström, Berkeley: Asian Humanities Press, 2003.

36 Saveros Pou, "Inscriptions modernes d'Angkor 10, 11, 12, 13, 14, 15, 16a, 16b, et 16c", *BEFEO* 59, 1972: pp. 226–7.

37 Saveros Pou, "Inscriptions modernes d'Angkor 34 et 38", *BEFEO* 62, 1975a: pp. 285–6. I wish to acknowledge U-tain Wongsathit for drawing this textual source to my attention, and Trent Walker for these published references in the *IMA*.

38 Peter Skilling, "King, *Saṅgha*, and Brahmans: Ideology, ritual, and power in pre-modern Siam", in *Buddhism, Power and Political Order*, ed. Ian Harris, London and New York: Routledge, 2007, pp. 195–203.

39 Variant: *Piyadassī ca.*

40 Variant: *Dīpankaro.*

41 Variant: *Saraṇaṁkaro.*

42 Jaini, "*Mahādibbamanta*", p. 66.

43 The grammar of the last sentence is not very obvious. For example, it is not clear how *rājadhammassa* functions here, all the more since the variant *rājakammassa* ("royal deeds"?) also exists in some unpublished Thai manuscripts, for example in MS # Or 14526, f. 19r, kept at the British Library (www.bl.uk/manuscripts). Could *rājadhamma* be implicitly understood as the "ten royal virtues" (*dasavidharājadhamma*)? These ten virtues are enumerated for example at J III 273f (Jāt no. 385), J III 320 (Jāt no. 396), J III 412 (Jāt no. 415), and J V 378 (Jāt no. 534) as *dāna, sīla, pariccāga, ajjava, maddava, tapa,*

akkodha, *avihiṁsā*, *khanti*, *avirodhana*, that is, almsgiving, morality, generosity, directness, gentleness, austerity, non-anger, non-harming, forbearance, and non-opposition. They are already cited in Sukhothai inscriptions (e.g. Alexander B. Griswold and Prasert na Nagara, "The Epigraphy of Mahādharmarājā I of Sukhodaya: Epigraphic and Historical Studies No. 11 Part I", *JSS* 61, no. 1, 1973: p. 108, n. 118). For a discussion of these "ten royal virtues", see also Skilling, 2007: pp. 195–6 and Woodward, 2015: pp. 189–93.

44 Tsugunari Kubo and Akira Yuyama, *The Lotus Sutra (Taishō Volume 9, Number 262), translated from the Chinese of Kumārajiva*, Berkeley: Numata Center for Buddhist Translation and Research, 2007, p. 24ff.

45 The *Buddhavaṁsa* and its commentary (Horner, *Buddhavaṁsa (Chronicle of Buddhas) and Cariyāpiṭaka (Basket of Conduct)*; and *The Clarifier of the Sweet Meaning (Madhuratthavilāsinī)*) only know of a certain Buddha Maṅgala, while he is known in the *Mahādibbamanta* and in the *Namo buddhāya siddhaṁ*, v. 25, as Sumaṅgala (François Bizot and Oskar von Hinüber, eds., *La guirlande de Joyaux*, Paris, Chiang Mai, Phnom Penh, Vientiane: EFEO, 1994: p. 201, n. 9). In the "apocryphal" *Aṭṭhaparikkhārajātaka*, Buddha Sumaṅgala predicted Buddhahood to the bodhisattva, that is, the future Sākyamuni (Horner and Padmanabh S. Jaini, *Apocryphal Birth-Stories (Paññāsa-jātaka), Volume I*. London: The Pāli Text Society, 1985: p. 222ff.). Sumaṅgala is also the name of a Pacceka Buddha (Dictionary of Pali Proper Names, s.v.), and that of the tenth future Buddha according to the *Dasabodhisatta-uddesa* (see *infra*).

46 De Bernon, *Le manuel des maîtres de kammaṭṭhān : Étude et présentation de rituels de méditation dans la tradition du bouddhisme khmer*, Institut National des Langues et Civilisations Orientales, 2 vols, Paris, 2000, pp. 310–1, 328–30.

47 Emmanuel Guillon, "À propos d'une version mône inédite de l'épisode de Vasundharā", *JA* 275, no. 1–2, 1987: pp. 149, 153.

48 See Jaini, "*Mahādibbamanta*", pp. 66, 73–4 (vv. 18–20).

49 Maung Htin Aung, *Folk Elements in Burmese Buddhism*, London: Oxford University Press, 1962, pp. 8–11; Guillon, "À propos d'une version mône inédite de l'épisode de Vasundharā", pp. 148–9.

50 François Bizot, "La grotte de la naissance", *BEFEO* 67, 1980: pp. 226, 248, 252, 256; de Bernon, *Le manuel des maîtres de kammaṭṭhān*, pp. 307–14.

51 Justin Thomas McDaniel, *The Lovelorn Ghost and the Magical Monk: Practicing Buddhism in Modern Thailand*, New York: Columbia University Press, 2011, p. 77ff.

52 Roger R. Jackson, "A Tantric Echo in Sinhalese Theravāda?: Pirit Ritual, the Book of Paritta and the *Jinapañjaraya*", *Dhīḥ* 19, 1994: pp. 127–9.

53 On this practice in South Asia, see André Padoux, "Contributions à l'étude du *Mantraśāstra*. II. *nyāsa* : l'imposition rituelle des *mantra*", *BEFEO* 67, 1980. According to the explanation provided in the *Vairocanābhisaṁbodhi*, each letter of the Sanskrit alphabet has been ascribed to different parts of the body (trans. Stephen Hodge, *The Mahā-Vairocana-Abhisaṁbodhi Tantra: With Buddhaguhya's Commentary*, New York: Routledge Curzon, 2003: pp. 333–4; Rolf Giebel, *The Vairocanābhisaṁbodhi Sutra*, Berkeley: Numata Center for Buddhist Translation and Research, 2005: pp. 163–4). Similar practices are also attested in the Old Javano-Balinese textual tradition, on which see Andrea Acri, "Imposition of the Syllabary (*svaravyañjana-nyāsa*) in the Old Javano-Balinese Tradition in the Light of South Asian Tantric Sources", in *The Materiality and Efficacy of Balinese Letters: Situating Scriptural Practices*, eds. Richard Fox and Annette Hornbacher, Leiden: Brill, 2016, pp. 123–65.

54 François Bizot and François Lagirarde, *La pureté par les mots*, Paris, Chiang Mai, Phnom Penh, Vientiane: EFEO, 1996, pp. 44–5, 220.

55 Anna A. Ślączka, *Temple Consecration Rituals in Ancient India: Text and Archaeology*, Leiden: Brill, 2007. No substantial studies of the Dikpālas in ancient Cambodia seem to exist. For a brief survey, however, see Kamaleswar Bhattacharya, *Les religions brahmaniques dans l'ancien Cambodge d'après l'épigraphie et l'iconographie*, Paris: EFEO, 1961: pp. 138–43; and Vittorio Roveda, *Images of the Gods: Khmer Mythology in Cambodia, Thailand and Laos*, Bangkok: River Books, 2005: pp. 191–3, 389 (I thank Thierry Zéphir for these references). For an iconographic study of Dikpālas in Campā, see Pierre Baptiste, "Le piédestal de Van Trac Hoa : un *bali-pīṭha* d'un type inédit. Note concernant l'iconographie des *dikpāla* au Champa", *AA* 58, 2003: pp. 168–76; for the case of ancient Java, see Véronique Degroot, Arlo Griffiths and Baskoro Tjahjono, "Les pierres cylindriques inscrites du Candi Gunung Sari (Java Centre, Indonésie) et les noms des directions de l'espace en vieux javanais", *BEFEO* 97–8, 2010–1: pp. 367–90; Andrea Acri and Roy Jordaan, "The Dikpālas of Ancient Java Revisited: A New Identification for the Twenty Four Directional Deities on the Śiva Temple of the Loro Jonggrang Complex", *Bijdragen tot de Taal-, Land- en Volkenkunde* 168, 2012: pp. 274–313.

56 Corinna Wessels-Mevissen, *The Gods of the Directions in Ancient India: Origin and Early Development in Art and Literature (until c. l000 A.D.)*, Berlin: Dietrich Reimer Verlag, 2001, p. 1.

57 Ibid., p. 18ff. They can also be invoked in a Buddhist tantric ritual context, for example in the *Sarvadurgatipariśodhanatantra* (Tadeusz Skorupski, *The Sarvadurgatipariśodhana Tantra: Elimination of All Evil Destinies: Sanskrit and Tibetan Texts with Introduction, English Translation and Notes*, Delhi: Motilal Banarsidass, 1983, 51ff, 95ff.

58 Madeleine Giteau, *Le bornage rituel des temples bouddhiques au Cambodge*, Paris: EFEO, 1969, pp. 15–8, 25ff.

59 Ibid., p. 18.

60 Ibid., p. 49, (my translation). Certain *sīmā* of Angkor actually depict images of Dikpālas on their face (e.g. ibid.: pl. XIV, Fig. a, photo no. 24).

61 Ibid., p. 71.

62 Ibid.

63 Martin Polkinghorne, Christophe Pottier and Christian Fisher, "Evidence for the 15th-Century Ayutthayan Occupation of Angkor", in *The Renaissance Princess Lectures: In Honour of Her Royal Highness Princess Maha Chakri Sirindhorn on Her Fifth Cycle Anniversary*, Bangkok: The Siam Society, 2018, pp. 99–132.

64 Prapod Assavavirulhakarn, "Mahādibbamanta: A Reflection on Thai Chanting Tradition", in *Jainism and Early Buddhism: Essays in Honor of Padmanabh S. Jaini*, ed. Olle Qvarnström, Berkeley: Asian Humanities Press, 2003, p. 389.

65 As it occurs for example in the Śaiva *Jñānasiddhānta* and the *Bhuvanasaṃkṣepa* composed in ancient Indonesia (Haryati Soebadio ,*Jñānasiddhānta*, The Hague: Martinus Nijhoff, 1971: pp. 212–3; Sudarshana Devi Singhal, "*Bhuvana-saṃkṣepa*: Śaiva Cosmology in Indonesia", in *Cultural Horizons of India*, Vol. 5, ed. Lokesh Chandra, New Delhi: Aditya Prakashan, 1997: pp. 122–3). I wish to thank Andrea Acri for these references.

66 For François Bizot, see: *Le figuier à cinq branches*, Paris: EFEO, 1976; "La grotte de la naissance", 1980; *Le Chemin de Laṅkā*, Paris, Chiang Mai, Phnom Penh: EFEO, 1992; Bizot and Hinüber, *La guirlande de Joyaux*, 1994; Bizot and

Lagirarde, *La pureté par les mots*. For the other authors, see: de Bernon, *Le manuel des maîtres de kammaṭṭhān*; Catherine Becchetti, *Le mystère dans les lettres: Étude sur les* yantra *bouddhiques du Cambodge et de la Thaïlande*, Bangkok: Édition des Cahiers de France, 1991; Kate Crosby, "Tantric Theravāda: A Bibliographic Essay on the Writings of François Bizot and Others on the Yogāvacara Tradition", *Contemporary Buddhism* 1, no. 2, 2000: pp. 141–98; Andrew Skilton and Phibul Choompolpaisal, "The Old Meditation (*boran kammatthan*), a Pre-reform Theravāda Meditation System from Wat Ratchasittharam: The *Piti* Section of the *Kammatthan matchima baep lamdap*", *Aséanie* 33, 2014: pp. 83–116. The oldest extant manuscript related to this tradition is reported to come from Wat Ratchathiwat in Bangkok, and is dated 1661 (de Bernon, "Le *mūl kămmăṭṭhān* du Wat Ratchecathiwat daté de 1661 A.D. : présentation et traduction", *JSS* 90, no. 1–2, 2002: pp. 149–60). Interestingly, *IMA 38* (dated 1623 *śaka* = 1701 CE), stanza 10, pays homage to the Master, the Triple Gem and the five Buddhas (Pou, "Inscriptions modernes d'Angkor 34 et 38", 1975a: pp. 298, 307).

67 De Bernon, *Le manuel des maîtres de kammaṭṭhān*, p. 301ff.

68 Donald K. Swearer, "A Summary of the Seven Books of the Abhidhamma", in *Buddhism in Practice*, ed. Donald S. Lopez Jr., Princeton: Princeton University Press, 1995, pp. 338–40.

69 A similar quinary association of the five cosmic Jinas with the five colours, five aggregates, five elements, five senses, five heart syllables, and so on, as well as their related cardinal directions, is also attested in ancient Javano-Balinese sources (Louis-Charles Damais, "Études javanaises III. À propos des couleurs symboliques des points cardinaux", *BEFEO* 56, 1969: p. 87ff; Lokesh Chandra, "Śaiva Version of the *San Hyan Kamahāyānikan*", in *Cultural Horizons of India*, Vol. 5, ed. Lokesh Chandra, pp. 18–9.

70 Variant: ears.

71 Variant: water (*āpodhātu*).

72 Variant: earth (*paṭhavīdhātu*).

73 Variant: white.

74 Variant: red.

75 Variant: yellow.

76 Adapted from Bizot, *Le figuier à cinq branches*, pp. 87–91; *Le Chemin de Lankā*, pp. 229–31, 257; Bizot and Lagirarde, *La pureté par les mots*, pp. 212–3.

77 Transliterated from Nuon Saṁ-ān, *Gihippatipatti gharāvāsadharm* [Lay Practice and Dharma for Home-Dwellers], Phnom Penh: Private Publisher, 2547 BE/2004, p. 4. I am grateful to Trent Walker for this reference and his assistance with the Khmer-Pāli. Related homages to the five Buddhas also appear frequently in modern Thai-Mon chanting books.

78 Bizot, "Notes sur les *yantra* bouddhiques d'Indochine", in *Tantric and Taoist Studies in Honour of R.A. Stein* (Volume 1), ed. Michel Strickmann, Brussels: Institut belge des Hautes Études chinoises, 1981, pp. 157–8, 171–2; Becchetti, *Le mystère dans les lettres*, 1991, pp. 51 (Fig. 1a), 56, 72.

79 Susan Conway, *Tai Magic: Arts of the Supernatural in the Shan States and Lan Na*, Bangkok: River Books, 2014, pp. 87–8, Fig. 3.

80 Vittorio Roveda and Sothon Yem, *Preah Bot: Buddhist Painted Scrolls in Cambodia*, Bangkok: River Books, 2010, p. 49ff.

81 Knowledge of the ten bodhisattvas appears earlier in a mid 14th-century Pāli inscription of Sukhothai, Face C, l. 12 (George Cœdès, "Documents sur la dynastie de Sukodaya", *BEFEO* 17, 1917: pp. 30, 32), a concept that seems to

have not been totally understood by Griswold and Prasert, "The Epigraphy of Mahādharmarājā I of Sukhodaya", p. 165, n. 27. See also, Saveros Pou, "Inscriptions modernes d'Angkor 26, 27, 28, 29, 30, 31, 32, 33", *BEFEO* 60, 1973: pp. 220, 224.

82 See for example MS Code # 023*.III.1-PP.03.03.03, # b.287.III.1, and # b.288. III.1 (khmermanuscripts.efeo.fr).

83 François Martini, "*Dasa-bodhisatta-uddesa* : texte pâli publié avec une traduction et un index grammatical", *BEFEO* 36, 1936.

84 Ian Harris, *Cambodian Buddhism*, p. 82ff; de Bernon, "The Status of Pāli in Cambodia: From Canonical to Esoteric Language", in *Buddhist Legacies in Mainland Southeast Asia*, eds. François Lagirarde and Paritta Chalermpow Koanantakool, pp. 53–66.

85 Revire, "Buddhas of the Past and of the Future", in *Brill's Encyclopedia of Buddhism*, Vol. II: Lives, pp. 109–120.

86 Hammalawa Saddhatissa, *The Birth Stories of the Ten Bodhisattas and the Dasabodhisattuppattikathā*, London: The Pāli Text Society, 1975.

87 For example, the *vān* manuscript from Wat Bahupupharam from Srei Santhor district in Kampong Cham. I am grateful to Olivier de Bernon and his assistant Kun Sopheap for graciously pointing out this reference to me. Other short versions of this liturgical text exist in Cambodia (Trent Walker, Pers. Comm.).

88 Martini, "*Dasa-bodhisatta-uddesa*", p. 367.

89 Ibid., p. 334.

90 I wish to acknowledge the assistance of the late Peter Masefield in reading this text in Pāli. Except for the first paragraph which does not correlate exactly, the subsequent verses are totally absent in the colophon of the Sinhalese edition of Saddhatissa, *The Birth Stories of the Ten Bodhisattas and the Dasabodhisattuppattikathā*, 1975: pp. 92, 162, or that found as an appendix to Martini, "*Dasa-bodhisatta-uddesa*", p. 413.

91 Nandana Chutiwongs and Leelananda Prematilleke, "The Ten Buddhas of the Future", in *Studies & Reflections on Asian Art History and Archaeology: Essays in Honour of H.S.H Professor Subhadradis Diskul*, eds. Khaisri Sri-Aroon et al, Bangkok: Silpakorn University Press, 1997, pp. 351–64.

92 Suphicha Saengsukiam, "Chitrakam phap phra phothisat nai samai phra anakataphut chao 10 phra ong bon phaeng mai kho song sala kan prian langkao wat nai klang changwat phetchaburi [Ten Future Bodhisattvas on Panel Painting from the Old Sermon Hall of Wat Nai Klang, Phetchaburi Province]", *Warasan Sinlapakon/The Journal of Silpakorn University* 30, no. 1, 2553 BE/2010: pp. 69–82.

93 For the story, see Martini, "*Dasa-bodhisatta-uddesa*", pp. 330ff, 363ff.

94 I am obliged to Grégory Mikaelian and Michel Antelme for the reading of these captions.

95 Sūryavarman I's inscription found in Lopburi, Thailand (*K. 410* or *LB 2*), dated 944 and 947 *śaka* (= 1022 and 1025 CE) and written in Old Khmer, refers to "those who have been ordained as *bhikṣu mahāyānasthavira*" and who lived in close proximity to non-Buddhist ascetics or *tāpasa* (Cœdès, *Recueil des inscriptions du Siam—2. Inscriptions de Dvāravatī, Çrīvijaya et Lāvo*, Bangkok: Fine Arts Department, 2nd ed., 1961: pp. 10–2, inscription no. XIX, l. 6–7). However, I contest Cœdès' rendition of this compound (*mahāyānasthavira*) that those monks (*bhikṣu*) belong either to the "Mahāyāna sect" and/or "the Sthavira [i.e. Theravāda] sect". This seems to be technically impossible in the context of ancient Buddhist monastic practice, since there was probably no such

thing as a "Mahāyāna Vinaya" in the past and hence no specific Mahāyāna monastic order or ordination lineage. Moreover, in canonical texts as well as in epigraphy, the Sanskrit term *sthavira* (Pāli: *thera*) was used mainly as an epithet or a honorific title based on ordination age and not employed in a denominational sense, denoting a specific *nikāya* affiliation (Sthaviravāda or Theravāda). Thus, the Sanskrit compound *mahāyānasthavira* may either refer to "Elders [not necessarily Theravādins] who follow the Mahāyāna path" or, less likely, "Mahāyanist [monks = *bhikṣu*] on the Sthavira path". Put simply, the assumption of distinct Mahāyāna and Theravāda "schools" as well as the dichotomy made between Mahāyāna and Sthavira/Thera[vāda] Buddhist monks is wrong.

96 Jonathan S. Walters, "Mahāyāna Theravāda and the Origins of the Mahāvihāra", *The Sri Lanka Journal of the Humanities* 23, no. 1–2, 1997: pp. 100–19; Lance S. Cousins, "The Teachings of the Abhayagiri School", in *How Theravāda is Theravāda?*, eds. Peter Skilling et al, pp. 66–127.

97 Saveros Pou, "Les traits bouddhiques du *Rāmakerti*", *BEFEO* 62, 1975b: pp. 355–68.

98 Bizot, *Rāmaker ou l'amour symbolique de Rām et Setā*, Paris: EFEO, 1989.

99 For an English translation of the legend as found in Northern Thailand, see Swearer, "*Tamnan Kā Phū'ak* [The Chronicle of the White Crow]", in *Becoming the Buddha: The Ritual of Image Consecration in Thailand*. Princeton: Princeton University Press, 2004, pp. 197–205. It is also found in manuscript form in Cambodia (MS Code # 027.III.1-A.10.10.01; khmermanuscripts.efeo.fr), but a detailed and comparative study remains to be done. It is to be distinguished with the *Pañcabuddhabyākaraṇa* or the "Prediction concerning the five buddhas", a unique text composed in Pāli (and translated in Thai), perhaps going back to the Sukhothai period. The opening paragraph of this text states that, in the past, the five bodhisattvas were simultaneously and respectively born as a jungle-fowl, a king of snakes, a tortoise, a king of bulls, and a king of lions. The story that follows this introduction is localised in the area of Thung Yang, Uttaradit province, in Northern Thailand (Ginette Martini, "*Pañcabuddhabyākaraṇa*", *BEFEO* 55, no. 1, 1969: pp. 125–44).

100 Vittorio Roveda and Sothon Yem, *Preah Bot*, pp. 53, 55, Figs. 55–8.

101 In the same vein, modern mural paintings from Wat Phathumwan in Bangkok show a clear correlation between the five bodhisattvas, the respective animals, and the five transcendental Jinas (Pitchaya, "'Phrachomklao' kap 'phra thammakai' nai chitrakam wat pathumwanaram" [King Rama IV and the 'Dharma-body' in the Mural Paintings of Wat Pathumwanaram]", *Sinlapa Watthanatham/Art & Culture Magazine* 37, 2559 BE/2016: pp. 66–85).

102 As attested by epigraphic evidence. See in particular *K. 111*, stanza 44, *K. 214*, stanza 7, *K. 225*, stanzas 2 and 11, *K. 273*, stanza 35, and *K. 872*, stanza 4, cited in Hedwige Multzer o'Naghten, "Prajñāpāramitā dans le bouddhisme du Cambodge ancien", *AA* 71, 2016: pp. 34–5, 43.

103 Ibid.

104 Jaini, "*Mahādibbamanta*", pp. 61–80.

105 Harris, *Cambodian Buddhism*, p. 85.

106 Ibid.

107 Prapod, "Mahādibbamanta: A Reflection on Thai Chanting Tradition", p. 402.

108 C.f. Crosby, "Tantric Theravāda".

109 A case in mind is the non-canonical *Uṇhissavijaya* which circulates in

Cambodia in Pāli and Khmer, in both verses and prose (Trent Walker, "Echoes of a Sanskrit Past: Liturgical Curricula and the Pali *Uṇhissavijaya* in Cambodia", in *Katā Me Rakkhā, Katā Me Parittā: Protecting the Protective Texts and Manuscripts: Proceedings of the Second International Pali Studies Week (Paris 2016)*, ed. Claudio Cicuzza, Bangkok and Lumbini: Lumbini International Research Institute, 2018, pp. 55–134). The frame narrative of this powerful ritual text is virtually identical to that given in the Sanskrit *Uṣṇīṣavijayādhāraṇī*[-*sūtra*] but is different from that of the *Sarvadurgatipariśodhanatantra*, "Elimination of all evil destinies", which highlights a five-Jina system centred on Vairocana. In the latter narrative, Indra/Śakra and his fellow residents in Trāyastriṁśa are powerless to help their deceased colleague Vimalamaṇiprabha, not even knowing into which realm he has been reborn. They must therefore seek the aid of Vairocana, first locating their fallen cohort in the most tortuous hell (*avīci*) and, second, setting forth a *maṇḍala* with the proper prescribed death rites for his benefit. Accordingly, Indra performs these specifically Buddhist tantric rites through which Vimalamaṇiprabha is liberated from hell and reborn in a better destiny (Skorupski, *The Sarvadurgatipariśodhana Tantra*). In the Pāli *Uṇhissavijaya*, however, there is neither trace of the actual *dhāraṇī* or "spell" that gives its name to the text nor is there any presence of the five cosmic Buddhas such as Vairocana. Thus, the terminology and doctrinal background of the narrative appear to be entirely Theravāda in tenor. Other Thai, Mon, and Lao versions of this text also exist which are recited in long-life ceremonies (Skilling, "Pieces in the Puzzle: Sanskrit Literature in Pre-modern Siam", in *Buddhism and Buddhist Literature of South-East Asia: Selected Papers*, ed. Peter Skilling, Bangkok and Lumbini: Fragile Palm Leaves Foundation/Lumbini International Research Institute, 2009: pp. 32–6, App. 1–5; Kourilsky, "The *Uṇhissa-vijaya-sutta* in Laos and Thailand: A Philological Approach", in *Katā Me Rakkhā, Katā Me Parittā*, ed. Claudio Cicuzza, pp. 1–54).

110 Harris, *Cambodian Buddhism*, p. 93ff.
111 Ibid., p. 94.

References

Acri, Andrea. "Imposition of the Syllabary (*svaravyañjana-nyāsa*) in the Old Javano-Balinese Tradition in the Light of South Asian Tantric Sources". In *The Materiality and Efficacy of Balinese Letters: Situating Scriptural Practices*, eds. Richard Fox and Annette Hornbacher. Leiden: Brill, 2016, pp. 123–65.

Acri, Andrea and Roy Jordaan. "The Dikpālas of Ancient Java Revisited: A New Identification for the Twenty Four Directional Deities on the Śiva Temple of the Loro Jonggrang Complex". *Bijdragen tot de Taal-, Land- en Volkenkunde* 168, 2012: pp. 274–313.

Baptiste, Pierre. "Le piédestal de Van Trac Hoa: un *bali-pīṭha* d'un type inédit. Note concernant l'iconographie des *dikpāla* au Champa". *AA* 58, 2003: pp. 168–76.

Becchetti, Catherine. *Le mystère dans les lettres: Étude sur les* yantra *bouddhiques du Cambodge et de la Thaïlande*. Bangkok: Édition des Cahiers de France, 1991.

Bernon, Olivier de. "'Des buddha aussi nombreux que les grains de sable' : Note sur une métaphore figée dans la langue khmère". *Aséanie* 7, 2001: pp. 13–7.

———. *Le manuel des maîtres de kammaṭṭhān: Étude et présentation de rituels de méditation dans la tradition du bouddhisme khmer*. Institut National des Langues et Civilisations Orientales, 2 vols, Paris, 2000.

———. "Le *mūl kāmmāṭṭhān* du Wat Ratchathiwat daté de 1661 A.D. : présentation et traduction". *JSS* 90, no. 1–2, 2002: pp. 149–60.

———. "The Status of Pāli in Cambodia: From Canonical to Esoteric Language". In *Buddhist Legacies in Mainland Southeast Asia: Mentalities, Interpretations and Practices*, eds. François Lagirarde and Paritta Chalermpow Koanantakool. Bangkok: Princess Maha Chakri Sirindhorn Anthropology Centre, 2006, pp. 53–66.

Bhattacharya, Kamaleswar. *Les religions brahmaniques dans l'ancien Cambodge d'après l'épigraphie et l'iconographie*. Paris: EFEO, 1961.

Bhattacharyya, Benoytosh. *The Indian Buddhist Iconography*. Calcutta: Mukhopadhyay, 1968. (Reprint of 2nd edition.)

Birnbaum, Raoul. *The Healing Buddha*. Boulder: Shambhala, 1979.

Bizot, François. *Le Chemin de Laṅkā*. Paris, Chiang Mai, Phnom Penh: EFEO, 1992.

———. *Le figuier à cinq branches*. Paris: EFEO, 1976.

———. "La grotte de la naissance". *BEFEO* 67, 1980: pp. 221–73.

———. "Notes sur les *yantra* bouddhiques d'Indochine". In *Tantric and Taoist Studies in Honour of R.A. Stein* (Volume 1), ed. Michel Strickmann. Brussels: Institut belge des Hautes Études chinoises, 1981, pp. 155–91.

———. *Rāmaker ou l'amour symbolique de Rām et Setā*. Paris: EFEO, 1989.

Bizot, François and Oskar von Hinüber. *La guirlande de Joyaux*. Paris, Chiang Mai, Phnom Penh, Vientiane: EFEO, 1994.

Bizot, François and François Lagirarde. *La pureté par les mots*. Paris, Chiang Mai, Phnom Penh, Vientiane: EFEO, 1996.

Both, Leo. "The *Saptabuddhastotra* and the *Saptatathāgatastotra*, Two Hymns Praising the Seven Previous Buddhas". In *Glimpses of the Sanskrit Buddhist Literature (Volume 1)*, ed. Kameshwar Nath Mishra. Sarnath: Central Institute of Higher Tibetan Studies, 1997, pp. 57–73.

Bruguier, Bruno et al. *Banteay Chhmar et les provinces occidentales. Tome III : Guide archéologique du Cambodge*. Phnom Penh: Éditions Reyum, 2015.

Chhem, Rethy. "Bhaiṣajyaguru and Tantric Medicine in Jayavarman VII Hospitals". *Siksacakr* 7, 2007: pp. 8–19.

Chirapat Prapandvidya. "The Sab Bāk Inscription: Evidence of an Early Vajrayana Buddhist Presence in Thailand". *JSS* 78, no. 2, 1990: pp. 11–4.

Cœdès, George. "Documents sur la dynastie de Sukhodaya". *BEFEO* 17, 1917: pp. 1–47.

———. *Recueil des inscriptions du Siam—2. Inscriptions de Dvāravatī, Çrīvijaya et Lāvo*. Bangkok: Fine Arts Department, 2nd ed., 1961. (First edition 1929.)

Conti, Pia. "Tantric Buddhism at Prasat Hin Phimai: A New Reading of Its Iconographic Message". In *Before Siam: Essays in Art and Archaeology*, eds. Nicolas Revire and Stephen A. Murphy. Bangkok: River Books & The Siam Society, 2014, pp. 374–95.

Conway, Susan. *Tai Magic: Arts of the Supernatural in the Shan States and Lan Na*. Bangkok: River Books, 2014.

Conze, Edward et al. *Buddhist Texts Through the Ages*. London: One World Publications, reprint, 2007.

Cousins, Lance S. "The Teachings of the Abhayagiri School". In *How Theravāda is Theravāda?: Exploring Buddhist Identities*, eds. Peter Skilling et al. Chiang Mai: Silkworm Books, 2012, pp. 66–127.

Crosby, Kate. "Tantric Theravāda: A Bibliographic Essay on the Writings of François Bizot and Others on the Yogāvacara Tradition". *Contemporary Buddhism* 1, no. 2, 2000: pp. 141–98.

Damais, Louis-Charles. "Études javanaises III. À propos des couleurs symboliques des points cardinaux". *BEFEO* 56, 1969: pp. 75–118.

Degroot, Véronique, Arlo Griffiths and Baskoro Tjahjono. "Les pierres cylindriques inscrites du Candi Gunung Sari (Java Centre, Indonésie) et les noms des directions de l'espace en vieux javanais". *BEFEO* 97–8, 2010–1: pp. 367–90.

Estève, Julia. *Étude critique des phénomènes de syncrétisme religieux dans le Cambodge angkorien*. Doctoral dissertation, École Pratique des Hautes Études, Paris, 2009.

Filliozat, Jean. "Une inscription cambodgienne en pāli et en khmer de 1566 (K 82 Vatt Nagar)". *Comptes rendus des séances de l'Académie des Inscriptions et Belles-Lettres*, 113e année, no. 1, 1969: pp. 93–106.

Getty, Alice. *The Gods of Northern Buddhism: Their History and Iconography*. New York: Dover Publications, 1988. (Reprint of 2nd edition.)

Giebel, Rolf. *The Vairocanābhisaṃbodhi Sutra: Translated from the Chinese (Taishō Vol. 18, Nr 848)*. Berkeley: Numata Center for Buddhist Translation and Research, 2005.

Giteau, Madeleine. *Le bornage rituel des temples bouddhiques au Cambodge*. Paris: EFEO, 1969.

Gombrich, Richard. "The Significance of Former Buddhas in the Theravādin Tradition". In *Buddhist Studies in Honour of Walpola Rahula*, eds. Walpola Rahula et al. London: Gordon Fraser, 1980, pp. 62–72.

Goudriaan, Teun and Christiaan Hooykaas. *Stuti and Stava (Bauddha, Śaiva and Vaiṣṇava) of Balinese Brahman Priests*. Amsterdam & London: North-Holland Publishing Company, 1971.

Griswold, Alexander B. *Wat Pra Yün Reconsidered*. Bangkok: The Siam Society, 1975.

Griswold, Alexander B. and Prasert na Nagara. "The Epigraphy of Mahādharmarājā I of Sukhodaya. Epigraphic and Historical Studies No. 11 Part I". *JSS* 61, no. 1, 1973: pp. 71–180.

Guillon, Emmanuel. "À propos d'une version môn inédite de l'épisode de Vasundharā". *JA* 275, no. 1–2, 1987: pp. 143–62.

Harris, Ian. *Cambodian Buddhism: History and Practice*. Honolulu: University of Hawai'i Press, 2005.

Hodge, Stephen. *The Mahā-Vairocana-Abhisaṃbodhi Tantra: With Buddhaguhya's Commentary*. New York: Routledge Curzon, 2003.

Horner, I. B. *Buddhavaṃsa (Chronicle of Buddhas) and Cariyāpiṭaka (Basket of Conduct)*. London: The Pāli Text Society, 1975.

———. *The Clarifier of the Sweet Meaning (Madhuratthavilāsinī): Commentaries on the Chronicle of Buddhas (Buddhavaṃsa)*. London: The Pāli Text Society, 1978.

Horner, I. B. and Padmanabh S. Jaini. *Apocryphal Birth-Stories (Paññāsa-jātaka), Volume I*. London: The Pāli Text Society, 1985.

Jackson, Roger R. "A Tantric Echo in Sinhalese Theravāda? Pirit Ritual, the Book of Paritta and the *Jinapañjaraya*". *Dhīḥ* 19, 1994: pp. 121–40.

Jacques, Claude. "The Buddhist Sect of Śrīghana in Ancient Khmer Lands". In *Buddhist Legacies in Mainland Southeast Asia: Mentalities, Interpretations and Practices*, eds. François Lagirarde and Paritta Chalermpow Koanantakool. Bangkok: Princess Maha Chakri Sirindhorn Anthropology Centre, 2006, pp. 71–7.

Jaini, Padmanabh S. "*Mahādibbamanta*: A *Paritta* Manuscript from Cambodia". *BSOAS* 28, no. 1, 1965: pp. 61–80.

Jing, Anning. "The Yuan Buddhist Mural of the Paradise of Bhaiṣajyaguru". *Metropolitan Museum Journal* 26, 1991: pp. 147–66.

Kourilsky, Grégory. "Le 'bouddhisme *theravāda*', cette autre invention de l'Occident".

BEFEO 100, 2014: pp. 361–8.

———. "The *Uṇhissa-vijaya-sutta* in Laos and Thailand: A Philological Approach". In *Katā Me Rakkhā, Katā Me Parittā: Protecting the Protective Texts and Manuscripts. Proceedings of the Second International Pali Studies Week (Paris 2016)*, ed. Claudio Cicuzza. Bangkok and Lumbini: Lumbini International Research Institute, 2018, pp. 1–54.

Kubo, Tsugunari and Akira Yuyama. *The Lotus Sutra (Taishō Volume 9, Number 262). Translated from the Chinese of Kumārajiva*. Berkeley: Numata Center for Buddhist Translation and Research, 2007.

Lokesh Chandra. "Śaiva Version of the *San Hyan Kamahāyānikan*". In *Cultural Horizons of India*, Vol. 5, ed. Lokesh Chandra. New Delhi: Aditya Prakashan, 1997, pp. 7–101.

Lubotsky, Alexander. "The 'Sarvatobhadra' Temple of the Viṣṇudharmottarapurāṇa and the Viṣṇu Temple at Deogarh". In *Ritual, State and History in South Asia: Essays in Honour of J.C. Heesterman*, eds. A.W. van der Hoek et al. Leiden: Brill, 1992, pp. 199–221.

McDaniel, Justin Thomas. *The Lovelorn Ghost and the Magical Monk: Practicing Buddhism in Modern Thailand*. New York: Columbia University Press, 2011.

Martini, François. "*Dasa-bodhisatta-uddesa* : texte pâli publié avec une traduction et un index grammatical". *BEFEO* 36, 1936: pp. 287–413.

Martini, Ginette. "*Pañcabuddhabyākaraṇa*". *BEFEO* 55, no. 1, 1969: 125–44.

Maung Htin Aung. *Folk Elements in Burmese Buddhism*. London: Oxford University Press, 1962.

Multzer o'Naghten, Hedwige. "Prajñāpāramitā dans le bouddhisme du Cambodge ancien". *AA* 71, 2016: pp. 31–54.

Nandana Chutiwongs and Leelananda Prematilleke. "The Ten Buddhas of the Future". In *Studies & Reflections on Asian Art History and Archaeology: Essays in Honour of H.S.H Professor Subhadradis Diskul*, eds. Khaisri Sri-Aroon et al. Bangkok: Silpakorn University Press, 1997, pp. 351–64.

Nuon Saṁ-ān. *Gihippatipatti gharāvāsadharm* [Lay Practice and Dharma for Home-Dwellers]. Phnom Penh: Private Publisher, 2547 BE/2004. (In Khmer.)

Padoux, André. "Contributions à l'étude du *Mantraśāstra*. II. *nyāsa* : l'imposition rituelle des *mantra*". *BEFEO* 67, 1980: pp. 59–102.

Phuthorn Bhumadhon. "Buddhist Artifacts Recently Unearthed in Lopburi". In *Interpreting Southeast Asia's Past: Monument, Image and Text*, eds. E. A. Bacus, I. C. Glover and P. D. Sharrock. Singapore: NUS Press, 2008, pp. 156–64.

Pichard, Pierre. *The Pentagonal Monuments of Pagan*. Bangkok: White Lotus, 1991.

Pitchaya Soomjinda. "Khamwa 'srikhana' nai charuek kampucha: 'nikai' rue 'nimankai' ['Śrīghana' in Cambodian Inscriptions: 'Buddhist Sect' or 'Buddha's Transformation Body']". *Thai Khadi Sueksa/ The Journal of the Thai Khadi Research Institute* 11, 2557 BE/2014: pp. 175–217. (In Thai).

———. "'Phrachomklao' kap 'phra thammakai' nai chitrakam wat pathumwanaram" [King Rama IV and the 'Dharma-body' in the Mural Paintings of Wat Pathumwanaram]". *Sinlapa Watthanatham/Art & Culture Magazine* 37, 2559 BE/2016: pp. 66–85. (In Thai.)

Polkinghorne, Martin, Christophe Pottier and Christian Fisher. "Evidence for the 15th-Century Ayutthayan Occupation of Angkor". In *The Renaissance Princess Lectures: In Honour of Her Royal Highness Princess Maha Chakri Sirindhorn on Her Fifth Cycle Anniversary*. Bangkok: The Siam Society, 2018, pp. 99–132.

Pou (*aka* Lewitz), Saveros. "Textes en kmer moyen. Inscriptions modernes d'Angkor 2 et 3". *BEFEO* 57, 1970: pp. 99–126.

———. "Inscriptions modernes d'Ankgor 4, 5, 6 et 7". *BEFEO* 58, 1971: pp. 105–23.

———. "Inscriptions modernes d'Angkor 10, 11, 12, 13, 14, 15, 16a, 16b, et 16c". *BEFEO* 59, 1972: pp. 221–49.

———. "Inscriptions modernes d'Angkor 26, 27, 28, 29, 30, 31, 32, 33". *BEFEO* 60, 1973: pp. 205–42.

———. "Inscriptions modernes d'Angkor 35, 36, 37 et 39". *BEFEO* 61, 1974: pp. 301–37.

———. "Inscriptions modernes d'Angkor 34 et 38". *BEFEO* 62, 1975a: pp. 283–353.

———. "Les traits bouddhiques du *Rāmakerti*". *BEFEO* 62, 1975b: pp. 355–68.

———. *Nouvelles inscriptions du Cambodge*, Vol. 1. Paris: EFEO, 1989.

Prapod Assavavirulhakarn. "Mahādibbamanta: A Reflection on Thai Chanting Tradition". In *Jainism and Early Buddhism: Essays in Honor of Padmanabh. S. Jaini,* ed. Olle Qvarnström. Berkeley: Asian Humanities Press, 2003, pp. 379–406.

Revire, Nicolas. "Buddhas of the Past and of the Future: Southeast Asia". In *Brill's Encyclopedia of Buddhism*, Vol. II: Lives, eds. Silk, Jonathan et al. Leiden: Brill, 2019, pp. 109–120.

———. "Iconographical Issues in the Archeology of Wat Phra Men, Nakhon Pathom". *JSS* 98, 2010: pp. 75–115.

Roche-Provost, Ludivine. *Les derniers siècles de l'époque angkorienne au Cambodge (env. 1220–env. 1500)*. PhD dissertation, Université Paris 3–Sorbonne Nouvelle, 2010.

Roveda, Vittorio. *Images of the Gods: Khmer Mythology in Cambodia, Thailand and Laos*. Bangkok: River Books, 2005.

Roveda, Vittorio and Sothon Yem. *Preah Bot: Buddhist Painted Scrolls in Cambodia*. Bangkok: River Books, 2010.

Saddhatissa, Hammalawa. *The Birth Stories of the Ten Bodhisattas and the Dasabodhisattuppattikathā*. London: The Pāli Text Society, 1975.

Sato, Yuni. "New Elements of Theravada Buddhism Found at Western Prasat Top". In *Annual Report on the Research and Restoration Work of the Western Prasat Top. II: Dismantling Process of the Southern Sanctuary*, eds. Hiroshi Sugiyama and Yuni Sato. Nara: Nara National Research Institute for Cultural Properties, 2015, pp. 56–64.

Sharrock, Peter D. "Berlin's 1182–86 CE Bodhisattva 'Sunlight' or 'Moonlight'". *Indo-Asiatische Zeitschrift* 15, 2011: pp. 31–40.

———. "Serpent-enthroned Buddha of Angkor". *Marg* 67, no. 2 [Special Issue *Art of Cambodia: Interactions with India*, ed. by Swati Chemburkar], 2016: pp. 20–31.

Singhal, Sudarshana Devi. "*Bhuvana-saṁkṣepa*: Śaiva Cosmology in Indonesia". In *Cultural Horizons of India*, Vol. 5, ed. Lokesh Chandra, New Delhi: Aditya Prakashan, 1997, pp. 102–61.

Skilling, Peter. "Random Jottings on Śrīghana: An Epithet of the Buddha". *Annual Report of the International Research Institute for Advanced Buddhology* 7, 2004: pp. 147–58.

———. "King, *Saṅgha*, and Brahmans: Ideology, Ritual, and Power in Pre-modern Siam". In *Buddhism, Power and Political Order*, ed. Ian Harris. London and New York: Routledge, 2007, pp. 182–215.

———. "Pieces in the Puzzle: Sanskrit Literature in Pre-modern Siam". In *Buddhism and Buddhist Literature of South-East Asia: Selected Papers*, ed. Peter Skilling. Bangkok and Lumbini: Fragile Palm Leaves Foundation/Lumbini International Research Institute, 2009, pp. 27–45.

———. "Namo Buddhāya Gurave (K. 888): Circulation of a Liturgical Formula Across Asia". *JSS* 106, 2018: pp. 109–28.

Skilling, Peter et al. *How Theravāda is Theravāda?: Exploring Buddhist Identities*. Chiang Mai: Silkworm Books, 2012.

Skilton, Andrew and Phibul Choompolpaisal. "The Old Meditation (*boran kammatthan*), a Pre-reform Theravāda Meditation System from Wat Ratchasittharam: The *Piti* Section of the *Kammatthan matchima baep lamdap*". *Aséanie* 33, 2014: pp. 83–116.

Skorupski, Tadeusz. *The Sarvadurgatipariśodhana Tantra: Elimination of All Evil Destinies. Sanskrit and Tibetan Texts with Introduction, English Translation and Notes*. Delhi: Motilal Banarsidass, 1983.

Ślączka, Anna A. *Temple Consecration Rituals in Ancient India: Text and Archaeology*. Leiden: Brill, 2007.

Soebadio, Haryati. *Jñānasiddhânta*. The Hague: Martinus Nijhoff, 1971.

Sovannara, Sok Keo. "The Western Top Temple's Stone Blocks". In *Annual Report on the Research and Restoration Work of the Western Prasat Top. II: Dismantling Process of the Southern Sanctuary*, eds. Hiroshi Sugiyama and Yuni Sato. Nara: Nara National Research Institute for Cultural Properties, 2015, pp. 49–55.

Stadtner, Donald M. *Sacred Sites of Burma: Myth and Folklore in an Evolving Spiritual Realm*. Bangkok: River Books, 2011.

Subhadradis Diskul M. C. *Sinlapa Samai Lopburi* [Lopburi Period Art]. Bangkok: Fine Arts Department, 2510 BE/1967. (In Thai.)

Suphicha Saengsukiam. "Chitrakam phap phra phothisat nai samai phra anakataphut chao 10 phra ong bon phaeng mai kho song sala kan prian langkao wat nai klang changwat phetchaburi [Ten Future Bodhisattvas on Panel Painting from the Old Sermon Hall of Wat Nai Klang, Phetchaburi Province]". *Warasan Sinlapakon/The Journal of Silpakorn University* 30, no. 1, 2553 BE/2010: pp. 69–82. (In Thai.)

Swearer, Donald K. "A Summary of the Seven Books of the Abhidhamma". In *Buddhism in Practice*, ed. Donald S. Lopez Jr. Princeton: Princeton University Press, 1995, pp. 336–42.

———. "*Tamnan Kā Phū'ak* [The Chronicle of the White Crow]". In *Becoming the Buddha: The Ritual of Image Consecration in Thailand*. Princeton: Princeton University Press, 2004, pp. 197–205.

Thompson, Ashley. "The Future of Cambodia's Past: A Messianic Middle-period Cambodian Royal Cult". In *History, Buddhism, and New Religious Movements in Cambodia*, eds. John Marston and Elizabeth Guthrie. Chiang Mai: Silkworm Books, 2006, pp. 13–39.

———. "Lost and Found: The *Stupa*, the Four-faced Buddha, and the Seat of Royal Power in Middle Cambodia". In *Proceedings of the 7th International Conference of the European Association of Southeast Asian Archaeologists, Berlin, 31 August–4 September 1998*, eds. Wibke Lobo and Stephanie Reimann, 2000, pp. 245–63.

Tournier, Vincent. "Buddhas of the Past: South Asia". In *Brill's Encyclopedia of Buddhism*, Vol. II: Lives, eds. Jonathan Silk et al. Leiden: Brill, 2019, pp. 95–107.

Walker, Trent. "Echoes of a Sanskrit Past: Liturgical Curricula and the Pali *Uṇhissavijaya* in Cambodia". In *Katā Me Rakkhā, Katā Me Parittā: Protecting the Protective Texts and Manuscripts: Proceedings of the Second International Pali Studies Week (Paris 2016)*, ed. Claudio Cicuzza. Bangkok and Lumbini: Lumbini International Research Institute, 2018, pp. 55–134.

Wallis, Glenn. "Advayavajra's Instructions on the Adikarma". *Pacific World: Journal of the Institute of Buddhist Studies*, Third Series, no. 5, 2003: pp. 203–30.

Walters, Jonathan S. "Mahāyāna Theravāda and the Origins of the Mahāvihāra". *The Sri Lanka Journal of the Humanities* 23, no. 1–2, 1997: pp. 100–19.

Wessels-Mevissen, Corinna. *The Gods of the Directions in Ancient India: Origin and Early Development in Art and Literature (until c. l000 A.D.)*. Berlin: Dietrich Reimer Verlag, 2001.

Woodward, Hiram. "Bangkok Kingship: The Role of Sukhothai". *JSS* 103, 2015: pp. 183–97.

———. "Cambodian Images of Bhaiṣajyaguru". In *Khmer Bronzes: New Interpretations of the Past*, eds. Emma Bunker and Douglas Latchford. Chicago: Art Media Resources, 2011, pp. 497–502.

17TH- AND 18TH-CENTURY IMAGES OF THE BUDDHA FROM AYUTTHAYA AND LAN XANG AT ANGKOR WAT

Martin Polkinghorne

INTRODUCTION

Accomplished scholarship of Cambodian history after Angkor seeks to interrogate the established characterisation of the period as a time of absence, defeat, retreat and instability.[1] Traits that had defined the great Angkorian civilisation: enormous agro-urban cities, monumental stone architecture, landscape-scale infrastructure, specialised craft production, and epigraphy had diminished to a skerrick of their former significance. It is thought that at roughly the same time, members of the *sangha* travelling from the Khorat plateau introduced a form of Theravāda Buddhism. While the notion of decline at Angkor is contested, a more challenging task is filling the purported blank space of the Cambodian early modern period with knowledge about its material world.[2] New studies on material culture and texts, in addition to new themes of investigation, are recasting this period as complex and vibrant, and help to define the transformations of Cambodian Theravāda.

Many sources of knowledge regarding the emergence of Cambodian Theravāda in the early modern period remain unstudied. Examining the historical sources, which were composed centuries after the events they allege to recount and often sire factually unreliable information, has necessarily been the first task to appraise the Cambodian early modern period,[3] but a great deal of information also resides in its material culture. Significantly, the known historical narratives do not correspond with the material culture of the early modern period, and specifically, the sculptures of Angkor Wat. This chapter focuses on 17th- or 18th-century sculptures related to the present-day territories of Thailand and Laos found in the galleries of Angkor Wat. Historical research of this period is difficult because of the paucity and complexity of sources.[4] Art historical and archaeological studies are equally challenging.

In this enquiry it might be understandable to seek correspondence with known or recorded historical events, and yet this chapter is restrained in doing so without decisive evidence.[5] Nevertheless, I will attempt to elaborate the relevant historical contexts that demonstrate the continuous reverence of Angkor Wat as the most important site of Theravāda pilgrimage in mainland Southeast Asia. Moreover, the presence of 17th- and 18th-century foreign images from territories that were at times at war with the Cambodian polity, confirm that Angkor Wat operated as a supernatural authority with multifarious relationships to political developments. Although the donors cannot be specified, we might envisage that the *sangha*, other religious or lay people, or those with established regional kinship or political networks coordinated these initiatives.

When compared to classic period Angkor, Cambodia of the 17th and 18th centuries might be appraised as the recent past, but very little is known about its material culture. While there are some accomplished studies[6], the period has been the focus of relatively little cross-disciplinary research. Indispensible to new work is *Iconographie du Cambodge Post-Angkorien* by Madeleine Giteau[7], which remains the only formalist, methodical and published study of early modern Cambodian sculpture. Giteau was a gifted art historian who lived in Cambodia for nearly 20 years. When she declared it was "virtually impossible" to place the stylistic evolution of the early modern period sculptures on a time scale and acknowledged "that dating remains elusive and often tainted with

Fig 8.1 South gallery, Preah Pean, Angkor Wat. Left: Photographer unknown, 1906, Kerncollectie Fotografie, A319-73, courtesy Museum Volkenkunde. Right: Photograph by author, 2013.

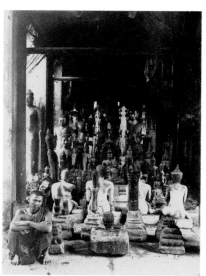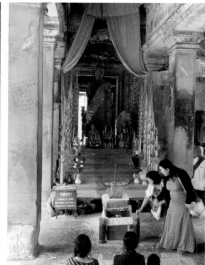

8.1

doubt"[8], we can begin to appreciate the difficulty of the task. The Buddhist sculptures of Angkor Wat provide a tightly defined sample offering new perspectives on Cambodia in the early modern period and of Cambodian Theravāda.

In approaching this issue, we need to ask how and why 17th- and 18th-century images from Ayutthaya or Lan Xang ended up in Angkor. Were the images transported from Central Thailand and Central Laos to Angkor Wat, or were they made at Angkor by non-local artists trained in the traditions of those cultures? On the last question, we might eventually apply the methods of material science to provide a definitive answer.[9]

WERE SCULPTURES IMPORTED INTO CAMBODIA?

One might propose the sculptures presented in this chapter are Cambodian productions inspired by one or a group of imported images from Thailand and Laos, or perhaps parallel artistic developments. Despite the marked increase in variation of styles that accompanied decentralised artistic production in early modern Cambodia, these sculptures are unique in iconography, morphology and proportionality when compared to those designated as Cambodian of the 17th and 18th centuries.[10]

That is not to say Cambodian artists were not influenced by external factors, but akin to their Angkorian ancestors, the early modern period artists could not faithfully reproduce another tradition without calling on their own stylistic traditions. Even when Angkorian artists deliberately copied older sculptures they used stylistic elements of their own time.[11] We cannot know the origin of the makers, but their training and artistic lineage belong to cultures beyond the borders of Cambodia.

DISCONNECTING THE DEMISE OF THE CAPITAL AT ANGKOR AND THE EMERGENCE OF THERAVĀDA

Early interpretations of the demise of the capital at Angkor positioned the emergence of Theravāda as an instrumental factor in the fragmentation of established socio-political structures. As studies of Cambodian Theravāda demonstrate parallel development rather than causal stimulus, international pilgrimage to Angkor Wat was not necessarily attached to geo-political relations.

Frequently cited syntheses present Theravāda as a grassroots, popularist movement. To several writers, Theravāda offered a kind of anti-aristocratic message that led to the dissolution of Brahmanical power structures and eventually the collapse of the empire.[12] Using historic examples from Burma, Indonesia, Thailand and Malaysia, Stanley J. Tambiah argued that the different categorical levels of Southeast Asian

societies, for example, politico-economic, territorial, administrative or cosmological were not necessarily bound to each other. Rather, the traits of centre-orientated and centrifugally fragmenting "galactic polities", sometimes referred to as a *maṇḍala*, provide the pervasive, but non-deterministic structure for the operation of premodern Southeast Asian civilisations.[13] Additionally, Richard A. O'Connor, in examining religious change in Thailand, concluded that historically evident transformations of religion were internal, and should take precedence over external ones.[14] Correspondingly, in the case of Angkor, there was not a deterministic link between socio-political structures and the cosmology of Brahmanism, Mahāyāna or Theravāda. Moreover, the emergence of Theravāda can be understood as an endogenous development and counterpart to the demise of Angkor as the capital, but not a contributing factor.

At Angkor, Saveros Pou reasoned that, in terms of the epigraphic vocabulary, the transition from Mahāyāna to Theravāda was relatively smooth.[15] The Khmer portion of an early 14th-century inscription demonstrates an example of continuity in the royal and religious patronage structure. Just as kings and nobles attached their names to funding temples and images of the gods during the Angkorian period, the inscription of Prasat Kombot tells how the king sponsored the construction of a Buddha image and advanced the career of a senior member of the *saṅgha*.[16] How this transition was manifested in the material world was likely to be different, and Ashley Thompson has described the transformation of monumental Brahmanical architecture into spaces of Cambodian Theravāda devotion.[17] As it is often incorrect to attribute architecture, images, epigraphic declarations, or religious practices to any single religious orthodoxy, an emerging Cambodian Theravāda was not exclusive, and the key to its triumph may well have resided in underlying indigenous belief systems.[18]

As research about the demise of the capital at Angkor progresses,[19] the early 15th-century Ayutthayan occupation at the site might be recast as epilogue rather than catalyst. Furthermore, evidence of pilgrimage and donation possibly from the occupying force illustrate the inextricability of political sovereignty and religious veneration at Angkor Wat. Ayutthaya occupied Angkor from 1431/32 for a period of between 12 and 15 years.[20] At roughly the same time, the movement of the Angkorian elite evidenced in the relevant Cambodian and Thai chronicles might be associated with an array of contributing factors: intense monsoons and mega-droughts in the 14th and 15th centuries,[21] unsustainable modes of habitation and subsistence,[22] an over commitment to massive infrastructure,[23] or integration with an emerging China–Southeast Asia trading network.[24]

The significance and character of the Ayutthayan occupation is not yet fully understood, but accompanying the military force were artists trained

in the early Ayutthayan tradition who left behind at least 50 characteristic Ayutthayan images.[25] It is with caution that a finite group of sculptures is linked to a contested historical event, however these statues are the first extraterritorial images identified at Angkor through the combination of archaeology, art history and material science. In this case, the union of material culture and the Ayutthayan occupation is feasible and logical. It is therefore possible to consider ten images of the Buddha in *māravijaya* at Angkor Wat to have comprised offerings of the famed 1431/32 conquerors that were also pilgrims of Theravāda.

After disconnecting the demise of Angkor as the capital and Theravāda, the many Buddhist images curated by the monastic community of Angkor Wat are representative of a social and religious world that was not bound to known historical narratives. Within the Cambodian early modern period "rhetoric of loss and recovery",[26] the theme of international pilgrimage[27] can be supplemented with new material evidence. We can observe Theravāda at Angkor Wat in the 17th and 18th centuries through sculptures donated to the temple and produced by artists trained in present-day Laos and Thailand.

THE ANGKOR WAT BUDDHAS

The colonial narrative proposed that Angkor Wat was lost to the jungle.[28] But we know it remained in continuous use from the moment of its inauguration in the 12th century. Perhaps from around the early to mid 16th century, Angkor Wat became a repository of Cambodian Buddhist sculpture without equal, and correspondingly now offers a representative record of Cambodian Buddhism from the ninth century until the present day. Angkor Wat hosted hundreds of images of the Buddha donated by Cambodian and Asian pilgrims. Many were removed; some for safekeeping during periods of civil unrest, a selection for display in Cambodian museums, and an unknown number were lost to looting. Numerous Buddha images retain their sacred importance and are revered today. The majority of these images are different combinations of stone, wood, stucco and lacquer. Critically, the statues demonstrate that Angkor Wat was the focus of pilgrimage and restoration to accumulate merit and authority within Cambodian and other Southeast Asian Theravāda belief systems.[29]

The earliest textual evidence of Angkor Wat as a vehicle for securing merit and as sacred repository comes in an inscription dated paleographically to the first half of the 16th century.[30] However, it may be possible to consider that donations to the temple were meritorious from the early 15th century, as evidenced by early Ayutthayan images carved at Angkor.[31] The specific focus of the donations was Preah Pean, or the Hall of a Thousand Buddhas, already known by that toponym in the 1600s

(Figs. 8.1 & 8.2).[32] Over 15 inscriptions declare that images of the Buddha were donated, commissioned or restored in the temple precinct.[33] One text tells of six pious commoners who created, commissioned or restored 19 statues of the Buddha[34] The proliferation of images also continued at Bakan, the third and highest terrace of the monument. Connecting the pious works mentioned in the epigraphy to specific images or temple renovations is challenging, and perhaps unachievable. Nevertheless, this chapter will outline the relevant historical framework and present known events as opportunities for donation of the sculptures.

When colonial savants visited the site for the first time in the 1860s they found Angkor Wat, and in particular the southern gallery of the second stage occupied by hundreds of Buddha images (Fig. 8.1). It was, and continues as, a living monument dedicated to the Buddha, spirits and gods embodied in architecture, statues and symbols. Étienne Aymonier, visiting the site in the 1870s, reported that sculptures were piled on the floor without order.[35] The quantity and variety of images were incoherent to foreign and uninitiated eyes. However, in a monument as important and multifaceted as Angkor Wat, there is little doubt there was some pattern to the emplacement of images. Appraising the spatial rationale of images is a considerable task, but documenting the number and characteristics of each is the first undertaking.

From the beginning of the École Française d'Extreme-Orient (EFEO) interventions, Angkor Wat was the focus of restoration and research and the first task of its first conservator was to clear the temple of vegetation.[36] As Angkor Wat emerged onto the tourist route, unknown quantities and undocumented sculptures were plundered by souvenir hunters and looters.[37] Twenty years passed, and in 1928 conservator Henri Marchal recognised the need to protect the images by creating an inventory of the major pieces and relocating selected images to Bakan (the uppermost terrace of Angkor Wat) and the Angkor Conservation Depot in Siem Reap.[38] Additional sculptures were removed to the Depot for restoration and protection in the late 1960s and early 1970s under the direction of the EFEO as war descended upon Cambodia.[39]

During the civil conflicts of the 20th century many images were sold, some were burnt for firewood[40], and others buried on the grounds of Angkor Wat. A selection was later excavated in the late 1980s and recent work by the Authority for the Protection and Safeguarding of Angkor and the Region of Angkor (APSARA) discovered more than 100 Buddha images thought to have been buried during the 1960s or 1970s,[41] though rumours persist that many remain under the ground south of the central complex.[42] Successive photographic images taken between the late 19th century and mid 20th century illustrate the diminishing corpus of sculptures from this sacred repository. A final inventory was conducted by

the Angkor Conservation in 1993 to appraise the extent of the wartime pillage. Of the many hundreds of images that once called Angkor Wat home, only 37 were recorded in situ. Nonetheless, by assembling data from EFEO photographic archives, and a UNESCO-sponsored inventory of the Angkor Conservation conducted in the early 2000s, we can identify over 300 Buddhist sculptures originating from Angkor Wat. Additional 20th-century photographs and supplementary EFEO and UNESCO archives suggest there may be over 100 additional Buddhist sculptures attributable to Angkor Wat, but presently they cannot be cross-referenced. A small fraction of the Angkor Wat Buddha images were made in territories, or by artists trained beyond the borders of Cambodia. Because of the relative ease in their identification, three specific images are the focus of this chapter, and demonstrate the role of Angkor Wat amongst regional Theravāda communities.

PILGRIMAGE AT ANGKOR WAT

With roots in the oldest Pāli text, the *Mahāparinibbānasutta* of the *Dīghanikāya*, the Buddha sanctified four great biographical sites – his birthplace, the site of his enlightenment, the site of his first sermon, and the site of his *nirvāṇa* as places to visit that lead to attainment of happiness in heaven. When the Buddha entered *parinirvāṇa* his relics were enshrined within a series of *stūpa* that also became sites of pilgrimage.[43] Among the most famed of the pilgrimage sites was

Fig. 8.2 Late Ayutthayan image (cat#1) at south gallery, Preah Pean, Angkor Wat, terminus ante quem for photograph is 1928, Photographer unknown, Cliché EFEO, Fonds Cambodge, réf. EFEO_CAM04249.

8.2

Jetavana, the monastery in Śrāvastī, India, where the Lord Buddha spent 19 rainy season retreats.

The name Jetavana is used to designate Angkor Wat in a late 16th-century inscription from Phnom Kulen,[44] in a 17th-century Japanese diagram of the temple,[45] and in the Nong fragment of the Royal Cambodian Chronicles.[46] Correspondingly, Thompson argued that the inscriptions known as *satyapranidhāna*, or vows of truth, that adorn the pillars of Bakan and Preah Pean designate Angkor Wat as an international pilgrimage centre, with a spiritual value equal to that of Jetavana.[47] Inscriptions dating between the 16th and 18th centuries establish Angkor Wat as the destination for pilgrims who attained Buddhist merit by reciting and recording their *satyapranidhāna*. The epigraphy attests to the donation of sculptures, materials for their creation, and dutiful maintenance as habitual acts of honouring deities, ancestors and royalty.[48] Accordingly, I have catalogued over 300 images of the Buddha curated in the halls of Bakan and Preah Pean as acts of pilgrimage and acquiring merit.

Evidently the significance of Angkor and Angkor Wat was recognised throughout the region as an ongoing destination for pilgrims seeking merit. In the material sense, Angkor Wat was the terminus for transported, commissioned, or donated images of the Buddha. A series of 17th- and 18th-century images made by artists trained in Thailand and Laos, are testament to the international significance of Angkor Wat throughout the early modern period (Figs. 8.3 & 8.5, Table 8.1). There is little systematic research on the sculpture of mainland Southeast Asian during this period. The scarcity of studies on early modern Cambodian sculpture is evident across the region.

LATE AYUTTHAYAN IMAGES AT PREAH PEAN

Two nearly complete images of the Buddha in the Ayutthayan style date to the late 17th or 18th century (Figs. 8.2 & 8.3, Table 8.1). Three additional images may also be of this style, but they are without heads, and with significant evidence of restoration, their identification and dating can only be tentative.[49] One image (Cat. No. 1, Table 8.1) can be placed in the southern gallery of Preah Pean as captured in several early EFEO photographs (Fig. 8.2).[50] This gallery was the focus of worship for Theravāda devotees at Angkor Wat. The surfaces of its columns retain most of the early modern inscriptions. And logically the space accommodated the most revered and important sculptures of the Buddha, including a late Ayutthayan Buddha.

The sculptures depict the Buddha in the pose of double *abhayamudrā* with both hands raised in front of the chest, elbows bent

and palms facing forward. Etic interpretation suggests this *mudrā* signifies the absence of fear.[51] Although the arms no longer survive, the *mudrā* is distinguished from alternative models illustrating arms at the sides, or a hand across the chest, by the absence of remnants these elements would have left on the sculptures' robe or body. The sculptures are made of wood with various combinations of coverings in lacquer, gilding and other polychromatic coatings.

This image type is characterised by an oval face with a protruding and arched monobrow. The contours of the semi-closed eyelids are incised. The image possesses a short and pointed nose. Fleshy mouths are raised at the corners to form smiles. Pierced earlobes are detached from the head and are distended with turned-up ends. Where extant, two incised pleats appear at the bottom of the neck. Prominent points represent the Buddha's hair. The image was crowned by a long *uṣṇīṣa* in the form of a flame of wisdom. Unfortunately, the *uṣṇīṣa* disappeared sometime before Marchal's inventory of 1928. The sculpture's shoulders are straight and square, with pectoral muscles in relief, overlaid with marked nipples. The waist is slender with a slightly protuberant belly. The *uttarā saṅgha* (Mod. Kh. *cībar*) covers both shoulders. It is lined with a smooth strip, and flares at the bottom to form a curved, distinctive point. The *antaravāsa* (Mod. Kh. *span*) is worn tight on the hips, and the central vertical pleats are stylised into a narrow band superimposed on a wider strip.

Fig. 8.3 Standing Buddhas in *abhayamudrā*, c. late 17th or 18th century, Angkor Wat. Wood, lacquer, polychromy, inlay. See Table 8.1. *Left*: cat#1, Cliché EFEO, Fonds Cambodge, réf. EFEO_CAM19612_1, courtesy EFEO; *right*: cat#2, cliché EFEO, EFEO_CAM19832_3.

Fig. 8.4 Standing Buddhas in *abhayamudrā*, c. late 17th or 18th century, Chantharakasem National Museum (Ayutthaya). Wood, lacquer, polychromy, gilding, inlay. Photographs by author, with the permission of Chantharakasem National Museum (Ayutthaya).

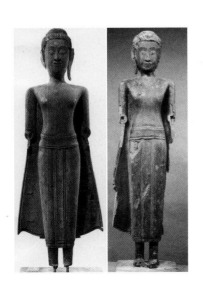

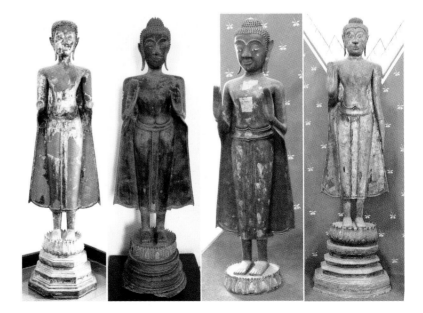

8.3

8.4

The combination of iconography, proportional morphology, and quality of carving of these images at Angkor Wat are so close to examples from Ayutthaya that I propose they are 17th- or 18th-century works made by artists trained in the territories of Ayutthaya. Fruitful comparisons can be made of the Angkor Wat images with a small corpus of wooden sculptures from the Chantharakasem National Museum in Ayutthaya (Fig. 8.4). In these images we see austere representations of the Buddha that are differentiated from types in the Narai period that are crowned, wear royal attire, and have florid and complex decoration.[52] The images may have a stronger connection with the early Bangkok style and fall into a category of late Ayutthayan art tentatively described by Hiram Woodward as "an alternative ideal".

A specific diagnostic aspect of this small corpus of sculptures are their belts (Mod. Kh. *uttakhut*). All belts form points at their centre and are composed of a strip of fabric superimposed on a wider strip. This precise form of belt is common in the sculpture of Thailand, and is observed in Lao sculpture, but is unknown in the sculpture of Cambodia.[53] Woodward recognises the origin of this type of belt on an image of a standing Buddha at Wat Song Phi Nong, Chainat province, dating to the second half of the 1300s.[54] It is likely that this image had stylistic roots in the earlier Khmer images of Lopburi.[55] We see the characteristic pointed

Cat#	Description	DCA Inventory #	NMC Inventory #	Location	Dimensions	Principal material	Photo credit
1	Standing Buddha in *abhayamudrā*	2168, 1314		DCA	164 x 58 x 17 cm	wood	cliché EFEO: EFEO_CAM19612_1, EFEO_CAM19612_2; cliché UNESCO DCA: CL21-210
2	Standing Buddha in *abhayamudrā*	48, 6978(?), 1341(?)	C.A.131	ANM	104 x 21 x 11 cm	wood	EFEO_CAM19832_3, EFEO_CAM19832_4
3	Seated Buddha in *māravijaya*		Ga.5421 (E.297), Ga.3376.1 (E.297D), Ga.3376.2 (E.297E), Ga.3376.3 (E.297C)	NMC	105 x 45 x 35 cm (approx)	copper-based alloy	cliché NMC

Table 8.1: Catalogue of late Ayutthayan and Lan Xang Buddhas at Angkor Wat

belt on numerous sculptures from Lopburi that are also decorated[56], and also Ayutthayan images from the 1300s[57], including stucco representations at Wat Ratchaburana.[58]

In every aesthetic aspect, especially demonstrated by the belt, the images from the Chantharakasem National Museum closely parallel those at Angkor Wat and make a likely date for pilgrimage and donation to be the late 17th or 18th century.

A LAN XANG BUDDHA AND THE SMALL *CHEDEI*

A mid 17th- to early 18th-century Lao image of the Buddha (Figs. 8.5, 8.8 [*left*], & 8.9 [*left*]) offers another aspect of reverence and memorialisation at Angkor Wat, in that it was not donated to Preah Pean or Bakan, but was interred as the sacred deposit of a small *stūpa* abutted next to the temple's famed bas-reliefs.

On 9 December 1919, under the direction of Marchal, excavation of a slight elevation of land south of the north staircase of the west gallery of

Fig. 8.5 Seated Buddha in *māravijaya*, late 17th or 18th century, Angkor Wat. Copper-base alloy. Cat# 3, see Table 8.1. NMC Inventory Numbers: Ga.5421 (E.297), Ga.3376.1 (E.297D), Ga.3376.2 (E.297E), Ga.3376.3 (E.297C). Photographs courtesy National Museum of Cambodia.

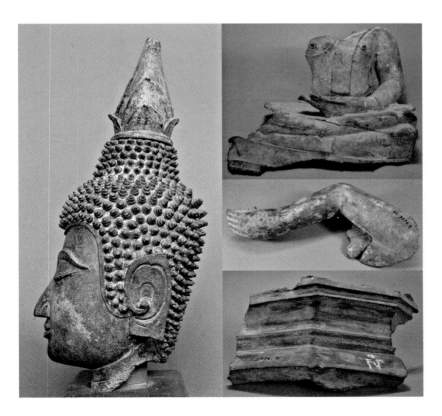

Angkor Wat revealed a square pit (six by six metres) bordered by sandstone blocks re-used from the temple (Fig. 8.6). Inside the pit Marchal found the sandstone hand of a divinity holding a lotus and a small bronze bell. After another two days of excavation debris of a bronze Buddha was recovered accompanied by bronze and earthenware bowls, pots, vases and fragments of bones. This site and Buddha was of little interest to Marchal who recognised it as the former location of a small *stūpa* or *chedei* as the Pāli term *cetiya* is pronounced in Khmer.[59]

The image illustrates the Buddha in *māravijaya*. Rendered in bronze, it survives in five pieces at the National Museum of Cambodia, which obtained the image in 1921. The image is replete with monastic robes, and an associated scarf (Mod. Kh. *saṅghāṭī*) with a flat hemline. The Buddha has an oval face, arched eyebrows, semi-closed eyes, a broad, triangular and slightly hooked nose resembling a beak, and smiling lips that are all incised. Even though the sculpture has been broken at the neck we can still observe furrows, typically associated with an ideal of beauty. The hair is characterised by many small round and prominent curls, each of which come to a point and is separated from the forehead by a narrow band. Limbs are fleshy and digits are elongated, with legs in the half-lotus position.

The iconography, morphology and quality of carving distinguish this image as made by an artist trained in Laos from the middle of the 17th to the beginning of the 18th century. A suite of diagnostic features demonstrates a Lao origin and these can be distinguished from other types associated with Khmer and Thai influences such as the Prah Bang and Walking Buddhas. A regional style concentrated around Vientiane is

Fig. 8.6 Rectangular brick foundation of *chedei*, find spot of Lan Xang Buddha in *māravijaya*, west of the western bas-relief gallery, Angkor Wat. Image by Henri Marchal, JFCA, 2, December 1918–February 1921: 116, image courtesy EFEO.

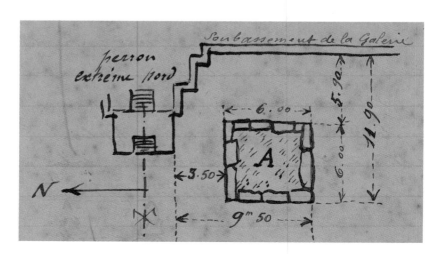

typically rendered in bronze and includes highly stylised *uṣṇīṣa*, ears, eyes, hair curls, appendages and pedestals. Giteau describes these images as presenting an "extreme stylisation" of facial features, with rigid bodies, straight limbs and exaggerated fingers.[60] Similarly, when defining the images of Lan Xang, Woodward observes an outward movement of facial features resulting in a "kind of angular individuality".[61]

It is impossible to know the ethnicity of the artist, though comparative materials analysis could eventually determine the location of the sculpture's manufacture. The detachable *uṣṇīṣa* is characterised by a flame of wisdom in the form of elongated lotus petals at its summit. The ears are extremely stylised. The helix is marked in relief and curls around to form the tragus situated in front of the ear canal.[62] According to Giteau this characteristic seldom appeared before the 18th century.[63] The nipples are in strong relief despite being covered by monastic robes. Pedestals of Lao Buddhas in the 17th and 18th centuries are unique. Each level or gradation of the dais terminates in distinctive stylised lotus petals that point and curve outwards.[64] The eyes frequently preserve inlays of silver, black stone and mother-of-pearl,[65] however without additional conservation or scientific analysis these materials have not been observed in the image from Angkor Wat.

Images with near identical characteristics to those listed above can be found in the pagoda collections of Vientiane (Fig. 8.7). We are fortunate that some of these images are dated by inscriptions that record their donation. For example, Buddha no. 7 from Wat Phra Keo was cast in 1706 (Fig. 8.7 [*right*]).[66] The image from Angkor Wat is so similar to Buddhas no. 8 and no. 12 from Wat Phra Keo[67] that one can propose it was produced by the same artist or workshop (Figs. 8.7 [*left*], 8.8 & 8.9). Alternatively, Lao artists of the mid 17th to early 18th centuries followed prescriptive models on an unparalleled level that rendered standardised images almost indistinguishable from each other.

A DONATION TO *NAGAR HLUOṄ*?

Once we have identified two wooden and lacquered images at Angkor Wat as late 17th- or 18th-century products of sculptors trained in Ayutthaya, we need to ask how they were donated to the temple. In early modern Cambodia Mak Phoeun has demonstrated the symbolic and tangible consequences of the creation, movement and destruction of sculptures.[68] The demolition and disappearance of the Braḥ Buddh Tralaeṅ Kaeṅ (installed at Wat Trâleng Kèng) and the Braḥ Buddh Kāyasiddhi (installed at Wat Preah In Tép), facilitated by two imposter monks who infiltrated the Cambodian court, is said to have precipitated the fall of Longvek.[69] Similarly, the capture of another two images and their spirits during the

same invasion, the brothers Preah Kô and Preah Keo, is thought to explain Cambodian cultural rupture at the hands of its neighbours.[70]

We may never know who offered the late Ayutthayan sculptures to Angkor Wat, and cannot ascribe the images to historical events without appropriate justification. There are numerous episodes of co-operation and conflict between Cambodian and Thai polities in the early modern period, but none of them provides sufficient evidence of a donation to Angkor Wat. Various historical events may provide the context within which the donations were made.

Angkor Wat and Angkor were consistently revered and visited by pilgrims from Ayutthaya. It may have hosted Ayutthayan pilgrims as part of an occupying force as early as the 15th century.[71] Angkor was recorded in the Royal Ayutthayan Chronicles as *nagar hluoň*, "the capital".[72] In the 16th century a pair of inscriptions,[73] one attached to an image of the

Fig. 8.7 Seated Buddha in *māravijaya*, Wat Phra Keo, Vientiane, Laos, Copper-base alloy. Buddha no. 12 (Giteau 1969 enumeration), late 17th to 18th centuries. Photograph by author, with the permission of Ho Prakeo Museum, 2004.

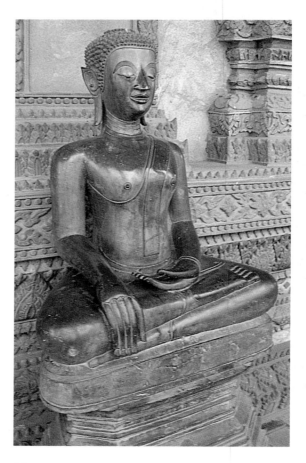

8.7

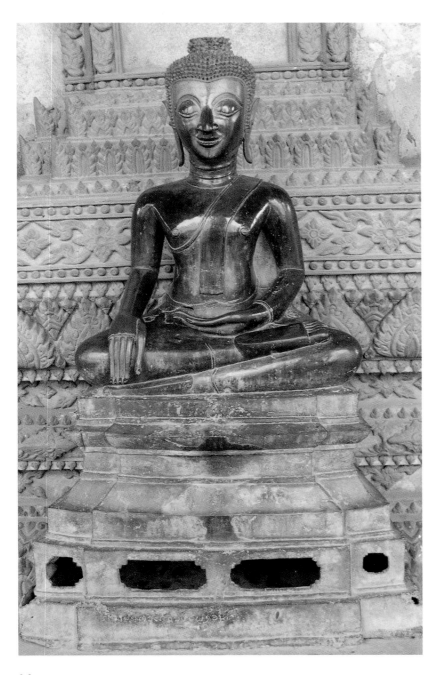

Fig. 8.8 Seated Buddha in *māravijaya*, Wat Phra Keo, Vientiane, Laos, Copper-base alloy. Buddha no. 7 (Giteau 1969 enumeration), inscription date: 1706. Photograph by author, with the permission of Ho Prakeo Museum, 2004.

Buddha, record the pious deeds accomplished in Cambodia by a monk who is presumed to be Ayutthayan. In 1583, after restoring images of the Buddha at Oudong, the monk restored 26 statues of the Buddha at Phnom Bakheng.[74] Without identifying its missing head, an attribution remains tentative, but the stylistic features of the Buddha in *dhyānamudrā* of *K. 465* suggests it was crafted in Angkor by a Cambodian artist.[75] Another inscription,[76] dated palaeographically to the same time, might recall the deeds of the same monk from Ayutthaya, visiting Phnom Kulen.[77] At the end of the 16th and beginning of the 17th centuries, awareness of Angkor's splendour flourished in the court of Ayutthaya where a division of the Khmer royal family were kept hostage after the capture of Longvek. A few years later, the instigator of this invasion, King Naresuan (r. 1590–1605), sent the Cambodian Prince, Soriyopoar (r. 1601–1618) to reign over Cambodia.[78] Ayutthayan attitudes to Angkor in the 17th century might also be represented by the That Phanom chronicle and the sculptures deposited at Phra That Phanom, Nakhon Phanom. According to Woodward, in the accompanying text, *Urāṅganidāna* ("Tale of the Breastbone"), the names of kings allude to the Angkorian period.[79] Although the interment date of the deposit is unclear we note at least ten votive tablets of the most common Mahāyāna Cambodian images reproduced during the late 12th and early 13th centuries at Angkor, that is the *nāga*-protected Buddha flanked by Avalokiteśvara and Prajñāpāramitā.[80]

The first potential pretender for donation as recorded by historical documentation is detailed in an episode of the 19th-century Royal Autograph version of the Ayutthayan Chronicles. In 1631/32, King

Fig. 8.9 *Left*: Head of Lan Xang Buddha at Angkor Wat, late 17th or 18th century, close-up of Fig. 9.5. Copper-base alloy. Cat# 3, see Table 8.1. NMC Inventory Number: Ga.5421 (E.297). Photograph courtesy National Museum of Cambodia. *Right*: Head of Buddha no. 12 (Giteau 1969 enumeration), close-up of left image in Fig. 8.7, Wat Phra Keo, Vientiane, late 17th to early 18th centuries, Photograph by author, with the permission of Ho Prakeo Museum, 2004.

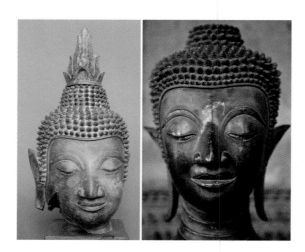

8.9

Prasat Thong (r. 1629–1656) purportedly sent architects to make plans of Angkor and the capital of Cambodia.[81] When Prasat Thong's architects returned to Ayutthaya, they are said to have built Wat Chaiwatthanaram and Prasat Nakhon Luang as copies of Angkor Wat. Although the form of these monuments may be considered an independent development of Thai architectural styles, rather than Angkorian facsimiles,[82] we might speculate that the reverent pilgrimage of architects from Ayutthaya included the donation of Buddhist sculptures.

Interaction between Siam and Cambodia was constant during the 1700s. During the first half of the 18th century Ayutthaya habitually supported Cambodian princes in internal struggles with their rivals who depended on Vietnamese support.[83] However, a good candidate for the donation might be Dhammarāja (r. 1738–1749), who had spent much of his life in Ayutthaya because of opposition to another Cambodian prince, Ang Em. An inscription dated 1747 at Preah Pean[84] recounts the return of Dhammarāja from Thailand and also his visit to Angkor Wat. The narrator, an official of Dhammarāja, notes the recitation of prayers associated with memorial services for the dead.[85] The official does not specify the donation of sculptures during his pilgrimage, or that of his king, but the date accords with the stylistic appraisal of the late Ayutthayan Buddhas. Significantly, this inscription demonstrated the continuous regional importance of Angkor Wat as an agent for accruing merit.

In spite of the Burmese defeat in 1767, the post-Ayutthayan Siamese state maintained influence in Cambodia. Recorded in the Moura chronicle of 1883, the third son of the last Ayutthayan king is thought to have sought refuge in Cambodia after fleeing the Burmese invasion.[86] The

Fig. 8.10 *Left*: Ear of Lan Xang Buddha at Angkor Wat, late 17th or 18th century, close-up of Fig. 9.5. Copper-base alloy. Cat# 3, see Table 8.1. NMC Inventory Number: Ga.5421 (E.297). Photograph courtesy National Museum of Cambodia. *Right*: Head of Buddha no. 12 (Giteau 1969 enumeration), Wat Phra Keo, Vientiane, late 17th to early 18th centuries. Photograph by author, with the permission of Ho Prakeo Museum, 2004.

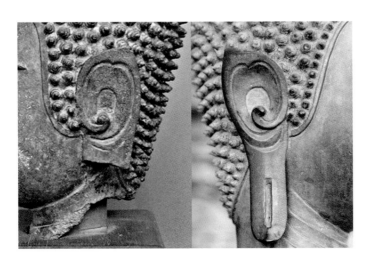

8.10

ascendency of Taksin (r. 1767–1782) in Siam may have also provided
opportunities for pilgrimage. As Taksin attempted to access the southern
ports of the mainland through Cambodia and Vietnam, he supported
prince Ang Non (r. 1775) who eventually became king in Cambodia for a
very short period.[87] There may also be a case for the donation during the
1790s when the province of Siem Reap, along with Battambang, was
administered by Viceroy Ben, who owed his allegiance to the Thai court.[88]
During this period it is easy to imagine freedom of travel between the
regions that facilitated the movement of sculptures and artists.

A COMMUNITY OF LAOTIANS: FROM BATI TO ANGKOR WAT?

The presence of the Lao Buddha alongside other objects including
human bone suggests this interment was a *chedei* dedicated to an
individual, memorialised in a modest monument terminus post quem
the mid 1600s. Using the Buddha as a guide, this is the earliest date
possible for construction of the *chedei*. A later construction is possible if
the Buddha was recognised as an antique and correspondingly revered as
a living image.[89]

Numerous examples of *stūpa* are known in Angkor. However, it is in
the early modern period that *stūpa* become a customary feature of the
architectural landscape. In the conventional monastery configuration, the
principal *stūpa* is built behind the *vihāra,* in the western part of the court.
Whereas the term *stūpa* in modern Cambodia designates a monument
commemorating an event, *chedei* (*cetiya*) unequivocally designates
funerary monuments.[90] Less important *chedei* are built within the
enclosure of the Wat to shelter and commemorate relics of monks, or
ashes of family members. Thompson demonstrates that Angkor Wat was
probably transformed from temple to *stūpa* in the 16th century.[91] Also at
Angkor Wat, the large laterite, sandstone and stucco *chedei* at the foot of
the eastern bas-relief gallery is the most visible symbol of early modern
period continuity. This structure is likely associated with an inscription[92]
in the adjacent eastern *gopura*, famed as the first known example of
Cambodian poetry, and dated to the turn of the 18th century.[93]

What is the origin of the small *chedei* precisely on the opposite side of
the temple and its Lao Buddha? As we might expect, the kingdoms of
Laos feature prominently in the history of Cambodia. Although the
legendary foundation of Lan Xang by an individual known as Fa Ngum
claiming Khmer descent might be interrogated with scepticism[94], the
kingdom's inaugural palladium known as the Phra Bang Buddha feasibly
concurs with a mid 14th-century date.[95] In the early modern period, Laos
is said to have attempted an attack on Cambodia in 1571[96], and after the

fall of Longvek in 1594, King Satha (r. 1579–1595) and his queen and sons sought refuge in Vientiane.[97]

Several historical records specify a possible background for the exchange of sculptures. In 1641 a representative of the Dutch East India Company, noted that Cambodian monks seeking instruction spent ten to twelve years in Laos.[98] Similarly, in 1668, the first Frenchman likely to have visited Angkor Wat, Louis Chevreuil, noted that the temple was famed amongst five or six great kingdoms, receiving habitual pilgrims from both Laos and Siam, even in times of war.[99]

A late 17th- and early 18th-century community of Laotians living in Cambodia provides the most promising speculative explanation for the Lao Buddha of Angkor Wat. As the Lao kingdoms fragmented at the turn of the 18th century, conflict between the polities of Luang Prabang and Vientiane led Lao refugees to Cambodia. According to the chronicle manuscript P57 *(brah rāj baṅsāvatar)* 2,800 soldiers and their families, commanded by the *uparāj* of the king of Vientiane, were granted sanctuary by King Ang Saur (Chey Chettha III) (various r. 1677–1709). In his benevolence Ang Saur is said to have offered land and dwellings to the Lao in the province of Bati, south of present-day Phnom Penh.[100]

In the 17th or 18th century, a dedicatory inscription[101] at Angkor Wat records the pilgrimage of an official and his wife from the village of Srama Khmaer Bān of Brai Krapās, Bati province. The pilgrims acquired merit in the name of their parents at Angkor Wat by restoring or building nine towers, 17 statues of the Buddha, and planting holy trees. Significantly, the pilgrims' parents are declared as being below the earth.[102] Does this inscription record pilgrims from Bati who interred the Lao Buddha into the *chedei* next to the bas-reliefs of Angkor Wat?

The term *sāṅ*, translated as "restore" or "build", is not clear in the context of early modern inscriptions. The word is used in a number of inscriptions to describe meritorious restoration and it might be applied to all good works including the creation of new Buddhist images, or perhaps even the reciting of sacred texts.[103] It seems improbable that pilgrims from Bati province could command the necessary resources or expertise to rebuild the towers of Angkor Wat in the 1700s. Furthermore, there is no material evidence of structural amendments to the temple's towers at this time. However, the testimony of the pilgrims' parents in the earth (Mid. Kh. *phdaiy kromm*), may refer to the interment of bones, and provides a hypothetical link to the fragments of bones found within the *chedei*.

Perhaps the association of refugees from Vientiane, the Lao Buddha, bone fragments in the *chedei* and pilgrims from Bati is a coincidence. While the identity of the donors remains obscure, it is clear this is an image made by Lao artists and testament to the ever-unfolding history and significance of Angkor Wat.

IMPLICATIONS AND CONCLUSIONS

The Buddhas of Angkor Wat are yet to tell all of their stories. It may be ambitious to correlate sculptures with known or recorded historical events but archaeology, art history and material science can define the detail and magnitude of cultural transformations not known from texts.

While Angkor Wat is purported to have become a beacon of regional activity from the early to mid 16th century, this date is based on limited information. There are nine inscriptions from the 1500s,[104] and perhaps only two can be dated to its first half.[105] The testimony of the Portuguese missionary, Gaspar da Cruz, who links a Cambodian king (probably Ang Chan I, r. 1516/17 or 1526–1566) to the site,[106] and the inscribed completion of the northeast bas-reliefs,[107] has arguably weighted the emphasis in favour of a 16th-century reoccupation. On the other hand, there are 29 inscriptions at Angkor Wat in the 1700s,[108] 17 of which can be dated to the second quarter of that century.[109] Recent absolute radiocarbon dating of stratified archaeological deposits from mounds in Angkor Wat's southeast quadrant indicate consistent occupation from the 14th or early 15th centuries to the 17th or 18th centuries.[110] Similarly, absolute dates and palaeoenvironmental proxies from inside Angkor Thom suggest limited forms of occupation there until the 17th century.[111] Nevertheless, with this information alone it is difficult to ascribe a date to Angkor Wat's re-emergence as a regional centre of Theravāda.

New evidence can eventually be extracted from nuanced understandings of the so-called Buddhist terraces. A tentative chronology would see the emergence of Theravāda and establishment of the terraces in the late 13th century evidenced by radiocarbon dating of possible *vihāra* or *uposathāgāra* pillar remains at Western Prasat Top,[112] and the construction layers of the Duṃnap Tūc embankment Buddhist terrace.[113] This was followed by continued activity at the Buddhist terraces at least until a probable contraction in the mid to late 1400s corresponding with the demise of the capital at Angkor (Sato, Chapter 6). Additional excavation may be able to date when activity ceased at the terraces. Despite the significant 16th-century inscriptions we do not know precisely how much of Angkor Wat's Buddhist statuary comes from the terraces of central and greater Angkor, and when such Buddhist sculptures would have been collected from the terraces and curated by the residing monastic community at Preah Pean and Bakan.

The continuity and chronology of Cambodian and mainland Southeast Asian sculpture from the 16th century requires considerably more research. Whereas at Angkor, most artistic production was attached to the court,[114] during the early modern period artists were not necessarily bound by institutional control. Fragmentation of established power

structures and decentralisation of artistic production led to a greater variation in artistic styles. Additionally, when the idea of individual Theravāda merit was entangled with artistic production, the commission of images was often made on an ad hoc basis.

I have identified over 300 documented images that can be linked to Angkor Wat, and future study can refine the spatial distribution or curatorial logic of their emplacement. In addition to new art historical analyses, collaborations with material scientists can consider the fabric of the Angkor Wat Buddhas. For example, lacquer is an unstudied material at Angkor, and has considerable potential for new discoveries, including absolute radiocarbon dating. A kind of lacquer mentioned in epigraphy as early as the tenth century,[115] known as *khmuk* (Mid. Kh. *kmuk*), was an essential material of early modern period merit-making restoration.[116] An inscription at Angkor Wat[117] reiterates the use of *khmuk* (a mixture of oleoresin and ash) in renovation and notes the inclusion of the donor's hair in its manufacture, forever binding herself to the restorative action.[118] Wood, the primary material of early modern period images is also insufficiently studied. Whilst anecdotal evidence suggests artists privileged a range of high-quality woods including *Fagraea fragrans* Roxb. (Mod. Kh. *Tatrav'*), *Sindora siamensis* Miq. (Mod. Kh. *Kakoḥ*) and *Hopea odorata* Roxb. (Mod. Kh. *Koki*),[119] species identification has not been conducted.

Materials analysis might interrogate models of restoration in Cambodian Theravāda sculpture. Though conventional interpretations suggest merit is acquired by commissioning the restorative act, another mode of memorial might be a staged abandonment consistent with the Buddhist necessity to realise impermanence. Wilful neglect is observed in contemporary Cambodian pagodas as an act of positive commemoration[120], and may also elucidate early modern Theravāda practice at Angkor. To what extent were images at Angkor Wat restored and others left to degrade?

In this chapter I have appraised the transcendence of Angkor Wat as a pilgrimage destination for Theravāda devotees through donation of images from Ayutthaya and Lan Xang. In doing so, I acknowledge the complexity of associating sculptures with specific historical events. Nevertheless, imported images of the Buddha from beyond the territories of Cambodia can clearly be considered agents of international relations. Identification of 17th- and 18th-century sculptures continues to recover the post-Angkorian history of Angkor Wat from exclusive textual interpretations framed in terms of decline, opens a path for research on Southeast Asian trans-border material culture, and locates Cambodia firmly within the context of regional and global history at the birth of the modern world.

Notes

1 Ashley Thompson, "The Ancestral Cult in Transition: Reflections on Spatial Organization of Cambodia's early Theravada Complex", in *Southeast Asian Archaeology: Proceedings of the 6th International Conference of the European Association of Southeast Asian Archaeologists, 2–6 September, Leiden.* eds. Marijke J. Klokke and Thomas de Brujin, Hull: Centre for Southeast Asian Studies, 1998, pp. 273–95. Ashley Thompson, "Introductory Remarks between the Lines: Writing Histories of Middle Cambodia", in *Other Pasts: Women, Gender and History in Early Modern Southeast Asia*, Honolulu Center for Southeast Asian Studies, University of Hawai'i, 2000, pp. 47–68. Ashley Thompson, "Pilgrims to Angkor: A Buddhist 'Cosmopolis' in Southeast Asia?", *Bulletin of Students of the Department of Archaeology, Royal University of Fine Arts, Phnom Penh* 3, 2004: pp. 88–119.

2 To situate the history of Cambodia in a global context, instead of using the designation of the Middle Period for the time between Angkor and colonialism, I prefer to use the term early modern period (c. 1450–c. 1850). Inspired by scholarship on Europe, some English-language historians of Southeast Asia began to actively use the term "early modern" from the late 1980s and early 1990s to recognise emerging communication and trade patterns that connected the globe (on this subject see Leonard Y. Andaya and Barbara Watson Andaya, "Southeast Asia in the Early Modern Period; Twenty-Five Years On", *Journal of Southeast Asian Studies* 26, no. 1, 1995: pp. 92–8. Leonard Y. Andaya and Barbara Watson Andaya, *A History of Early Modern Southeast Asia, 1400–1830*, Cambridge: Cambridge University Press, 2015, pp. 5–11). While some of the earliest scholarship of Cambodia's past categorised the period after Angkor as "modern times" to echo the imperial trope that rediscovering a lost civilisation was a component of "modernity" (see Étienne Aymonier, *Le Cambodge, III. Le groupe d'Angkor et l'histoire*, Paris: Ernest Leroux, 1904, pp. 734–807), for analysis see Penny Edwards, *Cambodge: The Cultivation of a Nation, 1860–1945.* Honolulu: University of Hawai'i Press, 2007. Grégory Mikaelian, "Des sources lacunaires de l'histoire à l'histoire complexifiée des sources. *Éléments* pour une histoire des renaissances khmères (c. XIVe–c. XVIIIe s.)", *Péninsule*, 65, no. 2, June 2012: pp. 259–304), the appellation of "early modern" is applied here without assuming the inevitability of, or other suppositions about, "modernity".

3 Michael Theodore Vickery, *Cambodia after Angkor: The Chronicular Evidence for the Fourteenth to Sixteenth Centuries*, PhD dissertation University of Michigan, 1977 [annotated 2012]. On contemporary 17th-century sources see Grégory Mikaelian, *La royauté d'Oudong. Réformes des institutions et crise du pouvoir dans le royaume khmer du xviie siècle*, Paris: Presses de l'Université Paris-Sorbonne, 2009.

4 Mikaelian, "Des sources lacunaires".

5 Cf. Martin Polkinghorne, Christophe Pottier and Christian Fischer, "One Buddha can Hide Another", *JA* 301, no. 2, 2013: pp. 575–624.

6 Jean Boisselier, "Note sur deux Buddha parés des Galeries d'Angkor Vat", *Bulletin de la Société des études indochinoises* 25, no. 3, 1950: pp. 299–306. Madeleine Giteau, "Note sur une école cambodgienne de statuaire bouddhique inspirée de l'art d'Angkor Vat" *AA* 13, 1966: pp. 115–26. Les étudiants de la Faculté Royale d'Archéologie de Phnom Penh, "Le monastère bouddhique de Tep Pranam à Oudong", *BEFEO* 56, 1969: pp. 29–57. Madeleine Giteau, "Note sur quelques pièces en bronze récemment découvertes à Vatt Deb Pranamy

d'Oudong", *AA* 24, 1971: pp. 149–55. San Sarin, "Quelques chedei du Phnom Preah Reach Treap" *Bulletin des Étudiants de la Faculté d'Archéologie* 3–4, November 1971: pp. 67–8. Ham Gim Sun, *Rājadhānī Uṭuṅg: Siksā aṃbī kanlaeṅ vāṃṅ cās'*, [The Royal Capital of Oudong: Study on the Location of the Ancient Palace], final year undergraduate thesis, Phnom Penh, Department of Archaeology, Royal University of Fine Arts, 1994. Ho Kusal, Dioe Vutthuna and Pan Vassa, *Rapāy kār stī aṃbī caṃlāk' sbān' nau phsār ṭaek niṅ kaṃbaṅ luoṅ*, [Report on Bronze Artisanry at Phsar Daek and Kompong Luong], Phnom Penh, Department of Archaeology, Royal University of Fine Arts 1995–6. Ashley Thompson, "Changing Perspectives: Cambodia after Angkor", in *Sculpture of Angkor and Ancient Cambodia: Millennium of Glory*, eds. Helen I. Jessup and Thierry Zéphir, Washington D.C.: National Gallery of Art, 1997, pp. 22–32. Thompson, "The Ancestral Cult". Takako Kitigawa, "Capitals of the Post-Angkor Period: Longvêk and Oudong", *Southeast Asia History and Culture* 27, no. 6, 1998: pp. 48–72. Khun Samen, *Post Angkorian Buddha*, Phnom Penh: Ministry of Culture and Fine Arts, 2000. Men Rath Sambath, *Les stoupas royaux de la colline d'Oudong*, Mémoire de DREA de Cambodgien, Spécialité Histoire du Cambodge, INALCO, Département de l'Asie du Sud-Est, June 2007. Gabrielle Ewington, *Yaśodharapura to Yaśodharapura. Mobility, Rupture and Continuity in the Khmer World*, unpublished honours thesis, Department of Archaeology, University of Sydney, 2008. Grégory Mikaelian, "Une 'révolution militaire' au pays khmer? note sur l'artillerie post-angkorienne (XVI–XIXe siècles)", *Udaya: Journal of Khmer Studies* 10, 2009: pp. 57–134. Nhim Sotheavin. "Factors that Led to the Change of the Khmer Capitals from the 15th to 17th Century", *Renaissance Culturelle du Cambodge* 29, 2014–2016: pp. 33–107. Martin Polkinghorne, "Reconfiguring Kingdoms: The End of Angkor and the Emergence of Early Modern Period Cambodia", in *Angkor: Exploring Cambodia's Sacred City*, eds. Theresa McCullough, Stephen A. Murphy, Pierre Baptiste and Thierry Zéphir, Singapore: Asian Civilisations Museum, 2018, pp. 252–71. David Brotherson, *Commerce, the Capital, & Community: Trade Ceramics, Settlement Patterns, & Continuity Throughout the Demise of Angkor*, PhD dissertation, University of Sydney, 2019. Tegan Hall, Dan Penny, Brice Vincent and Martin Polkinghorne, "An Integrated Palaeoenvironmental Record of Early Modern Occupancy and Land Use within Angkor Thom, Angkor", *Quaternary Science Reviews* 251, 2021, doi.org/10.1016/j.quascirev.2020.106710.

7 Madeleine Giteau, *Iconographie du Cambodge Post-Angkorien*. Paris: EFEO, 1975.

8 Giteau, *Iconographie du Cambodge*, p. 8.

9 Cf. Giteau, *Iconographie du Cambodge*.

10 Cf. Giteau, *Iconographie du Cambodge*.

11 Gilberte de Coral Rémusat, *L'art khmer: Les grandes étapes de son évolution*, Paris: Études d'art et d'ethnologie asiatiques, 1940, p. 47. Martin Polkinghorne, *Makers and Models: Decorative Lintels of Khmer Temples, 7th to 11th Centuries*, PhD dissertation, University of Sydney, 2007. Ludivine Provost-Roche, *Les derniers siècles de l'époque angkorienne au Cambodge [environ 1220–environ 1500]*, 2 vols., PhD dissertation, Université de Paris 3, 2010. Martin Polkinghorne, Janet Douglas and Federico Carò, "Carving at the Capital: A Stone Workshop at Hariharālaya, Angkor", *BEFEO* 101, 2015: pp. 55–90.

12 Adhémard Leclère, *Le buddhisme au Cambodge*, Paris: Ernest Leroux, 1899, p. 497. Louis Finot, "Les études indochinoises", *BEFEO* 8, 1908: p. 224.

Lawrence Palmer Briggs, *The Ancient Khmer Empire*. Philadelphia: American Philosophical Society, 1951, pp. 242–3, 257. George Cœdès, *Angkor: An Introduction*, Hong Kong: Oxford University Press, 1963, p. 107. Oliver W. Wolters. "The Khmer King at Basan (1371–3) and the Restoration of the Cambodian Chronology During the Fourteenth and Fifteenth Centuries", *Asia Major* 12, no. 1, 1966: pp. 86–7. Hermann Kulke, "The Devarāja Cult: Legitimation and Apotheosis of the Ruler in the Kingdom of Angkor" in *Kings and Cults: State Formation and Legitimation in India and Southeast Asia*, ed. Hermann Kulke, New Delhi: Manohar, 1993, pp. 375–6.

13 Stanley J. Tambiah, *World Conqueror and World Renouncer: A Study of Buddhism and Polity in Thailand against a Historical Background*, Cambridge: Cambridge University Press, 1976. Stanley J. Tambiah, "The Galactic Polity: The Structure of Traditional Kingdoms in Southeast Asia", *Annals of the New-York Academy of Sciences* 293, July 15, 1977: pp. 69–87.

14 Richard A. O'Connor, "Interpreting Thai Religious Change: Temples, Sangha Reform and Social Change", *Journal of Southeast Asian Studies* 24, no. 2, 1993: pp. 330–9.

15 Saveros Pou, "Subhāsit and Cpāp' in Khmer Literature", in *Ludwick Sternbach Felicitation Volume, Part One*, ed. Jagdamba Prasad Sinha, Lucknow: Akhila Bharatiya Sanskrit Parishad, 1979, p. 333.

16 *K.144* in Saveros Pou, "Inscriptions khmères K. 144 et K. 177", *BEFEO* 70, 1981: pp. 101–20.

17 Thompson, "The Ancestral Cult".

18 cf. Paul Mus, *India Seen from the East: Indian and Indigenous Cults in Champa*, trans. Ian W. Mabbett, eds. Ian W. Mabbett and David Chandler, Melbourne: Monash Papers on Southeast Asia, 2011 [1933]. Prapod Assavavirulhakarn, *The Ascendancy of Theravāda Buddhism in Southeast Asia*, Chiang Mai: Silkworm Books, 2010.

19 Dan Penny, Tegan Hall, Damian Evans and Martin Polkinghorne, "Geoarchaeological Evidence from Angkor, Cambodia, Reveals a Gradual Decline Rather than a Catastrophic 15th-century Collapse", *Proceedings of the National Academy of Sciences of the United States of America* 116, no. 11, 2019: pp. 4871–6. Hall et al, "An Integrated Palaeoenvironmental Record".

20 Vickery, *Cambodia After Angkor*.

21 Brendan M. Buckley, Roland J. Fletcher, Shi-Yu Simon Wang, Brian Zottoli and Christophe Pottier, "Monsoon Extremes and Society over the Past Millennium on Mainland Southeast Asia", *Quaternary Science Reviews* 95, 2014: pp. 1–19.

22 Damian H. Evans, Roland J. Fletcher, Christophe Pottier, Jean-Baptiste Chevance, Dominique Soutif, Tan Boun Suy, Im Sokrithy, Ea Darith, Tin Tina, Kim Samnang, Christopher Cromarty, Stéphane de Greef, Kaspar Hanus, Pierre Bâty, Robert Kuszinger, Ichita Shimoda and Glenn Boornazian, "Uncovering Archaeological Landscapes at Angkor using Lidar", *Proceedings of the National Academy of Sciences of the United States of America* 110, no. 31, 2013: pp. 12595–600.

23 Roland J. Fletcher, Dan Penny, Damian H. Evans, D, Christophe Pottier, Mike Barbetti, Matti Kummu, Terry Lustig and APSARA, "The Water Management Network of Angkor, Cambodia", *Antiquity* 82, 2008: pp. 658–70.

24 Vickery, *Cambodia after Angkor*.

25 Polkinghorne et al., "One Buddha". Martin Polkinghorne, Christophe Pottier and Christian Fischer, "Evidence for the 15th Century Ayutthayan Occupation of Angkor", in *The Renaissance Princess Lectures: In Honour of Her Royal*

Highness Princess Maha Chakri Sirindhorn, Bangkok: Siam Society, 2018, pp. 98–132.

26 Thompson, "Pilgrims to Angkor", p. 202.

27 Ibid.

28 Penny Edwards, *Cambodge: The Cultivation of a Nation*.

29 Thompson, "Pilgrims to Angkor". Ang Choulean, Chhay Rachna, Heng Than, Ieng Neang, In Sokretya, Khieu Chan, Khut Vuthyneath, Lim Srou, Uom Sineth, Say Sophearin, Tous Somoneath, Ven Sophorn, Kim Samnang, Ros Sokhom, Khut Vuthyneath, Tin Tina and Vitou Phirom, *Silācārik Aṅgar Vatt: samăy purāṇ, kaṇṭāl, thmī* [Inscriptions of Angkor Wat: Ancient, Middle and Modern Periods], Phnom Penh: APSARA, Center for Khmer Studies, 2013. Than Swe, Im Sokrithy and Elizabeth H. Moore, "Myanmar Inscriptions Found at Angkor", in *Advancing Southeast Asian Archaeology 2013: Selected Papers from the First SEAMEO SPAFA International Conference on Southeast Asian Archaeology*, ed. Noel Hidalgo Tan, Bangkok: SEAMEO SPAFA Regional Centre for Archaeology and Fine Arts, 2015, pp. 15–7. Similarly, Angkor Wat and Angkor also hosted non-Theravāda pilgrims who left behind inscriptions (Yoshiaki Ishizawa, "Les inscriptions calligraphiques japonaises du XVIIe siècle à Angkor Vat et le plan du Jetavana-vihara", *Manuel d'épigraphie du Cambodge*, vol. I, ed. Yoshiaki Ishizawa, Claude Jacques and Khin Sok, Paris: EFEO/UNESCO, 2007, pp. 169–79) and stele (Nasir Abdoul-Carime and Grégory Mikaelian, "Angkor et l'Islam, note sur la stèle arabe du Bhnaṃ Pākhaeṅ", *Péninsule* 63, no. 2, 2011: pp. 5–59).

30 *IMA 1*, in Saveros Lewitz, "Inscriptions modernes d'Angkor 1, 8, et 9", *BEFEO* 59, 1972: pp. 101–21. Unless otherwise indicated my readings of the *IMA* are limited to the translations of Pou/Lewitz cited in the text.

31 Polkinghorne et al., "One Buddha". Polkinghorne et al., "Evidence for the 15th Century".

32 *IMA 11*, in Étienne Aymonier, "Les inscriptions du Bakan et la grande inscription d'Angkor Vat", *JA* 15, no. 1, 1900: pp. 150–1, Aymonier *Le Cambodge,* pp. 298–9, Lewitz, "Inscriptions modernes d'Angkor 10, 11, 12, 13, 14, 15, 16a, 16b, et 16c".

33 *IMA 1* in Lewitz, "Inscriptions modernes d'Angkor 10, 11, 12, 13, 14, 15, 16a, 16b, et 16c". *IMA 2, IMA 3* in Saveros Lewitz, "Textes en khmer moyen. Inscriptions modernes d'Angkor 2 et 3", *BEFEO* 57, 1970: pp. 99–126. *IMA 4, IMA 6* in Saveros Lewitz, "Inscriptions modernes d'Angkor 4, 5, 6 et 7", *BEFEO* 58, 1971: pp. 105–23. *IMA 9* in Saveros Lewitz, "Inscriptions modernes d'Angkor 1, 8, et 9", *BEFEO* 59, 1972: pp. 101–21. *IMA 11, IMA 13, IMA 15, IMA 16b, IMA 16c* in Lewitz, "Inscriptions modernes d'Angkor 10, 11, 12, 13, 14, 15, 16a, 16b, et 16c". *IMA 21, IMA 22* in Saveros Lewitz, "Inscriptions modernes d'Angkor 17, 18, 19, 20, 21, 22, 23, 24 et 25", *BEFEO* 60, 1973: pp. 163–203. *IMA 26, IMA 29* in Saveros Lewitz, "Inscriptions modernes d'Angkor 26, 27, 28, 29, 30, 31, 32, 33", *BEFEO* 60, 1973: pp. 205–42. *IMA 36* in Saveros Lewitz, "Inscriptions modernes d'Angkor 35, 36, 37 et 39", *BEFEO* 61, 1974: pp. 301–37. *IMA 38* in Saveros Pou, "Inscriptions modernes d'Angkor 34 et 38", *BEFEO* 62, 1975: pp. 283–353.

34 *IMA 16b* in Lewitz, "Inscriptions modernes d'Angkor 10, 11, 12, 13, 14, 15, 16a, 16b, et 16c".

35 Aymonier, *Le Cambodge*, p. 210.

36 Jean Commaille, *Rapport de la Conservation d'Angkor, 1908*, unpublished manuscript, Paris: EFEO, 1908, January 1908 ff.

37 Edwards, *Cambodge: The Cultivation*. Pierre Singaravélou, *L'École française d'Extrême-Orient ou l'institution des marges (1898–1956). Essai d'histoire sociale et politique de la science coloniale*, Paris: Éditions L'Harmattan, 1999.

38 Henri Marchal, *Journal de Fouilles, Tome VI,* September 1926–July 1928, unpublished manuscript, Paris: EFEO, 1926–1928, pp. 204–6. The original inventory, rediscovered in 2018, resides in the archive of the National Museum of Cambodia (Boite n°10 - Conservation d'Angkor -Inventaire des statues du Preah Pean).

39 Christophe Pottier, email message to author, 24 May 2015.

40 Ang Choulean, Eric Prenowitz and Ashley Thompson, *Angkor: A Manual for the Past, Present, and Future*, Phnom Penh: APSARA, 1996.

41 Pech Sotheary, "Buddha Statues Unearthed in Siem Reap's Angkor Wat", *Khmer Times*, 17 April 2020, retrieved 14 December 2020. https://www.khmertimeskh.com/714120/buddha-statues-unearthed-in-siem-reaps-angkor-wat/.

42 Christophe Pottier email message to author, 24 May 2015, Simon Warrack email message to author, 15 June 2015.

43 *Dīghanikāya II*: 140–3 in *[Dīghanikāya] Dialogues of the Buddha, Part II,* trans. Thomas William Rhys Davids and Caroline Augusta Foley Rhys Davids, London: Oxford University Press, 1910.

44 *K. 1006* in Michael Theodore Vickery, "L'inscription K 1006 du Phnom Kulên", *BEFEO* 71, 1982: pp. 77–86.

45 Chuta Ito, "Gion-Shouja no zu and Angkor Wat", *Journal of Architecture and Building Science* 313, 1913: pp. 10–41, (in Japanese). Nöel Péri, "Un plan japonais d'Angkor Vat. Essai sur les relations du Japon et de l'Indochine aux XVIè et XVIIè siècles", *BEFEO* 23, 1923: pp. 1–104. Yoshiaki Ishizawa, "Les inscriptions calligraphiques japonaises du XVIIe siècle à Angkor Vat et le plan du Jetavana-vihara", *Manuel d'épigraphie du Cambodge*, vol. *I*, eds. Yoshiaki Ishizawa, Claude Jacques and Khin Sok, Paris: EFEO/UNESCO, 2007, pp. 169–79.

46 George Cœdès, "Essai de classification des documents historiques conservés à la bibliothèque de l'École française d'Extreme-Orient", *BEFEO* 18, 1918: pp. 26–7.

47 Thompson, "Pilgrims to Angkor". Also Olivier de Bernon, "Journeys to Jetavana: Poetic and Ideological Elaborations of Remembrance of Jetavana in Southeast Asia", in *Buddhist Narrative in Asia and Beyond, in Honour of HRH Princess Maha Chakri Sirindhorn on her Fifty-Fifth Birth Anniversary,* Bangkok: Bangkok Institute of Thai Studies, 2012, p. 178.

48 E.g. Lewitz, "Inscriptions modernes d'Angkor 4, 5, 6 et 7", p. 112.

49 DCA Inventory numbers: 5501/1410, 5501/1410, 2195/1348.

50 EFEO photothèque cliché Cambodge photo numbers: EFEO_CAM04249, EFEO_CAM04339, EFEO_CAM04792, EFEO_CAM05055.

51 For the emic name in Thai see Hiram W. Woodward Jr., "The Buddha Images of Ayutthaya", in *Kingdom of Siam: Art from Central Thailand (1350–1800 C.E.),* ed. Forrest McGill, Ghent: Snoeck Publishers; Bangkok: 1 Buppha Press; Chicago: Art Media Resources Inc.; San Francisco: The Asian Art Museum of San Francisco, 2005, p. 54.

52 Hiram W. Woodward Jr., *The Sacred Sculpture of Thailand*, Baltimore: The Trustees of the Walters Art Gallery, 1997, pp. 236–8, Fig. 233.

53 For a description of the monastic robes of Early Modern Cambodian sculptures see Khun Samen Post Angkorian Buddha, pp. 7–8. This specific spelling of

utttakhut is given in the Khmer version of the catalogue, pp. 11, 16.

54 Woodward, *Sacred Sculpture*, pp. 124, 139. See also Santi Leksukhum, *Wiwatthanakān khòng chan pradap luat lāi samai Ayutthayā tòn ton*, Bangkok: Amarin, 1979.

55 Woodward, *Sacred Sculpture*, p. 124.

56 Ibid., cat. nos. 18, 19, 22, 31.

57 Forrest McGill, *Kingdom of Siam: Art from Central Thailand (1350–1800 C.E.)*, ed. Forrest McGill, Ghent: Snoeck Publishers; Bangkok: 1 Buppha Press; Chicago: Art Media Resources Inc.; San Francisco: The Asian Art Museum of San Francisco, 2005. p. 114, cat. no. 8, Fig. 33. Polkinghorne et al., "One Buddha". Polkinghorne et al., "Evidence for the 15th Century".

58 Leksukhum, "*Wiwatthanakān khòng chan*".

59 Henri Marchal, *Journal de Fouilles, Tome II,* December 1918–February 1921, unpublished manuscript, Paris: EFEO, 1918–1921, pp. 116–7.

60 Madeleine Giteau, *Art et archéologie du Laos*, Paris: Picard, 2001, p, 156.

61 Woodward, *Sacred Sculpture*, p. 215.

62 Somkiart Lopetcharat, *Lao Buddha: The Image and Its History*, Bangkok: Amarin, 2001, p. 282. Giteau, *Art et archéologie du Laos*, Figs. 116, 117.

63 Giteau, *Art et archéologie du Laos*, p. 156.

64 Giteau, *Art et archéologie du Laos*, Figs. 119, 121.

65 Madeleine Giteau, "Catalogue des pièces déposées au Wat Phra Keo à Vientiane, Laos", in *Étude de collections d'art bouddhique, 17 décembre 1968–17 mars 1969*, Paris: UNESCO, 1969, p. 1. Giteau, *Art et archéologie du Laos*, pp. 154–6.

66 Giteau, "Catalogue des pièces déposées", pp. 28–9. Thao Boun Souk, *L'image du Buddha dans l'art Lao*, Vientiane: l'Imprimerie nationale, 1974, p. 17. Additional analogous dated images by inscription include those from Wat Sisakhet (no. 113: 1635CE, no. 54: 1672, no. 37: 1661, no. 66: 1671, no. 158: 1672, and no. 92: 1700), see Giteau, *Art et archéologie du Laos*, p. 155, note 43.

67 Giteau, "Catalogue des pièces déposées", pp. 29–30.

68 Mak Phoeun, "Quelques aspects des croyances religieuses liées aux guerres entre le Cambodge et le Siam", paper presented to the 3rd European-Japanese Seminar, Hamburg, September 1998.

69 Khin Sok, *Chroniques royales du Cambodge (de Bañā Yāt jusqu'à la prise de Laṅvaek: de 1417 à 1595). Traduction française avec comparaison des différentes versions et introduction*, Paris: EFEO, 1988, pp. 191–3, 347–54.

70 Mak Phoeun, *Chroniques royales du Cambodge (des origines légendaires jusqu'à Paramarājā Ier) I / Traduction française avec comparaison des différentes versions et introduction*, Paris: EFEO, 1984. Khing Hoc Dy, "La légende de Braḥ Go Braḥ Kaev", *Cahiers de l'Asie du Sud-Est* 29–30, 1991: pp. 169–90. Grégory Mikaelian, "Le passé entre mémoire d'Angkor et déni de Laṅvaek: la conscience de l'histoire dans le royaume khmer du XVIIe siècle", in *Le passé des Khmers. Langues, textes, rites*, eds. Nasir Abdoul-Carime, Grégory Mikaelian and Joseph Thach Berne, Peter Lang, 2016, pp. 167–212. On palladia see also Ang Choulean, "Nandin and His Avatars", in *Sculpture of Angkor and Ancient Cambodia: Millennium of Glory*, eds. Helen I. Jessup and Thiery Zephir, Washington: Thames & Hudson, 1997, pp. 62–9.

71 See above. Polkinghorne et al., "One Buddha". Polkinghorne et al., "Evidence for the 15th Century".

72 Various versions see Richard D. Cushman, trans., *The Royal Chronicles of Ayutthaya*, ed. David K. Wyatt, Bangkok: The Siam Society, 2000, p. 15. See also Vickery, *Cambodia after Angkor*, p. 517.

73 *K. 285* in Khin Sok. "Deux inscriptions tardives du Phnom Bàkhèn, K.465 et K.285", *BEFEO* 60, no. 1, 1978: pp. 271–80. *K. 465* in Khin, "Deux inscriptions tardives"; and Saveros Pou, "Inscription du Phnom Bakheng (K.465) ", *Nouvelles inscriptions du Cambodge I*, Paris: EFEO, 1989, pp. 20–5.

74 Khin, "Deux inscriptions tardives". Pou, "Inscription du Phnom Bakheng".

75 Thompson, "Pilgrims to Angkor", Fig. 15.

76 *K.1006* in Michael Theodore Vickery, "L'inscription K.1006 du Phnom Kulên", *BEFEO* 71, 1982: pp. 77–86.

77 Vickery, "L'inscription K.1006". Thompson, "Pilgrims to Angkor".

78 Mak Phoeun, *Histoire du Cambodge de la fin du XVIe siècle au début du XVIIIe siècle*, Paris: EFEO, 1995, pp. 100ff.

79 Hiram W. Woodward Jr., "Prologue. What there was before Siam: Traditional Views", in *Before Siam: Essays in Art and Archaeology*, eds. Nicolas Revire and Stephen A. Murphy, Bangkok: River Books, 2014, p. 19.

80 Fine Arts Department, *Chotmaihet kanburana patisangkhon 'ong Phra That Phanom*, Bangkok: Fine Arts Department, 2518–22 (1975–1979 CE).

81 Forrest McGill, "The Art and Architecture of the Reign of King Prasat Thong of Ayutthaya (1629–1656)", PhD dissertation, University of Michigan, 1977, p. 170.

82 McGill, "The Art and Architecture". Woodward, "The Buddha Images", p. 118.

83 Michael Theodore Vickery, "History of Cambodia. Summary of lectures given at the Faculty of Archaeology Royal University of Fine Arts", unpublished lecture notes, Phnom Penh, 2001–2, p. 152.

84 *IMA 39* in Lewitz, "Inscriptions modernes d'Angkor 35, 36, 37 et 39".

85 David Porter Chandler, "An Eighteenth-Century Inscription from Angkor Wat", *JSS* 59, no. 2, 1971: pp. 152–9. Saveros Pou, "Inscriptions khmères K. 39 et K. 27", *BEFEO* 70, 1981: pp. 121–34.

86 Jean Moura, *Le royaume du Cambodge*, 2 vols, Paris: Ernest Leroux, vol. II, p. 86.

87 Khin Sok, *Le Cambodge entre le Siam et le Viêtnam (de 1775 à 1860)*, Paris: EFEO, 1991, pp. 37ff.

88 David Porter Chandler, "Cambodia before the French: Politics in a Tributary Kingdom. 1794–1848", PhD dissertation, University of Michigan, 1973, pp. 77–9. Khin, *Le Cambodge entre*, pp. 49ff. Loch Chhanchhai, "Chronique des vice-rois de Battambang (XVIIIe–XXIe siècles): du régent Bên de Battambang à la famille Aphaiwong du Siam", *Péninsule* 68, no. 1, 2014: pp. 9–103.

89 Woodward, "Sacred Sculpture", pp. 20–1.

90 Jean Boisselier, *Asie du Sud-Est: I. Le Cambodge*, Paris: Picard, 1966, p. 98. Henri Marchal, "Note sur la forme du stupa au Cambodge", *BEFEO* 46, no. 2, 1951: pp. 581–690. Men Rath Sambath, "Les stoupas et les temples". Ashley Thompson, "Mémoires du Cambodge", PhD dissertation, Université de Paris VIII, 1999.

91 Thompson, "Pilgrims to Angkor".

92 *IMA 38* in Pou, "Inscriptions modernes d'Angkor 34 et 38".

93 Ibid.

94 Michel Lorillard, "d'Angkor au Lān Xāng: une révision des jugements", *Aséanie* 7, 2001: pp. 19–33. Cf. George Cœdès, *The Indianized States of Southeast Asia*, trans. Susan Brown Cowing, ed. Walter F. Vella, Canberra: Australian National University Press, 1968, p. 224.

95 Alternatively, Michel Lorillard suggests the Prah Bang Buddha has more stylistic

affinities with a Mon image from Ban Thalat (see Lorillard, "d'Angkor au Lān Xāng", p. 31).

96 Vickery, *Cambodia after Angkor*, pp. 74–6, 254–7.

97 Vickery, *Cambodia after Angkor*, p. 205 & *passim*.

98 Kersten, 2003: p. 38. Carool Kersten, ed., *Strange Events in the Kingdoms of Cambodia and Laos (1635–1644)*, Bangkok: White Lotus, 2003, p. 38.

99 Bernard-Philippe Groslier, *Angkor and Cambodia in the Sixteenth Century: According to Portuguese and Spanish Sources*, trans. Michael Smithies, Bangkok: Orchid Books, 2006 [1958], pp. 100–1.

100 Mak, *Histoire du Cambodge*, pp. 396–7. The recension used by Leclère, identifies the village in Bati as Phum Baray Kbal Choum. See Adhémard Leclère, *Histoire du Cambodge depuis le 1er siècle de notre ère, d'après les inscriptions lapidaires, les annales chinoises et annamites et les documents européens des six derniers siècles*, Paris: Paul Geuthner, 1914, p. 369. P57 dates this event to around 1691/92. Other royal chronicles place the arrival in 1705/06 (VJ [*Braḥ rāj baṅsāvatar mahākhsatr khmaer*], P63 [*Braḥ rāj baṅs sovatā khemmara lek oṅkar*], B39/12/B [*Rapāl khsāt*], cited in Mak, *Histoire du Cambodge*, p. 396.

101 *IMA 29* in Lewitz, "IX. Inscriptions modernes d'Angkor 26, 27, 28, 29, 30, 31, 32, 33". The date of this inscription is difficult to decipher and interpret. Billard and Eade read 1646, Lewitz reads 1706, See Roger Billard, and Christopher J. Eade, "Dates des inscriptions du pays khmer", *BEFEO* 93, 2006: pp. 395–428. Lewitz, "Inscriptions modernes d'Angkor 26, 27, 28, 29, 30, 31, 32, 33", p. 214.

102 Lewitz, "Inscriptions modernes d'Angkor 26, 27, 28, 29, 30, 31, 32, 33", pp. 214–6.

103 Lewitz, "Inscriptions modernes d'Ankgor 4, 5, 6 et 7", p. 112, note 7. Thompson, "Mémoires du Cambodge", pp. 187–92, "Pilgrims to Angkor", pp. 221–2, note 12, 13. See also Tuy Danel and Martin Polkinghorne, "Cambodian Narratives: Transformations of the Vessantara Jataka", *The Asian Art Society of Australia Review* 24, no. 2, 2015: pp. 7–9.

104 *IMA 1* in Lewitz, "Inscriptions modernes d'Angkor 1, 8, et 9". *K. 296, K. 297* in George Cœdès, "Date d'exécution des deux bas-reliefs tardifs d'Angkor Vat", *JA* 250, no. 2, 1962: pp. 235–43. *IMA 2, IMA 3* in Lewitz, "Textes en kmer moyen. Inscriptions modernes d'Angkor 2 et 3". *IMA 4, IMA 5, IMA 6* in Lewitz, "IV. Inscriptions modernes d'Ankgor 4, 5, 6 et 7". *K.1022* in Saveros Pou, "Angkor Vat. K.1022", in *Nouvelles inscriptions du Cambodge II & III*, Paris: EFEO, 2001, p. 270.

105 *IMA 1* in Lewitz, "Inscriptions modernes d'Angkor 1, 8, et 9". *K. 296* in Cœdès, "Date d'exécution".

106 Groslier, "Angkor and Cambodia in the Sixteenth". Jean-Claude Lejosne, "Historiographie du Cambodge aux 16e et 17e siècles: les sources portugaises et hollandaises", in *Bilan et perspectives des études khmères (langue et culture)*, ed. Pierre L. Lamant, Paris: L'Harmattan, 1998, pp. 179–200.

107 Jean Boisselier, "Note sur les bas-reliefs tardifs d'Angkor Vat", *JA* 250, no. 2, 1962: pp. 244–8. Cœdès, "Date d'exécution".

108 *IMA 7* in Lewitz, "Inscriptions modernes d'Angkor 4, 5, 6 et 7". *IMA 8, IMA 9* in Lewitz, "Inscriptions modernes d'Angkor 1, 8, et 9". *IMA 10, IMA 11, IMA 12, IMA 13, IMA 14, IMA 16A, IMA 15, IMA 16B* in Lewitz, "Inscriptions modernes d'Angkor 10, 11, 12, 13, 14, 15, 16a, 16b, et 16c". *IMA 17, IMA 18, IMA 19, IMA 20, IMA 21, IMA 23, IMA 24, IMA 25* in Lewitz, "Inscriptions modernes d'Angkor 17, 18, 19, 20, 21, 22, 23, 24 et 25". *IMA 26, IMA 27, IMA 28, IMA 30, IMA 31, K. 1021, IMA 32, IMA 33* in Lewitz, "Inscriptions

modernes d'Angkor 26, 27, 28, 29, 30, 31, 32, 33". *IMA 34* in Pou, "Inscriptions modernes d'Angkor 34 et 38". *IMA 35* in Lewitz, "Inscriptions modernes d'Angkor 35, 36, 37 et 39".

109 *IMA 8, IMA 9* in Lewitz, "III. Inscriptions modernes d'Angkor 1, 8, et 9". *IMA 10, IMA 11, IMA 12, IMA 13, IMA 14, IMA 16A, IMA 15, IMA 16B* in Lewitz, "Inscriptions modernes d'Angkor 10, 11, 12, 13, 14, 15, 16a, 16b, et 16c", *IMA 17, IMA 18, IMA 19, IMA 20, IMA 21, IMA 23, IMA 24* in Lewitz "Inscriptions modernes d'Angkor 17, 18, 19, 20, 21, 22, 23, 24 et 25".

110 Alison Kyra Carter, Miriam T. Stark, Seth Quintus, Yilie Zhuang, Hong Wang, Heng Piphal and Chhay Rachna, "Temple Occupation and the Tempo of Collapse at Angkor Wat, Cambodia", *Proceedings of the National Academy of Sciences of the United States of America* 116, no. 25, 2019, p. 12230.

111 Hall et al. 2021, "An Integrated Palaeoenvironmental Record".

112 Nara National Research Institute for Cultural Properties, *Western Prasat Top Site Survey Report on Joint Research for the Protection of the Angkor Historic Site*, Nara: Nara National Research Institute for Cultural Properties, 2012, p. 193.

113 GT83. Greater Angkor Project, *Tumnup Touich Terrace (GT83)*, unpublished report, Siem Reap: Greater Angkor Project, 2014.

114 Martin Polkinghorne, Brice Vincent, Nicolas Thomas and David Bourgarit, "Casting for the King: The Royal Palace Bronze Workshop of Angkor Thom", *BEFEO* 100, 2014: pp. 327–58. Polkinghorne et al., "Carving at the Capital", 2015.

115 *K. 444* in George Cœdès, *Inscriptions du Cambodge II*, Paris: EFEO, 1942, pp. 62–8. Saveros Pou, "Lexicographie vieux-khmère", *Seksa Khmer* 7, 1984: pp. 67–175.
 "Lexicographie vieux-khmère", *Seksa Khmer* 7 (1984): 67–175.

116 Cœdès, *Inscriptions du Cambodge II*, pp. 62–8. Pou, "Lexicographie vieux-khmère", p. 117.

117 *IMA 2* in Lewitz, "Textes en kmer moyen. Inscriptions modernes d'Angkor 2 et 3".

118 Lewitz, "Textes en kmer moyen. Inscriptions modernes d'Angkor 2 et 3". Thompson, "Pilgrims to Angkor".

119 Pauline Dy Phon, *Vacanānukram rukkhajāti proe prās' knuṅ prades kambujā, Dictionnaire des plantes utilisées au Cambodge, Dictionary of Plants used in Cambodia*, Phnom Penh, 2000. Khun, *Post Angkorian Buddha*. Seng Chantha, *Conservation of Wooden Buddha. Post-Angkor Period*, unpublished Powerpoint presentation, Phnom Penh, 2017.

120 Ashley Thompson, "Forgetting to Remember, Again: On Curatorial Practice" and "Cambodian Art in the Wake of Genocide", *diacritics* 41, no. 2, 2014: pp. 82–109.

Referencees

Abdoul-Carime, Nasir and Grégory Mikaelian. "Angkor et l'Islam: note sur la stèle arabe du Bhnaṃ Pākhaeṅ". *Péninsule* 63, no. 2, 2011: pp. 5–59.

Ang Choulean. "Nandin and His Avatars". In *Sculpture of Angkor and Ancient Cambodia: Millennium of Glory*, ed. Helen I. Jessup and Thierry Zéphir. Washington: Thames and Hudson, 1997, pp. 62–9.

Ang, Choulean, Eric Prenowitz, and Ashley Thompson. *Angkor: A Manual for the Past, Present, and Future*, Phnom Penh: APSARA, 1996.

Ang Choulean, Chhay Rachna, Heng Than, Ieng Neang, In Sokretya, Khieu Chan,

Khut Vuthyneath, Lim Srou, Uom Sineth, Say Sophearin, Tous Somoneath, Ven Sophorn, Kim Samnang, Ros Sokhom, Khut Vuthyneath, Tin Tina, and Vitou Phirom. *Silācārik Aṅgar Vatt : samăy purāṇ, kaṇṭāl, thmī* [Inscriptions of Angkor Wat: Ancient, Middle and Modern Periods]. Phnom Penh: APSARA, Center for Khmer Studies, 2013.

Assavavirulhakarn, Prapod. *The Ascendancy of Theravāda Buddhism in Southeast Asia.* Chiang Mai: Silkworm Books, 2010.

Aymonier, Étienne. *Le Cambodge, III. Le groupe d'Angkor et l'histoire*. Paris: Ernest Leroux, 1904.

———. "Les inscriptions du Bakan et la grande inscription d'Angkor Vat". *JA* 15, no. 1, 1900: pp. 143–75.

De Bernon, Olivier. "Journeys to Jetavana: Poetic and Ideological Elaborations of Remembrance of Jetavana in Southeast Asia". In *Buddhist Narrative in Asia and Beyond, in Honour of HRH Princess Maha Chakri Sirindhorn on her Fifty-Fifth Birth Anniversary*. Bangkok: Bangkok Institute of Thai Studies, 2012: pp. 167–93.

Billard, Roger and Christopher J. Eade. "Dates des inscriptions du pays khmer". *BEFEO* 93, 2006: pp. 395–428.

Boisselier, Jean. *Asie du Sud-Est: I. Le Cambodge,* Paris: Picard, 1966.

———. "Note sur les bas-reliefs tardifs d'Angkor Vat". *JA* 250, no. 2, 1962: pp. 244–8.

———. "Note sur deux Buddha parés des Galeries d'Angkor Vat". *Bulletin de la Société des études indochinoises* 25, no. 3, 1950: pp. 299–306.

Briggs, Lawrence Palmer. *The Ancient Khmer Empire*. Philadelphia: American Philosophical Society, 1951.

Brotherson, David. *Commerce, the Capital, & Community: Trade Ceramics, Settlement Patterns, & Continuity Throughout the Demise of Angkor*. PhD dissertation, University of Sydney, 2019.

Buckley, Brendan M., Roland J. Fletcher, Shi-Yu Simon Wang, Brian Zottoli and Christophe Pottier. "Monsoon Extremes and Society over the Past Millennium on Mainland Southeast Asia". *Quaternary Science Reviews* 95, 2014: pp. 1–19.

Boun Souk, Thao. *L'image du Buddha dans l'art Lao*. Vientiane: Imprimerie nationale, 1974.

Carter, Alison Kyra, Miriam T. Stark, Seth Quintus, Yijie Zhuang, Hong Wang, Piphal Heng and Chhay Rachna. "Temple Occupation and the Tempo of Collapse at Angkor Wat, Cambodia". *Proceedings of the National Academy of Sciences of the United States of America* 116, no. 25, 2019: pp. 12226–31.

Chandler, David Porter. "An Eighteenth-Century Inscription from Angkor Wat". *JSS* 59, no. 2, 1971: pp. 152–9.

———. *Cambodia before the French: Politics in a Tributary Kingdom. 1794–1848*. PhD dissertation, University of Michigan, 1973.

Coe, Michael and Damian Evans. *Angkor and the Khmer Civilization*. London: Thames & Hudson, 2018.

Cœdès, George. *Angkor: An Introduction*. Hong Kong: Oxford University Press, 1963.

———. "Date d'exécution des deux bas-reliefs tardifs d'Angkor Vat". *JA* 250, no. 2, 1962: pp. 235–43.

———. "Essai de classification des documents historiques conservés à la bibliothèque de l'École Française d'Extreme-Orient". *BEFEO* 18, 1918: pp. 15–28.

———. *The Indianized States of Southeast Asia*, trans. Susan Brown Cowing, ed. Walter F. Vella. Canberra: Australian National University Press, 1968.

———. *Inscriptions du Cambodge II*. Paris: EFEO, 1942.

Commaille, Jean. *Rapport de la Conservation d'Angkor, 1908*. Unpublished

manuscript, Paris: EFEO, 1908.

De Coral-Rémusat, Gilberte. *L'art khmer. Les grandes étapes de son évolution*. Paris: Études d'art et d'ethnologie asiatiques, 1940.

Cushman, Richard D., trans. *The Royal Chronicles of Ayutthaya*, ed. David K. Wyatt Bangkok: The Siam Society, 2000.

[*Dīghanikāya*] *Dialogues of the Buddha, Part II*, trans.Thomas William Rhys Davids and Caroline Augusta Foley Rhys Davids, London: Oxford University Press, 1910.

Dy Phon, Pauline. *Vacanānukram rukkhajāti proe prās' knuṅ prades kambujā, Dictionnaire des plantes utilisées au Cambodge, Dictionary of Plants used in Cambodia*. Phnom Penh, 2000.

Edwards, Penny. *Cambodge: The Cultivation of a Nation, 1860–1945*. Honolulu: University of Hawai'i Press, 2007.

Les étudiants de la Faculté Royale d'Archéologie de Phnom Penh. "Le monastère bouddhique de Tep Pranam à Oudong". *BEFEO* 56, 1969: pp. 29–57.

Evans, Damian H., Roland J. Fletcher, Christophe Pottier, Jean-Baptiste Chevance, Dominique Soutif, Tan Boun Suy, Im Sokrithy, Ea Darith, Tin Tina, Kim Samnang, Christopher Cromarty, Stéphane de Greef, Kaspar Hanus, Pierre Bâty, Robert Kuszinger, Ichita Shimoda and Glenn Boornazian. "Uncovering Archaeological Landscapes at Angkor using Lidar". *Proceedings of the National Academy of Sciences of the United States of America* 110, no. 31, 2013: pp. 12595–600.

Ewington, Gabrielle. *Yaśodharapura to Yaśodharapura: Mobility, Rupture and Continuity in the Khmer World*. Unpublished honours thesis, Department of Archaeology, University of Sydney, 2008.

Fine Arts Department. *Chotmaihet kanburana patisangkhon 'ong Phra That Phanom* Bangkok: Fine Arts Department, 1975–1979, pp. 2518–2522. (In Thai.)

Finot, Louis. "Les études indochinoises". *BEFEO* 8, 1908: pp. 221–33.

Fletcher, Roland J., Dan Penny, Damian H. Evans, Christophe Pottier, Mike Barbetti, Matti Kummu, Terry Lustig and APSARA. "The Water Management Network of Angkor, Cambodia". *Antiquity* 82, 2008: pp. 658–70.

Giteau, Madeleine. *Art et archéologie du Laos*. Paris: Picard, 2001.

———. "Catalogue des pièces déposées au Wat Phra Keo à Vientiane, Laos". In *Étude de collections d'art bouddhique, 17 décembre 1968– 17 mars 1969*. Paris: UNESCO, 1969.

———. *Iconographie du Cambodge Post-Angkorien*. Paris: EFEO, 1975.

———. "Note sur une école cambodgienne de statuaire bouddhique inspirée de l'art d'Angkor Vat". *AA* 13, 1966: pp. 115–26.

———. "Note sur quelques pièces en bronze récemment découvertes à Vatt Deb Pranamy d'Oudong". *AA* 24, 1971: pp. 149–155.

Greater Angkor Project, *Tumnup Touich Terrace (GT83)*. Unpublished report, Siem Reap: Greater Angkor Project, 2014.

Groslier, Bernard-Philippe. *Angkor and Cambodia in the Sixteenth Century. According to Portuguese and Spanish Sources*, trans. Michael Smithies. Bangkok: Orchid Books, 2006. First Published 1958.

Hall, Tegan, Dan Penny, Brice Vincent and Martin Polkinghorne. "An Integrated Palaeoenvironmental Record of Early Modern Occupancy and Land Use within Angkor Thom, Angkor". *Quaternary Science Reviews* 251, 2021. doi. org/10.1016/j.quascirev.2020.106710.

Ham Gim Sun, *Rājadhānī Uṭuṅ: Siksā aṃbī kanlaeṅ vāṃṅ cās'* [The Royal Capital of Oudong: Study on the Location of the Ancient Palace]. Final Year

undergraduate thesis, Phnom Penh, Department of Archaeology, Royal University of Fine Arts, 1994.

Ho Kusal, Dioe Vutthuna and Pan Vassa, *Rapāy kār stī aṃbī caṃlāk' sbān' nau phsār ṭaek niṅ kaṃbaṅ luoṅ* [Report on bronze artisanry at Phsar Daek and Kompong Luong]. Phnom Penh, Department of Archaeology, Royal University of Fine Arts, 1995–6.

Ishizawa, Yoshiaki. "Les inscriptions calligraphiques japonaises du XVIIe siècle à Angkor Vat et le plan du Jetavana-vihara". *Manuel d'épigraphie du Cambodge, vol. I,* eds. Yoshiaki Ishizawa, Claude Jacques and Khin Sok. Paris: EFEO/ UNESCO, 2007, pp. 169–79.

Ito, Chuta. "Gion-Shouja no zu and Angkor Wat". *Journal of Architecture and Building Science* 313, 1913: pp. 10–41. (In Japanese.)

Kersten, Carool, ed. *Strange Events in the Kingdoms of Cambodia and Laos (1635–1644).* Bangkok: White Lotus, 2003.

Khin Sok. *Le Cambodge entre le Siam et le Viêtnam (de 1775 à 1860).* Paris: EFEO, 1991.

———. *Chroniques royales du Cambodge (de Bañā Yāt jusqu'à la prise de Laṅvaek: de 1417 à 1595). Traduction française avec comparaison des différentes versions et introduction.* Paris: EFEO, 1988.

———. "Deux inscriptions tardives du Phnom Bàkhèn, K.465 et K.285". *BEFEO* 60, no. 1, 1978: pp. 271–80.

Khing Hoc Dy. "La légende de Braḥ Go Braḥ Kaev". *Cahiers de l'Asie du Sud-Est* 29–30, 1991: pp. 169–90.

Khun Samen. *Post Angkorian Buddha.* Phnom Penh: Ministry of Culture and Fine Arts, 2000. (Khmer version: *Buddh paṭimā kroy samăy aṅgar.*)

Kitigawa, Takako. "Capitals of the Post-Angkor Period: Longvêk and Oudong". *Southeast Asia History and Culture* 27, no. 6, 1998: pp. 48–72.

Kulke, Hermann. "The Devaràja Cult: Legitimation and Apotheosis of the Ruler in the Kingdom of Angkor". In *Kings and Cults: State Formation and Legitimation in India and Southeast Asia*, ed. Hermann Kulke. New Delhi: Manohar, 1993, pp. 327–81.

Leclère, Adhémard. *Le buddhisme au Cambodge.* Paris: Ernest Leroux, 1899.

———. *Histoire du Cambodge depuis le 1er siècle de notre ère, d'après les inscriptions lapidaires, les annales chinoises et annamites et les documents européens des six derniers siècles.* Paris: Paul Geuthner, 1914.

Lejosne, Jean-Claude. "Historiographie du Cambodge aux 16e et 17e siècles: les sources portugaises et hollandaises". In *Bilan et perspectives des études khmères (langue et culture)*, ed. Pierre L. Lamant. Paris: L'Harmattan, 1998, pp. 179–200.

Leksukhum, Santi. *Wiwatthanakān khòng chan pradap luat lāi samai Ayutthayā tòn ton.* Bangkok: Amarin, 1979. (In Thai.)

Lewitz, Saveros. "Inscriptions modernes d'Angkor 35, 36, 37 et 39". *BEFEO* 61, 1974: pp. 301–37.

———. "Inscriptions modernes d'Angkor 4, 5, 6 et 7". *BEFEO* 58, 1971: pp. 105–23.

———. "Inscriptions modernes d'Angkor 1, 8, et 9". *BEFEO* 59, 1972: pp. 101–21.

———. "Inscriptions modernes d'Angkor 10, 11, 12, 13, 14, 15, 16a, 16b, et 16c". *BEFEO* 59, 1972: pp. 221–49.

———. "Inscriptions modernes d'Angkor 17, 18, 19, 20, 21, 22, 23, 24 et 25". *BEFEO* 60, 1973: pp. 163–203.

———. "Inscriptions modernes d'Angkor 26, 27, 28, 29, 30, 31, 32, 33". *BEFEO* 60, 1973: pp. 205–42.

————. "Textes en khmer moyen. Inscriptions modernes d'Angkor 2 et 3". *BEFEO* 57, 1970: pp. 99–126.

Loch Chhanchhai. "Chronique des vice-rois de Battambang (XVIIIe–XXIe siècles): du régent Bên de Battambang à la famille Aphaiwong du Siam". *Péninsule* 68, no. 1, 2014: pp. 9–103.

Lopetcharat, Somkiart. *Lao Buddha: The Image and Its History*. Bangkok: Amarin, 2001.

Lorillard, Michel. "d'Angkor au Lān Xāng: une révision des jugements". *Aséanie* 7, 2001: pp. 19–33.

Mak Phoeun. *Chroniques royales du Cambodge (des origines légendaires jusqu'à Paramarājā Ier) I / Traduction française avec comparaison des différentes versions et introduction*. Paris: EFEO, 1984.

————. *Histoire du Cambodge de la fin du XVIe siècle au début du XVIIIe siècle*. Paris: EFEO, 1995.

————. "Quelques aspects des croyances religieuses liées aux guerres entre le Cambodge et le Siam". Paper presented to the 3rd European-Japanese Seminar, Hamburg, September 1998.

Marchal, Henri. *Journal de Fouilles, Tome II,* December 1918–February 1921. Unpublished manuscript, Paris: EFEO, 1918–21.

————. *Journal de Fouilles, Tome VI,* September 1926–July 1928. Unpublished manuscript, Paris: EFEO, 1926–8.

————. "Note sur la forme du stupa au Cambodge". *BEFEO* 46, no. 2, 1951: pp. 581–690.

McGill, Forrest. "The Art and Architecture of the reign of King Prasat Thong of Ayutthaya (1629–1656)". PhD dissertation, University of Michigan, 1977.

————. *Kingdom of Siam: Art from Central Thailand (1350–1800 C.E.)*, ed. Forrest McGill. Ghent: Snoeck Publishers; Bangkok: 1 Buppha Press; Chicago: Art Media Resources Inc.; San Francisco: The Asian Art Museum of San Francisco, 2005.

Men Rath Sambath. "Les stoupas et les temples de la colline d'Oudong". Mémoire pour le diplôme de Master, Institut National des Langues et Civilisations Orientales, 2007.

Mikaelian, Grégory. "Des sources lacunaires de l'histoire à l'histoire complexifiée des sources. Éléments pour une histoire des renaissances khmères (c. XIVe–c. XVIIIe s.)". *Péninsule* 65, no. 2, June 2012: pp. 259–304.

————. "Le passé entre mémoire d'Angkor et déni de Laṅvaek: la conscience de l'histoire dans le royaume khmer du XVIIe siècle". In *Le passé des Khmers. Langues, textes, rites*, ed. Nasir Abdoul-Carime, Grégory Mikaelian and Joseph Thach. Berne: Peter Lang, 2016, pp. 167–212.

————. *La royauté d'Oudong. Réformes des institutions et crise du pouvoir dans le royaume khmer du xviie siècle*. Paris: Presses de l'Université Paris-Sorbonne, 2009.

————. "Une 'révolution militaire' au pays khmer? note sur l'artillerie post-angkorienne (XVI–XIXe siècles)". *Udaya Journal of Khmer Studies* 10, 2009: pp. 57–134.

Moura, Jean. *Le royaume du Cambodge*, 2 vols. Paris: Ernest Leroux, 1883.

Mus, Paul. *India seen from the East: Indian and Indigenous Cults in Champa*, trans. Ian W. Mabbett, eds. Ian W. Mabbett and David Chandler. Melbourne: Monash Papers on Southeast Asia, Melbourne, 2011. (First Published 1933.)

Nara National Research Institute for Cultural Properties. *Western Prasat Top Site Survey Report on Joint Research for the Protection of the Angkor Historic Site*. Nara: Nara National Research Institute for Cultural Properties, 2012.

Nhim Sotheavin. "Factors that led to the Change of the Khmer Capitals from the 15th to 17th Century". *Renaissance Culturelle du Cambodge* 29, 2014–6: pp. 33–107.

O'Connor, Richard A. "Interpreting Thai Religious Change: Temples, Sangha Reform and Social Change". *Journal of Southeast Asian Studies* 24, no. 2, 1993: pp. 330–9.

Pech Sotheary. "Buddha Statues Unearthed in Siem Reap's Angkor Wat". *Khmer Times* April 17, 2020. Retrieved 14 December 2020, https://www.khmertimeskh.com/714120/buddha-statues-unearthed-in-siem-reaps-angkor-wat/.

Péri, Nöel. "Un plan japonais d'Angkor Vat. Essai sur les relations du Japon et de l'Indochine aux XVIè et XVIIè siècles". *BEFEO* 23, 1923: pp. 1–104.

Penny, Dan, Tegan Hall, Damian Evans and Martin Polkinghorne. "Geoarchaeological Evidence from Angkor, Cambodia, Reveals a Gradual Decline Rather than a Catastrophic 15th-century Collapse". *Proceedings of the National Academy of Sciences of the United States of America* 116, no. 11, 2019: pp. 4871–6.

Polkinghorne, Martin. "Makers and Models: Decorative Lintels of Khmer Temples, 7th to 11th centuries". PhD dissertation, University of Sydney, 2007.

———."Reconfiguring Kingdoms: The End of Angkor and the Emergence of Early Modern Period Cambodia". In *Angkor: Exploring Cambodia's Sacred City*, eds. Theresa McCullough, Stephen A. Murphy, Pierre Baptiste and Thierry Zéphir. Singapore: Asian Civilisations Museum, 2018, pp. 252–71.

Polkinghorne, Martin, Janet Douglas and Federico Carò. "Carving at the Capital: A Stone Workshop at Hariharālaya, Angkor". *BEFEO* 101, 2015: pp. 55–90.

Polkinghorne, Martin, Christophe Pottier and Christian Fischer. "Evidence for the 15th-Century Ayutthayan Occupation of Angkor". In *The Renaissance Princess Lectures: In Honour of Her Royal Highness Princess Maha Chakri Sirindhorn*. Bangkok: Siam Society, pp. 98–132.

———. "One Buddha can Hide Another". *JA* 301, no. 2, 2013: pp. 575–624.

Polkinghorne, Martin, Brice Vincent, Nicolas Thomas and David Bourgarit. "Casting for the King: The Royal Palace Bronze Workshop of Angkor Thom". *BEFEO* 100, 2014: pp. 327–58.

Pou, Saveros. "Angkor Vat. K.1022". In *Nouvelles inscriptions du Cambodge II & III* Paris: EFEO, 2001, p. 270.

———. "Inscription du Phnom Bakheng (K.465) ". *Nouvelles inscriptions du Cambodge I*. Paris: EFEO, 1989, pp. 20–5.

———. "Inscriptions khmères K. 144 et K. 177". *BEFEO* 70, 1981: pp. 101–20.

———. "Inscriptions khmères K. 39 et K. 27". *BEFEO* 70, 1981: pp. 121–34.

———. "Inscriptions modernes d'Angkor 34 et 38". *BEFEO* 62, 1975: pp. 283–353.

———. "Lexicographie vieux-khmère". *Seksa Khmer* 7, 1984: pp. 67–175.

———. "Subhāsit and Cpāp' in Khmer Literature". In *Ludwick Sternbach Felicitation Volume, Part One*, ed. Jagdamba Prasad Sinha. Lucknow: Akhila Bharatiya Sanskrit Parishad, 1979, pp. 331–48.

Provost-Roche, Ludivine. *Les derniers siècles de l'époque angkorienne au Cambodge [environ 1220–environ 1500]*, 2 vols. PhD dissertation, Université de Paris 3, 2010.

San Sarin. "Quelques chedei du Phnom Preah Reach Treap". *Bulletin des Étudiants de la Faculté d'Archéologie* 3-4, November 1971: pp. 67–8.

Singaravélou, Pierre. *L'École française d'Extrême-Orient ou l'institution des marges (1898–1956). Essai d'histoire sociale et politique de la science coloniale*. Paris: Éditions L'Harmattan, 1999.

Seng Chantha. *Conservation of Wooden Buddha: Post-Angkor Period*. Unpublished Powerpoint presentation, Phnom Penh, 2017.

Tambiah, Stanley J. "The Galactic Polity: The Structure of Traditional Kingdoms in Southeast Asia". *Annals of the New-York Academy of Sciences* 293, 15 July 1977: pp. 69–87.

———. *World Conqueror and World Renouncer: A Study of Buddhism and Polity in Thailand against a Historical Background*. Cambridge: Cambridge University Press, 1976.

Than Swe, Im Sokrithy and Elizabeth H. Moore. "Myanmar Inscriptions Found at Angkor". In *Advancing Southeast Asian Archaeology 2013: Selected Papers from the First SEAMEO SPAFA International Conference on Southeast Asian Archaeology*, ed. Noel Hidalgo Tan. Bangkok: SEAMEO SPAFA Regional Centre for Archaeology and Fine Arts, 2015, pp. 15–7.

Thompson, Ashley. "The Ancestral Cult in Transition: Reflections on Spatial Organization of Cambodia's Early Theravada Complex". In *Southeast Asian Archaeology: Proceedings of the 6th International Conference of the European Association of Southeast Asian Archaeologists, 2–6 September, Leiden*, eds. Marijke J. Klokke and Thomas de Brujin. Hull: Centre for Southeast Asian Studies, 1998, pp. 273–95.

———. "Changing Perspectives: Cambodia after Angkor". In *Sculpture of Angkor and Ancient Cambodia: Millennium of Glory*, eds. Helen I. Jessup and Thierry Zéphir. Washington D.C.: National Gallery of Art, 1997, pp. 22–32.

———. "Forgetting to Remember, Again: On Curatorial Practice and 'Cambodian Art' in the Wake of Genocide". *diacritics* 41, no. 2, 2014: pp. 82–109.

———. "Introductory Remarks between the Lines: Writing Histories of Middle Cambodia". In *Other Pasts: Women, Gender and History in Early Modern Southeast Asia*. Honolulu Center for Southeast Asian Studies, University of Hawai'i, 2000, pp. 47–68.

———. "Mémoires du Cambodge". PhD dissertation, Université de Paris VIII, 1999.

———. "Pilgrims to Angkor: A Buddhist 'Cosmopolis' in Southeast Asia?". *Bulletin of Students of the Department of Archaeology, Royal University of Fine Arts, Phnom Penh* 3, 2004: pp. 88–119.

Tuy Danel and Martin Polkinghorne. "Cambodian Narratives: Transformations of the Vessantara Jataka". *The Asian Art Society of Australia Review* 24, no. 2, 2015: pp. 7–9.

Vickery, Michael Theodore. *Cambodia after Angkor: The Chronicular Evidence for the Fourteenth to Sixteenth Centuries*. PhD dissertation, University of Michigan, 1977. (Annotated 2012.)

———. "L'inscription K.1006 du Phnom Kulên". *BEFEO* 71, 1982: pp. 77–86.

———. "History of Cambodia: Summary of Lectures given at the Faculty of Archaeology Royal University of Fine Arts". Unpublished Lecture Notes, Phnom Penh, 2001–2.

Wolters, Oliver William. "The Khmer King at Basan (1371–3) and the Restoration of the Cambodian Chronology During the Fourteenth and Fifteenth Centuries". *Asia Major* 12, no. 1, 1966: pp. 44–89.

Woodward, Hiram W., Jr. "The Buddha images of Ayutthaya". In *Kingdom of Siam: Art from Central Thailand (1350–1800 C.E.)*, ed. Forrest McGill. Ghent: Snoeck Publishers; Bangkok: 1 Buppha Press; Chicago: Art Media Resources Inc.; San Francisco: The Asian Art Museum of San Francisco, 2005. pp. 47–59.

———. "Prologue. What there was before Siam: Traditional Views". In *Before Siam: Essays in Art and Archaeology*, eds. Nicolas Revire and Stephen A. Murphy.

Bangkok: River Books, 2014, pp. 14–29.

——. *The Sacred Sculpture of Thailand*. Baltimore: The Trustees of the Walters Art Gallery, 1997.

LIST OF CONTRIBUTORS

Ea Darith received his Bachelor of Arts from the Royal University of Fine Arts in Phnom Penh in 1995, his MA from Kyoto University in 2000, and his PhD from Osaka Ohtani University in 2010. Since 2000, he has been working at APSARA , and teaching the history of Khmer ceramics at the Royal University of Fine Arts. He has long coordinated a spectrum of diverse projects between APSARA and numerous international teams. Darith's main research interests focus on Khmer stoneware ceramics from the ninth to fifteenth centuries. He has published widely on this subject in particular, and maintains an interest in the transition from the Angkorian to the Cambodian Middle Period at Angkor.

Acknowledgements

I would like to thank Professor Ashley Thompson for inviting me to participate in this book project I would like to thank the APSARA Authority for supporting my research projects in Angkor. I would like also to thank Dr. Kyle Latinis, the Senior Research Fellow, Nalanda Srivijaya Centre, Institute of Southeast Asian Studies, Yusof-Ishak Institute for helping to edit this paper.

Martin Polkinghorne is a Senior Lecturer in Archaeology, Flinders University, South Australia, and an Honorary Research Fellow of the University of Sydney. Martin completed his PhD at the University of Sydney and has held several Australian Research Council grants. He currently leads projects conducting the first archaeological investigations of Cambodia's Early Modern Period capitals on the banks of the Mekong and Tonle Sap arterial rivers. Polkinghorne is author of numerous articles including contributions to the *Journal Asiatique*, the *Bulletin de l'École française d'Extrême-Orient*, and the *Proceedings of the National Academy of Sciences of the United States of America*.

Acknowledgements

This chapter was conceived during a Terrence and Lynette Fern Cité Internationale des Arts Residency Fellowship 2015 awarded by the Power Institute for Art and Visual Cultures of The University of Sydney. I am grateful to the fellowship host institution, EFEO Paris, and in particular its photothèque and director Isabelle Poujol who generously provided access to their archives. Thanks to David Brotherson, Chhay Rachna, Nandana Chutiwongs, Gabrielle Ewington, Forrest McGill, Christophe Pottier, So Malay, Nalinthone Phannolath, Phouvieng Phothisane, Suy Pov, Tun Puthpiseth, Simon Warrack, the Chantharakasem National Museum (Ayutthaya), and the Ho Prakeo Museum for assistance on various aspects of the paper. Special thanks to David Chandler, Grégory Mikaelian, Ashley Thompson, and Hiram Woodward for discussions and insightful comments on a draft of the text. This work was supported by the Australian Research Council under Grants DE150100756 and DP170102574.

Samerchai Poolsuwan is professor of anthropology at Thammasat University, Thailand, and holds a doctorate degree from the University of Michigan, Ann Arbor. His current research, focusing on Buddhist iconography in the

Theravādin context of Southeast Asia, has yielded a number of publications on exploration of the Pagan-period and the early Thai Buddhist murals (for example: *Artibus Asiae*, 72(2): 377–97 & 76(1): 37–80; *Journal of the Royal Asiatic Society*, 27(2): 255–94; *Journal of Burma studies*, 19(1): 145–97; *SUVANNABHUMI*, 6(1): 27–65).

Acknowledgements

In preparing this manuscript, the author has benefitted from comments by Hiram Woodward, Ashley Thompson, Don Stadtner, Nandana Chutiwongs, Nicolas Revire and the anonymous reviewers. Saya Minbu Aung Kyaing assisted the author on reading inscriptions of the Pagan-period murals. Issarachai Buranaaj helped in providing the map used in the article. The work is supported by the Thailand Research Fund (TRF) (Grant RTA 5880010).

Nicolas Revire is assistant professor at Thammasat University, Faculty of Liberal Arts, Bangkok, and holds a doctoral degree from the Université Paris 3–Sorbonne nouvelle in France. He specialises in the Buddhist art and archaeology of mainland Southeast Asia with a research focus on pre-modern Thailand and Cambodia. He is general editor of a collective volume titled *Before Siam: Essays in Art and Archaeology* (Bangkok, 2014), and is conducting a research project on the "Life of the Buddha at Angkor" for the Centre of Khmer Studies and the École française d'Extrême-Orient.

Acknowledgements

It is my great pleasure to acknowledge the editor of this volume, Ashley Thompson, along with Hiram Woodward, for their close reading and useful comments on this essay. I am also grateful to Yuni Sato for providing a copy of the excavation report of Western Prasat Top in Angkor, and to many other colleagues who generously shared various material, references, and photos, and in particular Trent Walker for his decisive assistance regarding Khmer sources. As always, I am most obliged to Leedom Lefferts for editing the language. Finally, I also wish to acknowledge the gracious support of the Thai Research Fund (Grant RTA5880010).

Yuni Sato is a researcher at the Nara National Research Institute for Cultural Properties, Japan. She received her MA in Archaeology from Waseda University, Tokyo, in 2006. She is currently a PhD candidate in Archaeology at Waseda. She has been involved with research and restoration work at Western Prasat Top, Angkor Thom, Cambodia, since 2008. She co-leads a collaborative research project on the Cambodian Middle Period, and has published on cultural objects from late Angkorian to Middle Period Cambodia.

Ashley Thompson (BA Harvard, MA Université de Paris 3, PhD Université de Paris 8) is Hiram W Woodward Chair of Southeast Asian Art at SOAS University of London. Her research focuses on the classical and premodern arts and literatures of Southeast Asia, with a particular emphasis on Cambodia. Her most recent monograph is *Engendering the Buddhist State: Territory, Sovereignty and Sexual Difference in the Inventions of Angkor* (Routledge, Critical Buddhist Studies, 2016). She is co-editor of the *Routledge Handbook of Theravāda Buddhism* (2022).

Tuy Danel graduated in 2007 from the Department of Archaeology, Royal University of Fine Arts, Phnom Penh, after completing a BA thesis entitled "Gaṃnūr khmaer nau tām vatt knuṅ samǎy ekarājy" [Khmer Mural Painting of the Independence Period]. In 2010, with a grant from the French Embassy, he completed his MA in Art History at the Paris-Sorbonne University (Paris IV). Since 2017, he has been a doctoral student at INALCO in Paris, under the supervision of Professors Michel Antelme and Vincent Lefevre. The title of his PhD dissertation in progress is "The Ten *Jātaka*, from Buddhist Literature to Mural Paintings in Cambodia".

Hiram Woodward, Mr. and Mrs. Thomas Quincy Scott Curator of Asian Art Emeritus, the Walters Art Museum, is the author of *The Art and Architecture of Thailand From Prehistoric Times through the Thirteenth Century* and the principal author of *The Sacred Sculpture of Thailand: The Alexander B. Griswold Collection, The Walters Art Gallery*. He became Asian art curator at the Walters in 1986, after periods of teaching at the University of Michigan and the University of Vermont. His contribution to this volume draws on his dissertation, on the Lopburi art of Thailand (Yale University, 1975).

INDEX